TYPES OF EXHIBITORS

At the Palais de l'Industrie. At the Palais des Beaux-Arts.

Damourette in *L'Illustration*, 30 June 1855.
Bibliothèque Nationale, Paris.

ART AND POLITICS
OF THE SECOND EMPIRE

THE UNIVERSAL EXPOSITIONS OF 1855 AND 1867

Patricia Mainardi

Yale University Press
New Haven and London
1987

Set, printed and bound in Great Britain
at The Bath Press, Avon

Library of Congress Cataloging-in-Publication Data

Mainardi, Patricia.
　　Art and politics of the second empire.

　　Bibliography: p.
　　Includes index.
　　1. Eclecticism in art—France.　2. Art—Political
aspects—France.　3. Art, French.　4. Art, Modern—
19th century—France.　5. Art—France—Exhibitions—
19th century—History.　6. Napoleon III, Emperor of the
French, 1808–1873—Art patronage.　I. Title.
N6847.5.E34M3　1987　　　709′　　　87-6268
ISBN 0-300-03871-2

Front endpaper: *Artists bring work to the Palais des Beaux-Arts. Universal Exposition, 1855.*
Bibliothèque Nationale, Paris.

Back endpaper: *Taking down the Universal Exposition of 1867.* Bibliothèque Nationale, Paris.

Contents

Acknowledgments

DURING THE YEARS when this book was completing its journey from research notes to its present form, I have benefited from advice, assistance, and support from many individuals and institutions. I acknowledge them here with warmth and gratitude.

Research in France was made possible by a Chester Dale Fellowship from the Center for Advanced Study in the Visual Arts at the National Gallery of Art, Washington, D.C. and later by a faculty research grant from the City University of New York, through its PSC–CUNY Research Award Program. While in France, a residence grant from the Cleveland Institute of Art took me to its summer program in Lacoste; I am grateful to Bernard Pfriem, its director. The American College in Paris has provided support of various kinds throughout the years and it is a pleasure to acknowledge the assistance of its faculty and administration, in particular Filiz Burhan, Madeleine Fidell-Beaufort, Charlotte Lacaze, and G. Stephen Ryer. Much of the writing was done at the Artists for Environment Foundation in Walpack Center, New Jersey, where Trish Denby, Acting Director, invited me in the spring of 1983.

I began this study as a doctoral dissertation at the City University of New York under the supervision of John Rewald, completed under Linda Nochlin. I hope that my work at its best reflects what I have learned from them, for they have each had a profound influence on this book. Diane Kelder has made many valuable suggestions in the course of my work and Jack Spector, as both advisor and friend, was involved from the beginning and has contributed to every aspect. At a critical moment in its development, Stuart L. Campbell exerted a major influence both through his valuable study *Second Empire Revisited* and through many discussions on specific issues. Louis Finkelstein, always both friend and critic, has seen me through several drafts of this work, and has contributed a great deal to its development.

I feel it is appropriate also to acknowledge Minda Gunzburg and Philippe Roberts-Jones who have both written theses on aspects of this study, and those historians whose work has preceded and influenced mine: Albert Boime, Timothy J. Clark, Francis Haskell, Robert Herbert, Elizabeth Gilmore Holt, Joseph C. Sloane, Frank Anderson Trapp, Theodore Zeldin, Henri Zerner. Although we may differ on many issues, their work has informed my own and I am grateful for it.

Among those who have significantly aided my research, I thank Kenneth Carpenter of Harvard University, Madeleine Fidell-Beaufort of the American College in Paris, Geneviève Lacambre of the Musée d'Orsay, Mme Laffitte-Larnaudie of the Archives of

the Institut de France, François Pérot, of the Petit Palais, Mme Besson of the Archives du Louvre.

Many friends and colleagues have helped in various ways, and although debts of friendship can never be fully repaid, I express my gratitude to Dudley Barksdale, Morris Dorsky, Carol Duncan, Patricia Dunsmore, Pascale Falk, Jack Flam, Peter de Francia, Pamela and Michael DeSimone, Samuel Gelber, Joel Isaacson, Eugenia and Arthur Kaledin, Susan Koslow, Rose-Carol Washton Long, Theodore Reff, Angelica Rudenstein, Daniel Sherman, Sandra Kwock-Silve and Bernard Silve, Virginia Spate.

Over the past several years, a number of articles from this work have been published by various journals; I thank especially those editors for their support: Elizabeth C. Baker, *Art in America*; Beatrice Farwell, *Art Journal*; Richard Martin, *Arts Magazine*; Jean Adhémar, *Gazette des Beaux-Arts*; Elizabeth MacDougall, *Journal of the Society of Architectural Historians*. At Yale University Press, I owe a debt of gratitude to John Nicoll who sponsored this publication, to Judy Metro for her unfailing support, and, in particular, to my editor and designer Gillian Malpass with whom it was a pleasure to collaborate.

My last and greatest debt of gratitude is to my parents, Vonda and Louis E. Mainardi, who, in many ways, made this book possible. I dedicate it to them.

Brooklyn College and the Graduate Center Patricia Mainardi
City University of New York
March 1987

Note to the illustrations

Titles are translations of those used in the catalogues of the Universal Expositions; where these differ greatly from museum titles, the latter are given in parentheses at the end of the citation.

Introduction

MODERNISM, AS VARIOUSLY DESCRIBED, traces changes in aesthetics. But why do aesthetics change, and what is the meaning of aesthetic change by way of causation? This study seeks to answer part of that question through an exploration of the interaction of art and politics in the polemics accompanying the first Universal Expositions.

Such exhibitions have been held throughout the world since 1851, when the English invited all the nations of the world to come and display their products in the Crystal Palace. Designed to encourage industry and international trade, these huge, sprawling shows were encyclopedic in the nineteenth century, including a broad range of human productivity in all spheres. Within this context, the fine arts played a minor role. Why, then, devote a major study to what traditionally have been considered minor art-historical events?

It is my thesis that the two Universal Expositions of the Second Empire, 1855 and 1867, served as catalysts for the collision of art and politics which produced many of the institutions and attitudes which we still associate with Modernism. This is not to underestimate the role played by other structures and events, but rather to apply Marx's metaphor of revolution being like water boiling, events imperceptibly raising the temperature until, finally, there is a clear and visible qualitative change.

If we compare the art world before and after the Second Empire (1851–1870), it is evident that after 1870 the modern system was in place. The best artists no longer expected a career of government medals, honors and commissions. The Salon and the Académie des beaux-arts had lost their former authority, private galleries, dealers, even private art training, had replaced government institutions, and artists had begun to organize their own shows. The classical system of categories, according history painting the highest prestige, had been overturned; the best painting of the second half of the nineteenth century was intimate in subject, small in size. Art historians are virtually unanimous in placing the origins of Modernism in the Second Empire, and yet exactly why this came about has always been something of a mystery. Rather than proposing a neat solution to the question, my intention is to show the process by which this happened, focusing on the Universal Expositions of 1855 and 1867, the first major international fine-art exhibitions.

The Second Empire was itself a polyglot of diverse interest groups, the support of all of which was necessary for the maintenance of the regime. In the organization of the international expositions these converging and conflicting forces were forced to work

together for the first time: government officials, representatives of the Academy which had traditionally exercised a monopoly over national exhibitions, independent artists, industrialists, aristocrats old and new, journalists and men of letters of various political stripes, art critics, collectors, and what goes under the ambiguous name in France of *amateurs*. As a result of this move towards representation of all special interest groups, the world of art was forced abruptly into alignment with the new social and political reality. In the crucible of the Expositions, the force of politics in its larger sense, not simply control of government, but the orientation of values, symbols and images, the manoeuvring of certain perceived interests and norms, morality and behaviour, were brought to bear on the world of art, hastening a process whereby art institutions were becoming "modern" by taking on the image of the ruling economics, capitalism, the ruling politics, democracy, and the ruling class, the bourgeoisie. The Expositions reflected as much as provoked these new circumstances, but in either case it is the official government ratification of already existing social, political, economic and aesthetic forces which signals the beginning of the new order. The focus of this study is thus less on the development of what has been called the avant-garde than on the weight of the entire institutional structure which, by initiating or ratifying changes, provided the material base for these and other aesthetic developments. My intention is to show the role of art institutions and of forces—social, political, economic—which a Modernist reading has held to be external to the world of art.

This institutional structure was complex and many faceted. Certainly the organization and decisions taken by the various ministries, commissions and juries form an important part. The Imperial Commissions and International Juries, through their governmental authority, could and did propose aesthetic solutions whose influence was far greater than that of the annual Salon. Equally important was the reaction of the public which both influenced and was influenced by these decisions. My analysis of the critical reaction shows that there were many publics and that, despite censorship, each journal addressed itself to a different one. In this there was nothing particularly new, but as the Second Empire was based on universal manhood suffrage, the necessity of attending to the opinions of all constituencies became government policy, in aesthetics as in other spheres. The Universal Expositions of 1855 and 1867 and the Salon des refusés of 1863 were the manifestations of this exigency in the world of art.

The danger in studying the critical reaction to any event is that one can find almost anything there and prove almost anything thereby. What I have looked for instead is the common thread running through all the commentaries which reveals the issues incarnate in each Exposition: individual reactions form constellations around these issues and these constellations provide the basis for several of my division titles. Thus in 1855, it was the "Apotheosis of Eclecticism," in which the regime, in order to appease all factions at home and to present a united front in the face of foreign competition, was forced to ratify the various trends existing in contemporary French art. The hegemony of the Académie des beaux-arts over the French School was broken, and, despite its protests, all styles were sanctioned by Medals of Honor. Thus was abandoned, eight years before the Salon des refusés, traditional aesthetic leadership by Government and Academy. The immediate result was an uneasy coexistence among all styles which would henceforth have to compete for public favor. By 1867, the

overriding issue was the "Death of History Painting," the natural consequence of the passing-away of the earlier generation of painters and the loss of aesthetic leadership by Government and Academy. As a result, the Jury awarded most of the Medals of Honor to genre painters, the favorites of collectors and the public, and genre painting acceded to the place of honor formerly held by history painting. An important sub-theme here, in terms of official support and recognition is "Landscape: The Path Not Taken". Each Exposition was seen through a frame of such consensual issues, each artist viewed as an instance of these general concerns, each individual work of art a sub-category of that. Certainly some fine nuances of meaning are lost here, and yet that is precisely my point: that the individual work of art was (and still is) viewed through a frame of preconceptions and prejudices that either reveal or conceal aspects which at other times are taken as "true." During the Second Empire this frame was decidedly political. Extreme political reactions to works of art had, of course, begun earlier, and they by no means ended in 1870; nonetheless the Second Empire is unique in its attempt to use Government policy to depoliticize art.

Although in the course of this study I discuss, on occasion, individual works of art or artists' careers, my focus is on this political frame. I give unequal attention to the major artists of the period for the same reason. Artists as the nexus of controversy receive more attention since they represented forces that could not be assimilated; the resulting clash illuminates all camps. In order to establish the major forces in their historical context, I treat sometimes events, sometimes themes, in a kaleidoscopic mélange of the chronological and the theoretical—an approach suggested by the structure of the Universal Expositions themselves.

This study rejects both the role of justifying the avant-garde of established Modernism and that of revisionist history which promotes other artists into their place. I am trying instead to show the points of stress and accommodation between art and politics, art and institutions, and to show the process whereby the rule of popular taste was substituted for the authority of Government and Academy. Conservative art critics blamed this on democracy and saw quite clearly that it was the inevitable concomitant of the political and economic changes which had taken place since 1789. The bourgeoisie had replaced the aristocracy as the patron of art: the Second Empire celebrated the triumph of its taste. Although contemporaries, particularly political and aesthetic conservatives, emphasized the negative aspects of this change, it is important to understand its dialectics. For if the Grand Tradition of David and Ingres ended in the banalities of their students, then genre painting, first officially recognized at the Salon of 1868 by the bestowal of the Grand Medal of Honor on a mediocre painter, Gustave Brion, was what made possible and plausible the works of the future Impressionists.

I
THE ORIGINS OF
UNIVERSAL EXPOSITIONS IN FRANCE

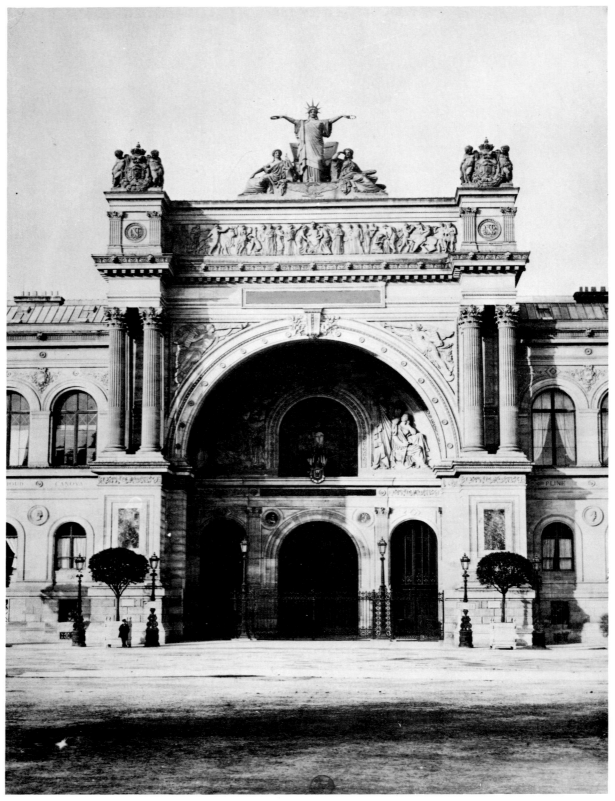

1. *Entrance to the Palais de l'Industrie*. Sculpture by Elias Robert, 1851. Photograph by Guevin, 1865. Bibliothèque Nationale, Paris.

I

Traditional Rivalries

ABOVE THE ENTRANCE PORTAL of the Palais de l'Industrie at the first French Universal Exposition, there stood a sculptural group by Elias Robert showing the allegorical figure of France offering crowns to Art and Industry (Plate 1). A contemporary account lamented that while Industry, energetic and confident, held a hammer and leaned on an anvil, Art, sad and dejected, gazed listlessly out into space.[1] Why, on this momentous occasion, should Art be so dispirited? We must begin by understanding traditional rivalries between art and craft in France.

In this conflict, the institution of "exposition" was a powerful ideological weapon. The first government-sponsored exposition of painting and sculpture had been held in 1667 during the reign of Louis XIV under the auspices of the newly founded Académie royale de peinture et de sculpture.[2] The first government-sponsored exposition of industry, however, was not held until after the Revolution, in 1798, under the auspices of the Directory. The former was intended to serve the interests of the monarchy, the latter those of the bourgeois Republic. This dialectic between art and industry, the monarchy and the bourgeoisie, had a long history in France, extending back to the beginning of guild chronicles. Although theoretically equal, some guilds were more privileged than others. Those in the luxury trades ranked highest, among them painters and sculptors, for, as their regulations stated, their clientele consisted of "the Church, Princes, Barons and other rich and noble men."[3] Their guild, the Communauté des maîtres peintres et sculpteurs de Paris, dated its origins from 1391. Its regulations stated that no foreign art could be sold in Paris unless first inspected by the *gardes du métier*, for, it was averred, foreign art was frequently of inferior quality.[4] Only eight years after this attempt to stop the influx of foreign art and, presumably, foreign artists, Charles VI made the first recorded exemptions from guild rule, thus establishing a breach between court and guild artists.[5] These exemptions, sometimes based on merit, sometimes on court favor, became more and more common until, by the end of the reign of Louis XIII (d. 1643), the title of *Peintre* or *Sculpteur du Roi* had been so freely bestowed on incompetents that it no longer carried any prestige.[6]

If enough artists were given exemptions, the guild itself would cease to exist, and it was this fear, no doubt, that prompted it to attack court artists in 1646 by requesting Parlement to curtail their numbers and privileges.[7] That body, however, representing the aristocratic and bourgeois opposition to the monarchy, supported the Communauté, and a long fight ensued which precipitated the foundation of the

Académie royale de peinture et de sculpture in 1648.[8] Led by the painter Charles LeBrun, recently returned from Italy, and Martin de Charmois, former secretary to the French ambassador to Rome, the artists petitioned the ten-year-old Louis XIV to restore the prestige these arts had enjoyed in Athens at the time of Alexander when "everybody knows they held first place among the liberal arts."[9] This was, of course, untrue; the traditional seven liberal arts (grammar, rhetoric, dialectic, arithmetic, geometry, astronomy and music) were those intellectual pursuits practiced "freely," that is, outside guild restrictions, by free men.[10] Painting and sculpture, considered work of the hand, not of the brain, were excluded, nor had they any muse. In the schema formulated in the twelfth century by Hugo of St. Victor, painting, sculpture and architecture were included as a subdivision of *armatura* (armaments) among seven mechanical arts corresponding to the liberal arts. They included *lanificium* (wool-working), *navigatio* (navigation), *agricultura* (agriculture), *venatio* (hunting), *medicina* (medicine), *theatrica* (theatre). This schema was followed until the Renaissance when, first in Italy and later in France, artists began the attempt to raise their status and free themselves from guilds and classification with the mechanical arts.

To this end, Charmois recounted how previous kings had honored artists, how François I had invited Leonardo to France where, under current guild restrictions, not even Michelangelo or Raphael would be allowed to work. The petition set forth in detail the concept of the "learned artist" who, in contrast to the "ignorant artisan," needed years of study to perfect his art.[11] It was a brilliant attempt to link painting and sculpture with the already accepted liberal arts, and it succeeded, for, in his response, Louis XIV condemned the "ignorance and vulgarity" of most artisans and pronounced painting and sculpture to be a branch of the liberal arts.[12]

From 1648 until the 1790s when both guilds and academies were suppressed, there was constant feuding.[13] Political opposition to the King could be legally expressed through court decisions against his Academy. He retaliated by giving Academicians privileges above those awarded to even the most privileged of guilds, and, as early as 1663, required membership of all court artists.[14] Thus was established the liaison between fine art and the monarchy on the one hand, against métier and the bourgeoisie on the other.

Throughout the seventeenth and eighteenth centuries, both King and Academy did their utmost to accentuate this division between art and craft, but, despite their efforts, painting and sculpture were usually included, as they had traditionally been, among the mechanical arts. The term *beaux-arts* made its first appearance in 1640 but did not officially enter the French language until 1798, for the reorientation of the system of the arts into those which admit of progress based on the accumulation of knowledge—what we now call sciences—and those based on individual talent and concepts of beauty and taste—what we now call fine arts—was just coming into being.[15]

In breaking away from guild rule, Academicians emphasized the theoretical and non-commercial aspects of their profession; as it was characteristic of artisans to keep open shops, they refused to do so. According to memoirs attributed to Henri Testelin, the first *secrétaire* of the Academy, this decision took place c.1648–1649:

> When this proposal was placed before a general assembly of the Academy, it was decided that all members, under penalty of being expelled, would refrain from

8

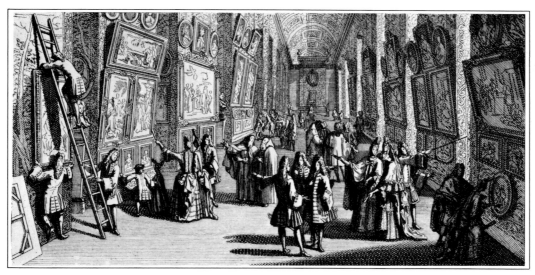

2. A. Hadamart, *The Salon of 1699, Grande galerie, Louvre*. Bibliothèque Nationale, Paris.

keeping an open shop for displaying their work, from exhibiting it in windows or outside their place of residence, from posting any commercial sign or inscription, or from doing anything which might confuse the honorable rank of Academician with the debased and mercenary rank of Guild Master.[16]

The very idea of exhibition was tainted with the commercialism that Academicians were trying to escape. It was thus with little enthusiasm that in 1663 they received new royal statutes which specified that at the annual election of officers, each Academician would be required to bring a work with which to decorate their meeting rooms in the Palais-Royal.[17]

By 1666 they had held only one such exhibition. In that year Colbert intervened; in desultory fashion, with many postponements and abstentions, the Academicians complied, the exhibition of 1667 often being cited as the first official Salon. In 1673 the exhibition, too large for the meeting rooms, was moved to the courtyard of the Palais-Royal, and, in 1699, Mansart arranged to have it moved into the Louvre where it remained for the next 150 years, eventually acquiring prestige (Plate 2).[18] Mansart's decision was a stroke of genius; a contemporary account in *Le Mercure galant* reveals a motivation as much political as aesthetic:

M. Mansard [sic], Surintendant & Ordonnateur des Batiments du Roi, Protecteur de l'Académie, wanting to transform everything which might contribute to the advancement of the fine arts, obtained from the King permission to hold an exhibition of the works of painters and sculptors in the *grande galerie* of his palace of the Louvre. The public has shown by its attendance the pleasure it has derived from the exhibition of so many masterpieces. Foreigners have admired them and have agreed that only France is capable of producing such marvels and that this is due to the King's protection and generosity, which has made it possible for the fine arts to reach

9

such a high degree of perfection that there is no nation today which can dare to challenge it.[19]

Exhibitions in France were proposed and maintained by the Government which derived political benefits from cultural prestige; they were received with interest by the public, which regarded them as a spectacle, and with distaste by Academicians, who thought them vulgar. Throughout the nineteenth century, the Academy maintained a contradictory attitude towards the Salons: it wanted to abolish them or hold them as infrequently as possible, for they still bore the odious taint of commercialism; at the same time it wanted to maintain total control of them and limit participation to Academicians, or at least to fellow travellers.[20] Implicit in both attitudes was the principle that the most distinguished artist worked only on commission and would exhibit solely for didactic purposes; to exhibit unsold work was like being a shopkeeper.

If it is understandable that painters and sculptors did not want to be considered ignorant artisans practicing a mechanical art, it is equally comprehensible that this was no more attractive to members of the Communauté who, to begin their own ascent in status, modelled their language and institutions on those of Academicians; they even retitled their guild ''l'Académie de Saint-Luc.''[21] Considering the variety of work done under its auspices—everything from theatre sets to funeral decorations—it is surprising that the Académie de Saint-Luc did not take the opportunity to mount the first industrial exposition. Instead, when it began holding regular exhibitions in 1751, it did its best to imitate the official Salon.[22] There were seven exhibitions in all, the fine artists meeting with increasing hostility from the artisan members. Violence erupted in 1764, no exhibitions were held for ten years, and in 1774 the Academy finally succeeded in having them suppressed. Their successor, the Exposition du Colisée, was, in turn, suppressed in 1777.[23]

A similar situation existed in the Académie royale des sciences, and demonstrates Roger Hahn's statement that ''The age-old disdain for *techne* was especially persistent in France.''[24] This academy was founded in 1666, somewhat later than the others, held its first public meeting in 1699, and was only legally recognized in 1713.[25] This corresponds to the lower esteem in which science, as opposed to literature and art, was held by the monarchy. From the beginning, artisans such as inventors were excluded, emphasis being placed on more theoretical pursuits such as mathematics. The one exposition of industry recorded in France before 1798 was held in Paris in 1683 and included only machines demonstrating laws of physics.[26] As a result of this neglect, France lagged behind Northern countries such as England, Holland and Germany, and did not develop the applied science and technology necessary for advances in theoretical knowledge.[27] In England, for example, from the 1645 foundation of the Royal Society for Improving Natural Knowledge, inventors were honored, and, beginning in 1761, the Society of Arts held exhibitions of machinery.[28] If Northern attitudes towards work can be attributed to a bourgeois Protestant ethic which assigns it a high value, France can be seen as belonging to the aristocratic, Catholic, and Latin tradition which, valuing the spiritual and intellectual component in work, downgrades the ''merely'' physical.

There were, of course, those in France who understood the necessity of encouraging industry and artisans. Colbert worked tirelessly to this end and even tried to persuade

Louis XIV to receive merchants at court.[29] Diderot understood very well that a nation that disdained industry could not survive; in his *Encyclopédie* he repeatedly attacked French prejudice against the mechanical arts.[30] Contempt for commerce and manual labor, however, made investment in industry unattractive to the aristocracy; it would take a revolution to revamp the structure of French society.

By the late eighteenth century, blame for the stagnating economy was being placed on the guild system which was accused of preventing all progress. Louis XVI abolished it altogether in 1776; within a few months, pressure from court and Parlement had forced its reinstatement.[31] The next year he issued a *Déclaration* clarifying the relationship between the Académie royale and the Académie de Saint-Luc, for, as he explained, "the arts of painting and sculpture must never be confused with the mechanical arts."[32] He decreed that anyone who dealt in art or art materials had to join the Guild, while all painters and sculptors would be forced to join the Académie royale which would henceforth operate the only legal art school. This decree not only outlawed the Académie de Saint-Luc, but it also completed the split between art and métier in France. Until 1777 there had always been artists of unquestioned eminence, such as Vincent and Vigée-Lebrun, who, by their presence in the Académie de Saint-Luc, lent prestige to an alternate system of art. From this date on, however, there was to be only one system for the fine arts. This was further clarified by a later decree specifically excluding from the Academy any artist involved in commercial dealings in art.[33] This was the real artistic legacy left by Louis XVI, and the Revolution did nothing to undo it.

In 1791 the National Assembly decreed the suppression of the guild system in its entirety, with all its rights and privileges; in 1793 the National Convention suppressed the academies, the last privileged groups.[34] In 1795 when the Institut national des sciences et des arts was established to replace the defunct academies, the order of prominence was reversed, both in its title and in the order of classes: the sciences were now first and the arts last.[35]

With one stroke, the old rights, privileges and monopolies were gone and both guilds and academies were abolished. Artists gained the right to exhibit their work and, from 1791 on, the Salon was theoretically open to all. Industry was free to develop and both the right to work and freedom of production were established, but the old contempt for the mechanical arts proved harder to erase.

2

Building the Temple of Industry

AFTER THE REVOLUTION the French economy was in shambles, for, with the aristocracy gone, the luxury trades had collapsed. Survival as a nation now depended on industrial development, in turn held back by traditional values and traditional rivalries. As part of the consequent plan to unite the French people behind revolutionary virtues, Jacques-Louis David orchestrated a series of public festivals into effective weapons of propaganda.[1] Involving thousands of people, they combined music and drama, oratory and chorus in great, choreographed spectacles. Robespierre's 1794 Fête de l'Etre suprême was undoubtedly the finest of these, including among its features an artificial mountain (Plate 3); in the same year, he proposed to the National Convention a new series of fêtes, one of which would honor industry.[2] It is, then, one of the ironies of history (but surely an example of dialectical materialism) that the concept of the Universal Exposition—the great festival of capitalism—owes its origins to Robespierre. The year 1794, however, saw Robespierre's fall and David's imprisonment; not until 1798, under the Directory, was the idea again taken up.

There are various accounts of the origin of this first industrial exhibition. The most credible was written by a contemporary, Anthelme Costaz and is worth quoting in its entirety, although, in translating the revolutionary calendar back into the Gregorian one, he has mistakenly given the date as 1797 instead of 1798:

> The idea of establishing expositions of the mechanical arts came on the occasion of a festival organized in 1797 by the Executive Directory to celebrate the anniversary of the Foundation of the Republic. They wanted this festival to be memorable and to this end François de Neufchâteau, then Ministre de l'Intérieur, invited several distinguished men to discuss what measures should be taken. Although at first there was a great divergence of opinion, all agreed that to be satisfied with dances, slippery poles, and other games would be to repeat what is seen everywhere, that it was necessary to find some novelty which would be astonishing and new. Someone suggested producing this effect by giving the festival the appearance of a village fair, quite lively but more grandiose. According to someone else, an exposition of painting, sculpture and engraving could be added to the dances, slippery poles, chariot and horse races, for still another source of enjoyment. This made François de Neufchâteau realize that if the pleasurable arts (*arts d'agrément*) were the object of such solemnity, it would be beneficial to give the mechanical arts the same advan-

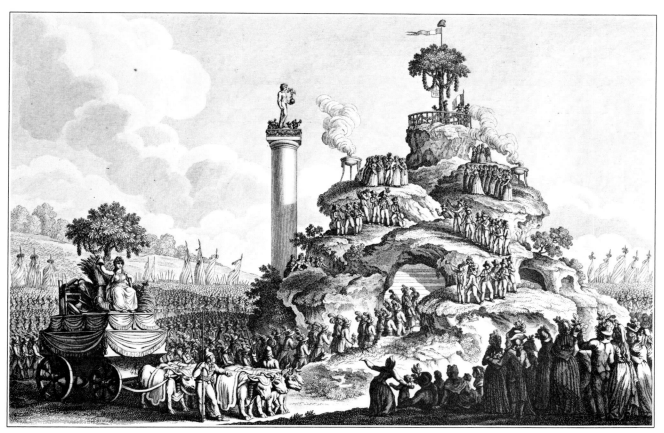

3. Fête de l'Etre suprême, Paris, 20 prairial, an II (10 May 1794). Bibliothèque Nationale, Paris.

tage. This proposal pleased all those present and they gave it their approval with all the more enthusiasm because it would result in a new and astonishing spectacle.[3]

This first Exposition publique des produits de l'industrie française took place during the jours complémentaires, an VI (17–21 September 1798), a modest event in the revolutionary New Year celebration of that year (Plate 4).[4] Notably absent were the allegorical figures and theatrics of earlier festivals; instead, 110 exhibitors solemnly marched across the Champ-de-Mars to an enclosed area behind the main fête where a tiny Temple of Industry, a replica of the Choreggic Monument of Lysicrates, had been erected (Plate 5).[5] They were accompanied by heralds, troops of cavalry, military bands, the jury, and the Ministre de l'Intérieur François de Neufchâteau. After a ceremonial procession once around the exposition, the cortège returned to the main fête where, at the Altar of the Fatherland, Neufchâteau made the opening speech. "This spectacle is truly Republican," he stated; "it doesn't resemble at all those frivolous displays from which nothing useful remains."[6]

Neufchâteau was no idle dreamer; he was responsible for many pragmatic reforms in France, including the standardization of weights and measures, the compilation of economic statistics by *département*, and the first population census.[7] The exposition of industry was intended as a cultural reform, designed to free the mechanical arts from contempt and encourage their development. To this end, he spoke in his opening

13

4. *Fête de la fondation de la République*, Paris, 1 vendémiaire, an VII (22 September 1798). Bibliothèque Nationale, Paris.

5 (facing page top). Piton, *Exposition publique des produits de l'industrie française, Champ-de-Mars*, Paris, an VI–VII (September 1798). Engraving by Piton. Bibliothèque Nationale, Paris.

address of the traditional rivalry between the mechanical and liberal arts, of how the former had been so scorned that the very word *mécanique* had developed pejorative connotations. Forced to be "slaves of idle luxury," these arts had been elevated by the Revolution, and would now become instruments of social welfare and progress.[8] The jury then selected twelve *artistes* whose products were considered worthy of emulation, and these products—pencils and printed fabric, pottery and scientific instruments— were ceremonially placed inside the Temple of Industry, at the feet of a statue representing its reigning deity.[9]

Shortly thereafter, Neufchâteau sent a memorandum to all *départements* announcing that the exposition had been an enormous success and henceforth would be held annually. "A new era has now begun for these nurturing arts," he wrote.[10] A new era had also begun in the history of exhibitions, for henceforth they would no longer be limited to the fine arts.

Despite the efforts of Sieyès, President of the Directory, who proposed to make the exposition of industry part of the annual Fête de la fondation de la République, the measure appears to have been lost in the turmoil of the summer of 1799.[11] In the *coup d'état* of 18 brumaire, the Directory was replaced by the Consulate and Bonaparte emerged as First Consul. Industry was not competely forgotten, however, for in the courtyard of the Louvre (renamed the Musée central des arts) was placed a statue of *Industrie*, probably the one that had graced the Temple of Industry the previous year.[12]

Not until 1801 was the plan revived, on the initiative of Chaptal, Napoléon's Ministre de l'Intérieur. The *Rapport* he presented to the Consuls recommending another exposition also suggested that it be held in the courtyard of the Louvre. This would be more convenient, he pointed out, for it was in the center of Paris and valuable displays would be easier to guard.[13] His proposal was accepted and, as a result, the 1801 exposition is often cited as the first attempt to unite art and industry (Plate 6). This misunderstanding has proceeded from the coincidence of three major exhibitions, unrelated but sharing the same locale: the Exposition publique des produits de l'indus-

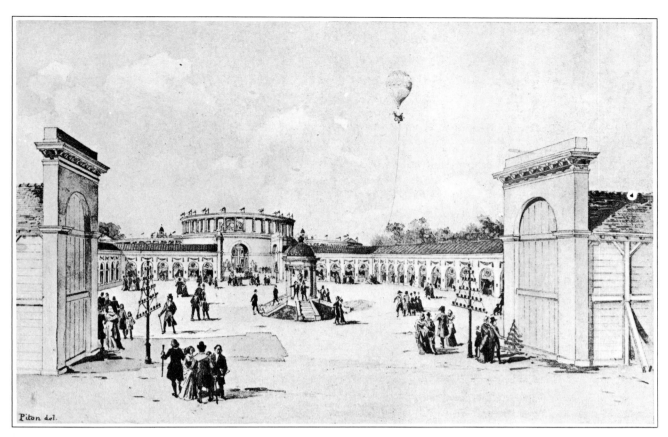

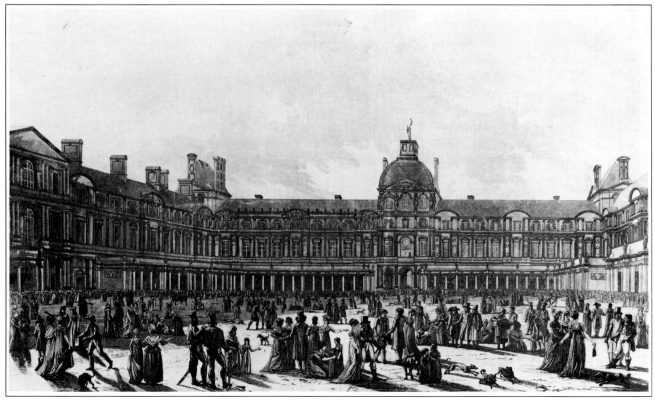

6 (above). *Exposition publique des produits de l'industrie française, Courtyard of the Louvre, Paris, an IX–X* (September 1801). Bibliothèque Nationale, Paris.

trie française, the annual Salon, and Jacques-Louis David's private exhibition.[14] Salons had been held in the Louvre from 1699, fêtes from 1799, and David, who like many artists of his time had a studio there, took advantage of the crowds to invite the public to view his paintings for a fee, a practice he had initiated two years earlier. The confusion has been augmented—or perhaps caused—by David's role in past fêtes, but after 1794 they were designed by the architect Chalgrin.[15] Coincidence though it may have been, the simultaneity of the three expositions in such a distinguished locale added immeasurably to the prestige of industry.[16]

A matter of semantics

Despite the undercurrent of resentment and competition which characterized the relationship of art to craft, there was also the recognition that artists enjoyed a prestige that artisans and industrialists would like to share. As a result, the terminology used in the early expositions is in need of clarification.

Throughout the eighteenth century, the distinction between the liberal arts and the mechanical arts was slowly giving way; the fine arts were gradually breaking away from the latter to form a separate category of the former. By 1789 the transformation was complete, and the fine arts, ruled by the Academy, constituted a privileged corporation. Only Academicians could receive government commissions or exhibit in the Salons, and within the Academy itself the hierarchy of *académicien*, *agréé*, and *élève* was similar to the guild ranking of *maître*, *compagnon*, and *apprenti*. As a result, the fine arts, only recently accepted into the liberal arts, were soon under attack, primarily for monopolizing the practice of exposition. In the first history of industrial expositions in France, presented to the Institut National in 1802, Citizen Camus explained that it was fitting to establish a national exposition of industry to take place concurrently with the Fête de la fondation de la République because only in a republic where liberty is everywhere could the mechanical arts be elevated to the status previously reserved to the liberal arts alone; this, he stated, would be done through the dignified practice of exposition.[17]

The term mechanical arts (*arts mécaniques*) was rarely used after the first exposition, probably because of its pejorative sense. One finds instead a new term, the useful arts (*arts utiles*), which emphasized both the value now attached to industry and what was perceived as the growing "uselessness" of the fine arts (*beaux-arts*), now often called the pleasurable arts (*arts d'agrément*).[18] The very concept of the liberal arts was under attack; in a struggle for national survival, they seemed a luxury France could ill afford.

As painters and sculptors were considered artisans practicing a mechanical art until well into the eighteenth century, their claim to the title of *artiste* was barely secure by 1789; the Revolution ushered in an era of equality in which that title, like the term *citoyen*, was freely applied to all. Virtually everyone was considered an *artiste* practicing an *art*; there were no longer *artisans* with *métiers*. This resulted in some peculiar rhetoric, as when the *Procès-verbal* of the 1798 exposition referred to "French artists in steel, in files, in crystal, in pottery, in printed fabric."[19]

In the early publications, the division between exhibitors was that of artists (*artistes*) and manufacturers (*fabricants*), the first category comprising all those who had a direct

relation to production, the second including those who owned the means of production but did not themselves work with their hands. The quarrels mentioned in the reports between *artiste* and *fabricant* (usually over prizes) were between worker and employer and not, as has often been stated, between artists and artisans.[20]

Throughout the nineteenth century it was emphasized that the industrial expositions were in the tradition of the Salon; any relationship to fairs or markets—considered crassly commercial ventures—was vigorously denied.[21] The twentieth century term "World's Fair" is, then, singularly inappropriate to describe these events. It was the idea of Progress which distinguished these *expositions* (the very word in French preserves a didactic meaning) from the fairs and bazaars of previous epochs. As in the Salon, there were honors and medals, not cash prizes, to stress the intellectual rather than commercial aspects of production. There were even *beaux-arts* sections in the industrial expositions; they included such products as wallpaper, fabrics, jewelry, furniture, bronze-casting, and art supplies. There were, however, no displays of painting and sculpture *per se*, although examples were sometimes included to illustrate materials or processes.[22]

Such semantic changes should be understood as part of the revolutionary attempt to remake all structures, including language, in the light of new politics.

Artistes et fabricants

During these years, the Exposition publique des produits de l'industrie française was repeatedly decreed an annual event, repeatedly postponed because of political exigencies. Nonetheless, eleven were held between 1798 and 1849. Kings, Emperors and Presidents came and went, Industry remained. Of all the Gods, Virtues and Fêtes of

7. Statistics for National Expositions of Industry, 1798–1849. Chart from the *Rapport général* of the 1889 Universal Exposition.

NUMÉROS D'ORDRE.	ANNÉES.	DATES D'OUVERTURE.	DURÉE.	EMPLACEMENT.	NOMBRE des EXPOSANTS.	NOMBRE des RÉCOM-PENSES.
1	An vi (1798)	3ᵉ jour complémentaire [1].	3 jours [1].	Champ de Mars.	110	31
2	An ix (1801)	2ᵉ jour complémentaire [1].	6 jours [1].	Cour du Louvre.	220	110
3	An x (1802)	1ᵉʳ jour complémentaire.	7 jours.	Cour du Louvre.	540	251
4	1806......	25 septembre.	24 jours.	Esplanade des Invalides.	1,422	610
5	1819......	25 août.	35 jours.	Palais du Louvre.	1,662	869
6	1823......	25 août.	50 jours.	Palais du Louvre.	1,642	1,091
7	1827......	1ᵉʳ août.	62 jours.	Palais du Louvre.	1,695	1,254
8	1834......	1ᵉʳ mai.	60 jours.	Place de la Concorde.	2,447	1,785
9	1839......	1ᵉʳ mai.	60 jours.	Champs-Élysées.	3,381	2,305
10	1844......	1ᵉʳ mai.	60 jours.	Champs-Élysées.	3,960	3,253
11	1849......	1ᵉʳ juin.	6 mois.	Champs-Élysées.	4,532	3,738

[1] Dates ou chiffres incertains (voir *supra*, p. 20 et 29).

the Revolution, Industry alone survived to become the reigning deity of the nineteenth century. Such expositions were held under the Directory (1798), the Consulate (1801, 1802), the Empire (1806), the Restoration (1819, 1823, 1827), the July Monarchy (1834, 1839, 1844) and the Second Republic (1849). Regardless of regime, the current ruler of the nation visited the exposition and presided over the Awards Ceremony; regardless of regime, the number of exhibitors and honors increased (Plate 7). There were 110 exhibitors and 23 honors in 1798; the Salon that year had 263 exhibitors. By 1849, there were 4,532 industrial exhibitors and 3,738 honors, while that year's Salon had only 1,272 exhibitors and 49 honors.[23] The Légion d'honneur, founded by Napoléon to honor the new aristocracy of merit, was extended by his royal successors to

8. *Precision Instruments, Armory, Printing, Ironwork.* Engravings after grisaille decorations by Nicolas-Louis-François Gosse for the 1834 Exposition publique des produits de l'industrie française, Paris. From Moléon et al., *Musée industriel.*

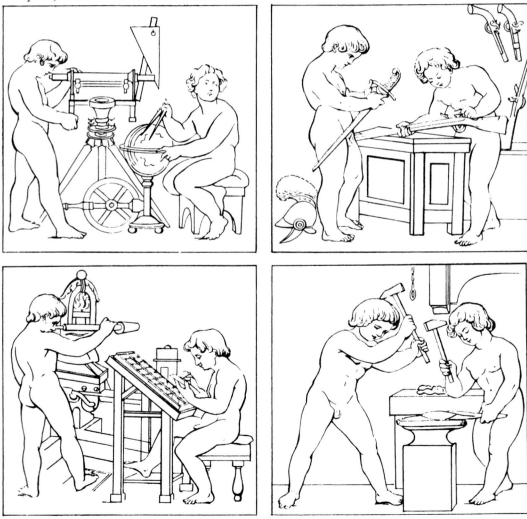

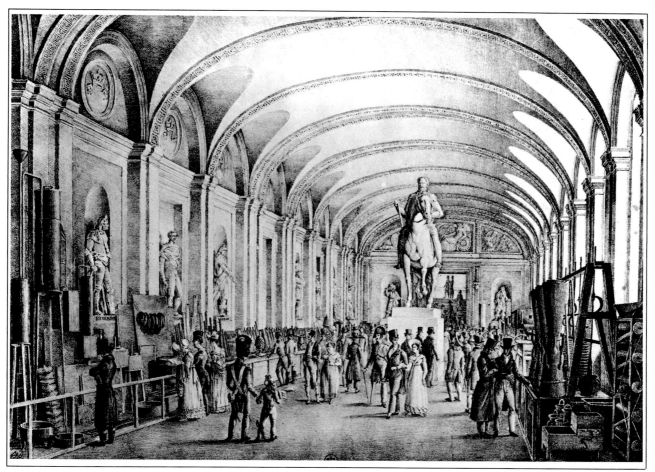

9. *Exposition publique des produits de l'industrie française, Interior of the Louvre, Paris, 1819.* Bibliothèque Nationale, Paris.

include industrialists; from 1819 on, an increasing number were so honored: 23 in 1819, 51 in 1849. In comparison to these 51 industrialists elevated in 1849, only 9 artists at that year's Salon received the same honor.[24] Gradually Industry was gaining ground that Art was losing.

Even the decor of the industrial expositions was designed to place them in the more prestigious fine-art tradition. A Temple of Industry and classical arcades characterized the first three. In 1819 industrialists succeeded in having their exposition moved inside the Louvre, where the conjunction of art and industry could be savored to the fullest (Plate 9). By 1827 the Louvre had become too small and the President of the Jury asked Charles X to move the next one.[25] By the time that exposition was held in 1834, Charles X had been replaced by Louis-Philippe, but the manufacturers had their way and the exposition took place on the Place de la Concorde, in temporary buildings expressly constructed for the event. Their decor consisted of allegorical subjects representing the mechanical arts: little naked putti were depicted setting type, weaving, hammering, printing, manifesting by their participation the dignity of these pursuits (Plate 8).[26]

That same year Jean Rey published a *Memoir on the Necessity of Building an Edifice Especially Intended for General Expositions of Industrial Products*, in which he requested of the King just that.[27] Despite Rey's plea, the expositions continued to be held in temporary structures, the decor manifesting the evolving aspirations of the manufacturing classes. In 1849 it included eighteen grisaille paintings representing Chemistry, Physics, Geography, Astronomy, Painting, Architecture, Sculpture, Furnishings, Ceramics, Agronomy, Horticulture, Metallurgy, Mechanics, Goldsmithing, Clockmaking, Photography, Glassmaking and the Manufacture of Stringed Instruments.[28] This mixture of liberal arts, fine arts, and mechanical arts represented a typical nineteenth-century vision of what constituted valid areas of human endeavor. It also represented a blatant attempt to elevate the traditionally lowest category, the mechanical arts, by setting it in such distinguished company. In this attempt we can hear distant echoes of the 1648 petition to Louis XIV claiming a place for painting and sculpture among the liberal arts.

Artistes et chefs-d'œuvre

As Neufchâteau had pointed out at the first industrial exposition, under the *ancien régime* industry had been harnessed to the production of luxury goods. With the departure of the aristocracy, the attention of the Republic turned towards mass production for its new citizens. But under the guild system, aesthetic standards revolved around the *chef-d'œuvre*, the masterpiece, intended as a virtuoso accomplishment.[29] Mass production, on the other hand, emphasized quantity over quality, machine over hand labor, and favoured cheapness and simplicity. An ever growing contradiction was forming between standards of industrial and art production, once united in common striving after "the masterpiece." Neufchâteau may have referred to the products of 1798 as "new masterpieces," but in 1801 the Jury advised against accepting such works in future expositions, judging that "they often attest only to the skill and patience of an individual and teach nothing of the industry of a nation."[30] The dilemma of wanting to reach a mass market with cheaply produced goods while at the same time preserving traditional high standards of workmanship—the Saint-Simonian ideal—was resolved as manufacturers increasingly sacrificed aesthetic standards to mass production. The devotees of progress had assumed that the removal of guild regulations would bring about competition which would steadily raise the quality of merchandise. They had not counted on the possibility that the same competition and lack of regulation would result in a lowering of standards and a vulgarization of taste.[31]

The same free-market economy, whose effect on the quality of manufactured goods was increasingly criticized, was operating with equal success on the fine arts. The Academy, having functioned in the seventeenth and eighteenth centuries as a guild, a closed corporation monopolizing the field and setting its own standards, had been stripped of that monopoly in 1791. Henceforth the fine arts, like the industrial arts, were forced to obey the laws of supply and demand. Criticism became commonplace that the Salon, now open to all, had become a picture shop, that there were too many artists producing small pictures for all tastes and purses. Such criticism was often linked to a condemnation by political conservatives of the bourgeoisie as a class.[32] Léon

de Laborde published one such lengthy analysis of the post-revolutionary Salon in a government report:

> The exposition . . . was no longer the work of a small number of artists whose merit was demonstrated by their title [N.B. of Academician], and who consented to show to a limited public some pictures commissioned in advance for a specific destination; it was now a contest where all came to compete and try their luck at gaining fame and fortune with no title but that of talent, with no judge but a mob of collectors which was, from this time on, immense . . . Left to themselves and having no outlet for their work other than public expositions, artists developed a corrupt style and a taste for the lower categories of art which allowed them to produce, without considering the destination, superficial little works suitable to all apartments, all purses, all tastes.[33]

Such indiscriminate production is exactly what had been encouraged in industry. It was an unforeseen—and unwelcome—side effect that the same phenomenon should be manifest in the elevated sphere of the fine arts. At the Universal Expositions, the issue would become crucial.

By 1849 the word *artiste* had virtually vanished from the official publications of the industrial expositions. There were now manufacturers (*fabricants*) and workers (*ouvriers*); *artistes* were those who showed their work in Salons.[34] The divergence of art and craft was virtually complete when, in England in 1851, the Great Exhibition of Works of Industry of All Nations began a new era and many of the traditional rivalries resurfaced.

3
The Crystal Palace, 1851

NATIONAL EXHIBITIONS OF INDUSTRY were held with increasing frequency throughout Europe during the first half of the nineteenth century. They were never popular in Britain, though, for British manufacturers were already leading the world and did not feel the need for what were seen as foreign-inspired events.[1] Nonetheless, it was Britain who initiated the era of international exhibitions by holding, in 1851, the Great Exhibition of Works of Industry of All Nations (Plate 10). So closely was it modelled on French precedents that it took as its basis a detailed report by Henry Cole and Digby Wyatt covering all aspects of the 1849 Exposition publique des produits de l'industrie française.[2] Although the two had visited Paris that year in preparation for an 1851 National Quinquennial Exhibition of British Industry, on their return Prince Albert took a broader view of the enterprise. "I asked the Prince if he had considered if the Exhibition should be a National or an International Exhibition," wrote Cole in his memoirs. "The Prince reflected for a minute, and then said, 'it must embrace foreign productions' to use his words, and added emphatically, 'International, certainly.'"[3]

Although told in understated British style, the story is based on nineteenth-century economic reality. The first half-century had been characterized by customs barriers and strict controls on foreign trade to protect local industries. When, around mid-century, an era of economic expansion began, the idea of exhibiting products of all nations followed logically from the necessity of selling to all nations. Just as logical was the British sponsorship of the first such event, for England was already the most advanced industrial nation with the most developed foreign markets.

The French failure to hold the first international exhibition resulted in national humiliation in which several lines of defense emerged, repeated to the present day. Most characteristic was that of Léon de Laborde, French Commissioner to the event: "England, shameless imitator, has stolen from us the initiative of a Universal Exposition."[4] It was (and still is) repeatedly stressed that France had held the *first* industrial exposition in 1798, that international ones had been suggested in 1833, 1844, 1849, but the idea had each time been defeated by a small clique of selfish businessmen.[5] Nonetheless, however distressed the French were at their loss of initiative, their own industrial aspirations left them no choice but to participate in the British event.

At the Great Exhibition of Works of Industry of All Nations, there was one major change in the structure taken over from France. The fine arts—painting alone excluded—would, for the first time, enjoy official status. The reason advanced by the

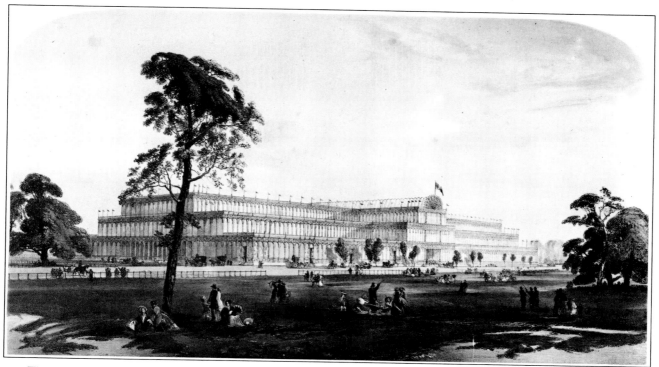

10. *The Great Exhibition of Works of Industry of All Nations, London 1851. The Crystal Palace.* Bibliothèque Nationale, Paris.

11. *The Interior of the Crystal Palace, London, 1851.* Bibliothèque Nationale, Paris.

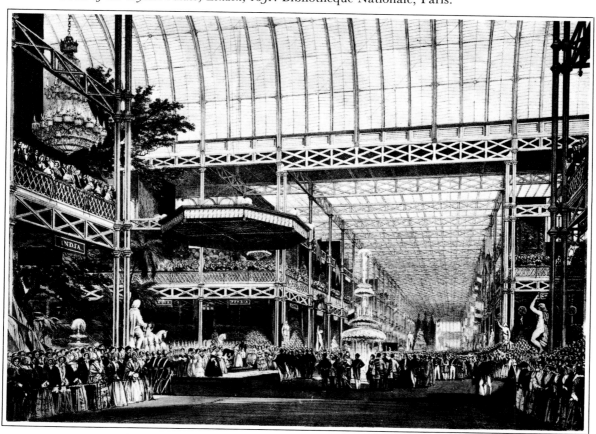

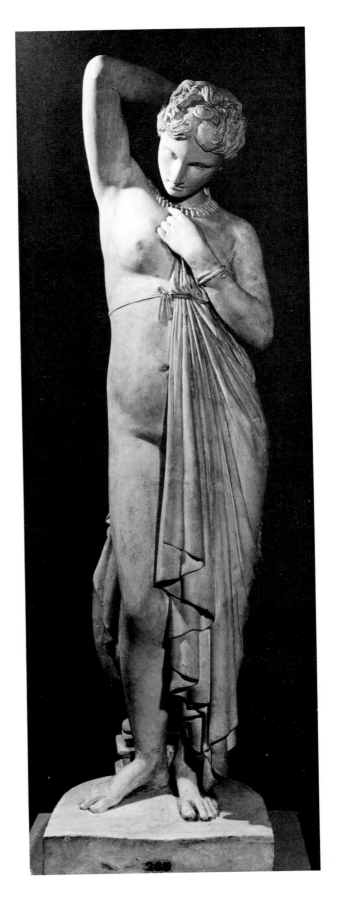

12. Jean-Jacques Pradier,
Phryne, 1845, plaster, 1.80 m.
Salon of 1845. Musée des
beaux-arts, Troyes. Marble
version exhibited 1851 no.
1407.

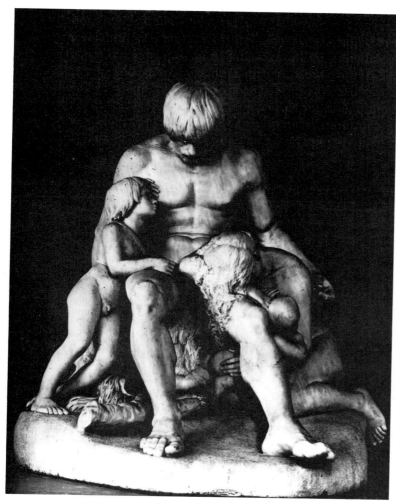

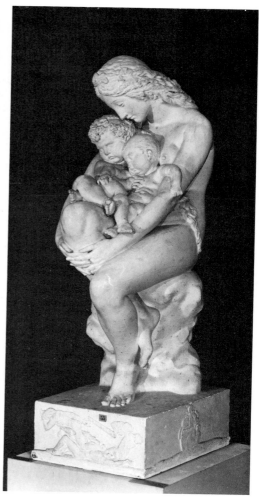

13. Antoine Etex, *Cain's Family*, marble, 2.05 × 1.65 × 1.70 m. Salon of 1831. Musée des beaux-arts, Lyons. Plaster version exhibited 1851 no. 1215.

14. Auguste DeBay, *Eve and her Children*, plaster. Salon of 1845. Musée des beaux-arts, Angers. Marble version exhibited 1851 no. 1845. (*Le Berceau primitif*).

Royal Commissioners for the exclusion of painting was that "being but little affected by material conditions, it seemed to rank as an independent art."[6] Art, however, was the one area in which the French felt confident of their superiority; with the decision to exclude painting, they lost that competitive edge. The result was a barrage of French criticism attacking the British as philistine.[7] In reality, the Great Exhibition of 1851 was an advance over the eleven French ones in terms of the fine arts: for the first time sculpture was included as the work of individual artists, not as the product of the foundry or atelier. Considered half-art, half-métier, sculpture would occupy an ambiguous position throughout the nineteenth century, but here, for the first time, in an industrial exposition, its creative aspect was recognized. Nonetheless, according to Laborde, French sculptors were unenthusiastic about participating.

Unfortunately our artists heard with great indifference the appeal that was made to them ... I had solicited and obtained from the French preparatory committee the

mission of visiting our studios and stimulating enthusiasm. I went everywhere. I found sympathy nowhere. "Art is not an industry," the artists replied to me. "What would we be doing in a bazaar?" Influenced by my studies to reject any distinction between art and industry, finding the most eminent minds set against this idea, I racked my brains trying to formulate precisely the distinction they were trying to establish and to arrive at the reconciliation which seemed so desirable to me . . . I spoke in vain. In vain I took as examples the greatest artists of antiquity and of the Renaissance. Nothing succeeded. It was an ingrained prejudice, and what is stronger than a prejudice? The opinion of the Academy perhaps? I thought so at the time, and I had the question brought before the fine arts class of the Institute, hoping that an enlightened appeal coming from so high would erase these dividing lines that time and progress, the march of ideas and the merging of classes have long since swept away. I was wrong. The old quarrel between art and métier flared up again just as on the first day of the creation of the Academy of painting and sculpture. That illustrious body decided that its members and artists in general would be urged to boycott the London exhibition with industry.[8]

Despite this setback, Laborde did convince some sculptors to exhibit. It turned out to be an Academician's nightmare, with both catalogue and installation conflating all types of work (Plate 11). Pradier, whose *Phryne* (Plate 12) obtained the Council Medal, the highest award, was listed along with *Specimens of woolen yarn combed by machinery*. Antoine Etex found his *Cain's Family* (Plate 13) neighbor to Madame Ernest's *Specimens of stays without seams*, and Auguste DeBay's *Eve and her Children* (Plate 14) made an appearance next to an artificial foot.[9] François Rude and David d'Angers prudently abstained.

Two hundred years of effort to elevate the status of the fine arts went for naught, it seemed, for the British had used sculpture to "decorate" the more important displays. The French critic Jules Janin raged: "How inept! Go on then, seat the *Venus de Milo* on an anvil; hitch up the *Apollo Belvedere* to a bale of merchandise, make a beer advertisement out of Phidias' *Jupiter*"[10] Had Janin seen the allegorical figures Elias Robert would carve for the 1855 Palais de l'Industrie (Plate 1), he might well have accused him of plagiarizing his metaphor.

French sculpture, English morals

The Great Exhibition of 1851 established a precedent for subsequent Universal Expositions, for it articulated the contradiction of industry that looked to the future and of art that looked to the past. Antoine Etex's *Cain's Family*, for example, had made his reputation at the Salon of 1831; DeBay's *Eve and her Children* and Pradier's *Phryne* had both enjoyed success at the Salon of 1845, and Clésinger's *Bacchante* (Plate 15) had been the sensation of the Salon of 1848. The art exhibitions at these international events would be retrospective at best, reactionary at worst.

Naturally enough, French sculptors in 1851 were rewarded with honors; to do less would have been impolite to invited guests.[11] And so was set another precedent, that Universal Expositions would honor abroad the very same artists who were most esteemed at home, and for the very same works. Yet there were exceptions which, because

26

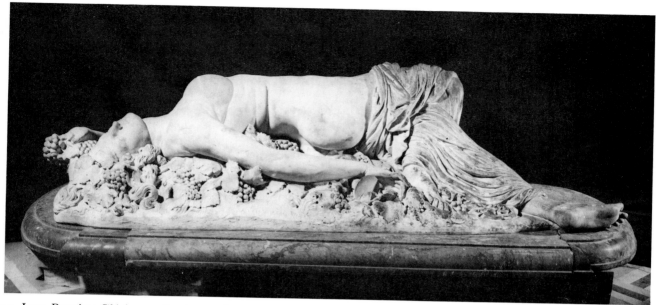

15. Jean-Baptiste Clésinger, *Bacchante*, 1847, marble, 0.64 × 1.94 m. Salon of 1848. Petit Palais, Paris. Exhibited 1851 no. 1709.

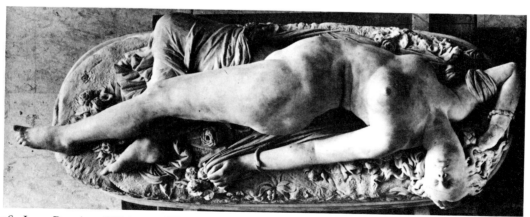

16. Jean-Baptiste Clésinger, *Woman Stung by a Serpent*, 1847, marble, 0.56 × 1.80 m. Salon of 1847 no. 2047. Musée d'Orsay, Paris.

of their rarity, are all the more interesting, occasions on which differing values at home and abroad produced violent clashes of opinion. Such was the case of Clésinger in 1851.

Clésinger's first Salon success had come in 1847 with his *Woman Stung by a Serpent*, (Plate 16).[12] Popularly known as *La Volupté*, it was supposedly modelled from life casts of Apollonie Sabatier, the well-known courtesan *La Présidente* who had been the mistress of many, including Baudelaire and Clésinger himself. The pose, characterized by Chopin as "worse than indecent," was somewhat delicately explained by Théophile Gautier: "Perhaps this reclining woman, before the serpent's sting, or, if you prefer, at the same time, has received a kiss . . .[13] The serpent, known to have been added at the

last minute merely to ensure the work's acceptance by the jury as a classical subject, in no way challenged the general perception of the work as "altogether modern."[14] For Gautier, it was "a masterpiece which is neither a goddess nor a nymph, not a forest nymph, not a mountain nymph, not a sea nymph, but simply a woman."[15] It was a *succès de scandale*, but a success nonetheless, and it immediately established Clésinger, at thirty-three, as one of France's leading sculptors.

In an attempt to capitalize on this success, and to defend himself from charges that he had produced merely a life cast, Clésinger soon began work on another sculpture, "an eight-foot Bacchante that can't be accused of being a life cast," as he wrote to a friend.[16] His *Bacchante* was instantly recognized to be superior to the *Woman Stung by a Serpent*—"a new lesson from the same text," Fabien Pillet called it in *Le Moniteur universel*—and in the Salon of 1848 it won a first class medal.[17] The work proved immensely popular; according to Pillet, the French public admired "the expression of voluptuous drunkenness which leaves no doubt as to the various kinds of pleasures openly enjoyed by the priestesses of Bacchus."[18] Gautier published, first in *La Presse* and later in *L'Artiste*, a long and glowing appreciation of *Bacchante*'s charms, pronouncing it "one of the most beautiful works of modern sculpture."[19]

It is not, then, surprising that Clésinger chose to send his *Bacchante* to London, no doubt expecting to reap similar praise in an international context. Alexis de Valon described the exhibition for the *Revue des deux-mondes*:

> Farther on, surrounded by tapestries from Gobelins, Beauvais, Aubusson, porcelains from Sèvres, writhes M. Clésinger's *Bacchante* ... This statue could well confirm the opinion that everyone has of us, and God knows it is not good. The other day, I went to book lodgings for one of my friends; the price was settled when the proprietor changed his mind. "It's for a *French gentleman?*" he asked me. "Yes, of course," I replied. "Then I can't rent to you," he continued, "we have *ladies* in the house."[20]

The Exhibition jury proved to be of the same opinion as the innkeeper. In his official, government report, Léon de Laborde stated that he had originally obtained a bronze medal for Clésinger:

> But, at the moment of the review, an English member of the Jury strongly opposed, on the grounds of morality and I believe even of religion, the decision to reward "a work whose beauty only renders more shameful its immoral purpose." I did my utmost to ward off this objection. I asked my colleagues to consider themselves judges of works of art and not of acts of virtue. I failed; the 30th class, acting like the 5th group, proceeded to set aside its own work and reversed its initial decision. M. Clésinger was struck off the awards list. The best I could do was to have inserted into the records the reasons for this exclusion.[21]

And indeed one can read in the official *Reports by the Juries* the following entry for Clésinger: "The Jury, for reasons totally independent of the acknowledged merits of this young artist, abstained, with regret, from awarding a high mark of approbation to this work."[22] Laborde could not, however, prevent the Royal Commissioners from publishing a *Supplementary Report* which described in detail their objections:

J. Clésinger, A Bacchante, °1709. A Bacchante who is rolling on the ground in a state of drunken excitement. This figure is remarkable for the masterly chiselling of the marble, the great knowledge of anatomy, and the beauty of the countenance; but these excellences do not sufficiently excuse the sculptor for having in this work allowed his imagination to be perverted and degraded to the service of a low sensuality. Moreover, the treatment of the hair is at variance with the principles of a good style, and there is a great want of taste in the arrangement of the folds of the drapery. The Jury considered this subject to be of an objectionable character, but have made Honorable Mention of the excellences pointed out above.[23]

More to the taste of the British was the coy sensuality and implicit voyeurism of Pradier's *Phryne*. "His is a cold and academic talent," Baudelaire had written of him, and Pradier was indeed detested by the entire Romantic generation.[24] He depicted Phryne, the famed Athenian courtesan, stripped by her lawyer in front of the court which was trying her for impiety. On seeing her naked, the jury promptly acquitted her; the 1851 jury was no less appreciative of Phryne's charms, and, just as promptly, awarded Pradier a Council Medal.[25]

The English reaction to Clésinger's *Bacchante* was either never known or soon forgotten in France where, in any case, the *coup d'état* of 2 December 1851 and the bleak beginnings of the Second Empire soon provided more serious subjects for discussion.[26] Although Clésinger refused his Honorable Mention, his *Bacchante* does deserve that here for, not only is it one of his best works, but, on the occasion of the first International Exhibition, it provoked the first of many aesthetic clashes between rival nations.

The painting exhibition that might have been

A good deal more public than the Clésinger affair was the French charge of philistinism directed against the British exclusion of painting in 1851. Yet either Laborde and the French critics were being less than candid in their outrage, or perhaps they honestly did not know that there had been a serious attempt to mount such an exhibition. A dossier in the Archives Nationales preserves an extensive correspondence between Prince, Green and Company of London and various French ministries in which the British offered to build a large Picture Gallery (Plate 17), as traditional as the Crystal Palace was modern, to house an international exhibition of predominantly French artists.[27] "One could wish for no more favorable occasion for making the great artists of your country known and worthily appreciated," the British wrote. When this offer became known in France, it immediately received the support of Baron Taylor and his Comité de l'association des artistes who urged the Government to accept. In addition, twenty-eight prominent artists signed a petition pledging their participation in the exhibition. Their letter tacitly supports Laborde's charge of an academic boycott, for it was signed by only one Academician, the liberal Cogniet. Most of the others, such as Delacroix, Barye, Corot, Couture, Rousseau, came from the Independent camp. Despite this support from the art community, the Government refused to subsidize the cost of shipping the work to London, the only expense France would incur. The budgetary appropriation had been voted for industry alone, explained the Ministre de l'Agricul-

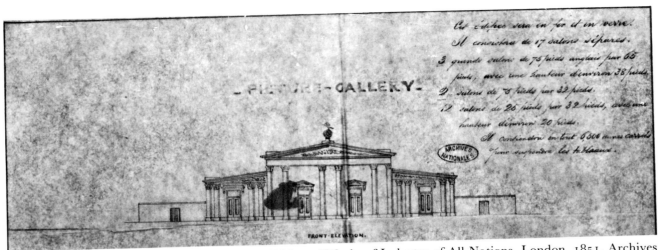

17. *Picture Gallery*, proposed for the Great Exhibition of Works of Industry of All Nations, London, 1851. Archives Nationales, Paris.

ture et du Commerce, and therefore could not be used for art. The proposed Picture Gallery was abandoned and the exhibition was never held.

The episode demonstrates the continued friction between the forces of art and industry in France and might well serve as an introduction to the era of Universal Expositions. Artists and industrialists were getting along no better than had artists and artisans two centuries before, but with the Second Republic, the bourgeoisie had replaced the monarchy as the nation's ruler, and had brought along its traditional preference for craft—now industry—as opposed to art. As a result, beginning in the Second Republic, the relationship between these two traditional rivals was transformed; industry from now on would play the dominant role.

From the Palace of Crystal to the Palace of Industry

Despite the absence of painting, France did well at the London Exhibition, winning 1,051 out of 5,187 prizes. In the area of fine arts, France received more awards than any other country, including England.[28] Throughout eleven National Expositions of Industry, France had directed manufacturers and juries to concentrate on massproduced goods for popular consumption, and had condemned the production of luxury items. Nonetheless, the first International Exhibition clearly demonstrated that the nation's strength lay precisely in this area, for it was luxury items, where aesthetic quality had not been sacrificed to cheap quantity production, which were rewarded. The unanticipated success of the fine-arts section was a major factor in the reversal of attitude that occurred in France by the 1855 Exposition Universelle, France's answer to the 1851 Great Exhibition. Not only would it be the first to include an official international section embracing all the fine arts, but the miserly attitude towards the arts characteristic of the Second Republic was forced—temporarily—to give way before the necessity of establishing the glory of the Second Empire. As *Le Mercure galant* had stated in 1699 of the first Salon, foreigners would come to admire and would be forced to admit that only France was capable of producing such masterpieces, and the glory would redound to the King (in this case Napoléon III) who, by his generosity and protection, had brought the arts to such a pinnacle of perfection.

30

II

THE UNIVERSAL EXPOSITION OF 1855: THE APOTHEOSIS OF ECLECTICISM

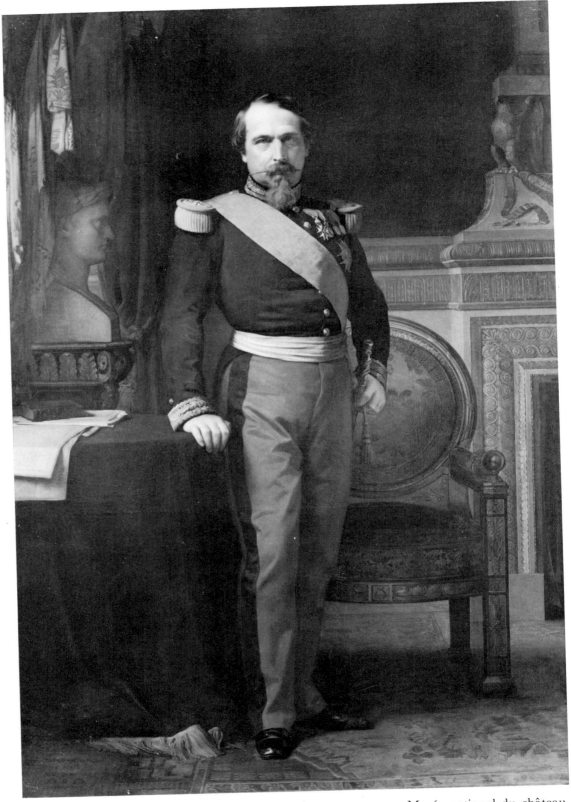

18. Hippolyte Flandrin, *Napoléon III*, ca. 1861–62, 2.12 × 1.47 m. Musée national du château, Versailles.

4
Second Empire Art Policy:
The 1850s

THE 1855 UNIVERSAL EXPOSITION marked both the end of one era and the beginning of another. Until the Second Republic, the world of art still clung to centuries-old tradition: artists of major importance, such as Ingres and Delacroix, were usually recognized by the Government and produced, on commission, large-scale history paintings for public consumption. Contemporary taste was defined by the Academy and by cultivated *amateurs* who played quasi-governmental roles in assuring that the King or Emperor had, or at least seemed to have, suitably elevated aesthetic judgment.[1] By the end of the Second Empire, the modern art world had emerged. Henceforth, neither Church nor State, neither aristocracy nor Academy would be able to set the rules: a new power, the bourgeoisie, had emerged, demanding recognition of its own taste. And although modern scholars might dispute the definition of the bourgeoisie, nineteenth-century art critics knew exactly whom they meant—the untitled but well-to-do members of the manufacturing and commercial classes who bought pictures for investment and decoration and preferred the lower genres of art.[2] If culture can be said to follow economics, then one might consider the Revolution of 1789, with its economic shift of power from the aristocracy to the bourgeoisie, as leading inexorably, almost a century later, to the aesthetic shift described here.

The major art event of the 1850s was the Universal Exposition of 1855, as much a political as a cultural event. This study, then, should begin with a survey of the political protagonists in the French art world of the 1850s, for it was they, and not artists, who set official standards of taste.

The cast of characters

Napoléon III (1808–1873) (Plate 18): By all accounts he preferred pretty girls to pictures, but if he had to have pictures too, he liked pictures of pretty girls. Nor was he adverse to portraits of himself or Napoléon I, depictions of imperial victories, nor, for that matter, to anything anyone else of importance liked; it wasn't worth splitting hairs over questions of taste. Maxime DuCamp's account of Napoléon's visit to the Salon of 1853 gives the flavor of the Emperor's taste:

> I was at the Salon the day before it opened. I had met Morny who was President of the Jury and we were talking together when someone announced that the Emperor

19. *Empress Eugénie*. Bibliothèque Nationale, Paris.

was coming. I started to leave when Morny said "Stay, come along with us, you'll hear some good observations." Napoléon III, escorted by several officers, government officials, and all the members of the Jury, was walking quickly through the galleries without uttering a word, without making an observation, passing before the best works with an indifference he didn't even try to hide. It was obvious that he was carrying out one of the thousand tasks that his role as sovereign demanded of him. He arrived at the last gallery, crammed with mediocre works which seemed to have been accepted only to cover the nudity of the walls. He stopped suddenly before a picture representing Mont-Blanc. It was pitiful and gave the impression of a group of sugar loaves of various sizes. For a long time he stood motionless, contemplating this daub, then, turning towards Morny on his left, he said: "The painter ought to have indicated the relative heights." After this "good observation" he resumed his task and went on his way.

DuCamp ended by characterizing the taste of Napoléon III thus: "Painting, a closed book; music, a dead letter; poetry, incomprehensible."[3] Apologists for Napoléon III point out that his background was military, his youth occupied with insurrections, exile, and imprisonment, leaving little time for the pursuit of culture. Coldly received by artists at the 1849 Salon and lacking confidence in his own taste, he fell back (publicly) on that of his predecessors and (privately) on whatever was pleasant and undemanding.[4]

Empress Eugénie (1826–1920) (Plate 19): Born Eugenia Maria de Montijo de Guzmàn, the daughter of a Spanish Grandee, she married Napoléon III in 1853. A religious Catholic, ultramontane, partisan of the Pope, her personal art collection was composed of imperial portraits by Winterhalter, Cabanel and Dedreux. Her biographers state that she knew nothing at all about art and preferred interior decoration.[5]

Prince Napoléon (1822–1891) (Plate 20): Cousin of Napoléon III and President of the 1855 Universal Exposition. His relations with Napoléon III were always difficult, for he was a self-proclaimed socialist, outspoken in his views, ever hopeful of ascending to the throne. He described his own taste as "traditional," while boasting that the Bonaparte family had always admired "the distinguished talents of all schools: David, Canova, Gros ..."[6] The breadth of his taste can be measured in the distance from David to Gros: for him this encompassed "all schools." He collected antiquities and is perhaps best known for the Maison pompéienne he had built in Paris where he and his friends dressed up in Roman costumes. His apologists stress that he received his early education in Italy

20. *Prince Napoléon.* Bibliothèque Nationale, Paris.

where he was deeply influenced by classical art, a taste he carried with him all his life, marrying Marie Clotilde, daughter of Victor Emmanuel II, and returning there after 1870.[7]

Princess Mathilde (1820–1904) (Plate 21): Cousin of Napoléon III, sister of Prince Napoléon, companion to Nieuwerkerke. Brought up in Rome and Florence, she was refused in marriage to Napoléon III during the years when everyone thought he was a worthless adventurer. She was then married to an even more worthless adventurer, Anatole Demidoff, in 1841, and legally separated from him in 1845. She had meanwhile met Emilien, le comte de Nieuwerkerke; their liaison would exercise the major influence on the art policy of the Second Empire for, the Emperor and Empress lacking interest and taste in art, Mathilde, who lacked taste only, became the power behind the throne. Even-handed, she disliked both Ingres and Delacroix. She collected lightweight genre paintings, principally by Eugène Giraud, her painting teacher. Her reputation as a cultivated *amateur* rests on the fact that her weekly *soirées* were attended by artists of the calibre of Giraud, Hébert, Baudry, that she exhibited in the Salon from 1859 to 1866 and was among the first to recognize the talent of Bonvin and Tissot. She was, however, among the last to recognize any of the major nineteenth-century artists.[8]

35

21. *Princess Mathilde*. After the photograph by Springler. Bibliothèque Nationale, Paris.

22. *Le comte de Nieuwerkerke*. Engraving by Riffaut after the drawing by Ingres. Bibliothèque Nationale, Paris.

Alfred-Emilien, le comte de Nieuwerkerke (1811–1892) (Plate 22): Among his titles were: Directeur général des musées impériaux, and Intendant des beaux-arts de la Maison de l'Empereur. He was also President of the Admissions Jury and Vice-President of the International Awards Jury at the 1855 Universal Exposition of Art. The most powerful individual in the world of art during the Second Empire, he was nicknamed "Castor" (beaver) by art students because it is an animal that builds with its tail. This was a sly reference to his liaison with Princess Mathilde, his only known qualification for any of the above appointments. Originally a legitimist and supporter of the comte de Chambord, Nieuwerkerke's taste in art was as murky as his politics. An amateur sculptor himself, he managed, during his administration, to mistreat virtually every major artist of the period, from the Barbizon painters through Cézanne, including Ingres, Delacroix and Courbet. He collected weaponry. Opportunist, ambitious, ruthless, he earned—and merited—the dislike of most of his contemporaries.[9]

Frédéric Bourgeois de Mercey (1803–1860) (Plate 23): As Chef de la section des beaux-arts du ministère d'Etat, he was the highest ranking government art administrator. At the 1855 Universal Exposition of Art, he held the top post of Commissaire général. The very type of the cultured aristocratic *amateur*, he wrote a little, painted a little, was a friend to artists, an administrator who tried to do the right thing. Nieuwerkerke hated him and craved his job, which Mathilde eventually obtained for him after Mercey's death.[10]

Achille Fould (1800–1867) (Plate 24): Ministre d'Etat, thus ultimately responsible for the 1855 Universal Exposition of Art, for, at the time, the fine arts were directed from this

23. *Frédéric Bourgeois de Mercey.* Bibliothèque Nationale, Paris.

24. *Achille Fould.* Bibliothèque Nationale, Paris.

ministry. He came from a rich banking family and was an early supporter of Napoléon III. He claimed to have an interest in art only during his years as Ministre de la Maison d l'Empereur.[11]

Le comte de Morny, later duc de Morny (1811–1865) (Plate 25): President of the Corps législatif, member of the Conseil supérieur du commerce, de l'agriculture et de l'industrie. He was President of the fine arts section of the Imperial Commission and President of the International Awards Jury at the 1855 Universal Exposition of Art. Half-brother to Napoléon III, he was his trusted ally and the chief architect of the 1851 *coup d'état.* He was also a collector of catholic taste, a speculator in art who amassed collections only to sell them at auction for profit. Napoléon III may not have known anything about art, but he knew enough to put Morny in charge to watch out for imperial interests.[12]

25. *Le comte de Morny.* Bibliothèque Nationale, Paris.

With a cast of characters like this, it is not surprising that the art policies of the Second Empire were undistinguished. The imperial couple's lack of interest was manifest in the invitation list to Compiègne: during the entire Second Empire, among several thousand guests, Cabanel was invited three times, Baudry, Meissonier and Doré twice, and twenty-two other painters (among them Delacroix and Ingres) once.[13] Persigny, Napoléon III's Ministre de l'Intérieur, seriously proposed emptying the Louvre so that it could be used for government offices; "What do the arts and pictures matter when faced with political necessity," he explained.[14] Even Prosper Mérimée, long-time friend of the Empress and director of the theatre at Compiègne, complained of the low level of culture at the court.[15]

As a result, Nieuwerkerke and Princess Mathilde made most of the day-to-day decisions on government policy, with Morny watching over important events such as the Universal Exposition of 1855. As Viel-Castel wrote in his memoirs, the old aristocracy of birth was being replaced by the new aristocracy of intrigue.[16]

The primary purpose of Second Empire patronage was to conciliate the Church, which had supported the *coup d'état*, and to glorify the regime. Thus the largest portion of the fine-arts budget (38%) was spent for religious works, including many copies donated to provincial churches. History painting made up the second category (18%), of which a third was devoted to depictions of contemporary events such as imperial victories. The third important category consisted of portraits of the Emperor or Empress (15.6%). Altogether, then, painting with a discernible political purpose received 71.6% of the budget, leaving less than 30% for all other categories, including genre, landscape, and still life.[17]

The frivolity with which commissions were awarded is demonstrated by an incident of 1852 in which Edouard Ney obtained for his mistress, Mlle Marquet, a dancer at the Opéra and amateur painter, a commission to paint a copy of Murillo's *Virgin with Rosary*. When the history painter Müller complained that worthy artists were impoverished while Romieu, Directeur des beaux-arts, was thus disposing of imperial commissions, he was forced to apologize to Mlle Marquet. The painting, sub-contracted out to an art student for a few hundred francs, was sent to a provincial church, as were most commissioned religious paintings, as examples of Imperial largesse.[18] Particularly on the Emperor's birthday, French churches and town halls were inundated with religious paintings and busts of Napoléon I.[19] An 1857 note from Buon of the Maison de l'Empereur to Nieuwerkerke reminded him of the importance of having the inscription *Donné par l'Empereur* (Gift of the Emperor) on the frames of all paintings sent to provincial museums.[20] Nor did Napoléon III himself choose the paintings to be purchased, as did his predecessor Louis-Philippe. In the Salon of 1857, for example, Buon, Achille Fould and Nieuwerkerke went through the Salon together, but the final list was made by Nieuwerkerke, the inscription on the frame being the limit of the Emperor's interest.[21]

Given this attitude towards art, it was only natural that the first Universal Exposition of Art was conceived and executed as the fulfillment of political rather than aesthetic aims.

5
Advance Planning:
Getting the Show Underway

THE ORIGINS OF THE 1855 Universal Exposition were frankly avowed by its President, Prince Napoléon: "The success of the London Universal Exposition impelled us to emulation. Scarcely had the doors of the Crystal Palace closed when everyone began to demand that we hold a similar event in Paris."[1] Whatever idealistic motives of "emulation" might have existed were probably mingled with financial ones as well, for the Great Exhibition had earned almost £200,000, a sum which was later used to finance the South Kensington complex of museums and schools.[2] There was also a strong political motivation. Prince Napoléon in his speech to the Emperor at the opening ceremonies stated: "You wanted the first years of your reign to be crowned by an Exposition of the entire world, following the traditions of the first Emperor, for the idea of *Exposition* is eminently French . . ."[3] While the concept of industrial expositions can in no way be attributed to Napoléon I, such a provenance would serve to link the first and second Empires and thus help to establish the legitimacy of the reign of Napoléon III. The innovation of holding a Universal Exposition of Art in addition to that of Industry would also serve as a valuable apology for the French claim of having sponsored the first "truly Universal" Exposition. The idea, however, had originally come, not from London, but from the Académie des beaux-arts, even before the 1851 Great Exhibition. It was the work of the marquis de Pastoret, an Academician, legitimist and supporter of the comte de Chambord who proposed, early in 1851, that the Academy sponsor "a general exposition of art by contemporary French and foreign artists, to include works from the beginning of the century, for the purpose of showing the course of art from that epoch to our own times."[4] A committee of Academicians formed to study Pastoret's proposal suggested that the Government sponsor such an exhibition in the Louvre when renovation there was completed. A letter to this effect was sent by the Académie des beaux-arts to the Ministre de l'Intérieur; there was no response for two years.

Nonetheless, art was not long to be excluded from international competition. After the unsuccessful British attempt to hold such an international painting exhibition in 1851, there was, that same summer, an *Exposition générale des beaux-arts* in Brussels; in 1852 one was held in Berlin.[5] International in that they included artists from many countries, they were in reality not too different from the Salon, for artists participated as individuals, not as members of a national section. The same distinction held for the

International Exhibitions of 1853 in Dublin and New York; both events included only unofficial, albeit international, exhibitions of fine art.[6]

Palais de l'Industrie

If the idea of having an international fine arts exhibition preceded the Universal Exposition by several years, so also did the plan for a Palais de l'Industrie. Complaints about the temporary buildings erected for national expositions of industry had been mounting since Rey's 1827 proposal. In addition, the annual Salon had become too large for the Louvre and, after 1848, it too was regularly moved to a different locale. And so on 27 March 1852 Napoléon III decreed the construction of a long-overdue Palais de l'Industrie, "similar to the Crystal Palace in London"; it was to house all future national exhibitions (Plates 26 and 27).[7]

The building was not erected at government expense, however, but by a private holding company, the Compagnie du Palais de l'Industrie, which would hold title until 1889, after which it would revert to the Government. The Government donated the terrain (on the Champs-Elysées, the site of the present Grand-Palais), guaranteed the shareholders 4% interest on their investment, and conceded to the Compagnie the right to charge admission to all events held there.[8] For the first time, the Government had abrogated its responsibility to construct its own monuments. *Noblesse oblige* was giving way to capitalism, and the Eiffel Tower would follow the Palais de l'Industrie as a privately owned, profit-making national monument.[9] Reflecting on this turn of events, Delacroix wrote in his *Journal*: "There is talk of selling the Champs-Elysées to speculators. It's the Palais de l'Industrie which is to blame. When we resemble the Americans a bit more we'll sell off the Jardin des Tuileries as a vacant useless plot of land."[10] The hybrid character of the Palais de l'Industrie, mortared with public interest and private speculation, soon became apparent in the conflicts which arose over its role in the Universal Exposition of 1855. Prince Napoléon claimed that the disputes between the Imperial Commission and the Compagnie du Palais de l'Industrie were caused by the Compagnie's inordinate craving for profits above all other considerations.[11] He was being a bit ingenuous, however, for the Compagnie had been set up as a profit-making enterprise; it was unrealistic to expect charitable sentiments from businessmen, particularly in the nineteenth century.

The Imperial Commission

The 1855 Universal Exposition was announced by decree on 8 March 1853.[12] Two months later, Napoléon III asked his Ministre d'Etat, Achille Fould, to invite a small group of artists, *amateurs*, and professionals to Saint-Cloud to discuss with him and Empress Eugénie the possibility of also holding a Universal Exposition of Art.[13] Both Prince Napoléon and Mercey credited the idea to Eugénie, but this was no doubt a gracious gesture on their part; the proposal probably derived from that of the marquis de Pastoret and the Academy in 1851.[14] Pastoret had, in the intervening time, abandoned his legitimist politics and rallied to the Empire; he was rewarded by being appointed Sénateur.[15] His role was tacitly acknowledged by his appointment to every

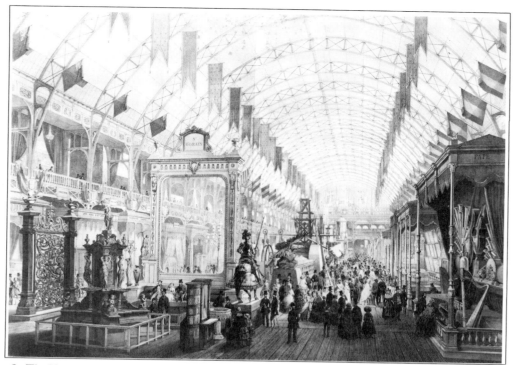

26. *The Universal Exposition, Paris, 1855. General View of the Interior of the Palais de l'Industrie.* Bibliothèque Nationale, Paris.

27. A. Deroy, *View of the Palais de l'Industrie, 1855*, Bibliothèque Nationale, Paris.

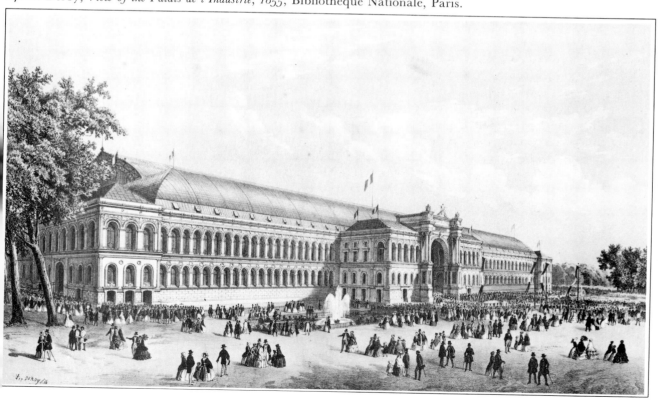

Commission and Jury of the Universal Exposition of Art, the only individual so honored who was neither a high government official nor an artist.

Most of the important decisions were made at the Saint-Cloud meeting: the exhibition would be retrospective, there would be no limit to the number of works each artist could submit, and there would be prizes and paid admission.[16] The Exposition Universelle des Beaux-Arts was decreed on 22 June 1853, the document setting forth a variety of motives: the event was to stimulate "progress" and "emulation" in art as well as industry; industrial standards would be raised by contact with the fine arts; France would also have the distinction of holding the first "truly Universal" Exposition.[17] The last reappeared constantly as a leitmotif throughout the Exposition. "It rests with our country to set the example of this alliance which corresponds so well to its initiating genius," Prince Napoléon announced.[18] France would make up for the humiliation of losing the first international exhibition to England by being the first to include the fine arts. And, just in case artists were inclined to boycott an exhibition with industry, the Salons of 1854 and 1855 were cancelled.[19]

By a decree of 24 December 1853, an Imperial Commission of thirty-seven members, with Prince Napoléon as President, was appointed to oversee the organization of the Universal Exposition.[20] Divided into two sections, one for agriculture and industry, the other for art, it was composed of the highest notables of the administration and from the spheres of learning, the arts, industry, and commerce; all had rallied to the Empire. There were representatives of government, such as the comte de Morny and Baroche, President of the Conseil d'Etat; financiers such as Emile Pereire and Schneider, who owned Le Creusot; a sprinkling of aristocrats such as the marquis de Pastoret and the duc de Mouchy. Especially there were Saint-Simonians, among them Frédéric LePlay who would later be named Commissaire général of the Exposition. There were also five artists: Ingres and Delacroix, the engraver Henriquel-Dupont, the sculptor Simart and the architect Visconti; Delacroix was the only non-Academician. Nieuwerkerke was excluded, despite his official position, for he was disliked by the entire imperial family, Mathilde excepted. He was furious; Mathilde complained to Fould; he remained excluded.[21]

No doubt many of the thirty-seven appointments were honorary or advisory, for a subcommittee of twelve was named to do the actual work of organization.[22] This was a no-nonsense group of representatives of industry and commerce with LePlay as President. The art section, unrepresented on the subcommittee, was left, by default, to define its own exhibition.

Palais des Beaux-Arts

Even before the appointment of the Imperial Commission, plans were moving ahead for the Universal Exposition of Art. At the Awards Ceremony of the 1853 Salon, Prince Napoléon had announced in glowing terms that this exposition would take place in the Louvre.[23] The artists' participation was essential and an exhibition in the Louvre would offer the necessary dignity to offset the "taint" of industry. One of the earliest government memoranda on the subject stated unequivocally: "From the moment the decree appeared, artists were very much concerned with the question of locale. They

attached a very great and altogether understandable importance to the necessity of separating their works as far as possible from the industrial exposition."[24] And yet, a few months later, unannounced, Fould signed a contract with the Compagnie for the construction of a temporary building along the Seine, linked to the Palais de l'Industrie; the fine-arts exhibition was to be housed there.[25] The government explanation was that the Louvre renovation would not be completed in time, but it must also be recalled that the unification of the two expositions was the official French rationalization of the importance of their, as opposed to the British, Exposition; Mercey later stated that the Imperial Commission had *always* wanted to unite the two shows under one roof.[26]

Artists were not pleased to hear that their Exposition would be held in an annex to the Palais de l'Industrie; the spectre of 1851 instantly reappeared in an article in the *Journal des débats*:

> In vain one repeats that since industry and art will each have its own section at the Palais des Champs-Elysées, the works of art will not be mixed in with industrial products as they were in Hyde Park. The charming *Phryne* of Pradier, for example, if it were to reappear here ... would not be affronted with competition from the Pilon hammer or the Nillus mill.[27]

Fortunately for the artists, it soon became clear that the industrial exposition would prove too large for the Palais de l'Industrie. The fine-arts annex was hastily requisitioned for industry (it became the Galerie des Machines), and, to the artists' delight, the show was—temporarily—rescheduled for the Louvre.[28] Then, at the last minute, the architect Hector LeFuel was commissioned to design a Palais des Beaux-Arts, a temporary building erected on rented land behind the Palais de l'Industrie (Plates 28

28. Thérond, *Entrance to the Palais des Beaux-Arts, avenue Montaigne at the Champs-Elysées, 1855.* Bibliothèque Nationale, Paris.

and 29). On 15 November 1854, the art community was informed of the future location of the Universal Exposition of Art; the show would not take place in the Louvre after all. *L'Artiste* was frankly disappointed, and so, no doubt, were the artists.[29]

Paid admission

Both Prince Napoléon and Frédéric de Mercey stressed paid admission as one of the great innovations of the 1855 Universal Exposition. In his opening speech, Prince Napoléon explained that in France the government traditionally sponsored all major undertakings but the Emperor wished instead to strengthen private enterprise.[30] The centuries-old French tradition that exhibitions should be free was abruptly terminated. Just as abruptly, the Age of Capital began in yet another sphere of life, the inspirational and didactic purposes of expositions giving way to entertainment, and entertainment becoming a commodity to be bought and paid for. Prince Napoléon then formulated the defense of paid admission that has become classic in our modern period:

> I consider the establishment of an entrance fee as an equitable measure. Rather than forcing everyone to pay for something which benefits only a part of the nation, let it be paid voluntarily by those who enjoy its advantages. In the last analysis someone always pays. To let the cost fall on the State rather than on the public which enjoys the Exposition is to make everyone pay for it in taxes, the provincial artisan or farmer as well as the Parisians, although the former derive no immediate benefit from it.[31]

The new concept of paid admission caused profound dislocation in France. It was considered an English innovation, for there, from the first Royal Academy exhibition in 1769, it was an established custom.[32] Jacques-Louis David did attempt to introduce it

29 (facing page). Map of the Universal Exposition of 1855, Paris. Bibliothèque Nationale, Paris.

30. Gustave Doré. "The Sunday Crowd at the Exposition." *Le Journal pour rire*, 27 July 1855.

in France in 1799 when he decided to exhibit his new painting of the *Sabines*, not at the Salon, but in his own studio for an entrance fee, accompanying his show with a pamphlet justifying his innovation.[33] The practice did not become a trend, however, and exhibitions continued to be free. For if in conservative quarters exhibitions still preserved a taint of commercialism, the whiff of a bazaar, how much worse to add to that the idea of theatre—the "show" with paid admission.

Under the Second Republic, however, the Government cut back drastically on all expenses connected with the fine arts. Government commissions fell over 50%, the budget for "Encouragements aux beaux-arts" was cut and one day of paid admission per week was instituted at the Salon; at the same time the Government attempted to schedule it biennially instead of annually.[34] By 1852 there were two paid-admission days per week at the Salon with the prospect of paid admission at all events to be held in the projected Palais de l'Industrie; this included the Universal Exposition of Art. The struggle between old aristocratic and new capitalist values can be seen in a government memorandum on the Universal Exposition which pleaded for a retention of free admission for art if not for industry: "This point would distinguish it essentially and quite nobly from the exposition of industry and would remind foreigners of the lovely custom, so exclusively French, of opening without charge our public buildings and our museums to the curiosity of travellers from all countries."[35]

In the end, however, art was not to be distinguished from industry, and the same admission fees were adopted for each, five francs during May and one day a week thereafter. Mérimée said no one attended on the five-franc days but "some tarts and five or six lords and ladies."[36] As a result, the price was dropped to two francs in August. Regular admission was one franc, and on Sundays, twenty centimes. Everyone went on Sundays, even the well-to-do, for, as was pointed out in the press, all understood that if the experiment succeeded, the "English system" would become a stan-

dard—and unwelcome—feature of French life (Plate 30).[37] Mercey's statistics showed that on five-franc days there were rarely more than 300 visitors, but on Sundays often 20,000.[38] Moreover, the public was less willing to pay to see the exposition of art than that of industry: there were 4,180,117 visitors at the Palais de l'Industrie, 935,601 at the Palais des Beaux-Arts. Unlike its English predecessor, the 1855 Universal Exposition operated at a loss. A report in the Archives explained somewhat tactfully of paid admission: "This innovation must have contributed in diminishing the curiosity of the public."[39]

A Show of Artists or a Show of Works?

The first major task of the Imperial Commission was to define the scope of the Universal Exposition, in the form of the *Règlement général*. It would have two major divisions, art and industry, with all the productivity of the human race subdivided into eight groups, art being the last.[40] This study is mainly concerned with painting, for this was the art to which the administration, the critics, and the public devoted most of their attention, and whose anticipated success was to establish the cultural superiority of France.

What kind of exhibition would it be? That it would be retrospective was established at the Saint-Cloud meeting, for its purpose was to manifest the glory of the French School, not to show the latest developments in art as in industry. Prince Napoléon described the basic choice as between "a show of artists" or "a show of works." Either the exposition would encompass the works of living artists only, or the focus would be on the works, whether the artists themselves were living or not.[41] This facile explanation concealed the major issues underlying the decision, probably the most hotly contested and far-reaching in consequence of the entire show. A government memorandum was more candid: if there were no rules about dates, it stated, the conservative School of David would come out in force and give a false picture of contemporary art.[42]

In the battle over the definition of the show, Prince Napoléon, supported by Ingres, took the position that the show should include all works completed since 1800 by the most celebrated artists, living or dead.[43] Delacroix, aided by Mérimée, managed to defeat this plan, and in the end the Exposition was limited to artists living on 22 June 1853, the date of the constitutive decree.[44]

Delacroix and Mérimée were both quick to realize that a general retrospective of nineteenth-century art would strengthen the past at the expense of the present and would reinforce the contemporary position of the School of David, Ingres and his followers. Opening the exposition only to living artists, on the other hand, would demonstrate the diversity and vitality of art at mid-century: the Romantics, the Realists, the painters of Barbizon and genre, all would bear witness that the classical tradition was no longer the exclusive representative of the French School. While it is surprising that Ingres, Pastoret and Prince Napoléon lost this battle to define narrowly the French School, it was no doubt because Delacroix had a more important ally than Mérimée: the comte de Morny. Eclectic though he was in his aesthetic tastes, there was one notable hiatus in his collection—no paintings by the School of David.[45] It would be Morny's eclecticism and not Prince Napoléon's classicism which would characterize the Exposition.

46

31. Henri Valentin, *The Opening Ceremony of the Universal Exposition, 15 May 1855*. Bibliothèque Nationale, Paris.

The most important evidence of Morny's influence was the Imperial Commission's decision to arrange special retrospective exhibitions for the most prominent French artists, each representing a different direction in art. Ingres, Delacroix, Vernet and Decamps were among artists mentioned as beneficiaries of this policy.[46] The decision was to be far-reaching in its implications, for, unlike previous regimes, that of the Second Empire no longer wished to *set* the direction of art, but was content merely to ratify existing popular choices. Provided that the principal artists rallied to the Empire, the Government was willing to endorse them all and include them all in the definition of the French School. All styles were thus implicitly considered neutral and inter-changeable, their differences reduced to questions of taste and popularity.[47] The Government's policy in art was, in fact, merely an extension of the system it used sucessfully in politics. Taxile Delord noted in his contemporary history of the Second Empire that "the dictatorship" had found it advantageous to allow one newspaper to each of the major political factions, despite its overall policy of strict censorship.[48] In its choice of official candidates for the elections, the Government looked for men "who will represent best the natural sympathies of the districts, while at the same time giving the Government the guarantees of sincere adhesion and devotion which it had a right to demand."[49] If this system worked so well in politics, why shouldn't it be equally successful in art?

32. *Jean-Auguste-Dominique Ingres*. Photograph by Disdéri. Bibliothèque Nationale, Paris.

6

Four Heroes and a Self-made Man

Napoléon III attempted to legitimize his regime by encouraging powerful individuals and groups who had supported previous regimes to rally to the Second Empire. A mixture of flattery and material incentives, secret deals and probably a threat or two ended up bringing him legitimists and Orleanists, republicans and Bonapartists, socialists and, above all, the Church.[1] This was the secret of the Second Empire's survival, but also the seed of its undoing for, when everything is promised to everyone, there are bound to be more than a few disappointed. So it happened also in art. Although surviving evidence is scanty, it appears that the Government actively courted the artists it wished to show off to the world, those prominent artists who, by decision of the Imperial Commission, would be accorded special retrospective exhibitions within the Universal Exposition of Art.

Ingres

From the Government's point of view, Ingres (Plate 32) was the most important artist alive, for he had worked for and been honored by every regime of the nineteenth century. He was most closely identified with the July Monarchy, and most of his friends were Orleanists, a group which Napoléon III was courting second only to the Church.[2] It was logical, then, to offer Ingres in 1852 a major commission, the ceiling of the Hôtel de Ville. The subject: *The Apotheosis of Napoléon I* (Plate 33). He accepted; according to his enemies, his political philosophy was "Never make fun of the defeated because they might return; nor of the victors because they are stronger."[3]

His participation in the 1855 Universal Exposition was of the utmost importance, for he was internationally known and respected. He had not, however, exhibited in the Salon since 1834, when his *Saint Symphorian* had been badly received. He had to be convinced to rally. First he was appointed to the Imperial Commission in December 1853. Then his ceiling was lavishly praised by Achille Fould, Ministre d'Etat. On 1 February 1854, Ingres wrote to his friend Marcotte:

> The Ministre d'Etat has told me several times that the Emperor wishes to see my work, but I'm not counting on it. All his family has come and they couldn't be more

33. Photograph of the Ingres installation at the 1855 Universal Exposition showing *The Apotheosis of Napoléon I*, 1853. (Destroyed. Exhibited 1855 no. 3343). Bibliothèque Nationale, Paris.

pleased with it. Everyone says it's a shame that such a beautiful work be destined for a ceiling and the Ministre wishes to have a copy made so that the original may be the diamond of the 1855 Universal Exposition.[4]

Napoléon III and Eugénie did come in person, and Ingres explained to them the symbolism of his painting. Neither the Emperor nor his officers liked the horses but, as Charles Blanc tactfully explained, they were "men who lacked a certain familiarity with aesthetic issues."[5] Fortunately, it was Prince Napoléon who was charged with Ingres's rallying, and he was a cultivated man. Expressing his profound admiration for Ingres's painting, which he esteemed above all modern art, Prince Napoléon then invited Ingres to assemble all his works at the Universal Exposition. Ingres asked for time to consider the proposal.[6] His friend Blanc described the artist's misgivings at the prospect of being judged by all Europe, subject to the whims of judges, jealous rivals and the ignorant public. "To overcome these misgivings," Blanc reported, "he was promised a separate Salon, reserved for him alone, where he could arrange his own

exhibition as he wished, keeping the key until opening day. This concession, above all so flattering, convinced him."[7]

That is not exactly the way it happened. Sometimes in late 1854, Ingres wrote to Mercey driving a very hard bargain in return for his participation:

I would like to draw your attention to the fact that I have kept aloof from public expositions for more than twenty years and that now, more than ever, I would like to continue to do so. My friends have convinced me, however, that the administration of the 1855 Universal Exposition intends to honor me and also, they say, it desires to see my work figure in this solemn exposition. I would be willing, then, to appear there at my best if the administration would consent to accord me the following privileges.

1. In the first place, I ask to be granted a private room or the far end of a gallery separated in some way according to the general layout of the locale.

2. That I keep the right to arrange my pictures myself, and that before the Exposition, as master of the locale, I be permitted to arrange or restore my pictures, if there is room, and to receive no one until the moment when the Jury honors me with its presence.

3. I also want to have some of my most important history paintings compete in the Exposition, such as the *Saint Symphorian* from the Cathedral of Autun and the *Vow of Louis XIII* at the Cathedral of Montauban; but I would like the administration to be responsible for the loan requests, transportation, costs, and responsibility involved.

4. As to the ceilings, whether the *Homer* at the Louvre or the *Napoléon* at the Hôtel de Ville, I insist that these works not be moved; that would only damage their effect as they were conceived and executed for the places they occupy.

5. As to the number of works, I can only consider an exposition that would be as complete as possible, for an artist ought to appear there in all his force. I cannot limit myself to fewer than thirty pictures large or small.[8]

Ingres was given everything he wanted and more. In January 1855 he wrote again to Mercey, asking that his fee be raised for *Jeanne d'Arc*, commissioned in 1851 for Reims. Mercey promptly recommended an increase of 5,000 francs, for, he stated, in his dealings with the administration, Ingres had always demonstrated sincerity and unselfishness.[9] Ingres eventually relented and allowed his two ceilings to appear in the Exposition, where the *Apotheosis of Napoléon I* was accompanied by this text: "He is carried on a chariot to the Temple of Glory and Immortality; Fame, the Crown, and Victory guide the horses; France mourns him; Nemesis, Goddess of Retribution casts down Anarchy."[10]

By the time the Exposition opened, Ingres and the Government were well pleased with each other.

Delacroix

Delacroix (Plate 34) apparently had no qualms at all about exhibiting; his *Journal* and correspondence of 1854–55 are full of positive references to his forthcoming exhibi-

tion.[11] The only artist appointed to the Imperial Commission who was not an Academician, Delacroix enjoyed amicable relationships with Prince Napoléon, Morny and Mercey, and had been in on the planning of the art exhibition right from the beginning: he noted in his *Journal* on 1 July 1853, six months before the Commission was even appointed, that he had attended a meeting with Achille Fould to plan the event.

In March 1854, Mercey gave him a commission for 12,000 francs for a painting to be done specifically for the Universal Exposition. The subject: *The Lion Hunt*, an appropriate image for the Government's efforts.[12] On 27 April 1854, Delacroix noted in his *Journal* that he was working away on his *Lion Hunt* (Plate 35) and (in the same sentence) that he was planning another painting to be titled *Genius Achieving Glory* (*Génie arrivant à la gloire*). He was expecting great things from the Exposition.

One year later, 24 March 1855, his mood had shifted. He wrote in his *Journal*: "Very disheartened at the lack of sympathy I find among the people of this exposition ... I feel

34. *Eugène Delacroix*. Photograph by Pierre Petit. Bibliothèque Nationale, Paris.

myself very isolated and this situation has me even more worried for the future." The same day he wrote to a friend: "The Jury is nearly entirely composed of members of the Institute on whom I doubt if my recommendations would have any effect."[13] To make matters worse, a wall panel promised to him for his exposition had been taken away and given to Ingres, and his complaints to Chennevières went without result.[14]

Chennevières, at this time a low-ranking member of the art administration, was, however, a protégé of Nieuwerkerke, and Delacroix had his problems with both master and man. Nieuwerkerke, in charge of museums, would not cooperate with Delacroix's request to remove *Liberty Leading the People* (Plate 36) from storage, where it had been confined since June 1848, in order to include it in his show. In exasperation, Delacroix finally appealed to Prince Napoléon who then demanded an explanation from Nieuwerkerke. Not easily defeated, Nieuwerkerke laid the decision before the Emperor, defending "the honorable reasons which from my point of view oppose the exhibition of a picture representing Liberty in a red cap standing on a barricade with French soldiers trampled underfoot in a riot."[15]

Alexandre Dumas (who was certainly not there) wrote a succinct account of the subsequent interview between Napoléon III and Nieuwerkerke: "'Is the picture any good,' he asked? 'Sire, M. Delacroix considers it one of his best.' 'Well then, let it be

35. Eugène Delacroix, *The Lion Hunt*, 1855 (partially destroyed), 2.60 × 3.59 m. Musée de peinture et de sculpture, Bordeaux. Exhibited 1855 no. 2939.

36. Eugène Delacroix, *28 July 1830*, 1830, 2.60 × 3.25 m. Salon of 1831. Louvre. Exhibited 1855 no. 2926. (*La Liberté guidant le peuple*).

37. Photograph of the Delacroix installation at the 1855 Universal Exposition. Bibliothèque Nationale, Paris.

shown with the others!' "[16] Albeit the reality was more prosaic than that, in any case it was due to the personal intervention of Napoléon III that *Liberty Leading the People* reappeared in 1855. And, no doubt, it was due to Mercey's intervention that Delacroix's exhibition ended up so well installed that, although he was not given a separate gallery, as were Ingres and Horace Vernet, he pronounced himself content. Shortly after the Exposition opened, he wrote to Baudelaire: "I must confess that I'm not dissatisfied. Something in me has gained immeasurably from seeing these pictures reunited" (Plate 37).[17]

Decamps

Decamps (Plate 38) had nothing but wealth and popularity. He was never elected to the Académie des beaux-arts, never given a government commission, never considered

54

38. *Alexandre-Gabriel Decamps.* Photograph by Disdéri. Bibliothèque Nationale, Paris.

39. Alexandre-Gabriel Decamps, *Turkish Children with Turtles*, 1836, 0.725 × 0.916 m. Musée Condé, Chantilly. Exhibited 1855 no. 2871. (*Enfants turcs auprès d'une fontaine.*)

a painter in the Grand Tradition of the French School.[18] On the other hand, he was a favorite of bourgeois collectors (and not a few aristocrats if the truth be known). His small jewel-like paintings with their rich color and texture had a certain elegance without the disturbing *angst* of Delacroix (Plate 39). Neither he nor his patrons (among them Morny) could be ignored, but he was not courted and flattered as were Ingres and Delacroix. In a sulk, he decided not to participate.

His friend Jadin then wrote to Nieuwerkerke, describing Decamps's state ("he is so sad and dejected that he hasn't the heart for anything") and suggesting "a letter from you could encourage him and convince him."[19] Nieuwerkerke wrote directly to Decamps:

> I hear that you don't intend to send your works to the 1855 Universal Exposition and I would be pleased if this request I'm making would convince you not to persist in your resolution. You are one of our eminent artists whose abstension would be most keenly felt. It would be so easy for you to assemble some of your masterpieces by requesting them from their fortunate collectors that I hope you will not want to cause us any regrets.[20]

The mixture of flattery and menace proved effective, and Decamps promptly set about assembling his exhibition.[21]

Perhaps the reason why there is so little surviving evidence of the administration's courtship of Horace Vernet (Plate 40) is that it would have been superfluous. He was

already their man. The most famous battle painter in the world (Plate 41), he had already spent several months of 1854 travelling with the French Army during the Crimean War, making notes and sketches for the series of paintings in which he intended to immortalize the victories of Napoléon III's Imperial Army.[22]

On 14 March 1855 he was given his first major commission of the Second Empire, *Napoléon I Surrounded by Marshals and Generals Dead on the Field of Battle*, an enormous painting of 9.48 by 5.06 meters, at an equally enormous price of 50,000 francs.[23] No wonder he could write smugly to a friend:

> X has just had an apoplectic stroke. He almost died, he's so worried about his exposition. How conceited these poor creatures are, they feel they must complain! What does their inflated self-esteem get them? They end up covered

40. *Horace Vernet*. Engraving by Masson after a photograph. Bibliothèque Nationale, Paris.

with mustard plasters and leeches God knows where. As for me, I'm not such a schemer and I can painlessly accept the place that has been prepared for me . . .[24]

Courbet

Separating fact from fiction in the career of Courbet is not easy. Both he and subsequent historians have dramatized his plight in 1855, and he emerges as somewhat of a martyr, persecuted by a blind administration and hostile critics. And yet, placed in context, a different picture emerges. The crucial information is that Courbet was thirty-six years old in 1855 (Plate 42), Ingres seventy-five, Vernet sixty-six, Delacroix fifty-seven and Decamps fifty-two. In the gerontocracy of French culture, he was a very young man indeed and would have to wait his turn to be recognized. But Courbet did not want to wait. He was determined to seize the occasion of the Universal Exposition to present a major retrospective of his work, such as had been officially given to these older artists. And yet he would not rally to the Empire as they had done.

42. *Gustave Courbet*, 1855. Photograph by Lainé. Bibliothèque Nationale, Paris.

There is evidence that the Government attempted to gain his loyalty in the same way as it had approached Delacroix, through the offer of a painting commissioned expressly for the Exposition. To this end, Nieuwerkerke invited him to luncheon sometime in 1854, and Courbet immortalized the interchange in a letter to his friend and patron Alfred Bruyas:

Before I left Paris, M. Nieuwerkerke, Directeur des beaux-arts, invited me to lunch in the name of the Government, and, fearing that I would refuse his invitation, he chose for ambassadors Messieurs Chenavard and Français, both *self-satisfied* and *decorated*. I must say to their shame that they carried out a governmental mission with regard to me. They paved the way for the Government's benevolence, and they seconded the opinions of the Directeur. Moreover they would have been happy for me to sell out like them. After they beseeched me to be what they called "a good boy," we went off to lunch at the restaurant Douix at the Palais-Royal where Nieuwerkerke was waiting for us. As soon as he saw me he threw himself at me, shook my hand and cried that he was delighted that I had accepted, that he wanted to deal openly with me and that he wasn't concealing the fact that he'd come to convert me! (The two others exchanged a glance as if to say "What clumsiness, he's just spoiled everything!") I answered that I was already converted but if he could change my point of view I would only ask to be educated. He continued, telling me that the Government was unhappy to see me going it alone, that it was necessary to moderate my views, to put some water in my wine, that the Government wanted to help me, that I ought not to be so obstinate, etc. Various stupidities of this sort; then he

41. Horace Vernet, sketch for *Smalah. The Duc d'Amale, 16 May 1843*, 0.32 × 0.47 m. Musée des arts africains et océaniens, Paris. (Finished painting, 4.89 × 21.39. Salon of 1845. Musée national du château, Versailles. Exhibited 1855 no. 4151.)

concluded his opening speech by telling me that the Government wanted to commission me to paint my best picture for the 1855 Exposition, that I could count on his word, and that he would set as conditions that I present a sketch and that the finished picture be submitted to a committee of artists that I would choose and a committee that he would choose. You can imagine my fury at such an offer; I immediately responded that I understood absolutely nothing of what he had just said, in the first place because he stated that he was a government and I didn't feel myself at all included in this government, that I also was a government and that I defied his to do anything at all for mine that I could accept. I continued by telling him that I considered his government a simple individual who, if my pictures pleased him, was free to buy them from me, and that I only asked one thing from him, that he leave art free in his Exposition and not maintain an army of 3,000 artists with a budget of 300,000 francs against me. I continued by telling him that I was the sole judge of my painting, that I was not only a painter but also a man, that I painted not to make art for art's sake but to gain my intellectual freedom, and that I had succeeded through studying tradition in breaking away from it, that I alone of all contemporary French artists had the power to render and translate in an original fashion both my personality and my society. At this he answered: "M. Courbet you are certainly a proud man!" "I am astonished," I told him, "that you have just noticed it. I, sir, am the most conceited man in France." This man, possibly the most inept I've ever met in my life, regarded me stupefied. He was all the more stupefied as he had, no doubt, promised his master and the court ladies to show them how you can buy a man for 20,- or 30,000 francs. He asked me again if I was going to send anything to this Exposition. I answered that I never competed as I didn't acknowledge judges, that nonetheless I might send, out of cynicism, my *Burial* which marked my debut and set forth my principles, that they could deal with this painting however they could but that I hoped (perhaps) to have the honor of mounting my own exposition in competition with theirs, and that I would make 40,000 francs from it which I would certainly not get from them. I also reminded him that he owed me 15,000 francs in entrance fees that he had collected for my pictures at previous expositions, that his employees assured me that they had each conducted 200 people a day to my *Bathers* to which he responded with the following stupidity: "But those people weren't going there to admire them." It was easy to respond by challenging his personal opinion, by stating that that wasn't the issue, that whether to admire them or criticize them, the truth was that he had taken the entrance fees and that half the newspaper reviews were about my pictures. He continued by saying that he was very unhappy that there were people in the world like me, that they were born to wreck the best plans and that I would be a striking example of that. I laughed until I almost cried, while assuring him that only he and the Academies would suffer because of me. I dare not go on any longer about this man, I'm afraid of boring you too much. Finally he ended up walking out on us, leaving us in the dining room. As he was going through the door I took his hand and said "Monsieur, I beg you to believe that we shall always remain friends." Then I turned to Chenavard and Français and begged them to believe that they were two imbeciles; then we went to drink some beer. Here's another thing Nieuwerkerke said that I remember; "I

58

hope," he said to me, "M. Courbet, that you will have nothing to complain about; the Government is making enough advances to you, no one could flatter themselves into thinking they have received more than you. Remember that it's the government and not I who invited you to lunch today." So now I owe the Government for a lunch. I wanted to pay him for it but that made Français and Chenavard angry.[25]

Courbet's account was somewhat exaggerated. His *Bathers*, for example, was shown in 1853 when there were only two, poorly attended, paid-admission days per week at the Salon; his claim for 15,000 francs was thus absurd. Nor did he inform Bruyas that the requirement of a preliminary sketch was a standard feature of government commissions, omitted only for well-established and "dependable" artists; Courbet was neither. Nonetheless, his account of the luncheon with Nieuwerkerke was corroborated by Français, who recalled that Courbet instantly began discussing politics, vociferously condemned the 1851 *coup d'état*, and in conclusion accused the Government of trying to corrupt artists.[26]

Courbet was determined to have his own show and had already begun grooming Bruyas to pay for it. Despite the exchange with Nieuwerkerke, in the fall of 1854 he sent the Imperial Commission a list of works he would like to exhibit; at the same time he wrote to Bruyas: "What a shame that we can't hold this exhibition on our own, that would be a broad-minded and innovative gesture, away from all these antiquated ideas from the past."[27] When he wrote to him the following March to say that he had obtained an extension on the deadline for submitting his works, he added: "If any disagreements arise with the Government, we could risk it all, the exposition of your entire gallery along with my pictures."[28] When three of Courbet's fourteen paintings, including his *Studio* (Plate 43), were refused by the Jury, he wrote again to Bruyas:

I'm sick with worry. Terrible things have happened to me, they've just refused my *Burial* and my last picture *The Studio* with the portrait of Champfleury. They've declared that it's necessary at all costs to put a stop to my tendencies in art which were disastrous for French art. I've had 11 pictures accepted, *The Meeting* is accepted with difficulty, as it's thought to be too personal and too pretentious. Everyone is urging me to have a private exposition. I've given in. I'm going to hold another exhibition of 27 pictures, old and new, while saying that I'm profiting from the advantage the government is giving me by accepting 11 pictures at its own exposition. To hold an exhibition of pictures from my studio, that will cost ten to twelve thousand. I already have the site at a rent of 2,000 for 6 months. The construction will cost me six or eight thousand. What is odd is that the site is enclosed among the very buildings of their exposition. I'm going before the Préfet de Police to take care of the formalities.[29]

He added "Paris is exasperated that they've refused me," and for once he was not exaggerating, only the exasperation was general at the severity of the Jury, of which he had become the symbol.

Had Courbet's two major paintings been accepted, he would have had a private retrospective exhibition equal to that of the four major painters; this, of course, was exactly what he wanted. He proceeded to set it up anyway, and that he conceived of it

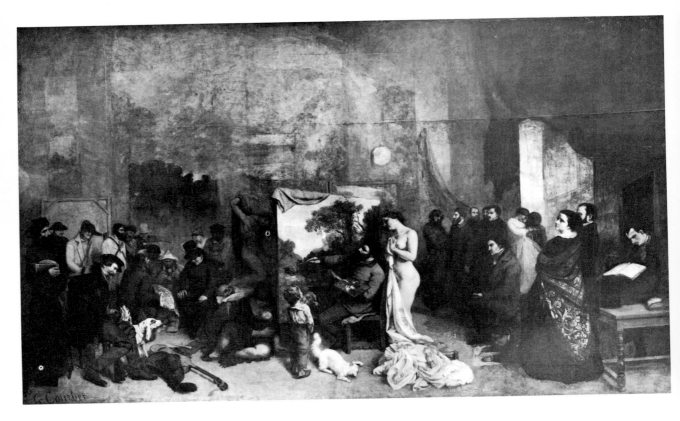

as theatre as much as art, relishing the gesture and the official outrage, is apparent in the letter he sent Bruyas after the latter agreed to foot the bill:

> So we're going to roll out our artillery and proceed to this great burial. Admit that the role of gravedigger is a splendid one and that to clear the earth of all this rubbish is not without charm.—40,000 francs, it's a dream. Here we are, obliged to rent a site in the city of Paris opposite their great exposition. From here I can already see an enormous tent with a single column in the center, for walls, scaffolding covered with canvas, all mounted on a platform, then the employees, a man in a black suit minding the office, opposite the canes and umbrellas, then two or three ushers. I believe we're going to earn them, these 40,000, even if we only count on hatred and envy. For the time being here's the title "Exposition of the Painting of Master Courbet and the Bruyas Gallery." This will really be enough to make Paris dance on its head. It will be without question the best comedy that's been played in our times; there are some people who will get sick over it, that's for sure.[30]

Across the letter, and symbolic of its contents, Courbet drew a carnival structure with a pennant flying in the breeze (Plate 44).

Courbet's request to the Préfet de Police gave the rue Amélot, far from the Exposition, as the site of his show. When the Préfet wrote to the Ministre d'Etat on 21 April 1855, asking for advice, he received a response from Mercey stating that there would be no objection.[31] Courbet then proposed the avenue d'Antin or the faubourg Montmartre; these sites were also approved. Then, on 1 May, he announced that actually he wanted to have his exhibition somewhere near the Champs-Elysées, but had not settled

43. (*opposite page*) Gustave Courbet, *The Painter's Studio, A Real Allegory Defining a Phase of Seven Years of my Artistic Life*, 1855, 3.59 × 5.98 m. Musée d'Orsay, Paris.

44. Gustave Courbet, drawing of exhibition tent across a letter to Bruyas, 1855. *The Art Bulletin*, XLIX.

on a location.[32] This brought a letter from Achille Fould himself to the Préfet de Police stating that Courbet could put his exhibition wherever he liked "except that it wouldn't be appropriate to have it very close to the Universal Exposition of Art, that is to say, at the very *door* of this Exposition as I believe is M. Courbet's intention."[33]

Of course Courbet intended all along to do exactly that, having announced to Bruyas several weeks earlier that he had already arranged the site "enclosed among the very buildings of their exposition."[34] But the Government had no desire to martyrize Courbet, despite the merry paperchase he had led, and so in the end he was given permission to put his show exactly where he wanted it, on the avenue Montaigne, opposite the Palais des Beaux-Arts, "at the very *door* of this Exposition," as Fould had predicted. Even Courbet had to admit that he had been given extraordinary freedom in organizing his exhibition.[35]

And so, without government interference, he built his pavilion opposite the Palais des Beaux-Arts, installed his show, published his manifesto "On Realism," plastered Paris with advertising posters (one franc admission), and waited for the 40,000 francs to begin rolling in.[36]

7

Choosing the Arms of France:
The Jury

The task of an Admissions Jury is a difficult and thankless one, especially at a
Universal Exposition where the principles of ordinary expositions no longer apply
and where the Jury had to choose the arms of France in this contest that was
unfolding.—*Prince Napoléon, at the opening of the Universal Exposition, 15 May 1855*[1]

NOT ALL ARTISTS were fortunate enough to be accorded individual exhibitions; for
most, the only way into the show was through the Jury. While each country was given
complete autonomy in the selection of its national representatives, France had par-
ticular difficulties in determining the structure of its Admissions Jury for Painting.
Power struggles were especially severe because traditionally the French School was
defined here; whoever controlled the Jury defined the show. Amidst a welter of pro-
posals and counter-proposals, each faction sought to define the Jury in such a way as to
favor—or eliminate—certain tendencies in art.[2] What, for example, should be the role
of the Academy? Should it make up the whole Jury, as it had during the July Mon-
archy, or contribute only a portion of its members? As it could be expected to vote in a
bloc, this was a crucial question. How many government appointees should be
included? What proportion of Academicians to independent artists, or should
Independents be included at all? Perhaps the Jury in whole or in part should be elected
by artists, as was the practice during the Second Republic? These and other questions
had to be answered before the Exposition could take shape. Or, put more succinctly,
the shape of the Exposition would reflect the answers to these questions.

In the end, despite the fact that Napoléon III's regime was based on universal
manhood suffrage, the Exposition was considered too politically important to be en-
trusted to the vagaries of democracy, and all the Juries were appointed by the Imperial
Commission.[3] As finally constituted, the Painting Jury included all fifteen members of
the Academy, save Schnetz who was Director of the French Academy in Rome and
Paul Delaroche who had withdrawn from public life. As Ingres and Vernet resigned
almost immediately, it was hardly a stellar group, and featured Abel de Pujol, Flan-
drin, Heim and Picot. The choice of the eleven independent artists was almost as
conservative, for several among them would become Academicians (Müller, Leh-
mann, Français, Meissonier); the true Independents (Couture, Delacroix, Troyon,
Rousseau) were hopelessly outnumbered. The most numerous group on the Jury were

the nineteen *amateurs*, for the most part friends of the regime or its appointed officials whose support could be counted upon. Nieuwerkerke was named President of the Admissions Jury, an appointment probably owing in equal parts to the influence of Mathilde and to the long-standing tradition which assigned this position to the Directeur général des musées impériaux.

In principle at least, all factions were represented on the Jury. On the basis of numbers alone, the regime had managed to guard the decision-making power for itself while at the same time giving a veneer—a very thin veneer—of democracy. Thus did the political system of Napoléon III work in art as in politics.[4]

And the results

George Sand was one of the few visitors willing to pay five francs to see the Universal Exposition of Art as soon as it opened. She wrote to her son Maurice: "Some artists got in through favoritism, some through luck."[5] The ones "through favoritism" took up the lion's share of the space. As we have seen, promises, offers, commissions and threats had been used to ensure the cooperation of artists whose participation was deemed advantageous to the Government. As none of their paintings was refused, it is unlikely that their works were really subject to Jury decisions.[6] Nor is it likely that the artists on the Jury had to submit their own works for judgment. Moreover, the lack of limitation on the number of works submitted meant that the "invited" artists would take up a disproportionate share of the space available. Delacroix, for example, showed thirty-five works, Ingres forty-one, Decamps forty-nine, and Vernet twenty-two. And so, when Prince Napoléon advised the French Admissions Jury to show "a just severity," he was really saying that there was a shortage of space.[7]

The artists were not at all pleased with this arrangement. *La Revue des beaux-arts* pointed out that, as they had been solicited from the beginning, they thought the Jury would be indulgent, especially as they had sent their best-known works exhibited at previous Salons. Instead they found "a tribunal of Aeacus and Rhadamanthus," the two judges of Hell.[8] This might have been a reference to Lehmann and Müller who, their ambitions set on the Academy, were reputedly the most severe members of the Jury. Taxile Delord wrote in *Charivari* that artists had originally been pleased to see so many of their colleagues on the Jury and were thus convinced that "The era of rejections is forever over, the age of exhibitions is about to begin." Then came the results. "What has become of all this goodwill? It has been transformed into bitterness, into sadness, into illness, into despair, into outrage."[9] *Charivari* illustrated this with Daumier's cartoon *Refused* (Plate 45), showing two dejected artists and captioned: "View of a studio, several days before the opening of the Exposition."

The dimensions of the debacle kept growing: the *Journal des arts, des sciences et des lettres de l'Exposition Universelle, 1855* announced that 7,000 works had been submitted to the Exposition. *La Revue des beaux-arts* put the figure at 8,000 to 10,000, and *La Revue universelle des arts* stated that 13,000 paintings had been submitted by French artists alone, and that eight out of ten had been rejected. Although the official records are incomplete, it seems that about 8,100 works were submitted to the Jury, three-quarters of which were refused.[10] As the outcry grew, Delacroix wrote to his fellow juror

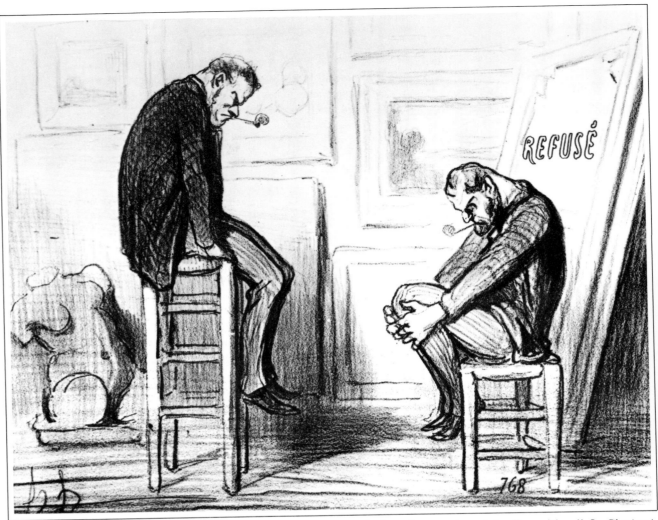

45. Honoré Daumier, "Refused. View of a studio, several days before the opening of the Exposition." *Le Charivari*, 4 May 1855. Bibliothèque Nationale, Paris.

Adolphe Moreau: "It's being said that there's going to be a revision of the Jury decisions. That seems to me an enormous task unless it will only include those works already mentioned."[11] And a month later the *Journal des arts* stated: "It seems that the Emperor has expressed his regrets over these outrageous exclusions; there has even been talk of a revision, but we don't believe it will happen."[12] It is possible that Napoléon III, alarmed by the complaints he was receiving, may well have thought of a revision—eight years before the Salon des refusés—for his regime was built on the continuing support of all special-interest groups. But there was simply not enough space to mount both a series of retrospectives by major artists and, at the same time, to represent adequately all the artists considered minor. Universal suffrage notwithstanding, democracy in this context was impractical. Some artists, however—Courbet among them—seem to have benefited from a partial revision: *The Meeting* and *A Spanish Lady* were both accepted on a second viewing after having previously been refused.[13]

In the end, 699 French painters exhibited 1,872 works.[14] Many of the rejected artists went away angry or depressed. Courbet, however, was already making plans to challenge the hegemony of official art by mounting his own show. He wrote, and for once he was telling the truth: "I am proclaiming liberty, I am saving the independence of art."[15]

The installation

There had been so many secret deals and private promises, and these promises had been so often disregarded in the exigencies of the moment that the installation turned into something of a free-for-all. Delacroix was unaware that separate galleries had been promised to Ingres and Vernet. Vernet saw his enormous *Smalah* (Plate 41) unceremoniously moved to a less desirable location during the show, Decamps found his works scattered despite administration promises to the contrary, and Théodore Rousseau threatened to withdraw completely from the exhibition, complaining that he was the only Jury member whose works were not hung together.[16] If this was the fate of the most sought-after artists, one can imagine how the others were treated.

And yet, despite the problems and complaints, there were achievements as well. Who was it on the Imperial Commission who first had the idea of grouping major artists' work into individual retrospective exhibitions? In the annual Salons, no attempt was made to group each artist's work, and in the studio exhibitions that artists held from time to time, they made no attempt to show their own development. Morny was probably responsible for the eclecticism of the choice, but Mercey wrote: "The Imperial Commission, wanting to satisfy the claims of our most eminent artists, had decided that the works of each artist would be assembled in the same area or on the same panel in order to present a sort of resumé of his entire career."[17] Ingres had written demanding his own show, and Delacroix may have expressed a similar desire. But in the context of the Universal Exposition, the idea of a simple grouping merged with the omnipresent ideal of "Progress." As Prince Napoléon stated: "Their works were often grouped so that their merit or their progress could be better judged through their successive efforts.[18]

Swept along in a tide of "Progress," it seemed perfectly natural that artists too should be required to show that their development followed the same immutable laws as industry, their latest productions indubitably superior to the preceding ones. At the same time, the concept of "Individualism," ushered in, according to conservatives, by the French Revolution and consecrated by Romanticism, had finally succeeded in redefining the nature of aesthetic achievement away from the traditional "School" where the artist's individuality is subsumed in the interests of shared concerns.[19] The School was replaced by the Modernist idea of the individual, self-referential style, manifest in the institution of the retrospective exhibition. And yet, far-reaching in consequence though it was, this concept of the retrospective exhibition, certainly one of the major innovations of the Universal Exposition, arrived in 1855 virtually unnoticed.

8

Critical Theories:
The Apotheosis of Eclecticism

Painting and sculpture will give, so to speak, a revelation of their future through an exhibition of their past, and a master whose recent works would be sufficient to immortalize his name will only be well known when the complete history of his talent is shown by the Exposition of 1855. In the arts as in all manifestations of intelligence and progress, it is useful at certain times to retrace one's steps, to measure the ground covered, to compare the present to the past, so that we can better understand where we have come from and where we are going and prepare more confidently the ground for the future.—*Prince Napoléon*[1]

ON 15 MAY 1855, the Exposition Universelle des Beaux-Arts opened (Plate 46). For the first time, the contemporary art of the whole world was gathered together. Foreign art had hitherto been known in France only through engravings or the occasional painting or sculpture that found its way into the Salon or picture shops. As the French rarely visited other countries, they had little first-hand experience, and thus were dependent on the evaluations of critics who travelled.[2] Now, for the first time, they would be able to see and compare the art, to form their own opinions. As Théophile Gautier remarked, the visitor to the Palais des Beaux-Arts would be able to learn more in four hours than he had in fifteen years of travelling.[3]

But, in fact, the critic became even more important than ever, for, alone and unprepared, the visitor would be unable to make sense out of this enormous display. Despite the fact that most of the French art had already been exhibited and discussed, it was now presented in a context that rendered previous critical approaches inadequate, for the Universal Exposition of Art was both international and retrospective. As it encompassed the art of twenty-eight countries, it produced in France a new aesthetic nationalism: for the first time French art could be experienced as a whole, internecine quarrels being temporarily put aside in the interest of meeting the challenge of the foreign Schools. The government dictum of eclecticism, honoring each of the major artists, established the precedent of attempting to see the validity of each style both at home and abroad, and the individual retrospective shows provoked the novel perception that each artist had a separate history to be written of the growth and development of his individual style. All these new factors invited broad evaluations of the direction contemporary art was taking.

66

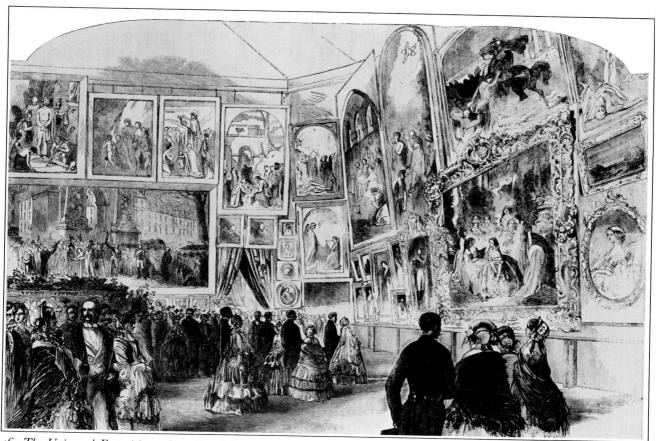

46. *The Universal Exposition, 1855. Grand Central Salon of the French Exhibition, Palais des Beaux-Arts.* The Bibliothèque Nationale, Paris.

In attempting to assess the import of the exhibition in France, the principal evidence is the writing of critics and artists (although that of the latter is scanty), changes in artists' work or careers, or subsequent changes in the administrative structure of the fine arts. It is to the critics that one looks first, for the official guides to the Exposition are merely lists.

Virtually every Parisian journal and revue published a series of articles, often twenty or more, designed to lead the public gently through the exhibition. As every shade of political and aesthetic opinion was represented in the press, albeit muffled to escape censorship, the average French citizen, whether legitimist, clerical, Orleanist, liberal, republican or socialist, could receive, along with the political news, the appropriate aesthetic opinion. At their most simplistic, these opinions ranged from a general approval of all new trends in art, an attitude linked by contemporaries to ideas of "progress," to a blanket condemnation of everything deviating from the Academy and tradition, a stance widely identified with conservative politics. Ever since the Romantic challenge to Classicism had produced an aesthetic schism in the 1820s, art and art criticism had been politicized in France, and artists and styles had come to stand for specific political positions.[4] There were, of course, individual defections from the ubiquitous generalizations linking artists, styles, and politics. The most outstanding

67

was the preference of Prince Napoléon, a self-proclaimed socialist, for classical art, a choice which must be understood in the context of Bonapartist strivings after legitimacy, an attribute of Classicism. There were also individual variations in intensity, for some artists and critics actively drew political parallels while others only reflected them in their language and values. In any case, during this period the political atmosphere was so highly charged as to color the most seemingly innocuous language and styles. Critics could not escape these pressures if they wrote for periodicals, each of which occupied a readily identifiable position on the political spectrum. Louis Auvray described the problems in his account of being summoned by the editor of an opposition journal who had commissioned him to review the Salon. The editor complained:

> I advised you not to discuss any act nor any official connected with the State and here you are praising a portrait of the Empress and complimenting the administration. I know very well that the portrait is good and the reforms are just and liberal but it's not for us to publicize those things, they must be passed over in silence.[5]

A few critics, notably the Goncourts, escaped these pressures by not aligning themselves with journals and publishing their reviews independently as books. The most influential, however, published first in journals, then reissued their collected essays as books, the first comprehensive histories of contemporary art. Among them one might cite (from Left to Right) the radical republican Maxime DuCamp, whose articles first appeared in *La Revue de Paris*, soon after suppressed, and then were published as *Les Beaux-Arts à l'Exposition Universelle de 1855*. Théophile Gautier, the only major art critic who had rallied to the Empire, wrote, appropriately enough, for the government journal *Le Moniteur universel*; he was thus the official spokesman for the Exposition. His articles, later published as *Les Beaux-Arts en Europe. 1855*, formed the basis for the subsequent *Visites et études de S.A.I. le prince Napoléon au Palais des Beaux-Arts*. The conservative E. J. Delécluze assured the readers of the Orleanist *Journal des débats* that art had been better in the past, but he was a red radical compared to the legitimist Claudius Lavergne who wrote for the ultramontane *L'Univers* and saw disorder, decadence and godlessness everywhere. Delécluze subsequently published *Les Beaux-Arts dans les deux mondes en 1855*, and Lavergne *Exposition Universelle de 1855. Beaux-Arts*. Thus did each shade of political opinion have, not only its own journal, but also its own version of contemporary art.[6]

The criticism published in 1855 can be analyzed to show the varied reactions to each artist's work, or to show the relation between each critic's judgment and his overall aesthetic theory; one might even relate the critic's judgments to the politics of his journal. A more important analysis, however, and the one followed here, would be to discover, not where they differed, but where they agreed, and thus to uncover the broad dimensions of the issues which formed the field of critical discourse in 1855. The danger is, of course, that citing art criticism is a bit like citing the Bible: almost anything can be proved thereby. But by beginning globally, identifying the general issues inhabiting the event—and such issues will surface in all the responses—we can then better understand, in context, the specific responses of individual critics. This does not mean, however, that critics dealt overly much with individual works of art; generalities about

each artist were the critic's stock in trade. The nuanced differences between, for example, Rousseau's early and later styles paled to insignificance as the critic (and probably most viewers as well) tried to encompass both in a generality which could stand next to that of, for example, Ingres or Courbet. Then, as now, specifics were seen through a frame of preconceptions and prejudices; during this period the frame had a decidedly political coloration.

The main problem of the critics was to find a structure, a theory, which could encompass in a coherent fashion the varied art of twenty-eight countries. The Government had already shown the way: eclecticism. Eclecticism in this sense refers less to the ancient Alexandrian philosophy than to its nineteenth-century French variant, formulated and popularized by Victor Cousin, the most influential philosopher in the first half of the century. "Eclecticism is the philosophy necessary to the century," he wrote in 1828.[7] Its enemies pointed out that it was born of the compromise between the *ancien régime* and the 1789 Revolution. Cousin's own account of its origins was frankly political; at the beginning of the Restoration, he stated, and after much personal torment, he arrived at the conclusion that there are in consciousness (*conscience*) many phenomena which although they seem mutually exclusive, can and must coexist.[8] Applied to politics, eclecticism promised Utopia: "By the grace of God, everything proclaims that time in its irresistible march will little by little unite all minds and hearts in the intelligence and love of this constitution which includes at the same time the throne and country, monarchy and democracy, order and liberty, aristocracy and equality, all the elements of history, of thought and of things."[9] Unfortunately, neither Charles X nor Louis-Philippe could make it work. Now it was the turn of Napoléon III to attempt to reconcile the contradictions of post-revolutionary France. It is well known that he attempted to do this in the broad arena of politics by encouraging notables of all political persuasions to rally to the empire. In the field of art, he hoped to accomplish the same thing through eclecticism.

Eclecticism in art had two meanings during this period. It signified, according to Adophe Thiers, "a taste which consists in combining the qualities of different schools into a harmonious ensemble. It is also in criticism the ability to appreciate and praise individual and contradictory qualities of these schools."[10] In the first sense, the art of the *juste milieu* was created; in the second, the 1855 Universal Exposition of Art. The harmonious whole that the Government was trying to create was not an individual work of art, but an exhibition which would encompass all the various French schools. Until 1855 warring and considered mutually exclusive, they were to be reconciled into a strong united front which would meet and vanquish the foreign schools on the peaceable battleground of the fine-arts exposition. Cousin himself had provided the philosophical apology for this when he wrote in his widely reprinted study of aesthetics *Du Vrai, du beau et du bien*: "Every one of the Schools represents, in some manner, some aspect of the Beautiful."[11]

Théophile Gautier set this forth as the official government line when he wrote of France: "It possesses in its art all climates and all temperaments. It can oppose Ingres to Delacroix, Decamps to Meissonier, Flandrin to Couture, Aligny to Rousseau, reconciling all oppositions and accommodating the most diverse originalities."[12] What had previously been the lament of critics, the fragmentation of the French School, has here

become its greatest strength, eclecticism. Thus was eclecticism established as the national character, even the genius, of France and, for the 1855 Universal Exposition of Art, a species of democratic sentiment was decreed which would replace the hierarchical ranking of categories characteristic of the classical system. Virtually every critic repeated the government dictum on eclecticism; the only holdouts were, as might be expected, the legitimists who, true to their politics, saw eclecticism as compromise and the Government's pluralism as anarchy and confusion.[13]

Eclecticism at home had international benefits as well. Cousin had written: "There are within an epoch different peoples because there are within an epoch different ideas. Each people represents one idea and not another.[14] Gautier established this as the framework for evaluating the different national styles, proposing England as the representative of Individuality, Belgium of Facility (savoir-faire), Germany of Intellectualism and France of Eclecticism.[15] This was taken up by all the critics, who explained at length that eclecticism led to universality, and universality led to superiority.[16] France, encompassing the styles of all countries, was thus the artistic capital of the world.

A public unfamiliar with contemporary foreign art went to see the Italian painting at the Palais des Beaux-Arts looking for the heirs of Raphael, Titian and Michelangelo; at the Belgian exhibit they looked for Rubens.[17] As a glorious past often led to an abysmal present—an eternal possibility in France as well—the public anxiously awaited an explanation. To provide it, the critics added to the government-sponsored theory of eclecticism, a cyclical theory of art which they derived from Universal History. As this theory, with its concepts of progress and decadence, informed all the critiques written in 1855, it is important to understand both its genesis and its political significance.

Like eclecticism, Universal History had a special meaning for the generations following the Revolutionary period. The nineteenth-century French interest in Universal History (sometimes called Social Palingenesis) has been related to the discovery of the Orient in the previous century, but a more plausible explanation was provided by Victor Cousin who felt that only with enough experience of the rise and fall of empires, religions, political systems, could the possibility of comparative study arise. Only those who had experienced and survived many revolutions and periods of civil disorder would begin to seek out the rules of Universal History.[18]

Its major sources in France were the eighteenth-century philosophers Giambattista Vico and Johann Gottfried Herder, both popularized by Cousin's 1828 lectures on the subject.[19] Cousin summarized Vico's theory in one sentence: "Each people has its point of departure, its maturity, its end; each people has its progress, its history."[20] Vico, essentially aristocratic and pessimistic, saw humanity condemned to an endless repetition of a cycle of three stages. For each society, there was an Age of Gods in which religion dominates, then an Age of Heroes and Kings, and lastly an Age of Men in which democracy leads to decadence and civilization dies out; the cycle then recommences elsewhere: both Delacroix's murals in the Palais Bourbon and Chenavard's cartoons for the Panthéon were influenced by this theory (Plate 47).[21] Herder was more optimistic; Cousin called his work "the first great monument erected to the idea of the eternal progress of humanity in all aspects and in all directions."[22] It is obvious that these two versions of Universal History could have opposite political applications:

47. Paul Chenavard, *Calendar for a Philosophy of History*. From Théophile Silvestre, *Histoire des artistes vivants*, 1855.

Vico for those who saw 1789 as the beginning of the Age of Decadence brought on by unbridled democracy, Herder for those who saw it as the commencement of the Age of Progress, with mankind evolving regardless of minor vicissitudes.

Herder claimed credit for the metaphor of the ages of civilization being like the ages of man, for, he said, he had developed this concept in a short treatise written in 1774.[23] His metaphorical use of such terms as infancy, youth, maturity, senility entered popular culture through a variety of channels. Perhaps the most direct was provided by Prévost-Paradol in his *Revue de l'histoire universelle*, a textbook for female lycée students first published in 1854.[24] Written in simple language, the book presented Herder's theory of history as the guiding principle behind every civilization from the beginnings in Asia to the rule of the bourgeoisie in contemporary France. Perhaps because of its

71

simplicity and optimism, the book became astonishingly successful with a general audience, even being lavishly praised in *L'Artiste*.[25] Eclecticism had enforced at least a veneer of acceptance of all styles, but cyclical history allowed critics to decide for themselves whether a given style was a symptom of progress or decadence, youth, maturity or senility.

Herder's metaphor was very much in evidence in 1855, from Prince Napoléon who wrote: "Races grow old like individuals," to Baudelaire: "One must not forget that nations, vast collective beings, are subject to the same laws as individuals. As in infancy they cry, stammer, fatten, grow taller. As in youth and maturity, they produce wise and courageous works. As in old age, they doze off over their acquired wealth."[26]

Such metaphorical language was by no means neutral in its political significance. Just as eclecticism was rejected by legitimists, who felt that, Truth being singular, pluralism could only mean compromise, cyclical history with its concepts of progress and decadence was equally charged. Throughout the nineteenth century, the concept of decadence was used politically to criticize a detested regime—usually the one in power.[27]

In the world of art, the 1789 Revolution had marked the temporary suppression of the Academy and the permanent loss of the Salon as a closed exhibition for its members. This, coupled with the subsequent rise of the bourgeoisie with its own taste in art—small easel pictures replacing the grand "machines" of the neoclassical period—could be seen either as the beginning of decadence—or the revitalization of art. It was important to distinguish which, for, as Achille Fould pointed out, "In France, the prosperity of the arts is a public good; their decadence seems a step backward in the march of civilization."[28]

Of the 935,601 visitors to the Palais des Beaux-Arts, it is unlikely that many were cultivated *amateurs*. And yet, judging by the passionate art criticism emanating from every camp, the public possessed quite definite aesthetic preferences. How were these opinions formed? Even a cursory examination of the art criticism of 1855 shows that artists were praised or damned for qualities which have become invisible to the modern viewer. Eugène Loudun explained: "In our time more than ever, works of art reflect the ideas of the century; they represent its doctrines and, as the rules which direct the arts and letters are correlatives of social principles, one is obliged when judging them to take sides, to be exclusive."[29] In addition, in an era of press censorship, one could often say obliquely what could not be said directly. Art and artists themselves became symbols for politics they may not even have shared. No matter. Although public images do not always reflect private realities, the public arena, with its myths and symbols, often reflects a larger and more powerful reality, the aspirations of a culture.

In the following analysis of how each artist was perceived in France in 1855, it will be shown that each was considered symbolic of a segment of the population necessary to the survival of the Second Empire. Thus "The Apotheosis of Eclecticism," as the Government of Napoléon III attempted to make Victor Cousin's program work, to harness to the regime the forces of King and Country, Monarchy and Democracy, Order and Liberty, Aristocracy and Equality.

9
Looking at French Art: Eclecticism in Practice

Le Charivari PUBLISHED A HUMOROUS monologue, "M. Prudhomme at the Exposition," which shows how all the philosophical and political eclecticism was understood by the average viewer:

> I begin by making my profession of faith:
> M. Delacroix and M. Ingres, M. Ingres and M. Delacroix.
> M. Delacroix is not M. Ingres, but, on the other hand,
> M. Ingres is not M. Delacroix. That's certainly clear!
> Ah! if only M. Delacroix could be M. Ingres, if only
> M. Ingres could be M. Delacroix!
> But M. Delacroix is not M. Ingres and
> M. Ingres is not M. Delacroix.[1]

On a more exalted, and certainly more verbose plane, the critics said the same thing, crowning Ingres "Master of the School of Line" and Delacroix "Master of the School of Color."[2]

As for the other artists—George Sand described the public's reaction:

> They go through in order to say "So many pictures!" and they ask each other to take them to the masters so as *not to lose time* by looking at the rest ... So at some points there's a crowd but vast galleries are empty, or there are a lot of strollers who converse without raising their heads because there's too much to see ... It's fine for the masters, it compliments them and shows them off. But everything new is lost in the crowd, without hope of finding one eye turned towards it.[3]

Nonetheless the critics and, we may assume, at least part of the public did view the rest of the Exposition. The Government's choice of artists to receive special exhibitions, Ingres, Delacroix, Decamps and Vernet, was applauded by the critics. Regardless of personal preferences, they did agree that these were major artists, worthy of being discussed in individual articles; the others were grouped together under broad categories, often more than twenty at a time, meriting—if they were lucky—a sentence apiece.

Ingres

There was nothing new in the precedence that Ingres enjoyed over other artists. Prince Napoléon visited his exhibition before all others, calling him "a page out of nineteenth-

century French history.''[4] He was not only an artist, he was an institution, and the new regime, in rendering him homage, placed itself in line with its more legitimate predecessors. Ingres, in accepting, returned the compliment, and the match was sealed with a freshly painted grisaille portrait of Prince Napoléon, added to his show during the last few weeks (visible in Plate 33).[5] Gautier, the official critic, announced that all reviews had to begin with Ingres because "it is impossible not to situate him at the summit of art."[6]

Ingres, more than any other painter, was known and admired throughout Europe, and, regardless of the internal disputes of the Academy, he was internationally hailed as the heir to David, the leader of the French School. In France, however, it was more complicated than that. Certainly Ingres was seen as the embodiment of the Academy and tradition, but also of the Church and public morality—in a word of Throne and Altar. His exhibition of over forty paintings included most of his masterpieces in a variety of categories such as history, religion, literature and portraiture, but the first seven listed in the catalogue were religious paintings, beginning with *Saint Symphorian* (Autun Cathedral) and *The Vow of Louis XIII* (Montauban Cathedral) (Plate 48). Scarcely a critic, friend or foe, neglected the seemingly obligatory statement, "He alone today represents the high traditions of History, of the Ideal, of Style."[7] And this was stated whether they thought those traditions were dead (Nadar), dying (Maxime DuCamp) or worth preserving (Delécluze).[8] It is even more striking how often religious terminology was used in descriptions of his work, which Maxime DuCamp, a fervent republican, characterized as "*catholico-aristocratique.*"[9] For Gautier, his style was "pure, austere, fervent, meditative."[10] Nadar called him "a bishop";[11] his criticism in *Le Figaro* was so harsh that it provoked a scandal, for he had written: "Before this antiquated and non-majestic painting, my nostrils are invaded by whiffs of warm, sour and nauseating air such as comes from the cells of Sainte-Perrine or the hospital of Petits-Ménages. I'm sorry to say this to delicate readers, but it's like a taste of a sick man's handkerchief."[12] Hippolyte de Villemessant, *Figaro*'s editor, joined in the fray and denounced the Ingrists for accusing the journal of "sacrilege and blasphemy."[13] In revenge he reprinted an article by Laurent-Jan, originally published in 1843, entitled: "M. Ingres, Painter and Martyr," written in mock heroic style.[14] Alphonse de Calonne and Louis Enault, both admirers of Ingres, used much the same language without satire, Calonne visualizing him, metaphorically, as Jesus standing at the right hand of God the Father.[15] Enault entitled an article: "The Chapel of M. Ingres," and was the first to publish the famous anecdote of Delacroix's visit to Ingres's "chapel" at the Palais des Beaux-Arts:

> One day M. Delacroix, who by chance was passing by, saw the curtain moving and the sanctuary abandoned. He entered, looked around and admired. M. Ingres returned, noticed his colleague, glanced first at his pictures, then at him, then again at his pictures. M. Delacroix left, a half smile on his thin lips . . . "How it smells of sulfur in here," said the old artist to the boy who brought him a nail.[16]

Like most representatives of morality, Ingres was not really popular—and he was the first to admit it.[17] To be *populaire* in nineteenth-century France was by no means a compliment in politically conservative circles, for it carried overtones of mobs, riots

48. Jean-Auguste-Dominique Ingres, *The Vow of Louis XIII*, 1824, 4.21 × 2.62 m. Salon of 1824, Cathédrale de Notre Dame, Montauban. Exhibited 1855 no. 3339.

Within the image: SE IPSE CARICATURA VIT ROMA

49. Marcelin, "The Public at the Exposition (Fine-Arts), The Color of Monsieur Ingres, '—It entrances me! —It leaves me cold!'" *Le Journal pour rire*, 17 November 1855. Bibliothèque Nationale, Paris.

and revolution. A cartoon (Plate 49) shows how Ingres's color was differently received by representatives of the upper and lower classes, for even formal qualities were politicized during this period. Several critics commented that one visited Ingres's Salon out of a sense of duty, but without real pleasure. Thus one went to Church.[18]

The numerous references to the "timeless and eternal" qualities of Ingres's art must also be understood politically. Conceptually there were two directions in which time could move during this period: forward, in the sense of "progress," or backward, in the sense of "decadence." "Timeless and eternal," in the sense of non-time, was the quality invoked by monarchists when referring to the aristocratic and "God-given" verities of the *ancien régime*. Ernest Gebaüer, for example, wrote of Ingres: "Obeying only inspiration, and seeking his subjects in the historic or glorious past, what does he care for an often sordid present! . . . Properly speaking, he has never had either beginning nor end,

neither *progress* nor *decadence*; at twenty years old he was as completely himself as at sixty."[19]

Gautier was no monarchist, but even he could write: "No, he is not of his time, for he is eternal."[20] Baudelaire, on the other hand, turned this same quality of "eternal" into condemnation by writing: "Whatever he is, he was from the beginning; thanks to his energy, he'll remain so until the end. As he hasn't made any progress, he'll never grow old."[21] Despite Baudelaire's much-vaunted contempt for the concept of "Progress," here, translated into the aesthetic concept of "Development," he implicitly accepts it.

The Apotheosis of Napoléon I (visible in Plate 33) proved a particularly inviting target for all the partisans of Romanticism and Liberty. It was in fact Baudelaire's harsh criticism of this painting that caused him to be dismissed from *Le Pays* which had commissioned from him a series of articles on the Universal Exposition of Art. He had written:

> I would very much like to state of the Emperor Napoléon that I have not at all recognized in him the epic and fateful beauty with which he is endowed by his contemporaries and his historians ... The principal characteristic of an apotheosis ought to be a supernatural feeling, a powerful ascent towards the higher regions, a drive, an irresistible flight to the sky, goal of all human aspirations, and classical dwelling place of all great men. This Apotheosis, or rather this team of horses, falls, falls with a speed proportionate to its weight. The horses drag the chariot down towards the earth. The whole thing is like a balloon without gas which, because of its ballast is inevitably going to smash on the surface of the planet.[22]

One can imagine the horror with which these sentiments were received at the journal which, having rallied, had added to its title *Journal de l'Empire*. "As of Sunday I've been *thanked* by *Le Pays*," wrote Baudelaire to François Buloz, editor of the *Revue des deux-mondes*, "Here I am, relieved of my insupportable *Salon*; here I am, free, but without a cent."[23] Eventually he did manage to publish his "insupportable *Salon*" in the little review *Le Portefeuille*, but he could not obtain a job on any other journal as a regular critic. In a year in which virtually every art critic in Paris managed to sign onto a journal for a lucrative six-month stint of weekly reviews of the Exposition, Baudelaire, the most brilliant critic of the period, found himself excluded and unemployable. No wonder, then, that others were more discreet.

It proved impossible to separate Ingres the artist from Ingres the political symbol. Love of antiquity carried overtones of love of the *ancien régime*; praise of his portraits of contemporaries in modern dress (the only paintings of his appreciated by political progressives) implied a preference for the new order of things. Conservatives and reactionaries praised the eternal and longed for its return; progressives, such as Paul Mantz, wrote: "Nothing in this world is eternal."[24] It was impossible even to *see* Ingres outside this frame of reference.

The Old Guard

The artists of the School of David that the administration wanted to exclude did, in fact, participate in the Exposition. Edmond About discussed them together under the

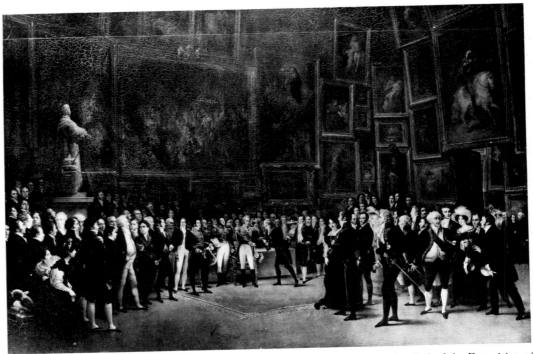

50. François-Joseph Heim, *Charles X Distributing Awards to Artists at the End of the Exposition of 1824*, 1825, 1.73 × 2.56 m. Salon of 1827. Louvre. Exhibited 1855 no. 3290.

title "The Old Guard."[25] Its members included Picot, Heim, Schnetz, Abel de Pujol—all Academicians, all born under the *ancien régime*. Ingres and his followers (notably Hippolyte Flandrin and Amaury-Duval) formed a rival camp. Ever since 1834 when Ingres's *Saint Symphorian* had been badly received at the Salon, there had been antagonism between the two factions.[26] This distinction was clear to conservative critics, less so to progressives who tended to lump all Academicians together with Ingres into what Nadar called "his detestable School."[27]

Heim was considered the best of the Old Guard (Plate 50). He had received the Prix de Rome in 1807 and had shown in the Salon regularly under the Restoration, less so during the July Monarchy. By 1855 he was virtually forgotten. Conservatives did not forget him, however, and he continued to receive commissions for Church decorations; Delécluze and Calonne considered him the equal of Ingres.[28] Even more importantly, Prince Napoléon, true to his classical taste, seems to have sincerely liked his work, and stated that "the Exposition of 1855 has restored Heim to the stature he deserves in our artistic Pléiade."[29] Appreciation of Heim was related to the question of religious painting in general. Although the Goncourts stated flatly: "Religious painting no longer exists," conservatives never tired of saying that it wasn't in the Salons because it was in the churches.[30] Even Prince Napoléon felt the necessity of repeating this rationale in 1855, for the Church was one of the main supports of the Empire.[31] Whether the great era of religious painting was actually over was another question; in the meantime, there was Heim.

Heim, however, was sixty-eight years old in 1855; when the critics looked for a continuation of his School, the most insightful of them were frankly worried. There was

51. Jean-Léon Gérôme, *The Century of Augustus: Birth of Our Saviour Jesus Christ*, 1855. Engraving from *L'Illustration*, 14 July 1855. (Painting in Musée d'Orsay, Paris. Exhibited 1855 no. 3164.)

52. Thomas Couture, *Romans of the Decadence*, 1847, 4.66 × 7.75 m. Salon of 1847. Musée d'Orsay, Paris. Exhibited 1855 no. 2819.

one hope, however: the young Gérôme. He had been given a government commission for *The Century of Augustus: Birth of Our Saviour Jesus Christ* (Plate 51), and this painting, commemorating the peace and prosperity of the first Roman Empire, was considered the Imperial answer to Couture's *Romans of the Decadence* (Plate 52).[32] Couture's version of history, although painted under the July Monarchy, was still disturbing enough in 1855 to merit a personal attack by Prince Napoléon at the Awards Ceremony: "As for those who, interested only in avenging their own impotence, set out to glorify the past and to represent the French people as the Romans of the Decadence, having well chosen their own image, their efforts in the future will be cursed with sterility as they have been in the past."[33]

Of the others, Chenavard's involvement with the Second Republic, from which he had accepted the unfortunate commission for the mural cycle at the Panthéon, had alienated the clericals and legitimists, by now the major constituency for *grande peinture*. Neither he nor the *juste milieu* painters such as Couture and Chassériau received much attention; they had no clearly defined constituency and, as George Sand noted, there was just too much to see.[34]

Delacroix

If Ingres was considered the representative of Throne, Altar, and Academy, Delacroix was seen as the harbinger of Revolution, Sin and Individuality. At this time, individuality had a negative connotation of egocentricity and selfishness, and was seen as proceeding from the 1789 Revolution, undermining the political and social order.[35] This, of course, was one definition of Romanticism, and Delacroix, as its *chef d'école* was held responsible. In this there was nothing new; he had been so criticized for several decades. Regarded by Ingres and his followers as "the apostle of ugliness" (Courbet inherited this title from him), he was also labelled, as Manet would be, "a painter of decadence." According to conservatives, he was the first in the period of decline ushered in by the excess of liberty resulting from the 1789 Revolution.[36]

Delacroix's show of thirty-five paintings, like that of Ingres, included most of his masterpieces (Plate 53). Like Ingres he exhibited a large proportion of religious, historic, and literary subjects, paintings drawn from Church and State collections. While the discourse around Ingres was conducted in terms of Throne and Altar, what was at issue with Delacroix was the concept of Liberty, for the question of how much liberty was enough was *the* burning question in nineteenth-century France. Cousin had written, and everyone to the right of the staunchest republican agreed: "Understand well that in France democracy always exceeds liberty and leads straight to disorder and from disorder to dictatorship. So then, don't demand more than moderate liberty and support this with all the strength of your soul."[37] Cousin wrote this, not in a political tract, as one might expect, but in a study of aesthetics; thus were all aesthetic questions politicized during this period. Individuals might deviate from the aesthetic attitudes expected of their political stance, but a general consensus did exist along political lines.[38] The legitimist Claudius Lavergne, for example, criticized Delacroix and the Romantics by writing in *L'Univers*: "authority, tradition and even common sense are there regarded as tyrannical laws and shackles on genius."[39] The republican

53. Eugène Delacroix, *Scene from the Massacre at Scio*, 1824, 4.17 × 3.54 m. Salon of 1824. Louvre. Exhibited 1855 no. 2924.

Pierre Petroz, on the other hand, defended the movement in the opposition *La Presse*: "It has broken arbitrary rules, overthrown the tyrannical sovereignity of academies, substituted the principle of liberty for the principle of authority, and especially because of that it merits our gratitude and admiration."[40]

Although his own politics were considerably less radical, to the general public, Delacroix was a wild-eyed revolutionary. Eugène Loudun described his constituency thus:

> Question the public. I don't mean the ignorant public but educated men distinguished by their intelligence, and ask them their opinion of the French Exposition; the results are striking. The painter they understand the best is M. E. Delacroix; for him they have enthusiasm and sympathy, his qualities please them, they explain and discuss him. There are few people at the present time who aren't in some way revolutionaries; Delacroix is their man.[41]

What is new in 1855 is the way this traditional image of Delacroix was transformed, "laundered" by the Government in recompense for his rallying. On 15 May, the day the Exposition opened, the *Revue des beaux-arts* reported that Napoléon III visited the Palais des Beaux-Arts and, having noticed the celebrated artist, spoke to him and warmly shook his hand.[42] Gautier, the official critic, was a particularly good choice to rehabilitate Delacroix because, in fact, he had supported him all along. He began by acknowledging his troubled past: "a quarter-century of violent attacks, diatribes and insults."[43] Then he announced that the Universal Exposition of 1855 had elevated his status, that, on seeing his pictures grouped together, "one is astonished to find them so beautiful, so visibly imprinted with the stamp of genius."[44] Delacroix was then eulogized: "Never has an artist more fiery, more savage, more passionate, depicted the anxieties and aspirations of our period: he has shared with us all the excitement, all the exaltation, and all the despair. The spirit of the nineteenth century has throbbed in him and does so still."[45] and finally, he was canonized by Prince Napoléon, who shamelessly stressed the benefits of rallying to the regime:

> There are no longer any violent discussions, inflammatory opinions about art, and in Delacroix the colorist one no longer recognizes the flaming revolutionary whom an immature school set in opposition to Ingres. Each artist today occupies his legitimate place. The 1855 Exposition, it must be said, has done well to elevate Delacroix; his works, judged in so many different ways, have now been reviewed, studied, admired, like all works marked by genius.[46]

And so, by Imperial fiat, Delacroix "the revolutionary" has become Delacroix "the colorist." His work had been depoliticized and neutralized and—except for a few diehard extremists—critics and the general public would begin to see it in exclusively formalist terms. Delacroix was delighted and wrote to Gautier, thanking him and adding: "This new approval has a great effect on people. Yesterday evening I met a woman I hadn't seen for ten years who assured me that, having heard part of your article read aloud, she thought I had died, thinking that one only so praises those dead and buried."[47]

Delacroix had accurately assessed the import of his canonization: his paintings had

been retired from the fray. Henceforth they would reside in the realm of the museum and would no longer play an active role in the ideological and political battles of the nineteenth century.

Landscape painting

Landscape painting in 1855 was thought to come in two varieties: the academic, represented by artists such as Cabat, Aligny, and Paul Flandrin (Plate 54), and the anti-academic, which encompassed the Romantics, the Barbizon painters, the Realists, and just about everyone else. The major division was, therefore, political rather than aesthetic: insofar as landscape painting deviated in any way from the classical Poussinesque prototype, it was considered a direct challenge to the Academy. Such painting labored under a double burden in 1855: its subject matter was considered inconsequential and its execution condemned as sketchy. Delacroix may have been suspected of revolutionary tendencies, but Rousseau, Courbet and Millet were actually identified as active revolutionaries; even worse, the first two were outspoken in their politics. Delacroix may have been criticized for the freedom of his brushstrokes, but his subjects remained in the Grand Tradition, similar to those of Ingres. In contrast, Rousseau painted swamps, Courbet, the barren landscape of Doubs, Millet, terrifying peasants. In 1855, their differences were less apparent than their similarities, for according to conservatives like Claudius Lavergne, they were all "nature lovers" who had abandoned "noble and elevated subjects."[48] To conservatives, Realists only followed the Romantics in their rejection of the Beautiful and their glorification of the ugly and disordered; the schism begun in the 1820s was steadily widening.[49]

At the Palais des Beaux-Arts, one could see the committed followers of Poussin next to Corot's dreamy Classicism; Barbizon painters such as Théodore Rousseau and Diaz de la Peña next to Independents such as Constant Troyon and Paul Huet; Realists such as Courbet and Millet next to the young Naturalists Daubigny and Jongkind; even Orientalists such as Decamps (Plates 54–61). This continuity between the generations was striking: the only category in which French painters seemed united into a School was that of landscape painting.[50] Although there was nowhere near a consensus as to who was the *chef d'école*, landscape painting could almost be used as litmus to reveal a critic's position. Delécluze showed himself a true conservative by choosing Paul Flandrin, followed by Aligny, and dismissing Corot, Rousseau and Huet.[51] Gustave Planche was more liberal, praising Huet's *Flood at Saint-Cloud* (Plate 58) because the artist "understood the necessity of not being satisfied with a sketch."[52] Paul Mantz, who defended the Romantics, championed Rousseau, and Pierre Petroz, a republican, announced that Millet had opened "a new path for art."[53] As Corot's art was—and still is—difficult to classify, he could not ride the crest of any political current, and was merely praised—and dismissed—as a poet.[54]

Everyone had to admit, even if reluctantly, that the landscape school was flourishing; some even linked this to the obvious exhaustion of the school of history painting. Whether this was seen as progress or decadence depended on the critic. Pierre Petroz put it in blatantly political terms: "Far from being a sign of decadence, this modification of received ideas, this reversal of the hierarchy, indicates progress, a return to truth."[55]

54. Paul Flandrin,
The Sabine Mountains,
1838, 2.01 × 1.50 m.
Salon of 1852.
Louvre. Exhibited
1855 no. 3085.

55. Jean-Baptiste-
Camille Corot,
*Souvenir of Marcoussy,
near Montlhéry*, ca
1855, 0.97 × 1.30 m.
Musée d'Orsay,
Paris. Exhibited 1855
no. 2792. (*La Charette.
Souvenir de Marcoussis,
près Montlhéry*).

56. Théodore Rousseau,
Group of Oaks, Apremont, 1852,
0.635 × 0.995 m. Louvre.
Exhibited 1855 no. 3935.

57. Constant Troyon, *Cattle
Going to Labor; Effect of
Morning*, 1855, 2.60 × 4.00 m.
Musée d'Orsay, Paris.
Exhibited 1855 no. 4094.

58. Paul Huet, *Flood at Saint-
Cloud*, 1855, 2.035 × 3.00 m.
Louvre. Exhibited 1855
no. 3325.

59. Gustave Courbet, *La Roche de dix-heures*, 1855, 0.855 × 1.60 m. Louvre. Exhibited 1855 no. 2809.

60. Jean-François Millet, *Peasant Grafting a Tree*, 1855, 0.81 × 1.00 m. Neue Pinakothek, Munich. Exhibited 1855 no. 3683.

The Government, however, was not enthusiastic; Prince Napoléon devoted one sentence to Rousseau and we are left with the impression that there was no clearly defined French constituency for landscape painting in 1855.[56] Certainly none was mentioned by the critics, and Alfred Sensier, Rousseau's biographer and friend, stated that the artist was supported by foreigners.[57]

The most prophetic judgment on landscape painting had the smallest voice in 1855, for the critique of the Goncourts was issued in a privately printed edition of forty copies: "Landscape is the victory of modern art. It is the honor of the nineteenth century. Spring, summer, autumn, winter have for servants the greatest and most magnificent talents who are preparing to pass it on to a younger generation still unknown but full of promise for the future and worthy of its hopes."[58]

61. Charles-François Daubigny, *Flood-Gate in the Valley of Optevoz (Isère)*, 1855, 0.44 × 0.56 m. Musée de peinture et de sculpture, Rouen. Exhibited 1855 no. 2844.

Decamps

Decamps was the dark horse among the major artists, the least favored by the Government, the most favored by collectors. Among the major artists in 1855, he was the least solicited by the Government, receiving neither a special commission for the Exposition, nor an appointment to any of the Commissions or Juries. In his autobiography, he recounts his sorrow over never having been judged worthy of receiving a government commission; by his own account, he loathed the small genre scenes that had made his

fortune and reputation.[59] At the 1855 Exposition, he received no special gallery, as did Ingres and Vernet, and, to make matters worse, his works were not displayed together.[60] And yet, despite its all-too-obvious lack of enthusiasm, the Government was apparently compelled to reckon with him. His works were everywhere, according to the critics, owned by shopkeepers and the wealthiest collectors alike.[61] His exhibition even included three paintings each from the comte de Morny and Dr. Véron, co-owners of *Le Constitutionnel*, the major imperialist journal. The commercial quality of Decamps's work was stressed repeatedly, at least partially as a veiled attack on the bourgeoisie that patronized him; Morny himself was known as a speculator who amassed collections only to sell them at auction. Decamps's small, pleasant genre scenes were easily comprehensible to those who lacked a classical education, and their richly encrusted surfaces, often compared to jewels, bespoke a conspicuous consumption; indeed, he did a brisk business at the Exposition, selling his pictures right off the walls.[62]

It would be a mistake, however, to attribute Decamps's appeal only to commercial interests; many quite sincerely preferred him to Ingres or Delacroix, and the Goncourts pronounced him the greatest painter of the century, "the modern master."[63] Claude Vignon described, in the new eclectic mode, the pleasures to be derived from each of the major artists. One visited Ingres's paintings from duty, respect and stubbornness, she wrote, Delacroix's from passion and intellectual ambition, Vernet's from patriotism. "But one returns ten times to the room where the paintings of Decamps are scattered, because all the fibers of the artist, the poet, and the collector are moved by this powerful master who knows how to seduce you through both your eyes and your soul."[64]

62. Alexandre-Gabriel Decamps, *The Experts*, 1837, 0.464 × 0.641 m. Salon of 1839. The Metropolitan Museum of Art, New York. Bequest of Mrs. H. O. Havemeyer, 1929., The H. O. Havemeyer Collection. Exhibited 1855 no. 2892.

Despite a brief period as student of Abel de Pujol, Decamps was considered to have had no master, to be self-taught and, according to Planche (who was properly horrified), to be anti-intellectual.[65] His paintings of monkeys (Plate 62) were widely interpreted as satires on Academicians, and did little to endear him in those quarters. And yet, with all of this, or perhaps because of it, he was the leading genre painter of the period. "For serious thinkers this was terrible. This success obtained without study, without learning, has resulted in a formidable army of amateur painters who want to gain wealth and honors through their ignorant painting."[66] Antoine Etex was only half-joking when he wrote this; Prince Napoléon, however, clearly disliked his paintings, consoling himself with the thought that at least Decamps was a unique phenomenon because he "hasn't any master, no more than he has produced any students or imitators."[67]

It was untrue, however, that Decamps had no followers; in reality, he had more followers than Ingres and Delacroix put together, for, as Etex had noted, the whole horde of nineteenth-century genre painters issued from his example that one could become rich and famous without elevated subject matter and without support from Government or Academy.

Genre painting

If the progressive critics had difficulty distinguishing between Ingres and the Old Guard, the conservatives considered as a single movement Romanticism and Realism, genre and landscape painting, for all were seen as deviations from the one true French School, namely the School of David. But it was for genre painting that they reserved their worst scorn, seeing in it only commercialism, ignorance and a pandering to the most debased taste, which they linked to the advent of bourgeois rule. Despite the masterpieces of Chardin, Greuze and the brothers Le Nain, it was considered a foreign style, an invasion from Northern Protestant and democratic countries, unsuitable for France with its Catholic, classical and aristocratic heritage.[68] What remained to be explained was why it was enormously popular in France, "practiced as a livelihood by all the talents of our time," according to the Goncourts.[69] Even the austere Ingres turned out a morsel of historical genre now and then, such as his *Tintoretto and Aretino* or *Henri IV Playing with his Children* (Plate 63).

Genre painting was widely considered to appeal to the common people who liked to look at it, as well as to the bourgeoisie who bought it. Although often purchased by aristocrats as well, it was commonly identified with the bourgeois class which could then be attacked through its aesthetic preference. Etex, for example, wrote: "Here in France there are no longer any art collectors; one can't so title that group of stock-market speculators who only encourage, who only buy, minor painting, little pictures worthy of decorating the boudoirs of their mistresses and who, even while buying them, hope to turn a profit by later reselling them to foreigners."[70] And yet, for those who were not locked into the classical tradition, genre painting had its charms, which Perrier described as based on "the intimate emotions which each man feels and which he is happy to recognize in all their naive simplicity."[71] Such democratic sentiments were shared by most politically progressive critics. The republican Petroz, for

63. Jean-Auguste-Dominique Ingres, *Henri IV Playing with his Children at the Moment when the Ambassador of Spain is Admitted to his Presence*, 1817,
0.991 × 1.250 m. Salon of 1824. Petit Palais, Paris. Replica of painting exhibited 1855 no. 3359.

64. Jean-Louis-Ernest Meissonier, *A Brawl*, 1855,
0.44 × 0.56 m. Windsor Castle, Windsor. Exhibited 1855 no. 3660.

example, praised genre for giving a moral significance to the most ordinary acts of everyday life, and DuCamp stated with approval that it was replacing history painting as a result of new social and economic conditions, divisions of great fortunes, smaller lodgings and greater democracy.[72]

Nonetheless, had it not been for the intervention of Prince Albert in French art history, genre painting would probably have remained the province of Decamps, as far as the Government was concerned. But, in a much publicized incident, while Prince Albert and Queen Victoria were visiting the Palais des Beaux-Arts, the Prince stopped to admire Meissonier's *A Brawl* (Plate 64), whereupon Napoléon III promptly purchased it and presented it to him.[73] This gesture and the price of 25,000 francs both served to raise esteem for genre painting to new heights, and to elevate Meissonier to the status previously held by Decamps alone.

The handwriting was on the wall; in the face of this new challenge, conservatives even began to look with nostalgia on the Romantics. Delécluze wrote: "In 1824, it was the *Ugly* we had to combat; today it's the *Pretty*, an enemy perhaps even more formidable."[74]

Horace Vernet

Ingres and Delacroix may have been acknowledged by the critics as the two major artists of 1855, but Prince Napoléon began his official visits with Ingres and Vernet, and only these two artists were given special galleries.[75] Obviously Vernet had an important constituency; just as obviously it was not the intellectuals or the critics who discussed him only grudgingly and with condescension, if at all. Edmond About wrote: "Outside of Paris no one knows either M. Ingres, or M. Delacroix, or M. Troyon, or M. Théodore Rousseau, or M. Corot, or M. Hamon; M. Horace Vernet is admired even in the Ardèche."[76] In a word, Vernet was *populaire*, adored by *la masse* who, if they could not afford to buy a picture, had, at least, one of the omnipresent engravings of his paintings.[77] The appeal, as Vignon had noted, was to patriotism, always important to governments, especially during a war. The Crimean War, however, was not popular with republicans, who, like Maxime DuCamp, saw Horace Vernet in another light and called his patriotism "the purest expression of French chauvinism."[78]

Conservative critics had trouble evaluating Vernet because, regardless of their personal opinions, he was a member of the Academy which had reluctantly accepted contemporary military painting as a hedge against Romanticism.[79] They nonetheless refused to accord him the title of History Painter (*Peintre d'histoire*), referring to him instead as a Painter of Historical Genre (*Peintre du genre historique*) or Painter–historian (*Peintre historien*), inspired by journalism rather than the great classical epics.[80] Academician he may have been, intellectual he was not: "He never confuses the naive crowd by the profundity of his compositions; he seeks neither symbols nor allusion nor allegory," Louis Enault wrote.[81] As a result, his *Barrier at Clichy* (Plate 65) was said to be one of the most popular pictures at the Exposition.[82]

It is evident that neither Prince Napoléon nor Gautier really liked the paintings of Vernet, and yet, as an official choice, he had to be praised. And so Prince Napoléon stressed his service as premier battle painter of France, and Gautier wrote simply this:

65. Horace Vernet, *The Barrier at Clichy or The Defense of Paris in 1814*, 1820, 0.975 × 1.305 m. Louvre. Exhibited 1855 no. 4149.

"M. Horace Vernet can probably not be compared in style or in color to the great masters of Italy, of Flanders, or of Spain; but he is original, witty, modern and French."[83]

Courbet

On reading through the response to Courbet in 1855, one is struck by how little relation it bears to Courbet's own version of the events, which history has by and large accepted. Who, for example, would have thought this could have been written in 1855:

M. Courbet, badly treated by the Jury of the Universal Exposition, opened at the end of June a private exposition near the Champs-Elysées where about 40 of his pictures can be seen. M. Courbet is a vigorous and original painter who has established himself among the true artists of Paris. His works would certainly have attracted a lot of attention at the Universal Exposition but he ought to be consoled for submitting in his turn to the fate which, not so very long ago, was that of Eugène

66. Gustave Courbet, *Young Ladies of the Village*, 1.95 × 2.61 m. Salon of 1852. The Metropolitan Museum of Art, New York. Exhibited 1855 no. 2802.

Delacroix, of Decamps, of Théodore Rousseau, of Diaz and of other great painters unanimously celebrated today.[84]

The author is anonymous, the publication, *La Revue universelle des arts*, one of several professional art journals, *all* of whom defended Courbet. *La Revue des beaux-arts*, for example, sympathetically reported the refusal of *A Burial at Ornans* and *The Studio* (Plate 43), and later, when Courbet opened his own exhibition, published his manifesto "On Realism."[85] The *Journal des arts* reported Courbet's partial rejection with sympathy, noting however, that *Bonjour M. Courbet* had been accepted; it later announced the opening of his show.[86] The most influential art journal, *L'Artiste*, despite its government subsidy, listed Courbet's accepted and rejected works in an article by its editor Edouard Houssaye. He concluded: "If M. Courbet has been mistreated on more than one occasion, he ought to console himself by thinking of how many of his pictures have been admitted, to the greatest despair of the adorers of Correggio and Racine who have no love for M. Courbet and M. Champfleury."[87] *L'Artiste* then published Champfleury's famous "On Realism. Letter to Madame Sand,"the longest

defense of Courbet yet written.[88] When its regular critic for the Exposition, Charles Perrier, responded with "On Realism. Letter to the Editor of *L'Artiste*," attacking Courbet as "the apostle of ugliness" (and thereby demonstrating admirable perspicacity in choosing the heir to Delacroix), the journal was, of course, obliged to print it.[89] It was not obliged, however, to publish yet another defense of the artist, by Fernand Desnoyers, which appeared several weeks later.[90]

This is not to say that Courbet was universally acclaimed as a major artist in 1855. To be sure, there was negative criticism, the worst of it almost as violent as that launched by progressives against Ingres and conservatives against Delacroix. Nadar had, after all, compared Ingres's painting to the taste of a snotty hanky, while Lavergne wrote of Delacroix's works: "they arouse immediate revulsion."[91] All the major artists encountered diatribes as hostile as those directed against Courbet; such was the free-swinging style of nineteenth-century art criticism. It is only when taken out of context that Courbet seems more victimized and less understood than the others.

The harshest criticism of Courbet in 1855 came from Augustin-Joseph DuPays, the literary critic (art critic for the occasion) for *L'Illustration*, with its rich and conservative readership. DuPays devoted an entire article to Realism, and used Courbet to attack the bourgeoisie, his real enemy. Because Courbet had often depicted the rural bourgeoisie, as in his *Young Ladies of the Village* (Plate 66), DuPays (and many others) identified him with this hated class, "a race of pretentious upstarts," as he called them.[92] The mixture of art and politics is evident: "The bourgeoisie, which grew up under the monarchy, which overthrew it, which has had in its turn an ephemeral reign, occupies an important place in history. But in art the bourgeois are only peasants. Art is aristocratic: accustomed to consorting with Gods and Heroes, it doesn't thrive in bad company."[93] *L'Illustration* also published – and this has become emblematic of Courbet's treatment in 1855 – an entire page of caricatures by Quillenbois of all his major paintings.[94] And yet, two even more gifted draughtsmen, Nadar and Daumier, published cartoons which were a good deal more sympathetic; Daumier's "Nobody's that Ugly" (Plate 67) might even be construed as a defense.[95] In truth, the most common response of conservatives towards Courbet in 1855 was that he was ignored; and yet his ambition was such that he preferred to be attacked, even martyrized, rather than ignored, as Nadar well understood (Plate 68). Of the major critics, those who refused to discuss him included the conservatives Claudius Lavergne, Alphonse de Calonne, E. J. Delécluze and Eugène Loudun, but also the more moderate Louis Enault; Maxime DuCamp, despite his republican sympathies, dismissed Courbet as a publicity hound.[96] Nor was he mentioned by Prince Napoléon, but, considering Courbet's comportment towards the Government, that was understandable.

The reaction to Courbet in 1855 was twofold: to Courbet's gesture of mounting his own show in defiance of the Government, and to Courbet's art itself. Few critics could see past the gesture. Champfleury, in his "On Realism," acknowledged the political context of Courbet's gesture when he wrote:

> This is incredible daring, it's the overturn of all juried institutions; it's a direct appeal to the public, it's liberty, say some.
> It's a scandal, it's anarchy, it's art dragged in the mud, it's a circus sideshow, say others.[97]

94

67. Honoré Daumier, "This Monsieur Courbet makes people much too vulgar, there's no one in the world as ugly as that!" *Le Charivari*, 8 June 1855. Bibliothèque Nationale, Paris.

68. Nadar, "St. Courbet, painter and martyr. How M. Courbet will offer us next year the 101st edition of his portrait." *Le Journal pour rire*, 13 October 1855. Bibliothèque Nationale, Paris.

Nor was it coincidental that the discussion was in terms of liberty versus order, the same issues that were at the root of the Delacroix–Ingres debate. In general, Courbet's gesture of setting up his own show was applauded by the constituency favoring artists' rights, such as the art journals, and the critics of the Left Opposition who also favored Delacroix. He was condemned or ignored by adherents of the *ancien régime* and the Academy, who supported Ingres. As the Orleanists were somewhat more progressive than the legitimists, it is not surprising that Gustave Planche, writing in the Orleanist *Revue des deux-mondes*, came up with a compromise: to support the gesture but dislike the art.[98]

It has already been shown that the discourse around Ingres was conducted in religious terminology, and that Ingres himself encouraged this; around Courbet it was the language of pure theatre. He himself had envisaged his exhibition as taking place in a carnival tent and, according to critics, had plastered the walls of Paris with posters advertising the event at one-franc admission.[99] Academicians had been stating metaphorically since the beginning of the century that the Salons had turned into bazaars and fairs; with Courbet, they actually saw it happen. When *Le Figaro* announced that Courbet's circus tent next to the Palais des Beaux-Arts was like a puppet show next to the Milan opera house, ('le théâtre de Guignol à côté de la Scala de Milan'), it had exactly comprehended Courbet's intention: to contrast popular and high-art culture.[100] Taxile Delord, in *Charivari*, was equally perceptive when he portrayed Courbet as a carnival barker shouting: "I am opening the era of personal art. One foot on the official Exposition, the other on my annex, I am the Colossus of Rhodes of art. I dominate the past and the tide of the future passes between my legs . . . From the height of these planks I shout to artists: 'Follow my example, build yourself an annex . . .'"[101]

Let us for the moment, pass by the responses to Realism in general, and Courbet's painting in particular, as being "vulgar" and "ugly." There was nothing new in this;

95

Courbet had been so criticized for a decade, just as Delacroix was still being called "disordered" and "decadent." What is more important is to see the stress caused by the new directive of eclecticism, now applied to Courbet. Ernest Gebaüer, for example, wrote:

> The uproar that's occurred for several years around the name of M. Courbet forces us to contend with this artist. Faithful to the principles which have guided us thus far, accepting, as we have said, all manners of understanding nature, all styles capable of expressing the ideas of the artist, provided that the artistic tendency be apparent in the productions submitted to our judgment, we do not at all affect the same disdain towards M. Courbet as certain other critics.[102]

Despite this heroic effect, Gebaüer couldn't really summon up any enthusiasm for Courbet's paintings. Auguste de Belloy, true to the fusionist politics of his journal *L'Assemblée nationale*, was more successful, praising Courbet's landscapes (Plate 59):

> If we can forget the reputation of agitator to which M. Courbet aspires, and only see in his works, especially the most recent ones, aspects of a particular and little-known countryside, rendered with feeling, very intimate and accurate, we shall be, I believe, grateful to have seen them and shall quickly forgive their author some childish, theatrical pranks which the public has encouraged by giving them an exaggerated importance.[103]

Paul Mantz, who had praised Delacroix, was also enthusiastic about Courbet: "There isn't a single painter in the Academy who can combine such an array of tones."[104] Delacroix himself wrote at length of Courbet's show in his *Journal*, stating of *The Studio*: "They have refused there one of the most remarkable works of our times"; he noted that Frédéric de Mercey shared his high esteem for the artist.[105]

Courbet succeeded in being discussed at greater length than all except the four chosen artists; much of the writing was intelligent and sympathetic; very little was overtly hostile. The Government encountered more hostility in instituting paid admission at the Palais des Beaux-Arts. If Courbet had to lower his entrance fee to attract visitors, so did the Government; if his exhibition did not draw the crowds he had hoped for, neither did theirs.[106] All in all, he was well satisfied when he wrote to Bruyas: "My exhibition went perfectly and has given me an enormous importance. Everything's going well."[107]

10

Looking at Foreign Art:
Reflections in a French Mirror

IN TRUTH, NO ONE in France liked any of the foreign art on display in 1855. While it would be easy to ascribe this to chauvinism, the fact remains that the best contemporary artists *were* French, for who was there to equal Ingres and Delacroix?

Most of the art shown by the other countries was unknown in France, but this did not at all prevent it from being pressed into service in the cause of current political battles. Pierre Petroz spoke for all when he wrote: "Everywhere in Europe the progress of art is explained and justified by national character, by social tendencies. Its development is always in relation to the state of science, to industry and to politics."[1] In practice, then, it was less the art that was judged than this "national character" which, insofar as it reflected similar tendencies at home, was either praised or damned by French critics. French art was, of course, similarly politicized during this period, the difference being that, whereas France's "national character" had been judged to be eclectic, the foreign nations were condemned—by the French—to have but a single, often overly simplified, national characteristic.

The *Règlement* had specified that every nation would name its own Commission to choose the work included in each section; as those appointed in the fine arts were usually art administrators or Academicians, their choice tended towards older, established artists.[2] The foreign displays were, then, like the French, representative but conservative. Most of the twenty-eight national exhibitions were grouped together by the critics as "the minor Schools"; they received little critical attention aside from enumeration and description.[3] Prince Napoléon, for example, dismissed the contemporary art of Spain and Italy as being "in a state of complete artistic decadence."[4] Three foreign nations were discussed at length, each in terms of what Gautier had established as its national character in art: Belgium, Facility; Germany, Intellectualism; England, Individuality.[5] And yet an analysis of the response to the foreign art shown in 1855 actually reveals more about France than about the paintings in question.

Belgium

Of all the foreign artists, the Belgians were the best known in France; many, such as Alfred Stevens (Plate 69), exhibited regularly in the Paris Salon. Their work, predominantly genre painting, was often indistinguishable from that of their French

69. Alfred Stevens, *They Call It Vagrancy*, ca 1855, 1.32 × 1.62 m. Musée d'Orsay, Paris. Exhibited 1855 no. 407.

colleagues. Belgian genre painting, however, managed to escape the wrath of French conservatives because in Belgium such painting was—the magic word—traditional. Eugène Loudun, for example, who refused even to discuss Decamps, could write: "These are imitations, but imitations of national masters; these painters are inspired by the genius of their country and they perpetuate it. They remain within their family; if they do not enrich it, they preserve it. That is still being rich; the impoverished are those who borrow."[6] His political and aesthetic opposite, Paul Mantz, also admired in Belgian art the continuation of the Flemish tradition, but the qualities he mentioned— truth in observation, dramatic contrasts of light and shade, broad execution, intensity of colour—had more in common with his favorites Delacroix and Courbet than with Loudun's vision of the perpetuation of an exhausted tradition.[7]

Gautier had identified *savoir-faire* as the national characteristic of the Belgian School; by this token, Henri Leys was universally chosen its leading artist. His historical genre paintings, such as *The Funeral Mass of Bertal de Haze* (Plate 70), were minute recon-

structions of a national past; this could not be called history painting, but it was more elevated than most genre painting, related to that of Paul Delaroche. This similarity to French art resulted in the conclusion that the Belgian School could be divided in two: half, including Leys, remained in Belgium and imitated seventeenth-century Flemish and Dutch masters; the other half, such as Stevens, lived in Paris, and imitated the French. In either case, the Belgian School was widely seen as a subdivision of the French.[8]

Perhaps this is why Prince Napoléon stated that Belgium ranked second only to France in the quality of its art.[9] This could be interpreted as extreme chauvinism on his part, or as an astute move to avoid taking sides on the politically loaded question of whether the art of the Germans was superior to that of the British, the major foreign protagonists.

Germany

During the first half of the nineteenth century, France's major political rivals were England, Russia and Germany (Prussia and Austria); in 1855 France was allied with the first, engaged in the Crimean War against the second (which, as a result, did not participate in the Universal Exposition) and was enjoying cordial relations with the third, Germany.

70. Henri Leys, *The Funeral Mass of Bertal de Haze*, 1854, 0.90 × 1.335 m. Musées royaux des beaux-arts de Belgique, Brussels. Exhibited 1855 no. 361.

71. Peter von Cornelius,
*The Destruction of the
Human Race by the Four
Horsemen (Apocalypse
C.VI), Pestilence, Famine,
War, and Death, 1846,*
cartoon for frescoes for
Campo Santo, Berlin.
(Destroyed. Formerly
Staaliches Museum,
Berlin.) Exhibited 1855
no. 1714 (2).

72. Wilhelm von
Kaulbach, *The Tower of
Babel*, cartoon for Berlin
Museum,
1.495 × 1.720 m.
Koninklijk Museum
voor Schone Kunsten,
Antwerp. Exhibited
1855 no. 1747.

French ideas of Germany were largely based on Mme de Staël's *On Germany* of 1813. Few French travellers had visited there, and even fewer knew the language. but it was widely considered the land of philosophy and culture, the home of intellectuals. Of German politics and nationalism, the French knew next to nothing.[10] The main artistic link between France and Germany was Rome, the home of the German Nazarenes and the home-away-from-home of the French Academy, where the most promising students of the Ecole des beaux-arts were sent to study the classical past. Rome provided the common ground for what were considered the highest aspirations of both Schools.

As Germany was not yet unified, work was sent to the Exposition under the sponsorship of Prussia, Bavaria, Saxony, and a host of smaller principalities. No matter; the critics grouped them together under the rubric of "Germany," occasionally adding Austria as well. The best known in France, the Düsseldorf artists and the Nazarenes, sent nothing, and the absence of Overbeck was particularly regretted.[11] Of the artists represented, the most distinguished were Cornelius and Kaulbach, both of whom showed with Prussia. Both sent only cartoons for fresco cycles, Cornelius his *Destruction of the Human Race by the Four Horsemen (Apocalypse C.VI), Pestilence, Famine, War and Death* (Plate 71), designed for the cemetery of Campo Santo in Berlin, and Kaulbach his *Tower of Babel* for the Berlin Museum (Plate 72). They were considered the epitome of both the strengths and weaknesses of the German School.

The tradition of *grande peinture* represented by Cornelius and Kaulbach was not, however, the only kind of painting done in Germany, as the few French devotees of German painting were well aware. Calonne, for example, stated that there were three

73. Franz-Xavier Winterhalter, *The Empress Surrounded by her Ladies-in-Waiting*, 1855, 3.00 × 4.20 m. Musée national du château de Compiègne. Exhibited 1855 no. 4209.

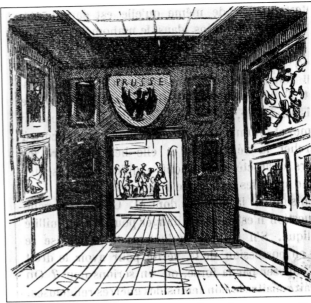

75. Cham, "The Public observing the strictest neutrality with regard to the Prussian School." *Le Charivari*, 14 June 1855. Bibliothèque Nationale, Paris.

74. Ludwig Knaus, *The Promenade*, 1855, 0.97 × 0.76 m. Musée des arts décoratifs, Paris. Exhibited 1855, 4th supplement, Bade and Nassau no. 2356.

German Schools: the High German School, represented by Cornelius, Kaulbach and the Nazarenes, the French German School, inspired by Paul Delaroche, of whom Winterhalter (Plate 73) was an example, and the Dutch German School of genre painting, represented by Ludwig Knaus (Plate 74).[12] As both Winterhalter and Knaus lived in Paris and showed at the Salon, their work was well known in France. Winterhalter, in fact, managed to show with both France and the German principalities of Bade and Nassau; his portrait, *The Empress Surrounded by her Ladies-in-Waiting*, was made the centerpiece of the main French gallery (see Plate 46). French conceptions of Germany, however, identified it as the land of elevated thought and so history painting was considered the "true" German School, next to which everything else paled to insignificance.

"They don't paint, they write out the idea," stated Gautier of the German School.[13] On its weaknesses, friend and foe were in accord with Louis Peisse (a friend) who wrote: "Their appearance is generally dismal, cold, stiff, and heavy. In these pictures there is neither grace nor charm."[14] Peisse quoted Cornelius as having said: "The intellect needs little skill to render what it conceives. By this principle I scorn all virtuosity."[15] This was even more extreme than the position taken by Ingres, who supposedly said that anything well enough drawn is well enough painted. Cham's cartoon (Plate 75) shows the reaction of the French public, and Gautier explained why:

We French who attach perhaps an excessive importance to the merits of execution, to the qualities of the paint, the skill of the touch, the harmony of color, to the

thousand resources of the palette, suffer a disappointment or a disagreeable impression before these immense works where an impersonal art is expressed by a foreign hand and seems to avoid giving pleasure to the eyes as a concession to vulgarity.[16]

Surprisingly enough, none of these flaws were considered fatal by the conservatives; indeed, these traits were thought to be salutary compared to the even more "dangerous tendencies" of Romanticism and Realism which were menacing the French School. Calonne explained that German painting, despite its flaws, was "preferable to the recklessness of certain colorists" and Planche praised the Germans for renouncing "prosaic imitation."[17] Germany was, if nothing else, an ally to conservative France in upholding classical ideals against the "vulgarities" that were swamping the art of the rest of the world. "While there is eagerness on all sides to suppress the ideal aspect of painting and sculpture, it continues to prefer the idea to the form," wrote Planche of the German School; "The excellence of its intentions compensates for the imperfection of its works."[18]

Opponents of German painting and the French Academy pointed to the same formal qualities mentioned by the conservatives but, instead of excusing them on the basis of the artists' excellent intentions, held them up as a dreadful example of the direction towards which all such elevated painting naturally tended. Maxime DuCamp wrote of Cornelius: "In sum, like the majority of painters of our epoch, he belongs to the past, disdains the present, and doesn't seem to care about the future."[19] And Paul Mantz closed his discussion with this imprecation: "May Germany, dragged by Düsseldorf and Munich along this sterile, retrograde path, be for us all an eternal example!"[20]

The diversity of modes actually practiced in Germany, and currently on display at the Palais des Beaux-Arts, was obviously known to the critics. Nonetheless, all this was considered of secondary importance; as reflected in a French mirror, the German School seemed synonymous with the most conservative traditions of the French Academy, and was praised or damned accordingly.

Britain

Britain, on the other hand, seen through a French looking-glass, seemed to be the dialectical opposite of Germany. While Germany was judged to exist in the elevated regions of philosophy, timeless and eternal as the classical ideal, Britain seemed to present the last word in modernity and industry, commerce and political freedom.[21] In a word, it represented *Progress*, and, although a longtime economic rival of France, was at the moment an ally in the Crimean War. The German School was Catholic, the British Protestant. The Germans painted major decorations for Church and State of religious and historical subjects; the British painted lively little genre pictures for private collectors. The Germans went to Rome to study, as did the French; the British were regarded as woefully ignorant and self-taught, lacking all contact with the grand tradition in art. In a word, the Germans were Idealist, the British Materialist.[22] Gautier called the British national characteristic "Individuality;" more conservative critics called it "Eccentricity" or even "Peculiarity."[23]

The British painting exhibition included works by the genre painters Sir Edwin

77. William Mulready, *The Wolf and the Lamb*, 1853, 0.60 × 0.51 m. The Royal Picture Collection, Buckingham Palace, London. Exhibited 1855 no. 893.

76. Sir Edwin Landseer, *Animals at the Forge*, exhibited in 1844, 1.422 × 1.118 m. The Tate Gallery, London. Exhibited 1855 no. 858. (*Shoeing*).

78. John Everett Millais, *The Order of Release*, 1853, 1.021 × 0.737 m. The Tate Gallery, London. Exhibited 1855 no. 886.

79. Cham, "M. Prudhomme at the Exposition. '—My friend, I believe there is a minor error in drawing in this English picture! —Madame, the English are our allies, I will never admit that they could err in one of their pictures, I ought not and will not!'" *Le Charivari*, 25 June 1855. Bibliothèque Nationale, Paris.

Landseer (Plate 76), a favorite of Queen Victoria, and William Mulready (Plate 77). Both artists were already known in France through engravings of their work.[24] There were also Pre-Raphaelites such as John Everett Millais (Plate 78) and William Holman Hunt, occasionally a history painter such as Sir Charles Eastlake, and a host of lesser-known genre and landscape painters. The British showed animal paintings, interiors, family scenes, landscapes, portraits—and a few history paintings. Gautier assured his readers that they put a dog in almost every picture.[25] Their paintings were witty, colorful, unpretentious and, being previously unknown in France, proved an immediate success with the public (Plate 79). The British exhibition was widely described as the most popular at the Palais des Beaux-Arts.[26] And yet, despite its success, there was critical agreement as to the formal weakness of British painting, for, with both Constable and Turner dead, the British had no artists of the stature of Ingres and Delacroix.[27] Pierre Petroz, an admirer of British painting, summed up what was apparent to all: "Their pictures shock at first by the dryness of their contours, by the faulty drawing, by a harsh and rarely harmonious color."[28] Despite these flaws—or perhaps because of them—the British School was universally considered the only real rival to France, for it alone had not succumbed to French influence.[29] The world of art, like the world of politics and economics, was thus seen as neatly divided into Britain, on the one side, and France (and the rest of the world), on the other. This was considered entirely logical, for, as Claudius Lavergne explained of the British School, "The strongly pronounced influence of religion, of customs, of national character gives it an original quality."[30] As with German art, French critics looked less *at* the paintings than *through* them to discuss their attitudes towards all things British, and, by extension, to comment on similar tendencies at home.

There was a long tradition for this, for French intellectuals had, since the eighteenth century, been looking across the Channel in admiration or disgust. Progressives admired England's rapid industrialization, capitalism and—by French standards—liberty. Conservatives looked with horror on England as the incarnation of a futuristic nightmare they feared would one day descend on France.[31] Furthermore, in an era of heavy press censorship, English politics and economics could be praised, all the better to criticize tacitly the French Government. But one had to be careful: Montalembert would spend a month in prison for praising the British Constitution.[32] If, then, we read the 1855 criticism of British painting in this light, we are doing exactly what the critics intended.

Genre painting was disliked by conservatives even more than Romanticism and Realism, possibly because, unlike these movements, it was genuinely *populaire*. Following Herder's methodology, Delécluze endeavored to show that it had arisen in Northern Protestant countries such as Britain, as a result of material conditions, such as geography, climate and the suppression of religious images, and was therefore unsuitable for France.[33] Most conservatives, however, were uninterested in searching out ultimate causes, such as geography or climate, which would have little political currency at home. Their real targets were the Protestant religion and the British Constitution. "Two things are missing there for the complete flowering of its faculties in the domains of statuary and painting: a poetic religion and the intervention of the State," Planche explained.[34]

Planche's argument, that lack of direction from State and Church (Throne and Altar) was responsible for the absence of *grande peinture* in England, was repeated by all the conservatives and was actually a thinly veiled attack on the current regime at home, where history painting was also languishing. Such a lack of direction from the State, they feared, could have only one result: the degradation of taste which would inevitably accompany such a political and economic shift.[35]

Britain and everything it stood for seemed to drive conservatives to diatribe rather than discussion. "As the tethered goat browses within a circle, they paint just what is around them," wrote Eugène Loudun.[36] Alphonse de Calonne wrote several pages in this vein:

> It is obvious to even the least perceptive that England today is atoning, through the poverty of its Grand Painting, for the wrong it has committed of not having any School properly speaking, of not having any Academy where the grand traditions are maintained and invigorated, of not having any museums which inspire vocations, of not having any religious art which develops them, no expositions nor national awards which encourage them . . . Slave of liberty, it doesn't believe it has the right to sustain and develop taste anymore than it has the right to control consciences . . . Liberty, always liberty, even the freedom to sink in the intellectual sphere, such is all they think about over there.[37]

In the end, it was Delécluze who articulated the underlying conservative anxiety: "We ought to fear that, within a certain time, if art continues to submit to the whims of rich collectors, we shall, like England, reject grand-style painting as the second-hand trash of mythological tales."[38]

Among progressives, British painting was praised for manifesting the same characteristic of British society so detested by conservatives, namely modernity. "The English, on the other hand, bring to their painting the spirit of independence which has given birth to their institutions, to their political organization, to their social customs," wrote Petroz.[39] Delacroix himself, as would be expected of a Romantic, praised the British cult of Individuality, a quality suspect in France.[40]

Just as those in political life discussed the British Constitution in order to comment on French politics, so art critics discussed the Royal Academy in order to better criticize the Académie des beaux-arts. Paul Mantz was the most extreme:

> The English Academy has a liberal and broad-minded organization; better than that it has an intelligent spirit. In order to stay in the contemporary movement, perhaps even to lead it, it is open to various schools, to innovations, to heresies. Youth doesn't systematically inspire it with horror. In fact, there is what seems in France an extreme peculiarity—it is composed of artists who can hold the brush with a virile hand; it's an active and energetic beehive and not a pathetic house of refuge inhabited by sick talents and paralyzed glories.[41]

It is evident that amidst these polemics, there was neither the time nor the interest to make a close examination of the works themselves. Generalizations, such as these, were made and applied indiscriminately to genre painters such as Mulready and Landseer and to the younger Pre-Raphaelites. Regardless of the variety existing within the British School, French critics noticed only British art taken as a whole against French standards.

Whether praised or damned, the British exhibition was unforgettable. Queen Victoria and Prince Albert took home with them a genre painting by Meissonier (Plate 64), but left in France an even more important souvenir, the memory of British painting. Maxime DuCamp wrote prophetically:

> The English Exposition ... is important and ought to be beneficial for us as it proves, one more time, that the field of art is unlimited, for they have been able to discover some effects, often remarkable, outside the realm to which our artists confined themselves.[42]

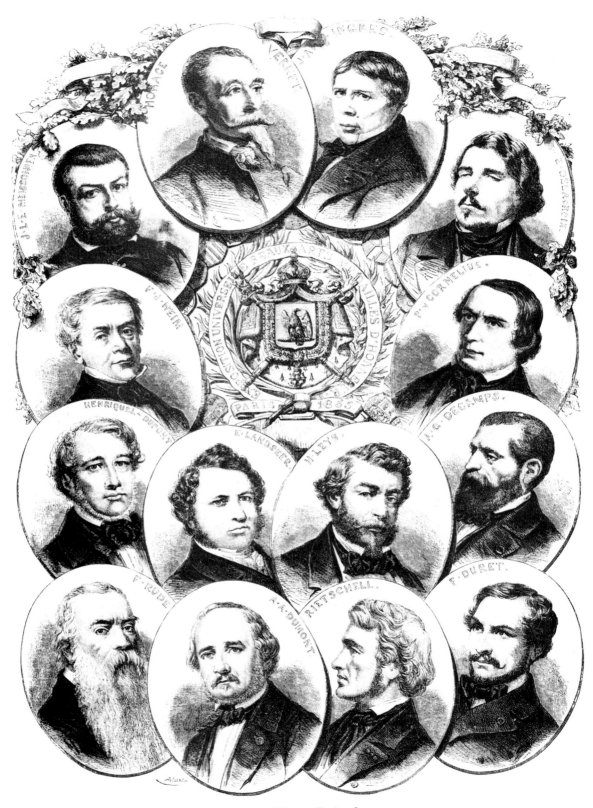

80. *Universal Exposition of Fine Arts. Medals of Honor. Paris 1855.*

II

Crowning the Victors

IN THE AUTUMN, after the public had come and gone and the critics had had their say, the Awards Jury began its deliberations. The Imperial Commission appointed Morny as President, for the task was too important to be left to artists, collectors or connoisseurs. National representation on the Jury was proportional to participation in the Exposition with each nation nominating its own members; as finally constituted it included fifteen French and sixteen foreign members, of whom the largest contingents were from Britain (four), Belgium (three) and Prussia (two). The manner in which the original French Admissions Jury was reduced to fifteen members was particularly revealing of the Government's intentions. Eliminated were the School of David (the most conservative group of the Academy), the two extremes among the Independents (the history painters and the landscapists; the Realists had never been represented), and all the collectors and connoisseurs. The remaining six Academicians (Alaux, Ingres, Forster, Picot, Robert-Fleury, Vernet) and four Independents (Dauzats, Delacroix, Français, Mouilleron) represented, with the exception of Ingres and Picot, an aesthetic position that could be characterized as liberal. The other five (Morny, Arago, Mercey, Pastoret, Villot), with the exception of Pastoret, were actually members of the Government, and could be expected to do its bidding. The foreign governments sent artists and art administrators.[1] There was thus little justification for characterizing the Jury as composed of "lawyers, government advisors and financiers," as did Charles Blanc, but, to staunch conservatives the unprecedented entry of an obviously political contingent into the precincts hitherto reserved for art professionals seemed a blatantly political ploy which made them—justifiably—apprehensive.[2]

The early memoranda called for one Grand Medal of Honor which, as it would undoubtedly be awarded to a French artist, would thus crown him the greatest living artist.[3] Was this award promised to Ingres to secure his cooperation? Probably so; anxious as he was about the outcome of his exhibition, it is unlikely that he would have participated otherwise. He was even offered, and accepted, the commission to design the Awards Diploma (Plate 81). The official decree, however, simply stated that 150,000 francs would be available for awards to art (the sum was later increased to 224,000 francs) but set no quota on the number of medals: that decision would be left to each individual Jury.[4]

The Awards Jury for Painting deliberated from 15 October to 8 November. On the

81. *Diploma of the Grand Medal of Honor, 1855*. Design by Ingres, engraving by Calamatta. Bibliothèque Nationale, Paris.

first day, Delacroix wrote in his *Journal*: "First Session of the Jury. Battle cry from the Institute over the plurality of medals."[5] Given the Government's policy of eclecticism, the multiplicity of medals should have been anticipated; to the Academicians, however, it must have seemed sacrilegious, a species of polytheism in the face of the One True Church. In the end there would be, for painting, drawing and engraving, 10 Medals of Honor, 48 First Class Medals, 51 Second Class, 57 Third Class and 151 Honorable Mentions. Altogether 469 medals were awarded to Art, 10,564 to Industry.[6]

 L'Artiste announced the awards for Grand Medals of Honor (Plate 80) as follows: "Horace Vernet, Ingres, Decamps, Cornelius (Prussia), Landseer (England), Leys (Belgium), Heim (!), Delacroix, Meissonier (after the fact)."[7] The awards were predictable in that, among the critics, there had been a general consensus that these were the outstanding artists—except for Heim and Meissonier. The voting records cast some light upon the awards. They show, for example, that although Troyon received more

votes than Heim in the preliminary voting, his name was mysteriously dropped from the ballot on the second round.[8] One might suggest as an explanation that Heim had a strong constituency in the School-of-David clique of the Academy, and that the Government was trying to propitiate all special-interest groups. Troyon and landscape painting in general had no special constituency at this time and so were not rewarded with a Medal of Honor.

International priorities came before national ones, however, and even Heim had to take a back seat to Meissonier. As the editor of *Revue des beaux-arts* explained: "At the session of the 6th, the Jury, on the proposal of M. le comte de Morny, reversing its earlier decision, voted a Medal of Honor to M. Meissonier when in the preceding session at the second vote, they had preferred Heim over him."[9] Meissonier's Medal of Honor was probably a tribute to British taste for, Prince Albert having preferred Meissonier above all other artists, Napoléon III had seconded his taste by presenting him with *A Brawl* (Plate 64). Morny no doubt interfered with the Jury proceedings in order to avoid the embarrassment to both sovereigns if that taste would be ranked at less than the highest quality. But in the end, probably because the story appeared in the press, Heim's name was restored to the list and he too received a Medal of Honor.

The other recorded incident of government interference was also intended to uphold the reputation of the somewhat dubious Imperial taste. Winterhalter, disliked by practically everyone except the Imperial couple, did not obtain enough votes to receive even a First Class Medal. He didn't even come close. The ballot was notated: "M. de Morny decided that the first nine names who received from 20 to 17 votes inclusive would be added to the list of First Class Medals."[10] The ninth name was Winterhalter.

The four principal French awards, to Ingres, Delacroix, Vernet and Decamps, surprised no one; one might even say that with the Government's decision to give each artist a retrospective show within the Exposition, the awards were built into its very structure. With these Medals of Honor, the Government acknowledged the same constituencies in art as it did in politics: Ingres—the Orleanists, legitimists, the Church and the Academy, in a word, all the conservatives; Delacroix—the intellectuals and revolutionaries of various degrees of radicalism; Decamps—the bourgeoisie; Vernet—the Army, the common people and all those susceptible to patriotism. The landscape painters, although they had not been deemed sufficiently important to have their School ratified by a Medal of Honor, were nonetheless recognized: Corot, Français, Huet, Rousseau and Troyon all received First Class Medals, and the young Daubigny was awarded a Third Class. Courbet received nothing, of course, but he had only himself to blame, for the Government had intended to honor him as well.

On an international level, the Jury had, for the most part, ratified the status quo. Cornelius, whose international reputation as a history painter was second only to that of Ingres, was given a Medal of Honor despite his limited participation and the even more limited enthusiasm of the French for his work. Kaulbach of Prussia, Winterhalter and Knaus from Bade and Nassau were each given First Class Medals; thus the Jury tacitly recognized, although the critics did not, the various German Schools. Of the British artists, Landseer seems to have been genuinely popular; he received as many votes as Ingres in the preliminary voting by the Jury, more than Delacroix in the finals. Sir Charles Eastlake and William Mulready received no awards, doubtless because

they refused to accept anything less than the highest.[11] Both were appointed Chevalier in the Légion d'honneur in compensation. Even the young Pre-Raphaelites were recognized: a Second Class Medal for Millais (who also received the rank of Chevalier), a Third Class for William Holman Hunt and an Honorable Mention for Francis Danby. Henri Leys, universally acknowledged as the leading painter of Belgium, was given a Medal of Honour; Alfred Stevens, representing the "French" Belgian School, received a Second Class Medal.

Frédéric de Mercey stated with satisfaction that each country had received awards in the exact proportion in which it had participated: France got ten of the fifteen Medals of Honor and more than half of the other awards: Britain received seventy awards, Belgium thirty-one, Prussia twenty-nine.[12] From a political point of view, justice had been done. If there was criticism that the status quo had been maintained, one might also note that in France the acknowledgment of the status quo was in reality a great leap forward.

The Government had shown an admirable eclecticism in taste; in principle, everyone should have been happy. Prince Napoléon, who had been pressed into service as the instrument of that eclecticism, was not, however, and complained in his official report: "Awards should be given not only to the work in itself, but just as much to the kind of painting which ought to be encouraged. Otherwise we risk falling into eclecticism, especially unfortunate in the direction set, for all eclecticism leads to impotence."[13] The deed was done, however; a variety of styles, in addition to history painting, had been encouraged.

Ingres was even less pleased than Prince Napoléon. Not only were there now nine true religions proclaimed in France, but, even worse, it had been leaked to the press that, in the Jury voting, Horace Vernet and not Ingres had been unanimously acclaimed.[14] Ingres wrote to a friend: "*More Grand Medals of Honor*. There are now nine and I, painter of elevated history, I am on the same level as the apostle of ugliness . . . Today, at this very moment, they are all busy at the assembly of all the committees ratifying these iniquities. In truth I don't know what I ought to do."[15]

Eventually Ingres did come to a decision, as Delacroix noted in his *Journal*:

> Horace told me a few days ago at the Jury sessions about the overtures made to Ingres, who had written refusing his medal. He was profoundly outraged at coming in after Vernet and even more, according to what several reliable people have told me, at the insolence of the special painting jury which had placed him on the same level as me in its preliminary ranking.[16]

Ingres's outrage was such that he refused to attend the Awards Ceremony to witness the "iniquities" committed in the name of eclecticism.[17] A solution had to be found, or an international scandal would result. Several days later, Mme Ingres wrote to his fellow Academician Jacques-Edouard Gatteaux:

> Everything has worked out and my poor husband is once again in *the best of moods*. M. Varcollier has just left; he came on behalf of the Prince to announce to M. Ingres that he would be named Grand Officier of the Légion d'honneur, the only such title which will be given at the Exposition! M. Ingres has, then, promised to go to the

Awards Ceremony on the 15th to receive this great honor from the hands of the Emperor.[18]

And so, Ingres received what he had probably been promised all along, the honor of being named the world's greatest living artist. He thus became the first artist or literary figure to attain the rank of Grand Officier de la Légion d'honneur. Delacroix, also promoted, was now Commandeur, a title he shared with Vernet.[19] But Vernet wasn't happy either. Prince Napoléon, in his speech at the Awards Ceremony, stressed that he had never interfered in jury deliberations, with one exception, Ingres's Légion d'honneur nomination: "I only expressed to Your Majesty the desire to nominate for a high honor the artist who, following the glorious tradition of centuries of antiquity, has dedicated his whole life and talent to the painting which, in my personal opinion, I regard as the eternal type of the Beautiful."[20] This may have been music to the ears of Ingres (he copied it into one of his notebooks)[21] but Vernet felt that *he* had been proclaimed Number One Artist in the World by both the Jury and the public. Silvestre quoted him as saying: "I'm not very happy to see Ingres placed above me in Prince Napoléon's speech at the Awards Ceremony of the Universal Exposition. He Grand Officier, me still Commandeur. He the only representative of the traditions of the Beautiful. That old prig! That old sneak!"[22] Whereupon he wrote to Prince Napoléon cancelling his commission for *The Battle of Alma*, and he abandoned *Napoléon I Surrounded by Marshals and Generals Dead on the Field of Battle*.[23]

And yet, despite these teapot tempests, perhaps the most significant result of the awards was intangible, a feeling that had no place in this positivistic universe: a fear and an acknowledgment that there had been a fundamental change. An anonymous article published by the *Revue universelle des arts* expressed this new mood:

If the Universal Exposition had taken place in 1835, M. Eugène Delacroix, at that time the terror of the Academy, M. Eugène Delacroix to whom the Jury denied any virtues, would not have received even an Honorable Mention. Who can assure me now that Courbet, whose name wasn't even mentioned at the Awards Ceremony, Courbet, the *bête noire* of the Institute, will not have a Grand Medal at the Universal Exposition of 1865, and that his pictures, so scorned today, will not then hold the place of honor? Alas! in art as in politics, isn't the error of today almost always the truth of tomorrow?[24]

12
The End of an Era

During the period when, as already impassioned witnesses, we became interested for the first time in this great spectacle, modern art was prey to the most violent clashes. One school, strongly organized, defended ancient traditions and battered in the breach an ardent group of innovators. Since then, the party of the resistance has little by little disappeared; from year to year we have seen it diminish and die away. The retrospective Exposition of 1855 has allowed it to mount its last effort: this will be, in history, its supreme declaration. And now calm has descended on all fronts and an indifferent generation begins to play with the flowers which have sprung up on the tombs of the dead.—*Paul Mantz*[1]

WHILE THE UNIVERSAL EXPOSITION at the Palais de l'Industrie had opened the door to the future, that at the Palais des Beaux-Arts closed the door on the past. The first half-century was over, and with it the historic battle between Ingres and Delacroix, Classicism and Romanticism. With the canonization—and "entombment"—of the two major protagonists, an era had come to an end. Ingres would live another twelve years, Delacroix eight, but for them, as Charles Perrier wrote, "posterity has already begun."[2] Rarely does a political event mark so clearly the division between art-historical periods.

Regardless of the political exigencies which had determined the awards decisions, the policy of eclecticism took root, for it did correspond to political, economic, and aesthetic realities. At the annual Awards Ceremony of the Ecole des beaux-arts in December 1855, Achille Fould spoke of the recent foreign exhibitions and, in the very center of the classical tradition, he extolled the merits of eclecticism. All Schools, he stated, have their own values and traditions as the Universal Exposition had shown; one can learn from them all. While one School has preserved the secret of warm and brilliant color, another continues the tradition of severity and precision. The only value of the past, he concluded, is to be useful to the present.[3]

The immediate beneficiary of this policy was Delacroix, who presented himself to the Academy as a candidate for the seat left vacant by the death of Paul Delaroche in 1856. Delacroix had tried unsuccessfully six times to gain membership to this august body; in 1851 he had not even been accepted as a candidate.[4] And yet, in January 1857, he was elected so quickly, by an absolute majority and without discussion, that one might

even suspect some form of behind-the-scenes pressure by the Government. Ingres, on hearing of Delacroix's election supposedly shouted: "The wolf is in the sheepfold!" and Horace Vernet immediately began protesting that the proceedings had been irregular.[5] While the quarrel was raging in the Academy, Napoléon III moved to accept Delacroix's election and the issue was closed.[6] Delacroix himself, claiming poor health, did not make his triumphal entry into the Academy until March, after the fuss had died down. Thereafter he was a model Academician who, although he did not have an exemplary attendance record at the weekly meetings, nonetheless took part in committees, juries, and other Academic responsibilities.[7]

The possibility of a "deal" between Government and Academy is likely, for their rapport certainly improved during this period. The reign of Louis-Philippe had been characterized by virtual open warfare, the King refusing to accept academic recommendations for official commissions, the Academy, in revenge, rejecting his favorites from the Salon. It even rejected his son, the duc d'Orléans, whose candidacy was proposed in 1839.[8] This was not the style of Louis-Napoléon, however, for his Government was built on compromise and the rallying of all important groups and institutions. Ever since the 1851 *coup d'état*, he had been attacked by the Académie française, a center of liberal opposition. The Académie des beaux-arts seems to have decided early in the Second Empire to abandon its opposition and rally to the regime in hopes of regaining some of its lost power and prestige. Nieuwerkerke was elected to membership in 1853, followed by Achille Fould and Prince Napoléon in 1857 and Mercey in 1859; the period of the 1850s was a honeymoon between the Government and the Académie des beaux-arts.

The Salon of 1857, the first held since the Universal Exposition, showed, even more clearly than the medals, what its effect had been. The first inkling that something had irrevocably changed came when *Le Moniteur universel* announced that the Salon would be held, not in the Louvre, as had been expected, but in the Palais de l'Industrie.[9] The century had begun with artisans and industrialists as temporary guests in the courtyard of the Louvre, the Palace of Art. Now roles were to be reversed, and artists were to be temporary guests in the Palace of Industry, sharing space with agricultural and industrial exhibitions. Problems began immediately when the Salon had to be postponed because an agricultural show was scheduled for the traditional May–June period. The Salon would open 15 June and continue through 15 August, a time when many Parisians would have already left the capital. The worst news was yet to come: the Jury would be the Académie des beaux-arts.[10]

The idea of returning the Salon to academic jurisdiction probably proceeded from Nieuwerkerke, with the Emperor merely agreeing. Nieuwerkerke was ambitious and was cultivating the Academy for his own purposes, and Napoléon III was trying to break the unanimous opposition of the Institute. The news of their return to power was greeted with enthusiasm and gratitude by Academicians, and a message was sent back with Nieuwerkerke: "The Emperor can count on the zeal of the Academy."[11]

There would be, during the 1850s, at least one branch of the Institut de France which had rallied, and if the price was to accept one wolf in the sheepfold, the benefits, it seemed, more than outweighed the perils.[12]

Potentially this Jury would be the most severe since the Restoration, for under the

July Monarchy even Academicians had to submit their own works for judgment, and since 1848, artists were accustomed to electing at least part of the Jury. In addition, this would be the first Salon with paid admission every day but Sunday. As a way of ameliorating the new policy, the Government promised to use the receipts to buy works of art, and, in addition, Napoléon III donated a special 4,000 franc Medal of Honor to be awarded at each Salon.[13] Nonetheless, art was being made to pay its own way, like other forms of entertainment; previous regimes had considered the commission and purchase of works of art as a responsibility, without arranging to be reimbursed.

The results of paid admission were immediately apparent. Critics noted that, in the past, visitors used to come to the Louvre an hour before the first day's opening time; when the doors were opened the crowd rushed in "like an army into a city under siege."[14] Now, because of the entry fee, workers, students, even artists themselves, had to wait a week before the first free day. The public used to come repeatedly, and it was to France's frequent and free exhibitions that critics attributed the traditional excellence of French taste. To the classic argument for paid admission advanced by Prince Napoléon in 1855, Anatole de Montaiglon responded in 1857 with what was to be the classic argument for free entry:

> Public interest cannot be put in jeopardy; the arts are an education for the spirit; expositions ought to be accessible to all without restriction; one can't ensure that everyone will benefit from them, but no one should be excluded and there is as much injustice in closing the door of annual expositions as there would be in having paid admission at the Louvre or at the Bibliothèque impérial.[15]

Paid admission remained, however, and to further reduce costs, as well as to please the Academy, the Salon would be held biennially instead of annually.

Despite artists' apprehensions, the Jury of Academicians in 1857 proved remarkably lenient, accepting 3,483 works by 1,454 artists—only 1,072 French artists had exhibited in 1855. Photography, which Gautier called "an unacknowledged master with many students," was shown at the Salon for the first time, and, undoubtedly at the suggestion of the Academy, a list of commissions for public monuments was included in the catalogue to compensate for the attention given to easel pictures.[16] It was said that the Jury accepted at least one work by almost every artist.[17] One might believe that even the Academy had been infected by the new spirit of eclecticism, but as this liberality was not repeated at the next Salon, it is more likely that the Government had requested it to placate the community of artists still angry over the exclusions of 1855.

The *Salon d'honneur* at the entrance had, in the past, assembled what were considered the best paintings. In 1857 it was used for blatantly political ends: included in it were portraits of the Emperor and Empress and paintings of the Crimean War.[18] It was an undisguised reflection of the Government's view of the utility of art. The Jury renounced for itself the new Medal of Honor and awarded it instead to Adolphe Yvon, who showed *The Capture of the Tower at Malakoff, 8 September 1855* (Plate 82), which depicted an incident from the Crimean War. Thus was the precedent set of awarding this medal to a young artist in the Grand Tradition, or as close to it as possible. Baudry, Pils and Bouguereau, all previous Prix de Rome winners, were awarded First Class Medals, but Daubigny (landscape), Desgoffe (still life), and Knaus (genre) were also

82. Adolphe Yvon, *The Capture of the Tower at Malakoff, 8 September 1855 (Crimea)*, 6.00 × 9.00 m. Salon of 1857. Musée national du château, Versailles.

honored, and Courbet, for his *Young Ladies on the Banks of the Seine*, was given a Second Class Medal.[19]

Achille Fould, who in 1855 had preached eclecticism at the Ecole des beaux-arts, spoke again at the Awards Ceremony of 1857 and warned against "the new School of Realism" in which he included genre and other lowly forms of painting. He held up, as an example to be emulated, Yvon, who painted France's military victories.[20] Thus was established a three-way tug of war between Academic, Official, and Bourgeois Art: the Academy wanted to perpetuate its own traditions, the Government wanted to use art to glorify itself, and the majority of artists simply wanted to sell their works to the only class of buyers available—the bourgeoisie. This triangulation would remain typical of the Second Empire, its seemingly erratic policies explained by the ascendancy of first one side, then another, as it tried to please everyone.

Everywhere there was the feeling that 1855 had marked the end of an era. Only die-hard conservatives of the older generation, such as Delécluze and Planche, refused to look to the future.[21] Perrier, for example, wrote: "Between the Universal Exposition of 1855 and the Salon of 1857 there is the entire distance separating a defunct generation from one just beginning.[22] In his first Salon review. Castagnary wrote: "Between the ruins of decrepit styles and the vague stirrings of new ideas, the Salon presents itself as the birthplace of a new art."[23]

"The New Art" was a phrase often heard in 1857; it meant Naturalism in both

83. Jean-Léon Gérôme, *After the Masked Ball*, 0.50 × 0.72 m. Salon of 1857. Musée Condé, Chantilly. Exhibited 1867 no. 1159.

landscape and genre. This was seen as the movement which had come to replace Classicism, Romanticism, and even Realism.[24] In the art of the first half-century, France had led the way; the foreign exhibitions of 1855, however, were to have a lasting influence on the future. Gautier wrote:

> The Universal Exposition of 1855 has provided us some elements of diversity. The nationalities of art have been introduced and, after the first astonishment, have quietly studied each other. Everyone has tried to adopt the style of his neighbor and we will recognize in more than one eminent work some traces of foreign influence. These cosmopolitan mixtures have produced combinations and results difficult to classify in the ancient categories.[25]

Nadar quoted Gautier approvingly and identified the influences that he had so discreetly mentioned as coming from the British and Belgian genre painters.[26] 1857 had also seen the British Art Treasures Exhibition at Manchester, where paintings of different epochs were arranged geographically, thus presenting a clear contrast between Northern genre and Southern classical modes.[27] In art as well as in industry, the days of isolationism and protectionism had ended.

The British artists seemed to be very much on the minds of critics in 1857, for many

painters in France were following along the same path, a fact made all the more apparent by the absence of Ingres and Delacroix at the 1857 Salon. About three-quarters of the paintings shown fell into a single category, which Castagnary described thus:

> The majority, and a clear majority at that, belongs to genre pictures. Interiors, landscapes, portraits, make up nearly the whole exposition: it's the human side of art which is replacing the heroic and divine and which is affirmed at the same time by the power of numbers and the authority of talent. Among nearly all the big canvases, all the old names: among the easel pictures, a host of unknowns.[28]

Ingres noticed the same phenomenon:

> We are like the Jews in captivity who weep over their misfortune. We too, we are weeping for an art overcome, day by day more unknown, dethroned by bad taste and, it seems, by the common people, in 4,000 or more genre pictures in the Salon that I have not yet seen. History painting, it is said, is worthless and forgotten by artists as well as spectators. It is sad, distressing, and I am sick over it.[29]

Most of the critics echoed Castagnary, however, and not Ingres. Among the conversions were the critic Perrier, a conservative in 1855 who now attacked tradition and espoused "the New Art." He who had once praised Ingres as timeless and eternal now announced that there was no such thing, that even the Greeks had been of their own time.[30] It was the painter Gérôme, however, whose defection from the ranks of history painting proved the greatest shock to conservatives. Having been extravagantly praised in 1855 for *The Century of Augustus* (Plate 51), and considered the young rising star of the traditional French School, Gérôme created a sensation in 1857 with *After the Masked Ball* (Plate 83), a genre subject from contemporary life. Calonne and Delécluze condemned him as a traitor but the public loved him and his reputation was made.[31]

Delacroix may have been the obvious victor of the Exposition of 1855, but Courbet had also managed to "legitimize" himself, as Bertall ironically noted (Plate 84). In 1856, *L'Artiste* published engravings of two of Courbet's landscapes, tucked in among the works of Ingres, Decamps and Bonvin.[32] By 1857, Courbet seemed almost respectable. Paul Mantz could write: "Today one looks calmly at his pictures and judges them in various ways but without anger, and the most epileptic bourgeois have finally regained their composure with regard to an

84. Bertall, "At the end of the Universal Exposition, Courbet awards himself some well-merited honors in the presence of a chosen few, composed of M. Bruyas and his dog." *Le Journal pour rire*, 12 January 1856. Bibliothèque Nationale, Paris.

artist who evidently is sincere and who, furthermore, is not free to modify his nature to please the admirers of M. Hamon."[33]

In the end, the critics found it difficult to articulate what had changed, except themselves. The Universal Exposition had, for the sake of political exigencies, instituted formalist readings of art that had hitherto incarnated the most violent political stances. It had provided the vehicle for a depoliticized self-referential view of art, namely the retrospective exhibition. In its pursuit of eclecticism, it had dealt a fatal blow to the traditional hierarchy of categories, and had created the pre-conditions for a Modernist view of art. It was, then, with a kind of nostalgia that Delacroix's friend Pérignon looked back on 1855 and wrote:

> Today everything is forgotten, everything is smoothed over. There are no longer either halos or scars; the works appear isolated, deprived of the interest they had borrowed from circumstances, from taste, from passing events. Above all, they've lost the train of violent passions that gave them their magic life.[34]

III

THE UNIVERSAL EXPOSITION OF 1867:
THE DEATH OF HISTORY PAINTING IN FRANCE

13
Second Empire Art Policy:
The 1860s

POLITICAL HISTORIANS DIVIDE THE Second Empire into the Authoritarian Empire of the 1850s, when Napoléon III attempted to consolidate his regime following his 1851 *coup d'état*, and the Liberal Empire of the 1860s when, in order to stay in power, he was compelled to make concessions to the growing pressure for liberty.[1] The world of art was subject to the same forces, and the Universal Exposition of 1867 must be seen against this new milieu. The relative power and influence of the protagonists of 1855, the Academy, the government art administration, the independent artists, had changed in the intervening decade, and an understanding of these changes is necessary to place the second French Universal Exposition in context.

We have already seen that, during the 1850s, the Salon became biennial, its jurisdiction taken from the artists and given to the Academy. As reward for rallying to the Empire, the Academy was accorded the privileged position it had enjoyed during the Restoration. In principle, the Government had struck a good bargain, for it had secured the support of a major cultural institution and made a breach in the united front of opposition presented by the Institut de France. In practice, the experiment was not a success for, typical of the Second Empire politics of appeasement, what was given with one hand was taken back with the other. Having set in motion the forces of eclecticism, having officially recognized, even rewarded, a number of different styles in art, the Government had dealt a severe blow to the prestige of the Academy. After the liberal Salon of 1857, the Academy attempted to repair this damage by becoming more and more severe and exclusive in its Salon decisions; beginning in 1859, artists' protests became both more vociferous and more conspicuous.[2]

The honeymoon period of Government and Academy abruptly ended in 1860; the cause: the incompetent restorations carried out on paintings in the Louvre under Nieuwerkerke's supervision. Such "restorations" had been criticized by Delacroix as early as 1853;[3] the Academy did not involve itself, however, until the *"conservateur"* Villot began repainting the Raphaels. Ingres supposedly took one look at the repainted *Saint Michael* and went straight to Napoléon III, stating of Nieuwerkerke "the future will severely judge this assassin!"[4] The result was described by Viel-Castel in his memoirs: "Nieuwerkerke detests the Academy and fears it."[5] Ingres was punished by having his paintings withdrawn from the gallery at the Luxembourg and hung in a

badly lit salon.[6] He had been correct in warning: "The wolf is in the sheepfold!" but the wolf turned out to be Nieuwerkerke, not Delacroix.

The rapport between Academy and Government deteriorated rapidly after this. In the summer of 1861, when plans were being made for French participation in the 1862 British International Exhibition, the Government suddenly redefined the fine-arts Admissions Jury, breaking it down into constituencies: three collectors of contemporary art, three members of the art administration, four elected by the Academy from among its members, and five artists elected by all those submitting work. For the first time since 1849, a species of universal suffrage was offered in art. The results were not revolutionary and must have been reassuring, for the artists elected Gérôme, Dauzats, Cavelier and Barye.[7] It was the beginning of the Liberal Empire in the world of art and its success led both to the 1863 Salon reforms and to the 1867 Universal Exposition.

The year 1863 marked a turning point in the Government's relations with both Academy and artists, for this was the year of the Salon des refusés and the reform of the Ecole des beaux-arts. In both cases criticism had been brewing for several years. In 1859 artists had demonstrated under Nieuwerkerke's windows against the harshness of that year's Salon Jury, and by 1863, when the Jury rejected seventy per cent of the works submitted, the outcry was so great that it reached the ears of Napoléon III, always finely attuned to majority opinions. After visiting the Palais de l'Industrie to view the rejected works, he decreed that they should be shown, with the artists' consent, in another part of the palace. As usual, he believed that compromise would placate both sides; as usual, he was wrong. Both the Jury of Academicians and Nieuwerkerke, its President, saw the Emperor's gesture as a public reprimand and attempted to justify their decisions by hanging the worst paintings in the best places. They were partially successful, for the public did come to laugh. Nonetheless, the Salon was reformed, it would henceforth be annual, its control wrested from the Academy; future Salons would have a Jury three-quarters elected by artists who had received medals or decorations at previous Salons, one-quarter appointed by the administration.[8] The narrowness of its judgments having excluded the majority of French artists, the Academy was deemed no longer to represent French art.

But there was more. In the fall of 1863, the Academy was again attacked by the Government. By imperial decree, control of the Ecole des beaux-arts was taken away from the Academy (which had founded it over two hundred years before) and given to the Government, which would henceforth appoint professors, administrators and jurors for its competitions.[9] Reform of the Ecole had been strongly urged by Léon de Laborde in his monumental report on the 1851 British Exhibition. Nothing had been done until the 1860s, however, after Nieuwerkerke had turned on the Academy and after it had become all too apparent that the Academy no longer represented the art community. Nonetheless, whatever the faults of the Academy, a dominant concern of the Government was to consolidate and centralize power in its own hands. Fortunately for the Académie française, its popularity made it invulnerable and the Government feared to attack. Unfortunately for the Académie des beaux-arts, it had become unpopular—a serious liability in the Second Empire—and, as events proved, it could be attacked with impunity.

The elected Jury of 1864, with Nieuwerkerke as President, showed itself extremely

124

liberal and the percentage of refused work dropped from seventy to thirty, with the most notorious artists of 1863, Manet among them, admitted.[10] As a result, the Salon des refusés held that year was a failure, being really a collection of inferior works. With this as an excuse, the experiment was dropped for the duration of the Second Empire, although artists continued to demand it. After 1864, the new Salon Jury, elected by those who had already won medals and decorations, proved no more lenient than the previous one composed of Academicians. As both groups were themselves exempt from the judgments of the Jury, the Salons resumed their earlier tradition of self-perpetuation.[11] Several years later, after the period of heavy press censorship was over, the critic Louis Auvray explained this phenomenon:

> Alas, the result remained always the same because the same interests and the same men found themselves seated face to face every time. Those decorated, ambitious to be accepted into the Institute, voted for and like the members of the Institute. Those bemedaled, avid for new awards, voted in the same manner to flatter both the gentlemen of the Institute and the gentlemen who were decorated, with the result that the reasons for complaint changed not at all or very little.[12]

Naturalism, the "New Art" heralded in 1857, flourished during this period, although often unrecognized in fact by the very critics who praised it in theory. The group of young artists eventually called Impressionists all made their Salon debuts; the "young radicals" of 1855, Courbet, Millet and the Barbizon painters, continued to exhibit regularly, gaining in both age and respectability. The older generation, Ingres and Delacroix, no longer exhibited; Delacroix died in 1863. The major new reputations were those of Meissonier, Gérôme and Cabanel, all elected to the Academy during this period. The "geography" of the art world was thus very different on the eve of the 1867 Universal Exposition from what it had been in 1855.

The cast of characters introduced earlier in this study was also undergoing changes between 1855 and 1867. Napoléon III, after the Universal Exposition of 1855, was more confident of his taste and even, according to Chennevières, became somewhat of a collector, personally choosing Cabanel's *Nymph Abducted by a Faun* in 1861 and *The Birth of Venus* in 1863 (Plate 99).[13] Meanwhile, Second Empire art policy continued to support artists favored by previous regimes, to glorify itself, to flatter the Church, and—this last coming from the Emperor himself—to reward the artists most favored by the public.[14]

The Empress Eugénie also came into her own during these years, discovering a passion for interior decoration which led her to borrow, rather freely, works from the Louvre to add the authentic period flavor to various ensembles. Needless to say, Nieuwerkerke was nothing loath to accommodate imperial fancies.[15]

Princess Mathilde began a literary Salon in 1860; it overshadowed her artistic Salon, which she continued nonetheless. Her literary friends included Sainte-Beuve, Gautier, Flaubert, the Goncourt brothers, Taine and Renan, while the brightest stars in her artistic circle were Hébert, Baudry, Gavarni, Fromentin and her teacher Giraud. In 1859 she began exhibiting watercolors at the Salon, and even received a medal in 1865. Her liaison with Nieuwerkerke continued through the 1860s, he becoming increasingly flagrant in his infidelities, she, pretending not to notice, continuing to advance his

career. In late 1869 she broke with him, his trajectory taking an immediate nosedive as a result.[16]

Prince Napoléon, after 1855, was not a conspicuous presence in the world of art. Appointed President of the French Commission for the British International Exhibition of 1862, he quite naturally assumed, once again, the Presidency of the 1867 Universal Exposition. His career was abruptly terminated in 1865, however, when political differences with Napoléon III resulted in his resignation. He lost interest in his Maison pompéienne and sold it in 1866, his collection of antiquities in 1868.[17]

The duc de Morny continued to indulge his tastes for collecting and speculation until his death in 1865. When he was a member of the Salon Jury, he always tried to buy what the jury praised, and even attempted to organize lotteries as a regular part of the Salon.[18] With his death and Prince Napoléon's resignation, the world of art was left in the hands of Nieuwerkerke.

The comte de Nieuwerkerke's star was in the ascendant in the period between the two Expositions, and in 1867 he emerged as President of both the Admissions and International Awards Juries for Fine Arts. Mistrusted, even disliked by artists, by the government administration, by all the Bonaparte family except Mathilde, he not only stayed in power, but managed to increase his influence during this period. From 1853 to 1860 he used the Academy for self-aggrandizement, then abandoned it and stripped it of much of its power when it criticized him. In 1863 Mathilde prevailed upon Napoléon III to create a new title for him, "Surintendant des beaux-arts"; in 1864 she had him made Sénateur. As Director of the Louvre, he freely disposed of its treasures for the benefit of himself, the imperial family and friends; when this became known he protested his innocence and threatened to resign. He weathered the scandals of the Louvre restorations, the acquisition of expensive fakes for museum collections, the loan of Louvre treasures for imperial interior decoration. He was President of the Salon Jury during the turbulent period which resulted in the Salon des refusés, and emerged even more powerful afterwards. He was chased from the Ecole des beaux-arts by angry students in 1864, in the company of Théophile Gautier and Viollet-le-Duc; Gautier ended up in jail, Viollet-le-Duc was forced to resign his chair, and Nieuwerkerke was made President of the Ecole's Conseil supérieur de l'enseignement.[19] The man had charm. Nonetheless, within months of Mathilde's break with him, he was stripped of his titles in the government reorganization of January 1870; all that remained was his post as Surintendant des musées impériaux.[20] No doubt the Franco-Prussian War and the collapse of the Second Empire saved him from further humiliation; with the rest of the Government of the Second Empire, he resigned on 4 September 1870. He spent his remaining years in Italy.

During this period, two new figures emerged in the art administration:

Jean-Baptiste Philibert Vaillant, maréchal de France (1790–1872) (Plate 85): Vice-President of the Imperial Commission and President of the International Awards Jury in 1867. Vaillant had a long and distinguished military career under all the regimes of the nineteenth century. In 1863 he was made Ministre de la Maison de l'Empereur et des Beaux-Arts, successor to Frédéric de Mercey (who had died in 1860) and the immediate superior of Nieuwerkerke. A member of the Académie des sciences, he

85. *Le Maréchal Vaillant.* Bibliothèque Nationale, Paris.

86. *Philippe de Chennevières.* Engraving after a photograph by Hélios. Bibliothèque Nationale, Paris.

seems to have had virtually no interest in art, introducing himself at the Salon of 1863 as "an old soldier." Nonetheless, he made speeches in the Emperor's name at every Salon, alternately praising originality and tradition.[21]

Charles-Philippe, marquis de Chennevières-Pointel (1820–1899) (Plate 86): Secretary to the Fine Arts Awards Jury in 1867. Chennevières, by his own admission, was a protégé of Nieuwerkerke whom he admired boundlessly and excessively. He began his administrative art career in 1846, was made (by Nieuwerkerke) Inspecteur des musées de province in 1852 and, in 1855, Inspecteur général des expositions d'art, responsible for the Salon. In 1857 he was made curator at the Louvre and, in 1863, at the Luxembourg. Under the Third Republic he rose to the post of Directeur des beaux-arts, Nieuwerkerke's job retitled. A prolific author, he produced many catalogues and books on art and his invaluable *Souvenirs d'un Directeur des beaux-arts*, reliable on all aspects of the world of art save those which reflected badly on Nieuwerkerke.[22]

14
Industry's Revenge

What a spectacle Sire! At the same time full of magnificence and charm. What other nation could produce it! What an incentive to the public spirit! What a source of prosperity for the present and for the future! And at the same moment of this admirable union of masterpieces of painting and industrial products, nature is covering our fertile lands with its gifts and abundant harvests are coming in from all sides, rewarding agriculture for its exhausting labor.—*Duc de la Rochefoucauld, President of the Jury, 1819 Exposition publique des produits de l'industrie française, speeech to Louis XVIII.*[1]

At the marvellous spectacle of tongs and of soaps, of wheelbarrows and of warming pans, all side by side with works of art, at the screech of machinery which disturbs the tranquillity so desirable for those who really want to study a statue or a painting, man feels his heart beat with noble pride.—*Emile Galichon, Editor of* Gazette des beaux-arts, *writing of the Universal Exposition, 1867.*[2]

JUST AS THE 1855 Universal Exposition was intended as the French response to Britain's Great Exhibition of 1851, the second French event, in 1867, followed the 1862 British International Exhibition. Others had been held in the intervening twelve years, in Brussels in 1857, Algeria in 1862, Dublin in 1865, but France still looked to England as its chief industrial rival.[3] In 1860, despite the opposition of French manufacturers, Napoléon III had managed to force passage of the Cobden Free Trade Treaty with England; with reductions in French tariffs, an international exhibition assumed a practical function. So much so that French manufacturers offered, immediately following the 1862 event, to form a holding company to raise the funds to finance the next one.[4] In view of the financial losses suffered by the 1855 Exposition, this is probably the only way that the Government would have consented. Within two years over ten million francs had been raised, mostly from industrialists; this, combined with grants from the Government and from the city of Paris, formed the economic base for the Exposition.

The Universal Exposition was decreed on 22 June 1863. Again there was an Imperial Commission and again Frédéric LePlay was named Commissaire général. Prince Napoléon, its President, resigned in 1865 and was replaced by the nine-year-old Prince Impérial. Fortunately, the position was honorary; Eugène Rouher, now Ministre

d'Etat, actually exercised the functions of the Presidency. The triumvirate that represented the Government included, besides Rouher, Armand Béhic, Ministre de l'Agriculture, du Commerce et des Travaux publics, soon replaced by Fourcade La Roquette, and maréchal Vaillant, Ministre de la Maison de l'Empéreur et des Beaux-Arts.[5] The sixty members of the Imperial Commission were mainly industrialists, Presidents of Chambres de Commerce, or members of the Government. Several had served in 1855, such as Baroche, now Ministre de la Justice, Fould, now Ministre des Finances, and the industrialists Péreire and Schneider. Now, however, the commercial sector that had financed the Exposition also wanted to control it; conspicuously absent were the *grands notables* and artists, whose illustrious presence in 1855 had helped to legitimize both the regime and the Exposition. Among artists, only Ingres and the architect Lefuel were included.

Although Rouher had requested a Universal Exposition of Art in 1863, at the same time as he recommended the Universal Exposition of Industry, it was not formally announced for two years.[6] The delay might be explained in part by the disarray in the world of art at that time, but it might also be construed as symptomatic of the secondary role that art would play at the 1867 Universal Exposition. The Exposition would be held on the Champ-de-Mars, site of the first national exposition of industry in 1798. It would be open from 1 April to 31 October 1867; classification would comprise ten groups, works of art being the first.[7] Only works executed since 1 January 1855 and not exhibited that year would be eligible. The French Admissions Jury for Painting and Drawing was set at twenty-four members, one-third elected by artists who were either recipients of medals or members of the Légion d'honneur, one-third chosen by the Académie des beaux-arts from among its own members, and one-third named directly by the Imperial Commission.[8] The Academy, eliminated from the Salon Jury in the 1863 reforms, was probably reinstated to demonstrate solidarity in an international context (echoing the eclecticism of 1855) and to guarantee a conservative selection. In either case the strategy failed, for the Academy, still outraged over its recent defeats, refused to play its assigned role.

In the heated debate in the Academy following the Government's invitation to participate on the Jury, two parties emerged.[9] One felt that academic influence would be greater than its numerical proportion would imply and that, as the Academy had formed a part of the 1855 Jury, it should do so again in 1867; a refusal might be construed as criticism of the Government. The opposition answered with an emotional plea in which the entire post-revolutionary history of the Academy was reflected:

> The Academy ... can't accept representation on a Jury composed in such a way as to nullify any influence it might have. In fact, after having been sovereign in its judgment on works of art sent to expositions, would it be fitting now to accept one-third representation? Systematically pushed aside in the name of doctrines that it has courageously combatted, how could it now assist in the acceptance of works created according to those same doctrines? If the Academy were to accept the invitation of the Ministre d'Etat, not only would it compromise its principles but, even worse, inevitably would be compelled by this precedent to follow the administration in all its efforts, for it could not later refuse to make up part of the annual

Fine Arts Jury, which would inevitably have a similar composition, and perhaps even the Jury for the Prix de Rome.[10]

In the vote that followed, the Academy declined the Government's invitation, recognizing that it was being used to legitimize an impending shift to a more popular taste, a taste which it had opposed for decades. Outnumbered, deprived of any real influence, it was reduced to choosing between an active or a passive role in the orchestration of its own demise. Its withdrawal left the door open to the very forces it feared.

As a result, the elected artists' section was increased to two-thirds of the Admissions Jury, and elections for the artist-members of the Jury were held in the Louvre on 15–16 November 1866.[11] As might have been expected, the elected Jury was conservative, no doubt truly representative of its bemedalled and decorated constituency. Chosen by 147 voters, the 16 "most popular" artists included Pils, Cabanel, Gérôme, Ingres, Bida, Hébert, Fromentin, Jules Breton, Baudry, Meissonier, Gleyre, Théodore Rousseau, Français, Brion, Jalabert, and Couture. Ingres resigned and was replaced by Dauzats.[12] The list included five Academicians and four future Academicians. Least represented were landscape painters, with only Rousseau and Français. The highest representation went to genre painting; encompassing historical genre as well, it was practiced by almost everyone. Despite the encouragement of history painting by Government and Academy, despite the Grand Medal of Honor which, since 1857, had been awarded at each Salon to a painter or sculptor of suitably elevated taste, the fastest growing and most popular category had become genre painting. This was the Naturalism heralded in 1857.

To this elected Jury the Government added eight other members: critics, curators, and collectors.[13] In comparison with 1855, when Prince Napoléon, Morny, and Baroche took part directly, this was a low-keyed group. The political heavyweights had been replaced by art professionals in the same way as, on the Imperial Commission, they had been replaced by professionals from the world of commerce and industry. The most striking difference between the Fine Arts Juries of 1855 and 1867 was that art critics, many of whom had played an adversary role in 1855, were now absorbed into the system. Charles Blanc, Paul de Saint-Victor, and Théophile Gautier, the three most powerful critics, all served on Juries, and Ernest Chesneau wrote the government report.[14] In the very structure of the Exposition, the Government had adopted a laissez-faire policy, in keeping with the liberalization of the 1860s.

Despite appearances, however, the Government was not prepared to surrender completely its role in the Art Exposition. When a complicated jurying system was announced, it became obvious that competition was to exist in name only. Artists were to submit their works before 15 October 1866; most private lenders would not yet have returned to Paris. Works would be held for more than a year. But what proved most disturbing was this clause: "The Jury may admit, with the consent of the artist or owner, works of unquestioned renown, not subject to preliminary deposit at the locale destined for Jury operations."[15] As criticism and anxiety mounted, the Imperial Commission would do no more than reiterate these rules. Until, that is, Emile Galichon, in a front-page editorial in *La Chronique des arts et de la curiosité* pointed out the embarrassing fact that the Jury would not be chosen until November. How, then, and by whom would "works of unquestioned renown" be chosen before 15 October?[16]

As a result of Galichon's criticism, the rules were hastily revised to give at least the appearance of fair play. All artists were now required to present, by 15 December, only a written and signed declaration of works they would like to exhibit. The "works of unquestioned renown" would then be selected from these lists and artists would be notified of the Jury decision by 1 January 1867. Artists who had not succeeded in this first competition could then submit their actual works to the Jury between 5 and 20 January. Nieuwerkerke, as Surintendant des beaux-arts, was appointed President of all the French Admissions Juries in the fine arts, and Théodore Rousseau was elected President of the French Admissions Jury for Painting and Drawing.[17] As in 1855, each country would choose its own show.

By 10 February 1867, the Admissions Jury had completed its work: only 550 paintings had been accepted. The bitterness among artists surpassed even that of the previous Universal Exposition where space had been found for 1,872 paintings.[18] A petition was sent to Vaillant criticizing the Jury for having reserved for itself 500 of the 700 places available.[19] The Government does not seem to have meddled in the Art Exposition, however: no retrospective shows were offered to individual artists, as had been done in 1855, nor was there evidence of a renewed attempt to encourage artists' participation. On the contrary, Yvon was outraged because the Government was unwilling to lend his huge battle paintings, and Prince Napoléon flatly refused to lend works from his collection. Galichon reported persistent rumors that the Government would refuse to lend any works in public collections.[20] Nieuwerkerke, now the only link between the world of art and the world of government, unlike Morny or Prince Napoléon, had no wider political view. As a result, the artists' fate had been left to the Jury, which took care of itself first.

The Jury and the older generation were liberally represented in the Exposition: Meissonier had fourteen paintings, Gérôme thirteen, Dupré twelve, Bouguereau, Breton, and Rosa Bonheur ten each, Millet nine, Théodore Rousseau, Daubigny, and Huet eight each, Corot seven. Courbet sent only four pictures but they were all accepted.[21] The younger Naturalist generation that followed Millet, Courbet and Daubigny—the future Impressionist group—was excluded. Like that of 1855, the Universal Exposition of 1867 was designed to be a retrospective event.

One of the major problems of 1855 had been that the Exposition was scattered among many buildings constructed to meet last-minute demands for space. This was, in fact, the official explanation for the heavy financial loss. In his *Rapport*, Prince Napoléon had suggested that future international expositions should be laid out on the grid system, with national sections along one axis and exhibition categories along the other.[22] His plan was adopted in 1867, and a vast oval exhibition hall, designed by Frédéric LePlay, was constructed on the Champ-de-Mars (Plate 87); symbolically, it was the progeny of the revolutionary fêtes and the Temple of Industry of 1798. Within, exhibitions were organized in concentric ovals, heavy industry being the outermost ring, the fine arts being near the center (and thus taking less space). Paul Mantz wrote: "Material things occupy the first ring and, with each circle crossed, you approach the spiritual."[23] This lovely symbolism was ruined, however, or perhaps in a moment of supreme honesty the Imperial Commission revealed its true spirit by placing in the innermost circle, at the heart of the Exposition, a display of money.[24]

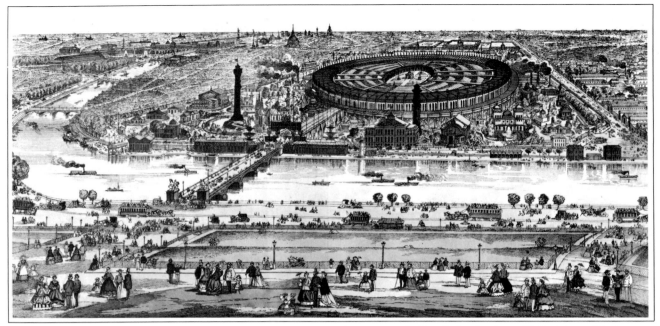

87. Pinot et Sagaire, *General View of Paris and of the Universal Exposition of 1867*, Epinal print. Bibliothèque Nationale, Paris.

The decision to downgrade the importance of the fine arts was undoubtedly made on economic grounds. The most outspoken critic of this situation was Emile Galichon, editor of *Gazette des beaux-arts*. In a long editorial, he related all the problems that had arisen.[25] Chief among them was the stinginess of the Imperial Commission which, with 146,000 square meters of space at its disposal, had allotted room for only 1,043 works of art; in 1855, with only 80,000 meters available, space had been found for 2,711 works. Proportionately, the exhibition was one-fifth the size. Nor did artists want to exhibit with industry. Galichon stated that there had been artists' petitions asking for a separate installation as in 1855, but the request had been rejected. In 1855 the Government had feared a boycott by artists; in 1867, the businessmen who organized the Exposition feared an unnecessary expense. Nor was the Government willing to come to the artists' aid: "As with all the industrial exhibitors, the Imperial Commission has only delivered to the artists a space, stingily measured—and the four walls, leaving to them the problem of decor. The State, on the other hand, considering the Exposition as a private enterprise, hasn't felt itself obligated to intervene and vote a subsidy." (Plates 88 and 89) Unlike industrialists who wanted to sell the products they displayed, and thus were willing to absorb the cost as a business expense, the artists did not even own most of the art exhibited, having borrowed it for the event. The contradictions between art and industry were once again asserting themselves, for art was more and more considered a product like any other. Galichon vividly described the results: statuettes of zinc, of soap, of chocolate, displayed on velvet in magnificent installations; sculpture placed on plain pedestals covered with "miserable green serge" (Plates 90 and 91). Paintings were hung in a narrow gallery, six rows high, up to twelve meters from the floor; many, for lack of space, were not shown at all. In order to conserve space, drawings and architectural plans were hung on the walls behind sculpture.[26]

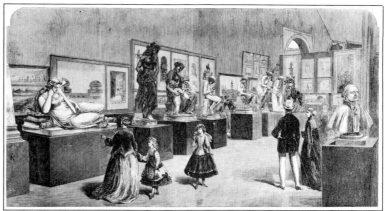

88 (top left). *The Vestibule of the French Fine Arts Section, Universal Exposition, 1867.* Bibliothèque Nationale, Paris.

89 (top right). Lancelot, *The Grand Vestibule, Universal Exposition, 1867.* Bibliothèque Nationale, Paris.

90 (left). *Perfume Section, Universal Exposition, 1867. Fountain of Eau de Botot.* Bibliothèque Nationale, Paris.

91 (above). *French Sculpture in the Universal Exposition, 1867.* Bibliothèque Nationale, Paris.

Most critics condemned the installation, which Paul Mantz called "without luxury, without comfort."[27] In 1851, Jules Janin had written a polemic against the philistinism of the British, who had used sculpture to decorate their Great Exhibition. In 1867 it seemed that the French were following suit. Charles Blanc, member of the Jury though he was, echoed Janin by asking in *Le Temps*: "Is it appropriate that art, whose mission is to manifest the Beautiful and to recall to us the Ideal, is presented in this event as a pleasant accessory, as an additional graciousness?"[28]

As a result of the criticism, some improvements were made. The sculpture of the French section was moved into the central garden (to join the exhibition of money), and benches were placed in the painting galleries; the installation was still considered far from adequate.[29] To add to the confusion, several countries, among them Belgium, Holland, Switzerland, Bavaria, Japan, erected separate buildings on the Champ-de-Mars where they installed their own exhibitions. The French decided to hold an annual Salon in addition to the Universal Exposition of Art, and, following Courbet's 1855 example, several artists decided to mount their own shows. By 1867 the forces of art were decidedly centrifugal; the center could not hold.

15
Artist Malcontents

The Salon of 1867

UNLIKE 1855, WHEN THE Salon was cancelled in order to encourage artists to participate in the Universal Exposition, in 1867 both shows took place simultaneously. At the Awards Ceremony following the 1866 Salon, maréchal Vaillant explained that each show would have a different purpose: the Universal Exposition would be a twelve-year retrospective while "the space reserved for the fine arts at the Palais du Champ-de-Mars being limited, recent works would encounter formidable competition from older ones."[1] The Salon, therefore, as was traditional, would exhibit recent works and the two shows, taken together, would complement each other and give an accurate impression of the true state of contemporary art in France. It would be worthwhile, then, before proceeding to an analysis of the Universal Exposition to cast a brief glance at the Salon of 1867.

For younger artists, shut out of the major show on the Champ-de-Mars, the annual Salon at the Palais de l'Industrie represented their only hope of being seen in this Exposition year. They were to be disappointed. The Salon Jury was elected on the same terms as that of the Universal Exposition and with much the same results; the administrative section included the same members as in 1866.[2] The Salon would last six weeks, 15 April to 31 May, while the Exposition would continue for six months. Artists petitioned the Government repeatedly to lengthen the Salon; the most they could accomplish was that it was extended another week, to 5 June, for the Palais de l'Industrie had to be emptied and prepared for the July Awards Ceremony of the Universal Exposition.[3]

The Admissions Jury of the 1867 Salon proved to be as harsh as that of the Universal Exposition. Castagnary published a report in *La Liberté*, stating: "Never in the memory of artists has a jury been more severe. Out of 3,000 artists who sent work, 2,000 have been refused ... the rejected painters and sculptors are petitioning the Surintendant des beaux-arts for permission to exhibit their works in one of the empty galleries of the Palais des Champs-Elysées."[4] Emile Zola wrote to his friend Valabrègue: "the Jury, irritated by my 'Salon' has thrown out all those who are taking the new road."[5] Cézanne, Sisley, Bazille, Pissarro, Renoir, Monet were all refused, the worst across-the-board rejection that this group of artists was ever to experience. Among them, only

Degas, Berthe Morisot and Fantin-Latour were accepted; Bazille decided to do something about it and composed a simple petition to Nieuwerkerke (probably the one referred to by Castagnary), signed by 125 artists, asking for another Salon des refusés:

> The undersigned artists, rejected at this year's Salon, are taking the liberty of appealing to your Excellency for an exposition of their works.
> Knowing your benevolent solicitude for our interests, we are hoping that you will be willing to take our request into consideration.[6]

The first to sign after Bazille were his friends Monet, Manet, Renoir, Pissarro, Sisley and Guillemet; Jongkind, Bracquemond, Diaz and Daubigny also signed. This was only one of the many letters and petitions that Nieuwerkerke received throughout the 1860s. Beginning with angry letters from individuals, they were progressing into informal alliances, such as this, eventually leading to results in the 1870s. Bazille's group apparently went so far as to elect a President (Grosclaude fils) and a committee of delegates (Honoré Pinel, A. Chataud, I. Bureau) who wrote to Nieuwerkerke and the Emperor, requesting an appointment to present their petition.[7] Nieuwerkerke responded: "I ought to warn you that if you are trying to obtain an exposition of the rejected paintings you will not succeed; it has been decided that the experiment was tried several years ago and will not be repeated."[8] The meeting did take place, however, and along with their request the artists presented the following manifesto which reflects the growing militance of the art community:

To Monsieur le Sénateur, Surintendant des beaux-arts

> At the moment when the Exposition on the Champs-Elysées is about to open, the excessive harshness of the Fine Arts Jury, only recently become known, has aroused strong feelings everywhere among artists, our colleagues.
> We know, Monsieur le Surintendant, that the decisions reached by the Jury with regard to the works presented at the Exposition are irrevocable. But as it is true that in the present state of our artistic institutions, we have no means of appeal to some other authority in order to obtain access to the official Salon, we are hoping nonetheless that your Excellence will take into consideration our attached petition. In permitting us to place our works before the public in a Salon especially intended for this purpose, your Excellence will facilitate the exercise of an incontestable right, the right of appeal to public opinion, of decisions that harm us and cause us, from every point of view, serious damage.
> If we are told that the attempt has been made and that the Salon des refusés has sufficiently demonstrated the justice of the Jury decisions, we will protest with all our might against such an assertion.
> Indeed, we believe that for all impartial and enlightened minds the question of the infallibility of the Jury, in fact as in principle, is answered negatively. During all epochs, the men appointed to accept or refuse the works of their colleagues for Expositions have committed errors of judgment often heavily criticized by public opinion. It is not for us to search out or to indicate here the cause of these errors, but it is our duty to insist on the deplorable consequences that they can have. Without attacking the character of our judges, without questioning their zeal, their good will,

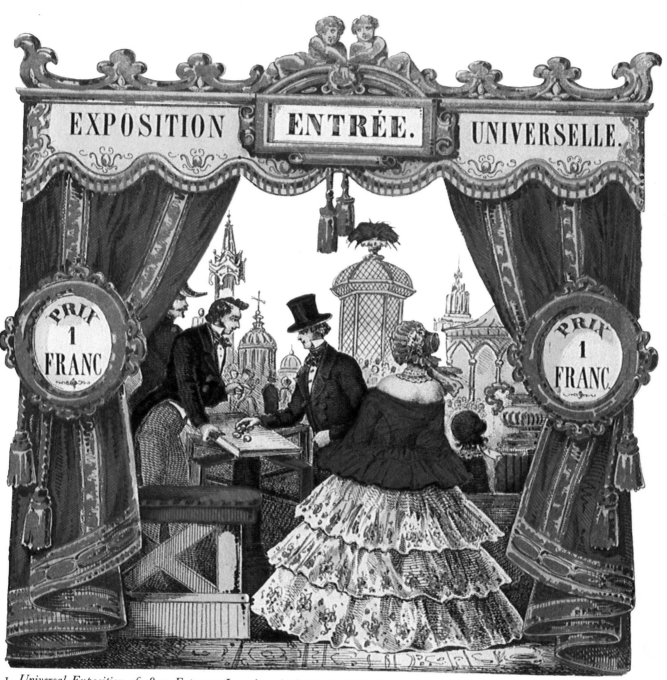

1. *Universal Exposition of 1855, Entrance.* Imprimerie Lith. de Pellerin à Epinal. Bibliothèque Nationale, Paris.

2. Edouard Manet, *View of the Universal Exposition of Paris, 1867*, 1.08 × 1.965 m. Najonalgalleriet, Oslo.

EXPOSITION SORTIE. UNIVERSELLE.

3. *Universal Exposition of 1855, Exit.* Imprimerie Lith. de Pellerin à Epinal. Bibliothèque Nationale, Paris.

their intelligence, we believe ourselves authorized by good sense and the experience of the past to state that they are capable of error.

We also believe that, until the freedom of Expositions is proclaimed and forever assured, the right to have special Expositions of rejected works ought to be permanently guaranteed to artists who believe themselves wrongly judged and possess the courage to submit to public judgment. We consider Expositions of Appeal as an indispensible safeguard against the fallibility of Jury decisions.

The refusal of a work of art at the Salon is always a painful humiliation for the stricken artist, but it can cause this artist's ruin, and this hypothesis alone seems grave enough to motivate our request. Please allow us to believe, Monsieur le Surintendant, that you wish to accord us an Exposition enabling us to learn the judgment of the public to whom we are appealing.

In the hope that you would be willing to grant our just request, we have the honor to be, with respect, Monsieur le Surintendant,

Your very humble and very obedient servants,

N.B. The undersigned signatories of this letter, sincerely convinced as they are of the justice of their complaints and of the urgency of their demands, formally engage themselves, if their petition is accepted, to send their works to the Salon des refusés.[9]

Among the twenty-five signatures (many of them illegible), the first were A. Chataud, F. Bazille, C. Pissarro, C. Monet, Bureau, Grosclaude fils, Guillemet, A. Renoir.

Although he rejected the artists' request for a new Salon des refusés, Nieuwerkerke did promise that at the Salon of 1868 the Jury would be elected by universal suffrage: all artists who had exhibited in at least one Salon (excepting that of 1848) would be allowed to vote.[10] This was not, however, a satisfactory solution for the artists in 1867, for this was the year when all of Europe, it seemed, would be in Paris. More petitions were signed.[11] A group of anonymous artists, calling themselves "The refused who know their value," wrote a menacing letter to Nieuwerkerke stating: "This injustice is revolting and you'd better believe that it's not a favor we're demanding, it's our right and we hope you will grant it."[12]

During this turbulent month, Bazille wrote to his parents, announcing that his paintings had been rejected at the Salon and that there was a petition for a Salon des refusés:

It is just too ridiculous, when you know you're not stupid, to be exposed to these whims of the administration, expecially when you don't care at all about medals and awards. A dozen talented young people feel the same as I do. So we have resolved to rent a big studio each year where we will show our works, as many as we please. We will invite painters we like to send some pictures. Courbet, Corot, Diaz, Daubigny and many others whom you may not know have promised to send pictures and very much approve our idea. With these people and Monet, the strongest of all, we are certain to succeed. You will see that everyone will be talking of us.[13]

Several weeks later, he wrote again: "By bleeding ourselves as much as possible we

managed to collect 2,500 francs which isn't enough. So we've been forced to give up what we wanted to do. We must return to the bosom of the administration that hasn't nourished us at all and that disowns us."[14]

For most of the younger generation of artists, then, 1867 was not a good year; it marked, however, the first attempt in over a hundred years, since the Salons of the Académie de Saint-Luc in the eighteenth century, to mount an independent series of exhibitions without government support. Abandoned in 1867, the attempt would succeed in 1874 with the first of the Impressionist shows. The artists did enjoy a kind of revenge, however, for by all accounts the Salon of 1867 was not a success. Whether the works were better or worse than usual was a matter of opinion; that it was unvisited and ignored was a fact. Many journals didn't even bother to review it; the ones that did all remarked the infrequency of visitors, even on opening day; there hadn't even been an official ceremony to mark its opening.[15] It seemed that everyone signed a petition in 1867: those excluded demanding a Salon des refusés, those included protesting official neglect and indifference.

In reviewing the Salon, Castagnary stated: "Despite the prejudices of the administration, despite the hostility of the Ecole, despite the opposition of the juries, Naturalism has won out on all fronts. Religion is dead, History is dead, Mythology is dead."[16] As a partisan of Naturalism, Castagnary would be expected to feel that way, but Paul de Saint-Victor, a conservative and a member of the Exposition Jury, came to the same conclusion, for, even with the severity of the Jury, about 1,000 of the 1,581 pictures exhibited were genre scenes.[17] He wrote: "Modern art seems to have definitively renounced the path of heroic form and pure beauty. It falls back on scenes of manners, on the little corners of history, on curiosities, on ethnography, and on genre."[18]

These sentiments had been expressed with increasing frequency since 1855, the annual Salon bringing forth annual lamentations. What made 1867 different was its international context.

Courbet

The inevitable reaction to the Universal Exposition was to hold private expositions. Next to the official basilica of industry and the arts were inevitably built temples of non-conformists, churches of dissidents, even chapels of Mormons.—*Hippolyte Babou, 1867.*[19]

Courbet again decided to mount his own exhibition, as he had done in 1855. This time, however, there was no high drama preceding it, and it is in an almost casual tone that he announced his decision in a letter to Bruyas: "This time it will be a permanent studio for the rest of my life and I will practically nevermore send anything to the expositions of the Government that has behaved so badly towards me up to now."[20]

Courbet had his pavilion constructed on the Place de l'Alma; it was a good location, for anyone going from the Salon at the Palais de l'Industrie to the Universal Exposition on the Champ-de-Mars would have to pass by. He wrote to Bruyas: "I have had a cathedral constructed on the most beautiful site in Europe at the Pont de l'Alma with its unlimited horizons, on the banks of the Seine and in the heart of Paris, and I will

92. Gustave Courbet, *Landscape*, 1865, 0.94 × 1.35 m. Musée d'Orsay, Paris. Exhibited 1867 no. 174. (*Le Ruisseau couvert, Ornans*).

astonish the entire world."[21] Courbet's carnival tent of 1855 had become, by his own admission, a cathedral (Plate 93). While it would be a mistake to think that he was wholly acceptable in 1867, his fortunes had certainly improved. In 1855 he had plastered Paris with posters advertising his show; in 1867 he mailed out 3,000 invitations and sent a copy of his catalogue to every artist in Paris.[22] *L'Artiste* noted that all of them praised his show, "even those who have been to Rome."[23] His portrait, palette and beer stein in hand, appeared on the cover of two revues, *Le Hanneton illustré* and *La Lune*.[24]

On the other hand, Ernest Chesneau, official critic for the Exposition, discussed Courbet in an article entitled "The Young School. Painters and Eccentrics" and, in his government report, dismissed him in one sentence consisting of an unfavorable comparison of his landscapes (Plate 92) to those of Troyon.[25] As a landscapist, Courbet was lauded, but his figure paintings and personal theatrical style were no more esteemed in 1867 than they had been in 1855.[26] For the older critics there was the same problem as in 1855, of judging the man apart from his work.

The younger generation of critics was not so equivocal: Théodore Duret placed him

93. G. Randon, "To the Temple of Memory. Courbet, Master Painter." *Le Journal amusant*, 15 June 1867. Bibliothèque Nationale, Paris.

94. G. Randon, "The Temple of Taste. The Exposition of Edouard Manet." *Le Journal amusant*, 29 June 1867. Bibliothèque Nationale, Paris.

"definitively among the masters of the Modern School."[27] The events of the early 1850s had now sufficiently receded into the past so that Courbet's paintings had lost what Pérignon had called "the train of violent passions that gave them their magic life."[28] Castagnary noted that foreigners visiting his exhibition were astonished at the controversy which had surrounded the artist's early works. Looking at Courbet's 1867 show, he pronounced that the exhibition had the importance of a museum:

> Even we who are reviewing after 12 or 15 years these works so strong and so beautiful, we ask ourselves in sadness by what strange aberration our elders so violently rejected an art for which contemporary life has furnished both the model and the inspiration and which, as a result, approaches the most authentic and lasting art produced by peoples of all epochs ... How did it happen, I ask, that this art, fifteen years ago, was greeted with universal horror when, in the hands of this bold and daring young man, marvellously endowed with natural gifts, it displayed so much power, precision and vitality? ... Well then, let's say it and say it bluntly because it's the exact truth: Courbet's painting was caught up in the reaction of 1850 and it fell under the same blows as the February Revolution.[29]

Courbet received no honors or awards in 1867; his gesture of setting up his own show in defiance of the Government could not, officially speaking, be rewarded. Nonetheless, he was promoted to a kind of "Old Master" status which permitted his earlier paintings, at least, to be seen outside of the partisan politics that had informed their creation and initial reception. It was not quite the canonization that had greeted Delacroix in 1855 or that the *Revue universelle des arts* had predicted for Courbet,[30] but it was about as close to official respectability as Courbet would ever be—or allow himself to be.

Manet's *View of the Universal Exposition*

On 1 January 1867, Emile Zola published a long defense of Edouard Manet in *La Revue du XIXe siècle*; the next day Manet wrote to thank him for the article, adding:

> It comes at a good time, for they have judged me unworthy to profit, as have so many others, from the advantages of the preferred list. As I expect nothing good from my judges, I will beware of sending them my pictures. They would only make a fool of me by accepting one or two and because of that, as far as the public is concerned, the others would be as good as thrown to the dogs.
>
> I have decided to hold a private exhibition. I have at least forty pictures to show. I have already been offered a place very well situated near the Champ-de-Mars: I am going to risk it, and, backed by men such as you, I can count on success.[31]

Manet's prediction that the Jury would have accepted one or two of his pictures (Zola was later to repeat this) was probably overly optimistic, for the Jury proved so severe that in the official report Daubigny—at fifty—became, by default, the leader of the "Young School."[32]

Manet was determined to be seen, however, with or without official approval, for the eyes of the world were on Paris in 1867. He borrowed money from his mother and had a private pavilion constructed, next to Courbet's, on the Place de l'Alma (Plate 94).[33] Courbet's motives were straightforward; he wrote to Bruyas: "All the painting of Europe is on display at this moment in Paris. My triumph is not only over the moderns but over the ancients as well."[34] Manet, younger and innately more modest, wrote in his exhibition catalogue: "To exhibit is the vital issue, the *sine qua non* for the artist, for it so happens after several confrontations that one becomes familiar with what had been surprising and, if you will, shocking. Little by little one understands it and accepts it . . . To exhibit is to find friends and allies for the struggle."[35]

Courbet and Manet were an odd couple to find themselves neighboring renegades on the Place de l'Alma, Courbet with his intentionally crude peasant ways, Manet with his refined manners. *L'Artiste*, after announcing that "the two ringleaders of *Realism*" would be holding private exhibitions, made only one comment, that in comparison with Courbet's show, Manet's was "the Chapel next to the Church."[36] Legend even has it that Courbet himself didn't approve of Manet. On visiting his exhibition, Courbet's only remark, occasioned by Manet's evident fondness for Velázquez, is reported to have been: "Nothing but Spaniards!"[37]

The enormity of Manet's act in setting himself in opposition to the art establishment can better be gauged by comparing him to his predecessors who took the same step. When Jacques-Louis David, after playing an active role in the French Revolution (and after spending time in jail when Robespierre fell), opened his one-man show in the Louvre in 1799, he accompanied his exhibition with an aggressively worded manifesto announcing that he was instituting a new custom in France, that henceforth the public should pay artists for the privilege of seeing their works.[38] When Horace Vernet, an outspoken republican, sent two anti-monarchist paintings to the Salon of 1822, which promptly rejected them, he withdrew all his works and refused to exhibit there. Instead, he held a large exhibition in his studio; it became as much a political as an

141

artistic event.[39] Courbet's *On Realism* was published in the catalogue of his 1855 exhibition and began: "The title of Realist has been imposed on me in the same way as the title of Romantic was imposed on the men of 1830. Titles have never given an accurate idea of things; if it were otherwise the works would be unnecessary."[40] In contrast to this militancy, Manet accompanied his exhibition with a statement so mild as to seem almost apologetic: "M. Manet has never wished to protest. On the contrary, it is against him, who did not expect it, that a protest has been made …"[41]

And yet, however distasteful it may have been for him, he did protest, by erecting his own pavilion and filling it with more than fifty paintings. The results were disappointing. His schoolmate and biographer Antonin Proust described the event in prose reminiscent of Zola's account of the Salon des refusés:

> The public was pitiless. They laughed in front of these masterpieces. Husbands escorted their wives to the Pont de l'Alma. Wives brought their children. The entire world had to avail itself of this rare opportunity to shake with laughter. All the so-called "respectable" painters of Paris made appointments to meet each other at the Manet exhibition. It was a concert of raving pot-bellies. One of them, I do not want to name him, indulged himself in vulgar jokes which vastly amused his audience. Faced with this spectacle, Théophile Gautier would have said, in his vivid style, that at this moment the crowd gave the impression of enormous pumpkins laughing at the jokes of a melon at a convention of squashes. The press was unanimous or nearly unanimous in echoing them. Never at any time was seen a spectacle of such revolting injustice.[42]

Proust's testimony notwithstanding, Manet was simply ignored. In this Exposition year, Manet seemed too insignificant to receive much attention. *La Chronique des arts et de la curiosité*, after announcing the opening of Manet's show, listing the principal works and where they had first been shown (beginning with the Salon des refusés), merely stated: "They have been judged in the *Gazette*. The new works add little to the discussion of the methods of the artist."[43]

Zola reissued his January article as a pamphlet (Manet feared it would be seen as bad taste to sell it at his exhibition)[44] and then went on to write one of the most wickedly funny pieces of art criticism ever published, "Our Painters on the Champ-de-Mars," in which he dissected the official prize-winners.[45] There were some caricatures in the press and a sympathetic account which appeared in *L'Indépendance belge*.[46] Théodore Duret, later to become one of Manet's friends and supporters, in 1867 damned him with faint praise. Admitting that he had been unjustly treated by juries and allowing that he had gifts as a colorist, Duret nonetheless stated that Manet had begun to paint without knowing how to use a brush, that he worked too quickly, and that he left his paintings unfinished.[47] Most of the other critics were busy with the two official shows and had no time for maverick exhibitions.

The major exception to this indifference came from a surprising quarter, the critic Ernest Chesneau. Conservative enough to be designated by the administration to write the official report, Chesneau had enough insight to realize that, although he himself was committed to *grande peinture*, such painting was on the decline. Unlike most critics, Chesneau did see very well what Manet was doing, and regarded it as a valid endeavor,

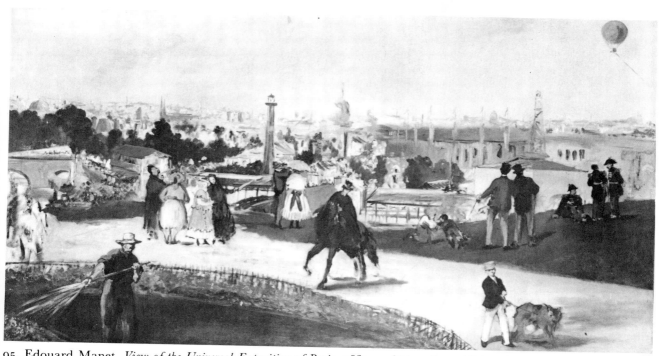

95. Edouard Manet, *View of the Universal Exposition of Paris, 1867*, 1.08 × 1.965 m. Najonalgalleriet, Oslo.

yet he could forgive neither his "inconceivable vulgarity" nor his "practically childlike ignorance of the basic elements of drawing."[48] In his essay, "The Young School. Painters and Eccentrics," he began with Courbet and ended with Manet as the latest entry into the "tribe of eccentrics" that had descended on the contemporary art scene.[49] He perceived Manet's intention to present "true tone," absolutely faithful to nature, rather than the synthetic color systems used by other artists. Provided that Manet placed his subjects in diffused light, Chesneau found him praiseworthy, but his attempt to paint sharp contrasts of light and shade, omitting half-tones, was criticized because it involved the creation of a new convention which was, as Manet had said, surprising, and even a little shocking. Nonetheless, Chesneau was second only to Zola in his understanding of Manet's painting in 1867.

Up until now we have traced the interaction of art and politics in the public sphere; here I would like to interrupt the narrative for a moment to focus on the same phenomenon on a more intimate scale, that is, in a single work of art, Manet's *View of the Universal Exposition of Paris, 1867* (Plate 95 and Color Plate 2). It was painted sometime between the opening of the Universal Exposition on 1 April and Manet's departure for Boulogne in August; it is a painting which broke all of Chesneau's rules against vulgar subjects, loose drawing and strong contrast of tones in outdoor light. Because this is the only painting of the Universal Exposition, and because Manet's intention was clearly to create a major work summing up both the event and his own aesthetic principles, issues both public and private, both aesthetic and political, can be illuminated through an analysis of this one painting.

This was Manet's first—and last—view of Paris, and if he painted it on the motif it would be his first *plein-air* picture.[50] Indeed, Monet and Renoir both began doing

cityscapes of Paris in 1867, Monet painting *The Garden of the Princess*, Renoir, *Le Pont des arts*. Manet's method of picture construction for outdoor subjects during this period, however, was to develop them in his studio from preliminary sketches and drawings. That is how *Concert in the Tuileries* (1862), the racetrack paintings (1864–65) and the 1869 paintings of Boulogne were done;[51] the *View of the Universal Exposition*, because of its size (1.08 × 1.965 m.), its disjunctive spatial construction, and its disposition of figures, seems to be in the same category.

Manet's vantage point for this painting has been identified as the upper meeting of the rue Franklin and rue Vineuse close to the Trocadéro, looking directly across the Pont d'Iéna to the Exposition on the Champ-de-Mars.[52] A comparison with popular prints (Plates 87 and 96) or with Berthe Morisot's later painting of the same motif (Plate 97) shows, however, that he has compressed the space into a more immediate image.[53] Most cities have one or two viewpoints which, favored by artists, come to symbolize the city itself.[54] In Paris in 1867 it was the view from the Trocadéro, recommended in popular literature and shown in a majority of popular images of the Exposition.[55] Many such images were available for inspiration or reference, and, in addition, Manet had probably seen, in the Prado, Mazo's *View of Saragossa* which employed a similar spatial convention.[56] The problem with cityscape as a motif is that, in order adequately to represent the subject, a high vantage point is necessary; this, however, reduces figures to ant-like proportions or presents them in severe foreshortening (like the old joke about a circle being a man seen from above). Most of the popular images of the Exposition minimized this problem by adopting a distant view and eliminating the foreground. The brightly colored Epinal print (Plate 87) is an exception for, in order to convey the immediacy of near and far seen together, it breaks all perspective rules. The figures are shown frontally, from eye level, and the panorama is in bird's-eye perspective. Manet, whom Zola had recently defended against the accusation that his painting was as primitive as Epinal prints, has here adopted a similar spatial disjunction and taken it even further.[57] He has dropped out the middleground completely and jammed together the two areas of maximum interest, the immediate foreground and the distant panorama. Instead of taking a long view, which would clarify the objective spatial relationships, he has thrust the viewer so abruptly into the foreground that the articulation of the Pont d'Iéna, the Seine and the Exposition itself has become almost indecipherable. Before noting the "modernity" of Manet's solution, however, it is worth remembering that the most famous cityscape of all, El Greco's *View of Toledo*, is also topographically inaccurate and that, in fact, paintings are rarely as accurate as maps.[58]

Even a comparison of the two popular images will show that, once the drawn-to-scale accuracy of a map is left behind, there is always a judgment necessary as to what should be included and how prominently it should be portrayed. A few significant landmarks come to stand for the whole: both prints and Manet's painting include the oval exhibition hall, the Palais de l'Exposition, the tall French lighthouse, the Phare des Roches-Douvres, and, that symbol of Paris, the domed church of the Invalides. In almost every other detail they differ. For example, while the dome of the Invalides is conspicuous in all the depictions, the masthead engraving gives almost equal prominence to the nearby dome of the Institut de France, while in the Epinal print this latter

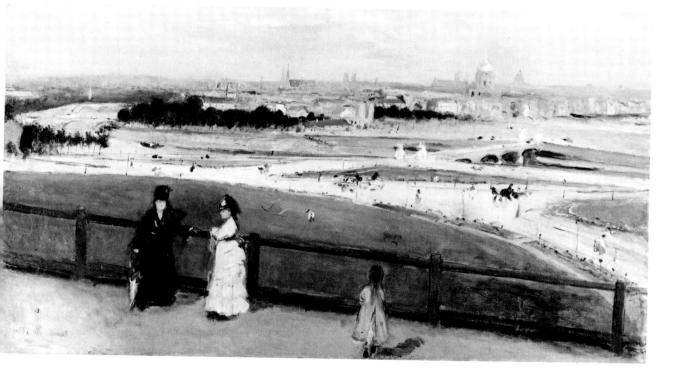

96. L. Dumont, *L'Exposition Universelle de 1867 illustrée,* masthead engraving.

97. Berthe Morisot, *View of Paris from the Heights of the Trocadéro,* 1872, 0.45 × 0.81 m. Santa Barbara Museum of Art. Gift of Mrs. Hugh N. Kirkland.

dome is greatly diminished in importance. Manet has reduced this symbol of the Academy so that it is barely visible.

Manet's panorama begins at the far left with, appropriately enough, the dome of the Panorama national; here changing panoramas of military subjects were constantly on display. Adjacent to the Panorama was the larger and more conspicuous Palais de l'Industrie where the annual Salon was being held; although the Palais is shown on the far left of Berthe Morisot's painting and was certainly within Manet's field of vision, he has omitted it. Below the Panorama is the Pont de l'Alma, the bridge leading to Manet's exhibition. Not only has he given it extreme prominence but, as a comparison with any of the other images (or even modern photographs) will show, its pylons have been made much more massive than they actually are. To the right of the Panorama can be seen the twin spires of the church of Sainte-Clotilde, recently completed. Commissioned by the city of Paris in what was considered the true national style of France, this Gothic Revival church had been built over the protests of Academicians who favored only classically inspired architecture.[59] Manet has painted it more distinctly than it would appear, and in contrast he has the dome of Saint-Louis-des-Invalides, built by Louis XIV and housing the tomb of Napoléon, partially obscured by a puff of smoke from the Exposition chimneys. Most popular images were careful to clearly articulate this landmark. Two other landmarks are identifiable: to the left of the tall French lighthouse can be seen the twin towers of Notre-Dame, and to the right of the Invalides dome, partially painted over, is the Panthéon. Both of these monuments are traditional symbols of Paris and all images tended to include them, even if their scale and location had to be shifted. Behind the oval of the Palais de l'Exposition containing the art exhibition rises the dome of the Ecole militaire; the Champ-de-Mars was actually its parade ground. The irony that an exhibition dedicated to peace should take place on a field associated with war was not lost to Parisians, and Daumier kept up a steady stream of lithographs on this theme. On 16 January 1867, in *Charivari*, he showed a father and son standing on the Trocadéro looking down on the Champ-de-Mars: "Oh my son! What a wonderful sight! Look there at the exhibition palace, the temple of peace!" "Yes papa, right next to the military school!"[60] Manet has somewhat exaggerated the size of the Ecole militaire to preserve this counterpoint. Most popular images did the same thing although the sentiment was not always ironic; in the popular press it ran to the mawkish, for example, "the field of war must now be renamed the field of peace."[61]

The relationship between Sainte-Clotilde and Saint-Louis-des-Invalides was echoed by that of the British and French lighthouses erected on the Exposition grounds. Electricity was something new (most of the Exposition was gas-lit) but the Phare des Roches-Douvres, resembling a neoclassical column, was traditional in both function and design. The British, however, chose to erect the skeletal structure, seen at the right, powered by electricity. It was greeted with the same cries of outrage as the Eiffel Tower would receive at the 1889 Exposition. The editor of *L'Exposition Universelle de 1867 illustrée* wrote: "Time after time we have begged the English to finish this enormous scaffold on which they have placed their electric light and which disgraces the Champ-de-Mars with its fleshless frame."[62] In consequence, most popular images either omitted it altogether or gave it a proper "finish." The quarrel over

whether the inner structure should be covered or exposed was one which had raged in painting ever since Delacroix had abandoned the smooth anonymous surface so desirable in academic paintings. Manet, whose painting facture had much in common with British lighthouse construction, and who was also criticized for leaving his work "unfinished," could be expected to be sympathetic to the English attempt (as Seurat was to the Eiffel Tower) and his depiction is more accurate than most popular images.

This discussion of the topography of Manet's panorama, with its inclusions, exclusions, exaggerations and diminutions, is not intended to impute to Manet an articulate programmatic intent, but rather to suggest that "seeing" is dependent as much on attitudes and expectations as on the topographical reality of the sight seen.[63]

The Seine, which should occupy the middleground, has been omitted by Manet, and the Pont d'Iéna makes a somewhat awkward transition to the foreground "stage" across which is strung a rather odd cast of characters. Because of the loose composition and the strange disjunctions of space, this painting has been called one of Manet's failures.[64] The workman at the lower left does not appear to be standing on the same ground plane as the women behind him, and the two gentlemen on the right, who seem to be in correct scale to the soldiers, are too large to be that far back from Léon Leenhoff and his dog. Not only do the figures exist in different perspectives from each other, they also seem to be in a different perspective from the panorama. The result is that while the figures in Berthe Morisot's painting explicate the unity of the space, Manet's figures are disruptive of any spatial continuity and can be seen only separately. In this sense they partake more of the character of icon than of genre.

The figure at the lower left provides a traditional entry into the painting—a *repoussoir* figure whose function is to establish the first plane. That a workman should be given this role is appropriate, for this was an exposition of products of industry whose central exhibit was "The History of Work." The two women behind him are sketched in a humorous, almost caricatural, style and present the conventional image of working-class women, one fat and dumpy with heavy legs, the other thin, standing stiff and awkward.[65] Next comes a most extravagant creature whose orange dress contrasts vividly with the more conventional attire of the other figures. She is dressed at the height of fashion: crinolines were "out" in 1867, "short" skirts (meaning that ankles showed) were all the rage, and tiny oval hats perched forward on the forehead were popular. A dress very like hers, double-skirted with turreted squares edged in contrasting trim, was described in the magazine *Le Follet* for August.[66] Historians of the period never tire of describing its eccentricities and excesses, for only with difficulty could a harlot be distinguished from a fashionable lady. Here the presence of her more soberly clad companion, possibly a chaperone, indicates that she is the latter, a *cocodotte* rather than a *cocotte*.[67] The *cocodotte*, also known as a *femmelette* (literally "little woman") was the female equivalent to the dandy. In French society, the complement of the *femmelette* was the *amazone*, the horsewoman who fenced, rode, hunted, and disdained ladylike behaviour. She too could be harlot or lady of fashion; Manet has painted her in the center of the picture.[68]

Between the *cocodotte* and the *amazone* stands a bourgeois couple whose informal dress suggests that they are provincials, or possibly English tourists.[69] The interest the man is taking in the captive balloon, observing it through his binoculars, implies that they

are visitors taking in the sights of the big city. The children playing on the grass are *gamins*, youngsters of the lower classes. In contrast, Manet's son Léon Leenhoff, walking his dog, at sixteen is already dressed as a young dandy.[70]

Behind him are two older dandies, the *petits crevés*, the male version of the *cocodotte*. They also are wearing the latest fashions, the short jackets and top hats which were just becoming popular during the spring of 1867 and which can be seen in illustrations slowly replacing the tall top hats and tailcoats favored by more conservative bourgeois gentlemen.[71] The three Imperial Guardsmen in their blue jackets and red trousers complete the cast. Obviously off-duty, they present a most unmilitary appearance, one lounging on the grass, another without his *bicorne* hat.[72] Manet has painted a "panorama" of types such as one might expect to see in Paris in 1867. There are men and women, children and adults, members of the working class, the bourgeoisie, the fashionable world of the capital, and the military. The concept itself is not original to Manet; from the beginning of townscape images there was a trend, particularly evident from the seventeenth century, to have the staffage indicate "all the world," thus adding overtones of universality, civic pride and world view.[73] The Epinal print reflects this earlier tradition as well as the mid-nineteenth-century interest in Parisian "types" to which such illustrations usually referred. Most illustrators, however, tended to depict a few normative "types," such as "the lady" or "the gentleman" over and over with little variation. Manet's concept differed in that he tended towards the encyclopedic; he presented one isolated figure group of each "type" with no repetitions. This further reinforced the emblematic rather than the genre aspect of the painting.

Although Manet's interest in Parisian "types"—from the lower classes of *The Old Musician* to the upper classes of *Concert in the Tuileries*—has been well documented, he never before—or after—attempted to paint the entire spectrum in a single picture.[74] Here, in the same way that the Panorama national has become emblematic of the entire painting, so also has the idea of Universal Exposition: Manet has extended it metaphorically from the topography to include the figures as well, and thus has painted a truly Universal Exposition of Paris in 1867.

The only aspect of Manet's painting which does not appear in the popular images of the Exposition is the balloon floating over the Champ-de-Mars, and yet it is a good touch as it represents the very essence of French Expositions. Balloons were a French invention: the first hydrogen balloon ascension had been made from the Champ-de-Mars in 1793. Thereafter balloons became part of all public fêtes, including the first Exposition publique des produits de l'industrie française on the Champ-de-Mars in 1798 (see Plates 4 and 5).[75] Manet's balloon is that of his friend Nadar. Called *The Giant* (*Le Géant*), it was, at the time, the largest ever built. It had made its first ascent in 1863, the year of the Salon des refusés, and had crashed in 1865, the year of the scandal over *Olympia*. It had survived, yet in 1867 there were still skeptics who considered aeronautics impossible and absurd. Nadar hoped that the Universal Exposition would establish its respectability.[76] *Le Géant* had, in many ways, a career parallel to Manet's.

The artist actually changed the silhouette of *Le Géant*: a popular print showed it as having a teardrop shape with a smaller teardrop below.[77] Manet painted it as a globe, making it a metaphor for the world. Nor was he the first to do this, for, in the eighteenth and nineteenth centuries, balloons (called *globes aérostatiques*) were sometimes shown

replacing a smaller sun as a symbol for the conquest of nature.[78] Victor Hugo's *Legend of the Centuries* of 1859 contained a long poem in which the balloon, "a globe like the world," became the symbol of his hope in the future.[79] He had concluded the preceding poem with the statement: "This world is dead . . . Look up above."[80] Throughout, the balloon is seen as ascending over all the baser qualities of human experience, everything old and vile:

> The old battlefields were there in the night;
> It passes by, and now—look there—the dawn is breaking
> over these vast graveyards of history.[81]

The balloon as a symbol of hope existed before Hugo; Charles Meryon, in the early stages of his etching *Le Pont-au-Change* (1854), placed in the sky a balloon labeled *Esperanza*. In a similar vein, although less poetically, Théophile Gautier wrote in 1848: "It is a profoundly human instinct which causes us to follow with our eyes until it is lost from sight this smoke-filled globe which carries the prophecy of the future."[82] Daumier, in an 1868 lithograph, was even more direct: on his balloon was written "Le Progrès."[83]

Hope, progress, the future, the world; in Manet's painting, the balloon floating over the old battlefield of the Champ-de-Mars, followed by the gaze of the man with the binoculars, becomes a symbol of the Exposition that brought together the art and industry of the entire world.[84] The painting itself is ambivalent as to its actual themes, and yet the coupling of images of peace and progress with reminders of military presence is an accurate reflection of the mood of Paris in 1867: a mixture of gaiety and apprehension, hope and fear. Prussia sent an enormous Krupp cannon to the Exposition, and the tensions that would lead to the Franco-Prussian War were already much in evidence.[85]

Manet saw his own artistic career in terms of military imagery. He wrote in his catalogue: "If the struggles of art are a combat, at least it is necessary to fight with equal weapons, that is, to be able to show what one has done." He concluded his preface with the statement: "The only thing that matters, then, is for the painter to win over the public which has been turned into his supposed enemy."[86] Zola's essay accompanying Manet's show was built around a similarly combative metaphor:

> I imagine that I am coming down the street and I meet up with a gang of street urchins who are throwing stones at Edouard Manet. The art critics, I mean the peace officers, are not doing their job; they are adding to the uproar instead of calming it and even, God help me, it seems to me that these officers have enormous paving stones in their own hands. There is something about this spectacle that is offensive, that saddens me who am just a casual uninvolved passer-by.
>
> I go up to them, I question the peace officers, I question Edouard Manet himself. And a conviction grows in me. I understand the anger of the street urchins and the indifference of the police; I know what crime has been committed by this pariah whom they have stoned. I return home and I prepare, for the sake of truth, this testimony that you are about to read.[87]

It is interesting to note that in Manet's painting the officers of the peace, Napoléon III's Imperial Guard, have been appeased, the street urchins are playing harmlessly

on the grass, and the fashionably dressed gentlemen (the art critics?) are regarding with great interest the two symbols of progress, the English lighthouse and Nadar's balloon. Whether he intended it or not, Manet has shown the results that Zola hoped his essay would achieve.

Manet's *View of the Universal Exposition* is an ambitious painting, both in size and scope. Attempting to combine slice-of-life immediacy with a more suggestive treatment of types and symbols, it wavers between genre and allegory, never quite becoming either. It is a hopeful painting, probably done in June after his show had opened but before he realized that it would not be a success.[88] It seems to be an unfinished painting; there is a large area of pentimenti on the left, and it was never signed.[89]

As the summer of 1867 wore on, Manet became deeply depressed; he rarely went out at all.[90] By August he had fled Paris for Boulogne. He stopped painting. Proust visited him in Boulogne, later recalling: "When the mail arrived, bringing him news of his Exposition, he said 'Here comes the muddy wave. The tide is coming in.'"[91] Fifteen years later, Proust described him looking back on his struggles: "'Those battles', he said to me, 'did me the greatest harm. I cruelly suffered from them but they goaded me on. I don't wish any artist to be praised and worshipped from the start. That would destroy his character.'"[92] But that was hindsight.

On 19 June 1867, the Emperor Maximilian was executed in Mexico. On 1 July, the day of the Awards Ceremony for the Universal Exposition, rumors of this event reached the Parisian press; the first accurate reports arrived on 10 August. During this time, Manet began painting again; he started the first version of *The Execution of Maximilian*, now in Boston; legend states that he intended to include it in his exhibition although he did not do so. Eventually he completed four paintings and a lithograph on the theme; when he placed the Mexican soldiers in French uniforms, the Government of Napoléon III, which had installed and then abandoned the unfortunate monarch, suppressed the lithograph.[93] These are the most explicitly political works Manet ever did, grim and pessimistic rejoinders to the optimism of his *View of the Universal Exposition*.

In setting up his own exhibition and in painting his *View of the Universal Exposition*, Manet sought to identify himself with the leading themes of the enterprise, optimism, universality and progress. The exhibition through which he had hoped to reach an understanding audience met with incomprehension and neglect; the painting was abandoned. Never exhibited during his lifetime, it remained in his studio, unsigned and unsold at his death.

Chesneau concluded his 1867 evaluation of Manet by stating: "They tell me that M. Manet himself, compared to a group of young people, already seems conservative, a bewigged Academician, and that we have seen nothing of the art of the future."[94] Chesneau was right, for in 1867 these young artists—Monet, Renoir, Cézanne, Pissarro—had been successfully eliminated from public view and, officially speaking, did not exist. But Manet, although his exhibition was not the success he had wished, did accomplish his purpose, for, ironically, his *View of the Universal Exposition* is the only memorable artistic evidence of the Exposition that had excluded him.

16
The Death of Ingres

WHILE IT IS TRUE that history has accorded more importance to the work of Manet, excluded from the 1867 Universal Exposition, than to that of his many contemporaries fortunate enough to receive the blessings of the State, it was the shadow of another absence, that of Ingres, that cast a pall over the entire fine-arts display. This absence would be consequential to the import of the Exposition.

Surveying the fine arts in 1867, Théophile Thoré wrote: "We are between two worlds ... between a world that is ending and a world that is beginning ..."[1] His conscious-ness of 1867 as a crossroads was shared by his fellow critics, for this was the year when the confluence of the death of Ingres and the Universal Exposition would bring about the general acknowledgment that the hegemony of history painting—for over two hundred years synonymous with the French School—had finally come to an end, and that it was necessary to look to other kinds of painting for its continuation. Thoré himself could hardly conceal his delight. He wrote: "'What is dead with M. Ingres,' according to one of his eulogists, M. de Ronchaud, 'is the last *authority* which has maintained a remnant of rule ... it is the glorious *past*.' The past being dead, let us try to console ourselves with the present, and especially, let us hope in the future."[2] But while Thoré was optimistic about the future of French art, there were others for whom the death of Ingres recalled the words of Louis XV: "After us, the deluge." The death of Ingres was announced on a black-bordered page in the *Gazette des beaux-arts* and in the obituary that followed, Léon Lagrange voiced the conservative fear:

> His presence among us was a guarantee, his life a safeguard. Silent champion of the principles of the Beautiful, he no longer taught, he didn't preach, he didn't write, he had stopped exhibiting. But he was alive and that was sufficient to impose respect, to slow down the torrent, to avert the storms. His death breaks the last tie of moderation that was holding back anarchy.[3]

The death of Ingres would have been felt as a severe loss at any time, but coming just before the Exposition, its consequences were even more extreme. For it was not just Ingres who had died since 1855: France had lost virtually the entire generation of history painters. Lagrange wrote: "Modern art resembles a temple which has been destroyed, all of its columns lying in the dust. Delaroche was the first to fall, then Ary Scheffer, then Horace Vernet, Eugène Delacroix, Hippolyte Flandrin ... Finally the one who was considered the strongest support of the sanctuary gave way in his turn and

the temple itself has crumbled with him."[4] The French art exposition was thus deprived of all those who had previously served to demonstrate to the world French superiority in what was considered the most elevated category of art. Even the republican Maxime DuCamp could write, looking back at 1855: "Since that time, death has been cruel to us, striking without pause, cutting down the best, killing off the generals one after another, opening up gaps that have not at all been filled, and leaving our army of artists without leaders and without discipline."[5] Practically all the critics mentioned the losses, from Thoré's "Alas! the best have passed away" to Pierre Dax's succinct "It's a disaster."[6]

To understand the magnitude of the disaster, however, it is necessary to remember that cultural predominance had real importance for France in maintaining international prestige; in a way it helped to make up for France's undeniable industrial inferiority. At home, cultural leadership continued to be necessary to establish the legitimacy of the Second Empire. It was no less true in 1867 than it had been in 1855 that charges of decadence in art were in reality veiled attacks on the regime. Charles Clément, for example, critic for the Orleanist *Journal des débats*, stated that the level of art had been declining for fifteen or twenty years, in other words since the advent of Louis-Napoléon.[7] It had become customary to invoke the lineage of artists associated with every past regime, from the School of Fontainebleau, established by François I, to David and Gros, favorites of Robespierre and Napoléon I, to Delacroix, honored by Louis-Philippe.[8] In 1867, with all the reliable names in Grand Painting gone, it was necessary for Napoléon III to choose *his* artists, the heirs to the Grand Tradition of the French School.

In 1855 the problem had been sidestepped by giving retrospective exhibitions to the representatives of the leading movements of the period, all of whom had been inherited from previous regimes. Had any of them survived to 1867, they undoubtedly would have been honored again, but by 1867 only Ingres remained. He was the sole artist Napoléon III appointed to the Imperial Commission. His death left the French School, as the critics said, "decapitated."[9] In the resulting absence of prefabricated choices, the Government preserved a discreet silence and abstained from the risk of designating in advance the major artists. The future of French art, officially speaking, was thus left in the hands of the Jury.

The first reaction to the death of Ingres was to offset this loss by organizing an immense commemorative exhibition at the Ecole des Beaux-Arts to run concurrently with the Universal Exposition. The idea for the show seems to have originated with Emile Galichon, editor of the *Gazette des beaux-arts*, who suggested it shortly after Ingres's death.[10] Organized by Nieuwerkerke, the show opened on 8 April 1867 and united almost six hundred works "in order to propose them to artists and the public as an education and an example."[11] It included, among other works, *The Apotheosis of Homer* (Plate 98), with fifty studies for it, *Roger and Angelica*, *The Vow of Louis XIII* (Plate 48), *Jupiter and Thetis*. As a demonstration of the methods of a great artist in the classical tradition, it was unsurpassed, but it had the reverse effect from that anticipated. Confronted with this magnificent exhibition, the poverty of contemporary history painting on display at the Universal Exposition could no longer be ignored. In his absence, Ingres's influence over the Exposition was thus greater than that of any living

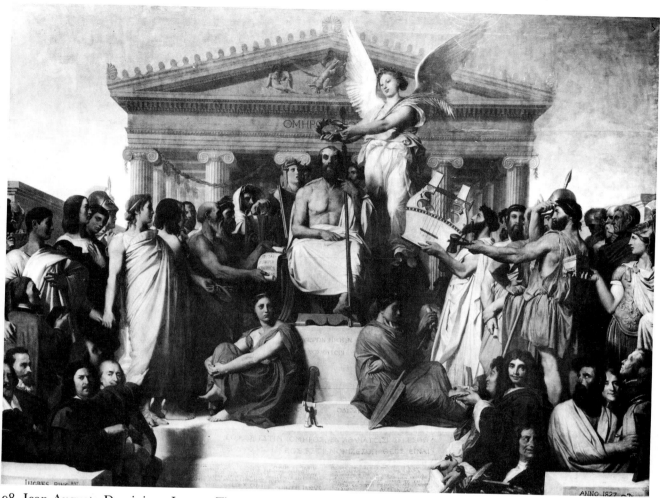

98. Jean-Auguste-Dominique Ingres, *The Apotheosis of Homer*, 1827, 3.86 × 5.15 m. Salon of 1827. Louvre. Exhibited 1855 no. 3345.

artist. His works did serve as "an education and an example," but what his contemporaries learned was that the tradition he represented was exhausted. As the Universal Exposition unfolded, it became universally apparent that the death of Ingres meant, in effect, the death of history painting in France.

17
The Death of History Painting

The study of European art as it is presented to us at this moment is truly apt to plunge us into the most extreme astonishment, and, if we don't remain steadfast, to upset our deepest convictions.—*Ernest Chesneau*[1]

ONE MAJOR DIFFERENCE BETWEEN the two Universal Expositions of the Second Empire was that in 1855 the awards were announced at the very end of the exhibition, while in 1867 these decisions were made right at the beginning. The response of the critics and public in 1867 reflected these decisions and most of the writing about the fine arts was structured after them. The death of history painting as a main theme of public consciousness in 1867 was, to be sure, the result of the almost simultaneous deaths of Ingres and Cornelius, but this event only assumed major significance in the light of the Jury's subsequent decision to bypass history painting in the awards. A discussion of the Jury and its verdicts is then necessary to introduce any analysis of the reception and influence of the Exposition.

As in 1855, the Awards Jury was made up of members appointed by and proportionate to participation of each nation. The Imperial Commission reserved the right to name the French members from the French Admissions Jury, half of whose twenty-four members were thus eliminated. The proportion of two-thirds chosen from the elected artists and one-third from the government appointees was retained.[2] Among the artists, the youngest and the least popular were eliminated, leaving Bida, Cabanel, Français, Fromentin, Gérôme, Meissonier, Pils, Théodore Rousseau. The Government's choices were more debatable, for the collectors Cottier and Lacaze were dropped in favor of the marquis Maison and the comte Welles de La Valette, neither of whom was particularly qualified except as a "government candidate." The curator Reiset and the critic Paul de Saint-Victor were, however, retained. It was, in general, a well-balanced and representative group, although decidedly conservative. To the French Jury were added fourteen foreigners, one or two from each of the major countries. The elected President of the Painting Jury, Lord Hardinge, was English, but the appointed President of the Jury de Groupe, encompassing all the Fine Arts Juries, was Nieuwerkerke.[3] By taking over Morny's 1855 role, he demonstrated that he had, in the intervening twelve years, become the undisputed art dictator of France.

How different this was from 1855, when the Juries were filled with political appointees, when Morny and Prince Napoléon oversaw even the smallest decisions.

Did this reflect changes in the political atmosphere of the 1860s, the growing liberalization and democratization of the Government? Or did it merely reflect the fact that in 1867 neither Napoléon III nor the Imperial Commission considered the Art Exposition important enough to manipulate? To be sure there was no one left who was qualified to do it. Probably all these factors came into play, but, in any case, the Jury seems to have been left to its own devices, and there is little evidence of attempts by the Government to interfere.

The *Règlement* established that there would be 8 Medals of Honor for painting (there had been 9 in 1855), 15 First Class medals (48 in 1855). 20 Second Class medals (51 in 1855), and 24 Third Class medals (57 in 1855). There had also been 222 Honorable Mentions in 1855, but in 1867 none were allowed in Art; Industry, on the other hand, awarded 6,247. In all, there had been almost six times as many awards for art in 1855 as were permitted in 1867.[4] As in 1855, the number of medals was increased during the period of jury deliberations; unlike 1855, the fine arts were not allowed to share in the largesse. In desperation, the Painting Jury asked for permission to reduce the value of the medals and thus award a greater number of them. Permission was refused.[5] Attempting to dissociate itself from the commercialism of the Exposition as a whole, the art juries voted to exclude themselves from awards. The Imperial Commission annulled the vote as contrary to the *Règlement* for, according to Charles Blanc, "The question of personal delicacy was here suppressed by a more important interest, that of France which, engaged in a solemn contest, couldn't subscribe in advance to its own defeat by authorizing the abdication of its strongest contestants."[6] Despite its qualms, the Jury soon adjusted to the necessity of being eligible for medals and, in the end, every French Juror was awarded either a Medal of Honor or a First Class medal.[7] One reason for the necessity of obtaining more medals for Art was that the Jury had taken the lion's share for itself.

While the awards were not officially announced until the ceremony of 1 July, the results found their way into the French press at the end of April.[8] In painting, the eight recipients of the Medal of Honor were: the history painter Cabanel (France), the historical genre painters Ussi (Italy), Leys (Belgium), Kaulbach (Bavaria); the genre painters Knaus (Prussia), Gérôme and Meissonier (France); the landscape painter Théodore Rousseau (France). Ernest Chesneau wrote in the official government report: "The decisions of the International Awards Jury have officially announced the abandonment of Grand Painting in contemporary Europe. Of the eight Medals of Honor which it could freely award, only one has been given to a history painter."[9] The shock of this decision reverberated through all the art criticism written in 1867.

Marc de Montifaud, writing in *L'Artiste*, asked rhetorically: "Could it be that the muse of history can't follow the muse of progress?"[10] And Charles Blanc, after surveying the contemporary mediocrities at the Universal Exposition, answered in *Le Temps*: "We can see it clearly today: twelve years have sufficed for us to lose interest in Grand Painting."[11] The twelve-year interval since 1855 had been marked by decline and attrition in history painting, noted from year to year in the annual Salon reviews. Yet only in 1867 did the concurrence of these two major events, the death of Ingres and the Universal Exposition, forcibly demand a reassessment of the direction French art had been taking since the glorious success of 1855.

In the wake of the first Universal Exposition, 1857 had marked for many critics the end of the era of *le style* and the beginning of *le naturalisme*: they were simply observing what was being exhibited as the major history painters aged, their places taken by a younger generation uninterested in the ancient verities. In the 1850s, so politically charged was the atmosphere that it had been the youngest and politically radical critics who remarked the impending demise of *grande peinture*, which they considered thoroughly imbued with the values of everything reactionary. In his first Salon of 1857, Castagnary, for example, had written that "Religious and historic or heroic painting have gradually disappeared to the same degree that theocracy and monarchy, the social structures that supported them, are dying out."[12] In 1867 even staunch conservatives were forced to acknowledge this reality. With the demise of history painting, they mourned more than the loss of a great tradition; they mourned the passing of, as Castagnary pointed out, theocracy and monarchy.

Despite many nuances of opinion, critics at this time can still be broadly divided into either the conservative or the progressive camp, into those who wished, at all costs, to hang onto the values of tradition and the glorious past, as opposed to those who looked hopefully towards the future for a new art more in keeping with modern times. Ingres had become the very symbol of this revered or hated tradition; reactions to his demise can thus be read as revelatory of the critic's position on the aesthetic spectrum.

In addition to Charles Blanc, Léon Lagrange and Marc de Montifaud, other conservative critics joined the funeral cortège. Paul de Saint-Victor wrote: "We are virtually obliged to go into mourning for history and religious painting."[13] Ernest Chesneau closed his report on religious painting thus: "Dare I conclude? It can only be said in trembling. How can one say, bluntly, that the immediate future of religious art seems to belong only to specialists?"[14]

These critics, by virtue of their age and position, had access to the most important journals. Yet there was another response to these same events which manifested itself in the writings of those who were either younger or politically progressive. Théodore Duret, for example, wrote of Ingres: "When it's said that the School of which he is the leader is dying out or is dead, one really can't regret seeing disappear with it from the realm of painting those ideas unconditionally abandoned so long ago in the other arts and in poetry."[15] And of course there was Thoré: "A police state can't live without pagan and Catholic mythology. What constitutes 'Great Art' is the perpetuation of these ancient forms foreign to life ... Everything that they call 'Grand Painting' is banal and insignificant. Nothing worth mentioning among the military, religious, allegorical or even history painting. It's pathetic."[16]

The French School of history painting was, by friend and foe alike, pronounced dead in 1867. But if it had ceased to exist in France, it was at least some comfort to know that history painting was no better off elsewhere. Cornelius, the only other European artist comparable to Ingres, had also died just before the Exposition. Charles Clément announced it thus in the *Journal des débats*: "The two most illustrious representatives of the German and French Schools, the last of that mighty race born of the Revolution, Ingres and Cornelius, have just died, almost at the same moment, burdened down with age and with glory."[17]

In 1855, French critics had looked to Germany as the land of philosophy and

intellectual painting. Conservatives at that time saw Germany as an ally in preserving traditional values and hierarchy in art. In 1867, German art continued to be seen as linked to the fate of the French School, and the almost simultaneous deaths of Ingres and Cornelius resulted in an almost superstitious belief that the "Age of History Painting" was now over.[18] Thus deprived of the two venerable representatives of history painting, the 1867 Universal Exposition revealed more accurately the true state of contemporary painting.

Cabanel

The one Medal of Honor awarded to a history painter went to Cabanel, a favorite of Napoléon III who had bought both his *Birth of Venus* (Plate 99) and his *Nymph Abducted by a Faun*. Damned with faint praise by the conservatives, Cabanel was damned outright by the progressives. Only conservatives, after all, were interested in providing an heir to the classical tradition of the French School; progressives could not care less and happily consigned it to oblivion. Yet conservatives who truly admired classical painting could not help but note the difference between the quality of Ingres and that of Cabanel and were frankly disappointed. Chesneau, for example, wrote of Cabanel:

> Are we saying that this painter, whose success has been so fortunate and swift, might be the master who could make us forget those we mourn, the Ingres and the Delacroix? I don't believe it, M. Cabanel himself doesn't believe it; but he is truly at this moment one of those very rare painters who doesn't recoil in front of a grand composition in which the nude plays a major role.[19]

99. Alexandre Cabanel, *The Birth of Venus*, 1.30 × 2.25 m. Salon of 1863. Musée d'Orsay, Paris. Exhibited 1867 no. 122.

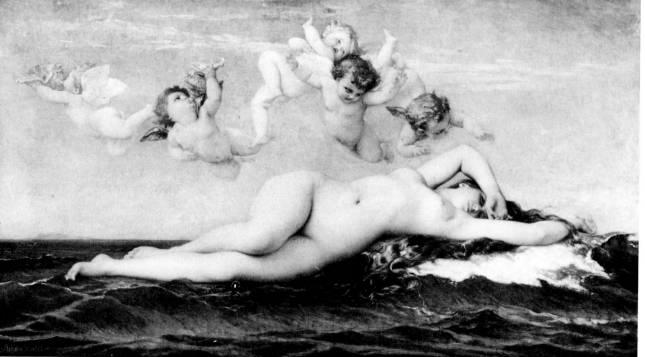

Several critics mentioned him as a possible successor to Ingres, for who else was there?[20] His supporters praised his eighteenth-century charm; Marius Chaumelin referred to him as "a pure Coypel."[21]

Cabanel's lightning rise to fame could be attributed both to his ability to appeal to the lascivious tastes of his patrons (Napoléon III included), and to the last ditch attempt of the Academy to preserve a semblance of the classical tradition. This winning combination was well described by Emile Zola:

> Take an antique Venus, an ordinary woman's body drawn according to the venerable rules, and lightly, with a powder puff, paint her up with rouge and rice powder; you will have Cabanel's ideal. This fortunate artist has resolved the problem of remaining serious and pleasing at the same time. To serious people he says "I am a student of the wise Picot, I have grown pale over the masters in Rome; look at my drawing, it is sober and correct." To frivolous people he says "I know how to please, I'm not stiff and severe like my former colleagues in Rome, I have grace and sensuality, delicate colors and melodious lines."
>
> From then on the crowd was won over. The women swooned and the men guarded a respectful attitude.[22]

Théophile Thoré, who had been in exile from 1852 to 1859 because of his republicanism and his opposition to Napoléon III, saw Cabanel as successor to Ingres, an official artist, representative of an odious regime: "What a fortunate man is this Cabanal! What amazing luck! Twelve years of uninterrupted triumphs! In 1855, a First Class Medal and the Légion d'honneur; in 1863, the Institute; in 1864, Officier of the Légion d'honneur; in 1865, the Grand Medal of Honor; in 1867, another Grand Medal!"[23] The only item that Thoré did not add was that Cabanel was one of the three professors of painting at the Ecole des beaux-arts. "that last title guaranteed him one of the Medals of Honor," was Zola's acid comment.[24]

Historical genre

One might assume that historical genre painting would supply a ready replacement to that of history, and yet it was particularly disliked by conservatives who preferred to see history painting dead rather than trivialized in works lacking the moral and didactic import of *grande peinture*. According to Ernest Chesneau, "It reduces a universal language to the paltry dimensions of a local idiom," and Charles Blanc thundered "The Antique is sacred: Woe betide him who profanes it!"[25] The artist held responsible for this hybrid category was Paul Delaroche for, as Chesneau explained to his readers, "He substituted the historical anecdote for history."[26] Among the Medal of Honor recipients, those identified with historical genre included Ussi (Italy), Leys (Belgium), Kaulbach (Bavaria) and Gérôme (France). Ussi was dismissed outright as a political rather than aesthetic choice, for it was widely known that he had ranked lowest in the voting, possibly added to the Medal of Honor list "after the fact," as Meissonier had been in 1855.[27] For Charles Blanc, as for most critics, he was "a second-rate Paul Delaroche."[28] Certainly his *Duke of Athens* (Plate 100) was mediocre, but in truth no more than others so honored. Despite charges that the Jury had been manipulated to honor, with Ussi, French support of the Italian War of Independence, the painting's

100. Stefano Ussi, *The Duke of Athens*, 1.62 × 2.25. Galleria nazionale d'arte moderna, Rome. Exhibited 1867, not in catalogue. (*La Cacciata del Duca di Atene*)

success might more reasonably be attributed to the fact that it was famous in Italy and had already been successfully exhibited in London and Milan.[29] Italy had one of the largest exhibitions in 1867, was thus entitled to more jurors than other countries, and loomed large in European consciousness because of the activities of Garibaldi and Cavour and the recent unification. It was only logical that the Jury would seek to honor the best-known Italian contemporary artist.

Leys, on the other hand, whose work had changed little since 1855, seems to have been genuinely popular in France. He was even chosen by Maxime DuCamp as the best foreign artist, for Belgian painting, exempt from the criticism usually directed at historical genre painting, was considered to be in the Flemish tradition.[30] Even Thoré could praise him for being nationalist enough to paint the history of his own country, rather than that of Greece or Rome.[31] His major entry in 1867 was *The Archduke Charles, at Fifteen Years Old (Later Charles V), Swearing an Oath before the Burgomaster and Elders of Antwerp* (Plate 101). Progressives admired his humanity and the decorative richness of his color, while conservatives could praise him as a hedge against the "excesses" of younger French painters such as Manet.[32] If quality were the issue, there would be little to choose between Leys and Ussi, but it was Ussi's misfortune to be practicing what was considered a debased form of history painting in Italy, the home of the

101. Henri Leys, *The Archduke Charles, at Fifteen Years Old (Later Charles V), Swearing an Oath before the Burgomaster and Elders of Antwerp*, ca 1863, 2.31 × 1.85 m. Musées royaux des beaux-arts de Belgique, Brussels. Exhibited 1867, Belgian catalogue no. 75.

102. After William von Kaulbach, cartoon for *The Age of Reformation*, 1862, for a fresco at Neuen Museum, Berlin. Present whereabouts unknown. From Richard Muther, *The History of Modern Painting*. Exhibited 1867, Bavaria, Drawings, no. 11.

classical tradition. This was unforgivable treason as far as French critics were concerned.

Kaulbach seems to have been honored more as a replacement for Cornelius than in his own right, in much the same way as Cabanel had substituted for Ingres. In both cases, there was evidenced the same decline. Kaulbach's large cartoon *The Age of Reformation* (Plate 102) should have entitled him to the rank of history painter, but instead he was identified as a painter of historical genre, his customary mode. His cartoon represented Luther surrounded by Erasmus, John Huss, Zwingli, Shakespeare, and others, and was described by Ernest Chesneau (who as official critic tried to be polite) as "a colossal rebus in the style of an epic poem by a student of rhetoric."[33] Others were even less kind, the complaints being similar to those voiced in 1855. Paul Mantz, for example, wrote "To listen to these fine intellectuals, the palette is materialist, the brush has vulgar instincts."[34] In 1855 such flaws had been overlooked as conservatives marshalled German painting to the defense of the French Academy and

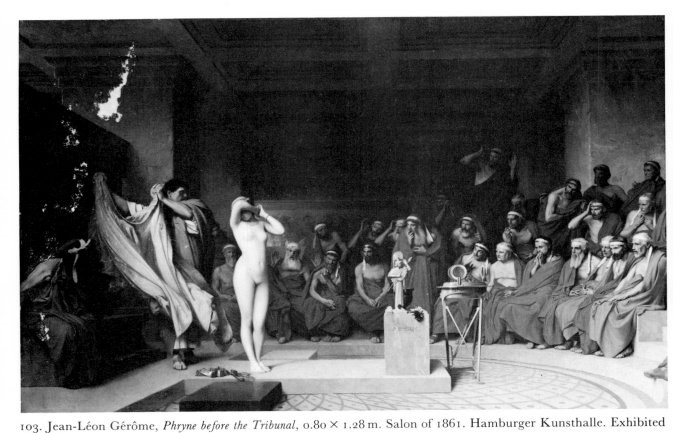

103. Jean-Léon Gérôme, *Phryne before the Tribunal*, 0.80 × 1.28 m. Salon of 1861. Hamburger Kunsthalle. Exhibited 1867 no. 290.

Tradition. In 1867, the battle was over and lost. Only Ussi received fewer votes than Kaulbach, whose Medal of Honor was more a tribute to the past than a recognition of the present.

Historical genre painting might be accepted as being in the Flemish tradition but, Paul Delaroche notwithstanding, it was judged un-French by the critics, although the public liked it. Leys might be praised, but Gérôme was damned. He was attacked with particular viciousness because he had begun in the Grand Tradition—his *Century of Augustus* (Plate 51) had been exhibited and rewarded in 1855—then had abruptly and ungratefully changed course in 1857 with his *After the Masked Ball* (Plate 83), abandoning the lofty heights for a popular success. Conservatives and progressives alike loathed his historical genre paintings. If Charles Blanc could write that Gérôme had "descended from the heights of history to the familiarities of anecdote," Théodore Duret could add that he had "reduced the great men who created the civilization of the world to a troupe of dirty old men out on the town or clowns who amuse the public."[35]

Gérôme's historical genre paintings, in particular *Phryne before the Tribunal* (Plate 103), were attacked as pornographic, as burlesque, as vaudeville, as antiquity done by Offenbach and even compared—unfavorably—to Daumier's caricatures of antiquity.[36] Thoré called it "Painting shrunken, constrained, constipated, afflicted, rigid, and paralyzed."[37] Of all the artists exhibiting in 1867, it was Gérôme, not Manet or Courbet, who received the harshest criticism. And a Medal of Honor.

Genre

Had Ingres and Cornelius survived, their advanced age would probably have been overlooked and the old verities proclaimed anew. In their absence, a new topography was apparent: genre painting. In his official report, Ernest Chesneau wrote: "Several times in the course of this study of European art at the Universal Exposition, we have pointed out the importance that the foreign Schools are according to genre painting. The French School is giving evidence of the same predilections."[38] Critics had noted the same preponderance of genre in the annual Salon, but there it could be dismissed, as it had been for a decade, as a temporary manifestation. At the Universal Exposition, genre painting was awarded an international success, by a Jury which had a majority of foreign members. For genre was already the Northern School, the traditional painting of Germany, Holland, Belgium, and England, countries which had escaped, according to Thoré, the pernicious influence of both Catholicism and the dead past.[39] In an attempt to explain this phenomenon, both Thoré and Chesneau discussed at length the concept of Northern versus Mediterranean art. Thoré, who had first developed this theory at the 1857 Manchester Exhibition, now wrote:

> On the one side, art which proceeds from the genius of the antique, Greek and Latin, mingling with it, more or less, its national genius; on the other side, an art independent of Southern traditions, freed from pagan and Catholic superstition ...
>
> In France and in Italy, mythological or "holy" subjects are still being painted. In Belgium, Holland, England, Northern Germany, contemporary life attracts artists and frees them from the old routines of the past. In France this modern tendancy, represented by Courbet especially, is still being attacked by juries, by academies, by official institutions and even by the most *official* critics in the press. France seems still to remain Latin while the world is being swept towards new destinies ...[40]

Chesneau, comparing Latin to Saxon art, arrived at a set of characteristics typical of each. Latin art, he wrote, is abstract in nature, general in form, concentrating on the ideal as manifested in the harmony and unity of *grande peinture*. Saxon art (which he identified with genre painting) manifests an interest in the real as opposed to the ideal, in the particular, individual detail as opposed to the general form, and in the accidental as opposed to the eternal.[41] The only problem with this chart of national characteristics was that, as Chesneau himself had pointed out, genre was increasingly as popular in the Latin countries, France in particular, as it was in the North.

Underlying the whole discussion of "Northern" versus "Southern" art was the cyclical theory of history, comprising young rising and old declining nations. In the 1840s, Edgar Quinet had articulated the fear that France was among the latter: "The family of nations to which we belong by birth and by blood includes Spain, Italy, and France. Of these three sisters, the first two are in the grave."[42] These concerns could be discussed economically in terms of rapidly industrializing nations versus stagnant agricultural ones; some also spoke ethnically of Protestant Anglo-Saxon nations given over to "Modernity" and "Progress" versus Mediterranean Catholic attachment to tradition and the past; or, as was done on the occasion of the 1867 Universal Exposition, art critics could analyze the growing importance of genre painting as opposed to

104. John Everett Millais, *The Eve of Saint Agnes*, 1863, 1.171 × 1.541 m. Collection of Queen Elizabeth the Queen Mother. Exhibited 1867, Great Britain no. 103.

the declining classical tradition. As Thoré pointed out, in all cases the future was to the North.

British genre

In 1855, British genre painting was seen as the product of the British Constitution, symbol of liberty and individualism, and praised or damned according to the politics of the viewer. By 1867 the French Empire itself had become liberal; the negative aspects of England's rapid industrialization, the vast urban slums, were well known in France, and the Crimean War was over. Britain receded from the forefront of French consciousness, and British art lost its special significance. The two veteran critics of 1855, Paul Mantz and Maxime DuCamp, now expressed a kind of bewildered disappointment; they could not comprehend what had changed. Mantz suggested that perhaps Britain, like France, had lost its best artists; actually Mulready was the only loss among those highly praised in 1855.[43] DuCamp thought that perhaps the 1867 British exhibition was inferior to that of 1855 (he wasn't quite sure), or perhaps the shock of the first

encounter with British art was now gone. In truth, it was his perceptions which had changed. England for him was no longer the land of liberty as manifest in its genre painting; it had now become synonymous with what he saw as the worst characteristics of the bourgeoisie, reflected in its favorite art form, the very same genre painting: "It resembles life in English society, everything is foreseen, ordered, preordained; it doesn't dare to deviate from the too narrow limits which it has imposed on itself and which suffocate it. No fire, no daring, no passion; bourgeois platitudes, tidy and well painted."[44] Ernest Chesneau, who was not a veteran of 1855, was even more be-wildered: "If it is true, as we have said, that English painting is so extremely shocking to our aesthetic principles . . . how then can we explain the vogue that it enjoyed in 1855 with our French public?"[45] Fortunately the question was rhetorical because, in fact, he could not answer it.

British art, as reflected in the 1867 Exposition, had not changed that much. If the sensation of 1855 had been Millais's *Order of Release* (Plate 78), that of 1867 was his *Eve of Saint Agnes* (Plate 104).[46] The majority opinion among Jury members as well as critics was accurately stated by Marius Chaumelin: "The disdain for the academic manner, the horror of conventions, the spontaneity, the freshness and originality which make the English school so interesting despite its faults, all these qualities can be found among the majority of Belgian and Dutch painters, combined with a more agreeable execution and a more intimate and profound feeling for reality."[47]

Having lost the political significance it enjoyed in 1855, British genre painting in 1867 was perceived as no better or worse than that of other countries, and in fact, Britain received no Medal of Honor, and very few medals at all.[48] Genre painting had become an international phenomenon, and the long discussions of 1855 on British versus French art had developed into the more general analysis of Northern versus Southern art. British art in 1867 was swallowed up in the general concept of Northern or "Saxon" art. In France in the late 1860s, that meant Germany.

German genre

Germany, not yet unified, was the only "country" besides France to receive more than one Medal of Honor in 1867; both Wilhelm von Kaulbach (Bavaria) and Ludwig Knaus (Prussia) were so honored. Altogether Germany received more medals than any other nation, a total of eight, thus taking the place of Britain as France's chief aesthetic—and political—rival.[49]

The German exhibition of 1867, however, unlike that of 1855, was filled with little genre paintings. The preponderance of such painting in Germany was not something that had happened abruptly since 1855. Here, as in France, the same generational process had been taking place, the history painters aging, younger painters turning increasingly to genre. In both countries, the death of the most esteemed history painter had suddenly revealed the true state of contemporary art.

Thoré had divided German art into two Schools: in Bavaria in the South, the Munich School was influenced by the classical tradition with Kaulbach its pre-eminent artist; in Prussia in the North, the Düsseldorf School was given over to genre scenes of contemporary life with Ludwig Knaus the acknowledged favorite.[50] Since the

1866 Battle of Sadowa, it was Prussia, however, which was perceived as the major political threat to France, and so it was logical for critics now to declare its genre painting the "real" German art, representative of its national genius. History painting was now judged to have been always an artificial and wholly inappropriate style for Germany.[51] In 1855, French critics had been confronted with the same artists but had seen in German art the reflections of a different set of circumstances at home, and had arrived at the opposite conclusion, pronouncing the classical and philosophical painting of Southern Germany to be the only authentic German art.

Ludwig Knaus was unanimously accepted, if not praised, as the leader of the Düsseldorf School. Considered in France an artist of secondary importance, lacking grand

105 Ludwig Knaus, *Shoemaker's Apprentices*, 1861, 0.41 × 0.485 m. Marburger Universitätsmuseum für Kunst und Kulturgeschichte. Exhibited 1867, Prussia, no. 62 (*Kartenspielende Schusterjungen*)

106. Hokusai, "Folding and Unfolding." *The Mangwa*. Bibliothèque Nationale, Paris. Exhibited 1867, not in catalogue.

ambitions, his witty little genre paintings were enormously popular in Germany (Plate 105).[52] In France, however, even genre painting had to preserve something of the elevated and universal. Humor in art was definitely unacceptable and Breton and Meissonier were often mentioned as examples Knaus would do well to emulate.[53] Fortunately for Knaus, the Jury was not made up of French art critics; he was awarded a Medal of Honor.

Japanese genre

Genre seemed to be everywhere in 1867, even in Japan. As part of its exhibition, the Japanese Government had sent Hokusai's sketchbooks for *The Mangwa*, presenting a veritable encyclopedia of human activities (Plate 106).[54] It was described thus by Chesneau:

One of their masters, Hokusai, has published fourteen albums of sketches from his notebooks, taken from everyday life, from nature, from the activity of cities and

ports, in theatres, in the arenas of wrestlers, on the banks of rivers, on the shores of the sea, in the fields, in the forests, everywhere his adventurous and migratory spirit leads him ... Scenes of private life are depicted here and also those of public life; women washing and dressing, intimate chats, little family concerts, brawls among the common people, exercises of acrobats, of jugglers, of archers, children's games, caricatures, grotesques, etc. etc.[55]

And what did this remind him of? "The analogy is striking between these painters of the Far East and those of the Flemish and Dutch Schools. they recall precisely the humor and at the same time the not overly refined accuracy that Teniers, Ostade, Jan Steen bring to the representation of popular scenes."[56] The Japanese exhibition also included painted screens with genre subjects. Zacharie Astruc described their reception as more enthusiastic than that accorded any other exhibition in 1867, and listed among their admirers: Alfred Stevens, Diaz, Tissot, the curator Villot, Champfleury, Bracquemond, Fantin-Latour, the critics Chesneau and Burty, the Goncourt brothers, Manet, Monet and himself.[57]

The formal influence of Japanese art has been widely studied, as has the exoticism of its decorative art, admired by artists such as Stevens and Whistler.[58] Certainly 1867 marked its apogee but, at the same time, in the context of the Universal Exposition, French artists and critics could not but see in Japanese art a reflection of the European interest in scenes from everyday life, namely genre painting.

French genre

Despite attempts to define genre painting as "un-French," it had, in fact, flourished in France with the art of the brothers Le Nain, Chardin and Greuze. In earlier periods, however, it existed, even thrived, as a minor category in the hierarchy of painting. In 1867 it threatened to become major. While it is impossible to give a simple answer to the complex question of why history painting declined and was replaced by genre, one must at least give credence to the opinions of the most thoughtful contemporary observers. Ernest Chesneau, a conservative, and Théodore Duret, a progressive, each cited as the cause changes in the material conditions of life. They pointed to the growing numbers of both artists and collectors, and in particular the change from a small audience of highly cultivated collectors, the aristocracy, to an enormous and relatively unsophisticated art-buying public who, with smaller fortunes and smaller living quarters, were not interested in large pictures or heroic themes.[59] Chesneau's government report was, in fact, a polemic directed against the taste of this class, the bourgeoisie, the most powerful economic class in nineteenth-century France. He wrote: "The melody of contours, the harmony of colors, are totally lost on them and are for them a closed book. Given the lack of cultivation among the public, given the characteristic of superficiality by which it judges works of art, it is not astonishing that its preferences are almost exclusively for genre painting."[60] He closed his study with a thunderous condemnation: "Insignificant size, insignificant subjects, insignificant painting."

Théodore Duret devoted an entire chapter in his book *Les Peintres français en 1867* to an attack on what he termed *l'art bourgeois*, whose distinguishing characteristics, he felt,

were vulgarity and mediocrity, a narrow-minded outlook on life, and a range of emotions characteristic of the bourgeoisie: "All production must in the long run adapt itself exactly to the taste of its consumers, of those who bring it forth or who encourage it..."[61] The preferred art of the bourgeoisie, genre painting, Duret described thus: "It's manufactured for every type of customer; there are domestic scenes and homey subjects for respectable folk, racy scenes and naked ladies for those with the opposite tastes."[62]

The attack on the bourgeoisie as the corruptor of art had originated in the first half of the nineteenth century with conservatives of all stripes who wished to demonstrate that, in the absence of Throne and Altar, art could not survive. For them "bourgeois" was a category encompassing all well-to-do city dwellers who were not aristocrats. While their definition of the term was none too precise in a modern sense—both shopkeepers and stockbrokers were included—it did serve to identify a taste for a certain kind of art largely patronized by these middle classes.[63] By 1867 the attack on "bourgeois art" had become general, embracing conservatives and progressives alike, for both groups demanded transcendent qualities of art. The "evidence" of decadence was no longer the ascent of Delacroix or Courbet, but the torrent of little pictures distinguished, as Duret said, chiefly by their vulgarity and mediocrity, which threatened to swamp French art. Among the legion of artists who devoted themselves to this category of painting, two stood out, Gérôme and Meissonier.

Gérôme

Condemned though he was for his historical genre painting, Gérôme's "ethnographic" painting was highly praised (Plate 107). Even conservative Charles Blanc could write: "Ethnography, there he excels."[64] *La peinture ethnographique* was, of course, just a new name for *l'orientalisme*, the genre painting of North African and Near Eastern subjects that was the by-product of French colonialism, and had been popular in France since Marilhat, Decamps and Delacroix.[65] As Romanticism gave way to Positivism, the romance and exoticism of far-off places was (supposedly) replaced by scientific observation of the customs of the natives. But this was a matter of semantics; the motifs had hardly changed at all.

Precisely because ethnographic painting did not tread on the sacred traditions of history painting, it could be highly praised by both progressives and conservatives: it offered subjects from modern life, but as exotic as any themes from literary sources, and it combined both observation and research. With Decamps and Delacroix both dead, Gérôme was recognized as the most distinguished Orientalist in 1867, but this was only one aspect of his talent, for he painted historical and contemporary genre as well.

Whatever the reservations of the critics, Gérôme was enormously popular with both collectors who bought his paintings and the general public which purchased engravings of them in all modes, historical, contemporary or ethnographic. Zola wrote:

There isn't a provincial Salon without an engraving representing *The Duel after the Masked Ball* or *Louis XIV and Molière*; in boys' dormitories one finds *The Almah* or *Phryne before the Tribunal*; these are the spicy subjects permissible among men. More serious folk have *The Gladiators* or *The Death of Caesar*.

M. Gérôme works for all tastes.[66]

107. Jean-Léon Gérôme, *Arnauts Playing Chess*, 1859, 0.38 × 0.27 m. The Wallace Collection, London. Exhibited 1867 no. 300. (*The Draught Players*)

108. Jean-Louis-Ernest Meissonier, *The Captain*, 1861, 0.23 × 0.15 m. The Wallace Collection, London. Exhibited 1867 no. 456. (*A Cavalier, Time of Louis XIII*)

Zola was, to be sure, a hostile witness to Gérôme's success, but Chesneau mentioned the same emphasis on anecdote adding in Gérôme's defense that at least *he* wasn't satisfied with a rapid sketch, for he labored long and hard over his pictures.[67] These were the same terms in which he had praised Cabanel, leaving no doubt that for him (and this was repeated by most of the critics), the primary formal division was still between sketch and finish (*fini*). For in facture, if not in subject matter, genre had much in common with history painting, both being based on painstaking and detailed studies, combined into synthetic and highly finished compositions.

Gérôme was indeed a painter for all tastes. If he did not have the enormous success among critics that he had with the public, it was because conservatives could never forgive his treason of 1857, and progressives could never forgive his vulgarity.

Meissonier

Meissonier received the Medal of Honor with more votes than anyone else. Not only did the Jury love him, but he was praised by the critics as well: here was a genre painter even a conservative could like. Marius Chaumelin wrote:

> In contrast with M. Gérôme who began as a history painter in the most elevated sense of the word and who has ended up limiting himself to genre painting, M. Meissonier abandoned some time ago the little anonymous and insignificant subjects—players, smokers, readers, musicians, picture collectors—which produced his reputation and has courageously taken on grand historic scenes.[68]

While it was not true that Meissonier had abandoned genre subjects (Plate 108), his larger battle paintings (Plate 109) served to make him acceptable both to those who hated genre (the conservatives) and those who criticized his exclusive concentration on subjects from the past (the progressives). With the exception of Thoré who, true to his politics, found the military paintings "souvenirs of chauvinism" (the republican criticism of Vernet in 1855) the critics roundly applauded them.[69]

It was his tiny genre scenes, however, which commanded enormous prices and brought him fame and fortune, not just in France, but in all of Europe and America. The double appeal Chesneau described, of form (the finely detailed, highly polished surface) and subject (the anecdote) was analyzed by Zola as attracting two different social classes. He described sophisticated collectors examining one of Meissonier's pictures with a magnifying glass, shrieking with delight: "The ear is there in its entirety. Look at the ear. The ear is priceless." After thus examining the entire picture, they declare that they have never seen anything "more delicate, livelier, finer, wittier, more finished, more solid, more precise and more perfect." A fat bourgeois couple, rich from the cinnamon and molasses trade, comes along next and stands speechless before the picture, finally murmuring "Oh Lord it's so pretty. How pretty it is." Zola concluded by announcing "The trick is to be skillful and make it pretty."[70]

Meissonier did both. While critics compared him to the seventeenth-century little Dutch masters, collectors appreciated his painstaking facture, and the general public liked the story. He was acclaimed the best genre painter in Europe and, now that Ingres was dead, the hope of the French School. On 5 June, after the Medals of Honor

109. Jean-Louis-Ernest Meissonier, *The Emperor at Solferino*, 1863, 0.435 × 0.76 m. Salon of 1864. Louvre. Exhibited 1867 no. 452.

had been announced in the press, Charles Blanc wrote: "Meissonier's exposition has no equal, neither in France nor elsewhere ... It's the last word in Grand Painting in miniature."[71] And he began his critique of French painting with Meissonier, an honor which, in 1855, critics had reserved for Ingres.

Other critics did the same. Paul Mantz wrote: "All things considered there is only Meissonier in Europe and he is one of ours," and he pronounced him "the hero of the French Exposition."[72] Within a few months of the death of Ingres, and after the awards decisions had become known, *L'Artiste* announced: "it's now Meissonier who is placed at the head of the French School. His name always comes first ... The French public now officially knows who are the most important official painters of our times. It's no longer Ingres, it's Meissonier."[73]

Only then, after he had already achieved a popular success, did the Government concur, promoting him to Commandeur in the Légion d'honneur.[74] He would eventually become the most decorated artist in nineteenth-century France, for while Ingres was the first to be named Grand Officier in the Légion d'honneur, Meissonier would eventually outrank him as Grand-Croix, the highest honor. His canonization as the leader of the French School was, then, the result of international as well as French taste. His rise had been accelerated in 1855 by Prince Albert's choosing him over all other French artists; a majority of his collectors listed in the Exposition catalogue were

173

foreign, particularly English, and in 1867 it was the International Jury which voted him the world's leading artist. This was particularly influential in France at a time when a major French fear was that it was doomed to be part of the declining Mediterranean South as opposed to the modern and industrial North. Northern art was genre painting; the Protestant emphasis on "modern life" seemed to be the wave of the future more than the Southern tradition, classicizing and backward-looking, so bitterly attacked by Thoré.

Genre painting in 1867 seemed to be the only area of art which could provide an international supremacy for France, equivalent to that previously enjoyed by history painting. Maxime DuCamp wrote: "It isn't enough to be the strongest; it is necessary to be strongest without rival, from an absolute point of view."[75] Only genre painting, and only Meissonier, could provide that kind of victory. So much the better that it was already the preference of the bourgeoisie and of a growing number of artists who could find in it a sure livelihood. So much the worse for critics such as Chesneau, who could see in it only "Insignificant size, insignificant subjects, insignificant painting."

18
Landscape: The Path Not Taken

IN THE EYES OF most critics, the major division in 1867 was between classically inspired works of *le style*, another name for history painting, and *le naturalisme*, a category which encompassed both genre and landscape. Yet despite the popularity and consequent triumph of genre, the major critics preferred landscape painting. In contrast to 1855, when there was general agreement among the public, the critics, the Jury, and the Government as to who were the major artists, in 1867 the critics did not ratify the official choices. Those choices may have accurately reflected popular taste, but that taste was now sufficiently divergent from that of the critics to result in a schism. This schism would be characteristic of the modern period.

Ernest Chesneau was a partisan of *le style*; nonetheless he wrote: "if we compare these diverse manifestations of the artistic impulse, it is on landscape that we must bestow, perhaps not our preference, but the prize of excellence."[1] Throughout his critique of the Exposition, he repeated this judgment, albeit reluctantly: "Landscape has found the path open to modern art, that of sincerity."[2] Optimistic though he was about the future of landscape painting, these remarks were edited out of his official government report. Nonetheless, his judgment was echoed by his fellow critics. Thoré, an admirer of Dutch painting, preferred genre, and yet he too had to confess: "In all conscience, it's landscape painting which will illustrate the French School of the nineteenth century."[3] And Théodore Duret, future defender of the Impressionists, didn't hesitate to praise the Naturalists, "where one finds the truest and most clearly defined originality of the modern French School."[4]

If art critics had the power frequently attributed to them, landscape painting would certainly have acceded to the titular leadership of the French School in 1867. Although landscape at this time still meant the Barbizon painters, their successors, the Impressionists, might then in turn have had an easier time of it. But while landscape painting had waited long enough for recognition—the generation of 1830 was still waiting in 1867—nonetheless it was genre and not landscape which had triumphed, carrying off the majority of prizes, Meissonier receiving more votes than anyone else.

Besides being the most vital movement at home, French landscape painting was unparalleled internationally. Paul Mantz, for example, could write, quite accurately: "What School today can show us landscapists such as Théodore Rousseau, Corot, Daubigny, Millet and so many others?"[5] And Maxime DuCamp could add: "It is

superfluous to state that our landscape painting is unrivaled in the world. It's a well-known fact that no longer needs to be proven."[6] But the truth was that landscape painting seemed a local, not an international, phenomenon. There was no other School of landscape painting represented in force at the Exposition: it may have been a victory without rival; it was also a victory without contestants.

Critics' preferences aside, landscape painting had the great disadvantage in France that, from the 1830s, it had been considered politically suspect. The Barbizon painters were seen as the last remnant of Romanticism and the least acceptable remnant at that, for, unlike Delacroix, they had no interest in *grande peinture*. In addition, they were held responsible for subsequent "errors," for, as Chesneau pointed out, "This Romantic landscape was, in fact, the first and most striking revelation of what has since been called Realist landscape."[7] To add to the problem, some of the best known of the landscape School, Courbet, Millet, Rousseau, were suspected of socialist leanings, hardly a trait endearing to either the Government or the bourgeoisie. Nor did landscape painters often take part in the incessant round of dinner parties and *soirées* characteristic of the nineteenth-century Parisian art world. One has only to read Delacroix's *Journal*, or the society columns of *L'Artiste* or *La Chronique des arts et de la curiosité* to be aware of the importance of these activities and the absence of the landscapists who preferred, naturally enough, to live and work in the country. Only Courbet managed to turn his distaste for the *mondaine* life into an asset: through his flagrant contempt for the Government and society of the Second Empire, he achieved a *succès de scandale*. Most of the landscapists, however, lived on the fringe—both geographically and socially—of the Parisian, i.e. French, art world.

As late as 1867, landscape painting continued to be seen as an attack on entrenched power and aesthetics. In that year Edmond About wrote: "The theory of landscape and that of politics is the same. It can be summed up in one single word, the proudest and sweetest in our language: Freedom."[8] This freedom was apparent in the formal qualities as well as in the choice of subject, and was not pleasing to the new public, which preferred the slick finish of a Meissonier. Chesneau analyzed it well:

The purchaser today doesn't hesitate to pay a considerable price for a work of art, but ... the public is rarely attracted to energetic and powerful works which, it feels, have an execution too lax and too easy. To put it crudely, it wants something for its money. The purchaser wants, the day of purchase, to be able to take the picture on his knees, to study it point by point through a magnifying glass, and he values the merit of the work all the more when he is able to count the minute details from close up.[9]

The battle of Romanticism versus Classicism, sketch versus finish, was continued in the relationship of landscape versus genre painting. The criticism is full of references to the work of Gérôme and Meissonier as detailed and conscientious, well researched and carefully painted. That of landscape, on the other hand, is full of references to freedom and liberty, spontaneity, passion—and sloppiness.

Chesneau praised Rousseau highly, yet he had reservations: "The execution isn't above reproach; with your nose on the canvas you will notice some unjustifiable flaws, you will count the strokes woven and knitted together like a crude fabric."[10] The

collector with a magnifying glass whom Zola described in raptures over a Meissonier, whom Chesneau described with his painting on his knees, carefully studying it, would clearly be horrified to examine a work of Rousseau and find its surface disintegrate on close inspection—exactly like a piece of shoddy merchandise. The criteria had obviously been taken over from a merchant economy. The aesthetic pleasures anticipated from art would be identical to those of purchasing an exquisitely detailed, well-crafted, hand-made object, at a time when early mass production had encouraged rampant shoddiness. As collectors were so often precisely those industrialists who had encouraged shoddiness and vulgarity in their quest for profits, one might assume that a "well-made" work of art would be all the more precious to them. It was not until the Third Republic that landscape painting developed a following among the French commercial and industrial classes; attitudes of suspicion and mistrust persisted through the Second Empire when what patronage existed seemed largely foreign.[11]

Landscapists were divided into two groups. The older generation, Huet, Rousseau and Corot, made both *études*, preliminary sketches done from nature, and *tableaux*, large, finished paintings worked up in the studio. As their working methods were similar to those of classical painters, they were somewhat acceptable to conservative taste. The younger landscapists, Courbet, Millet, and Daubigny, were accused of painting ugly motifs or dangerous peasants or of attempting to pass off sketches as finished paintings.

There was the same problem for the critics in 1867 as in 1855: it was impossible to reach a consensus as to who was *chef d'école*. Chesneau chose Huet (Plate 110); Thoré, Rousseau (Plate 111); Castagnary, Courbet (Plate 92); and Silvestre, Millet (Plate 112).[12] The very "anarchy" of the movement—so many talents differing in image and style—differentiated it from genre or history painting, where there was a common anonymous facture. This quality also pointed up landscape's roots in Romanticism with its emphasis on individual sensibility. But it was, at the same time, a liability for, with so many worthy candidates for *chef d'école*, the critics' "vote" was split and all the

110. Paul Huet, *Spring Tide near Honfleur*, 1861, 1.01 × 1.645 m. Salon of 1861. Musée de peinture et de sculpture, Bordeaux. Exhibited 1867 no. 357.

111. Théodore Rousseau, etching after *Oak in the Rocks*, 1861, 0.124 × 0.167 m. Bibliothèque Nationale, Paris. (Painting: Salon of 1861. Exhibited 1867 no. 544. Private collection, The Netherlands.)

landscapists came in second after Meissonier. Nonetheless, a number of landscapists did receive medals. Théodore Rousseau received the only Medal of Honor that went to a landscapist; First Class medals went to Millet, Fromentin, Français, Breton, and Daubigny (Plates 112–116); Second Class to Rosa Bonheur, Corot, and Dupré.[13] The awards to Daubigny and Millet were all the more impressive in that, aside from Robert-Fleury, the Director of the Ecole at Rome, they were the *only* medallists in the two highest categories who were not jurors.

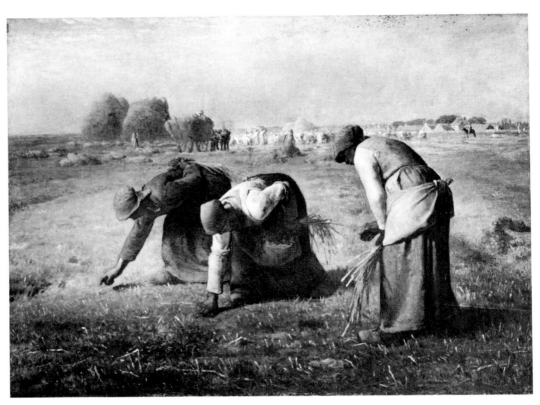

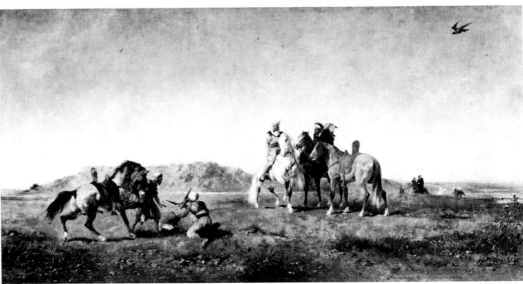

112 (facing page top). Jean-François Millet, *The Gleaners*, 0.835 × 1.11 m. Salon of 1857. Musée d'Orsay, Paris. Exhibited 1867 no. 474.

113 (facing page bottom). Eugène Fromentin, *Arab Falconer*, 1863, 0.74 × 0.95 m. Salon of 1863. Louvre. Exhibited 1867 no. 279. (*Chasse au faucon en Algérie*).

114. François-Louis Français, *The Sacred Wood*, 1864, 1.09 × 1.34 m. Salon of 1864. Musée de Lille. Exhibited 1867 no. 264.

115. Jules Breton, *Blessing the Wheat (Artois)*, 1857, 1.30 × 3.20 m. Louvre, on loan to Musée d'Arras. Exhibited 1867 no. 83.

116. Charles-François Daubigny, *Springtime*, 0.96 × 1.93 m. Salon of 1857. Louvre. Exhibited 1867 no. 187.

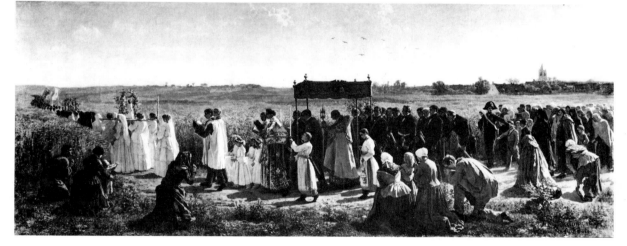

In many ways, Théodore Rousseau (Plate 117) would have made a likely companion for Manet and Courbet in mounting a private exhibition. He too had had problems with juries to the extent that, during the July Monarchy, he was known as *le grand refusé*. Like Courbet, his politics were to the Left, and if Courbet suffered in certain quarters because of his friendship with Proudhon, Rousseau was widely known as an intimate of Thoré. That Rousseau did not organize a private exhibition either in 1855 or in 1867 may be attributed as much to financial as to personality differences, for Rousseau had neither a wealthy family like Manet, nor a rich collector like Bruyas to foot the bill. Elected President of the Admissions Jury for both the Universal Exposition and the 1867 Salon, as well for the Salon Awards Jury, he had no problems in having his paintings accepted: he showed eight in the Exposition and four in the Salon. Yet he too must have dreamed of the large retrospectives given by the Government in 1855, for he showed, at the Cercle des Arts, eighty painted *études* (Plate 118) and twenty-nine *tableaux* dating back to the beginning of his career. Organized by Brame and Durand-Ruel, with a catalogue written by Philippe Burty, the show was obviously a major bid for international recognition.[14] Rousseau's historical position is reflected in this gesture. As a member of the older generation, he hesitated to send sketches to official government Expositions; as an ally of the younger generation, he wanted to exhibit them anyway. He had too much respect for authority to challenge it with a private exhibition, as did Courbet and Manet, and yet it was his solution and not theirs which would provide the model for the future. As artists turned away from official government institutions, they would increasingly entrust their careers to private dealers. Few could afford gestures like that of Courbet and Manet, and even Bazille's attempt to finance a group exhibition had proved impossible in 1867.

117. Théodore Rousseau. Photograph by Nadar.

Rousseau's exhibition at the Cercle des Arts must have been a magnificent show and was bound to have influenced the younger artists who embraced Naturalism and the *plein-air* method of working directly on the motif; it was they who Castagnary described as so disappointed with Ingres's memorial exhibition.[15] DuCamp wrote of Rousseau's show: "There were some masterpieces there, not only in execution but also in impression, in strength of feeling, in intimacy, in frankness and in sincerity. I deeply regret that this exposition could not take place on the Champ-de-Mars where it would have strongly served Théodore Rousseau and would have proclaimed him a master of the

highest order."[16] Everything was in place for Rousseau to be canonized in 1867, as Delacroix had been in 1855. Even such a conservative as Charles Blanc could recognize this and wrote that in thirty years Rousseau had passed "from the most cruel disgrace to the highest esteem."[17] Among his "followers" Thoré listed Diaz, Dupré, Troyon, Corot, Courbet, Huet, Marilhat, Cabat, Daubigny, "and a whole new generation that frankly loves nature."[18] He wrote that Rousseau excelled in representing "the character of a site and the capricious effects which animate the earth and the sky at certain phases of the seasons and at certain hours of the day."[19] Duret cited his greatest quality as "energy," his choice of motifs as "grand views of harsh, wild and solitary nature," and his formal gift, "great plays of light."[20] And Chesneau, although he criticized the younger landscapists, praised Rousseau as "an admirable witness who reports strictly what he sees but who knows enough to look only at those spectacles worthy of being depicted." And yet, despite this esteem he found Rousseau "a dangerous master" who, because of his unacceptable facture, would lead youth astray.[21] One would expect a conservative to so disapprove of any painted surface lacking the academic *fini*; one would also expect the younger more progressive critics to be more sympathetic. But—and here is the tragedy of Rousseau—their attention was fixed on younger artists, compared to whom Rousseau seemed old-fashioned and full of studio tricks. Zola even included Rousseau in his satirical review "Our Painters on the Champ-de-Mars," although he could not infuse his diatribe with the scathing wit which had distinguished his attacks on Cabanel, Gérôme and Meissonier. He ended his critique by stating: "I'm not even going to discuss the triumphant beam of sunshine that lights up half the picture and leaves the rest in shadow."[22] The "capricious effects" that Thoré admired, "the grand plays of light" praised by Duret, were simply cheap and incomprehensible theatrics to Zola. For Rousseau was, in the end, more a Romantic than

118. Théodore Rousseau, *View of Paris from the Terrace of Belleville*, n.d., 0.610 × 1.15 m. Musées royaux des beaux-arts de Belgique, Brussels. Exhibited at Cercle des Arts, 1867.

a Naturalist painter; he looked at nature not as a scientist but to find reflected there human passion, drama, and moods.

Rousseau's official recognition, and that of the entire Barbizon School, had been delayed long enough to overlap with the rise of the young Naturalists. As a result, in 1867, the year of his triumph, he was still considered dangerous and avant-garde by conservatives such as Chesneau, while either attacked or ignored by progressives such as Zola, Silvestre, Castagnary. A strong government spokesman could have canonized him, as Prince Napoléon had done for Delacroix in 1855, but the Government, as we have seen, had taken a back seat in the administration of the 1867 Exposition. In part, the Barbizon movement has never recovered from this unfortunate chronology; it fell between the slats. What would have been, at best, a delayed official recognition, was swallowed up in the cross-currents, and these artists, Rousseau in particular, have received less attention than any other major artists of a major modern School.

Even politically Rousseau fell between the slats. In his youth, *le grand refusé* had seen his paintings refused by academic juries year after year during the July Monarchy. His friend and biographer Sensier attributed this to Rousseau's participation in the foundation of the journal *La Liberté* in the 1830s which had attacked the Academy.[23] Other biographers have pointed to his friendship with Thoré, an avowed socialist.[24] Rousseau's fortunes improved during the Second Empire, even including an invitation to Compiègne in 1865. And in 1867 he was a member of all four Juries, President of three of them. The *grand refusé* had become, in turn, the judge. His old ally, Thoré, was not impressed:

> Who, if you please, is the artist who was the most persecuted by official institutions when a young School called Romantic struggled against those old potentates of art called Classic? Who is the painter whose name was mentioned time after time when the academic jury was being criticized for the rejection of talented men? The reputation of Théodore Rousseau began through repeated protests by the critics who wrote on his behalf. He became famous before one could see his work. For fifteen years the publicity offered by the Salons was refused him! ...
>
> It is then inexplicable—and very sad—that the former pariah has become in his turn the proscriber of youth who seek their own way. I hope that Rousseau himself didn't vote these rejections, but still a sense of loyalty and his own dignity ought to have compelled him to resign the Presidency and refuse his support to the decorated and licensed gentlemen who have, no doubt, their own reasons for pushing aside the new artists and, perhaps, a new art.[25]

Rousseau saw his jury membership not only as a chance to advance his own career, but also as an opportunity to obtain long-overdue honors for all he considered worthy of recognition. Sensier stated that he took his position very seriously, agonized over jury decisions, and kept his friends posted on the results; it is to his credit that so many medals did go to landscape painters.[26] He was very active behind the scenes, but he was a man caught in a slip tide between the rising seas of old and new injustices.

Despite Zola's charge that Rousseau had become acceptable, he made a mediocre showing in the voting, placed sixth out of eight, behind the other French winners. Meissonier, Cabanel and Gérôme were the first three; considering that France had the

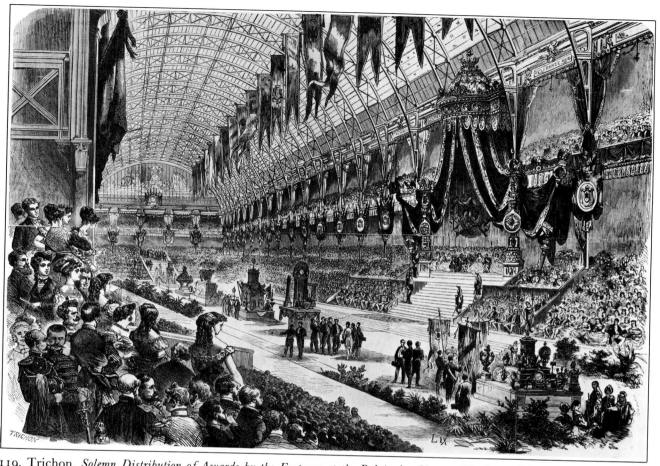

119. Trichon, *Solemn Distribution of Awards by the Emperor at the Palais des Champs-Elysées, 1 July 1867.* Bibliothèque Nationale, Paris.

largest bloc of votes, almost half, the fact that two foreigners were placed next (Leys and Knaus) indicated a massive defection of French votes. Philippe Burty wrote unequivocally: "The foreign artists enthusiastically awarded him a Grand Medal."[27] In truth, Rousseau and landscape painting in general was more popular abroad than at home. Collectors in England, Holland, Germany, and America sought after his work, and the Academy of Fine Arts in Amsterdam had made him an honorary member.[28] Even today there is relatively little of Rousseau's work in France, a surprising quantity of it in Northern Europe and, especially, America. Rousseau's triumph at the Universal Exposition owed more to foreign than to French esteem for his work.

In order to make his success complete, Rousseau awaited one more honor, to be promoted to Officier in the Légion d'honneur. Sensier wrote that for Rousseau this was "the goal of all his efforts."[29] Like his predecessor Delacroix and his successor Manet, Rousseau longed with his entire being for the respectability of official recognition.

Artists were nominated to or promoted in the Légion d'honneur for many reasons: as a mark of official favor, in recognition of services rendered, even—almost by accident, it

seems—for artistic excellence. For Rousseau, considering his Medal of Honor and his extensive jury duty, promotion should have been automatic. And yet, at the solemn distribution of awards on 1 July (Plate 119), Rousseau's name was not called to receive this honor. Among his fellow Medal of Honor winners, Meissonier was made Commandeur, Gérôme, Kaulbach, Leys, and Knaus were made Officiers, a rank Cabanel already held. Among the First Class medallists, Breton, Français, and Corot were named Officier. The names of Rousseau, Daubigny, Millet and Dupré, the "sloppy" landscapists, politically suspect as well, were conspicuously absent.[30] For Rousseau, more than the others, the humiliation was overwhelming, for he was a member of two Juries, President of the French Admissions Jury and the only French Medal of Honor winner not so honored; even worse, he was part of the official delegation at the Awards Ceremony.

Sensier wrote that "a hidden hand" was responsible; he meant Nieuwerkerke.[31] In 1855 such nominations had been made by the Juries; in 1867 there was no such provision and they were made through regular channels. As President of the Jury de Groupe for the fine arts, the task would thus fall to Nieuwerkerke. He had already pronounced his opinion of Barbizon painting some years earlier when he stated: "this is the painting of democrats, of men who don't change their underwear, who want to force their way into polite society; this art displeases and disgusts me."[32] His aversion had not mellowed with time.

Soon after the Awards Ceremony, Rousseau began to exhibit the symptoms of a cerebral hemorrhage.[33] He wrote whole journals about his pain on being publicly humiliated, and blamed it on "narrow-mindedness, prejudice, and intrigue." He wrote a *mémoire* to be presented to the Emperor; his friends Thoré, Sensier, and Silvestre acted on his behalf.[34] Eventually the resulting scandal produced results. Vaillant demanded an explanation from Nieuwerkerke who made a lame excuse, stating: "The high honors of the Légion d'honneur can never be, as the petitioner seems to believe, the *inevitable consequence* of the awards given by the Jury . . . If that were so one would be *just as equally obliged* to prefer candidates favored by age and seniority."[35]

On 1 August, Rousseau suffered a massive stroke. On 10 August, *La Chronique des arts et de la curiosité* announced that he was paralyzed.[36] Sensier stated that Rousseau became very depressed on reading of his condition in the press.[37] Then Napoléon III, to make amends and avoid further scandal, signed a special decree naming Rousseau Officier of the Légion d'honneur.[38] On 12 August, Millet wrote to Sensier from Paris: "Alfred Stevens came this morning with Puvis de Chavannes to announce to Rousseau that he has been named Officier. We received them, my wife and I, on the stairs, begging them not to come up so that Rousseau's repose might not be disturbed. I told him myself and he seemed very happy."[39] This honor was announced at the Salon of 1867 Awards Ceremony, 13 August, a much less prestigious event, lacking the international luster of the Universal Exposition.[40]

Rousseau did not attend. *La Chronique des arts et de la curiosité* reported that, at the announcement of Rousseau's promotion to Officier, there was a burst of applause, after which Nieuwerkerke explained that Rousseau was ill and could not attend. Commented *La Chronique*: "One can be sure that this promotion was due to protests reaching the Emperor by a route other than that of the fine arts administration."[41]

The next day, Rousseau sent an open letter to the press, published in *Le Figaro* and *La Chronique*:

Monsieur le directeur.

The day before yesterday at the Awards Ceremony in the Louvre, M. le comte de Nieuwerkerke, Surintendant des beaux-arts, thought he should add some flattering words about me when he read the decree naming me Officier in the Légion d'honneur.

If my health had allowed me to attend this event and to hear these compliments, I would have saved all my gratitude for the Emperor alone.

The Emperor, in his noble justice, has not allowed the verdict of the International Jury, partially forgotten on my behalf at the Awards Ceremony of 1 July, to remain any longer unfulfilled.

Be kind enough, M. le directeur, to publish my letter and receive in advance my gratitude.

Th. Rousseau[42]

But this was virtually Rousseau's last public act. His health broken, he lingered several months longer, and died at Barbizon, 22 December 1867.[43] Millet wrote to the collector Chassaing several days later, recounting the events leading up to Rousseau's death:

At the beginning of last July, and without any warning, he suddenly found that his left arm could no longer support the weight of his palette and that his leg on the same side functioned painfully. After several days in this state, he called his doctor who ordered complete rest, that is to say, no work at all and to leave Paris (where this happened) as quickly as possible to go to Barbizon. I was really shocked to see him arrive so crippled. He recounted to me what I have just told you; but he assured me that he wasn't worried and that his doctor had told him that this would be over in a month. He remained some time like that, with his arm useless and his leg dragging. One morning someone came running to my house to tell me that he was suffering horribly. He had just had a terrible attack (on 1 August) of horrible pains in his arm and his head. After that he got worse. His doctor wanted to send him to Switzerland, but the voyage, though begun, could not be completed. He was forced to stay in Paris where he had another stroke. Then, when the doctor felt he could travel, he sent him to Barbizon where he remained, going from crisis to crisis until the end.[44]

Nieuwerkerke did not arrange a memorial exhibition.

* * *

In retrospect it is clear why, at the crossroads of 1867, France officially took the high road of genre and not the low road of landscape. It was a decision fateful in consequence for the younger Naturalist generation for, although landscape painting would gain in both respectability and popularity after 1870, the future Impressionists would nonetheless be forced to continue this new tradition of the disenfranchised avant-garde. As the new arbiter of the nation's cultural life, the bourgeoisie had, with the help of

Nieuwerkerke and Napoléon III, set aside the centuries-old French tradition of government recognition of artistic excellence, and left us, as the official artists of the Second Empire, Cabanel, Gérôme, and Meissonier.

120. *Alexandre Cabanel*. Watercolor by Eugène Giraud. Bibliothèque Nationale, Paris.

121. *Jean-Léon Gérôme*. Watercolor by Eugène Giraud. Bibliothèque Nationale, Paris.

122. *Jean-Louis-Ernest Meissonier*. Watercolor by Eugène Giraud. Bibliothèque Nationale, Paris.

19
The Triumph of Genre

History painting was completing the process by which it led to *genre*; and *genre*, that is to say the customs, dress, personality, characteristics, manners, all the visual realities of the contemporary world, this *genre painting* so disparaged, so cursed, so persecuted, was developing, growing, breaking through its former limits, ascending to the heights of *history painting*, attacking the idea of universality of nature and of life, becoming finally the entire painting of the present as it will be, I hope, the entire painting of the future.—*Castagnary, "Salon of 1868"* [1]

As a result of the severity of the Juries for both the Universal Exposition and the Salon, 1867 had been a year of extraordinary protests. In order to avoid a Salon des refusés, Nieuwerkerke had promised a more lenient Salon in 1868.[2] This postponed the protest from a year when Paris was the center of international attention to a time when, the distinguished foreign visitors having left, France could cope with domestic problems in relative privacy. The Salon of 1868 was, then, a pendant to the Universal Exposition of 1867; many of the forces set in motion the one year came to fruition the next. The same phenomenon had taken place earlier when, after the 1855 Exposition had canonized the movements of the first half-century, the birth of Naturalism was proclaimed at the next Salon. In 1867 history painting was interred with Ingres, and 1868 signaled the triumph of genre, its successor. Both Expositions marked the end of an epoch; both Salons signaled the beginning of another. An analysis of the Salon of 1868 will, then, indicate the direction art would take under the Third Republic, just two years away. Such an analysis must examine both the institutional structure and the aesthetic content of the Salon, for, in both aspects, it showed marked differences from its predecessors.

The 1868 *Règlement*, as Nieuwerkerke had promised, specified a jury two-thirds elected by artists who had exhibited in any Salon except that of 1848, and one-third appointed by the Government.[3] It was thus the most democratically constituted of all the juries of the Second Empire, and achieved in art more than what had already been achieved in politics, namely true universal suffrage. To prepare for the elections, the artists held meetings, formed parties, and proposed slates of candidates. The most radical party was that organized by Castagnary, Courbet, and Manet, which called itself "The Committee of Non-Exempt Artists," that is, artists who were neither members of the Légion d'honneur, nor had won medals at previous Salons. Their

slogan was "Liberty in Art," and their platform, "no rejections except by unanimous vote of the Jury." Daubigny and Gleyre were elected on this ticket, Courbet himself not receiving enough votes.[4] Cabat was chosen from the slate of another party, and a third provided Robert-Fleury, Français, Bida, Gérôme, and Baudry, all of whom had been regularly elected under the old, more restrictive *Règlement*. The major change produced by universal suffrage was the election of Daubigny who had not placed at all under the more restrictive 1867 rules; he now obtained more votes than anyone else. Cabanel dropped from first to seventh place, Gérôme from third to twelfth, and Meissonier from tenth to fifteenth; all three resigned.[5] As finally constituted, the Jury consisted primarily of genre and landscape painters and was decidedly liberal; it accepted 4,213 works, as opposed to 2,745 in 1867.

Among the beneficiaries of this liberalism was the group of young Naturalists around Bazille who had fared so badly in 1867. If that was the year of their worst across-the-board rejection, 1868 was the year of their first taste of success. Renoir, Monet, Manet, Sisley, Pissarro, all except Cézanne, were now represented in the Salon.[6] Courbet, who had been almost acceptable in 1867, now outraged critics and the public by reopening his own exhibition while sending *The Beggar's Alms at Ornans* (Plate 123) to the Salon. Chesneau claimed that for Courbet and his friend Proudhon the painting was "A symbol of the France of the future."[7] Zola wrote of him: "The master is far from being accepted; at most he is tolerated; he is mistrusted, always suspected of playing a bad joke."[8] And Courbet did play a joke just often enough that he was always regarded with suspicion, never wholly accepted. Millet, on the other hand, received, in 1868, his belated ribbon of the Légion d'honneur. In the wake of Rousseau's death and his friends' success at the Salon, Castagnary wrote: "It is time to wrest from the Romantic School this beautiful flower of modern landscape which belongs to us." Henceforth, he declared, the landscape School should be linked to Naturalism.[9]

The real beneficiary in 1868 was Manet. He exhibited at the Salon his *Portrait of M. Émile Zola* (Plate 124) and *A Young Woman*, now known as *Woman with a Parrot*. "This year has brought him a real success," wrote Castagnary.[10] To be sure, there were still many critics who had nothing but harsh words, but Zola felt that the tide had turned: "The public is becoming accustomed to him, the critics are calming down and are willing to open their eyes, success is coming."[11] In this sense, 1868 was for Manet what 1857 had been for Courbet; having successfully challenged the Government and taken their fate into their own hands, they could not but be admired in a society in which all values were now open to question and only self-made men seemed to know the answers.

The swift turn-about in official favor between 1867 and 1868 elicited from Théophile Gautier his famous avowal which, fittingly enough, stands at the threshold of the modern era:

> One thinks of the antipathy, the horror, which the first paintings of Delacroix, of Decamps, of Boulanger, of Scheffer, of Corot, of Rousseau, so long exiled from the Salon, inspired around thirty years ago in people who lacked neither wit nor talent, neither taste nor intellect ... Nonetheless, these artists so spurned, so persecuted, have become illustrious masters, recognized by everyone, and they had as much talent then as they would ever have, perhaps even more, for they were then in the

123. Gustave Courbet, *The Beggar's Alms at Ornans*, 1868. 2.10 × 1.75 m. Salon of 1868. Burrell Collection, Glasgow Museums and Art Galleries.

124. Edouard Manet, *Portrait of M. Emile Zola*, 1868, 1.463 × 1.14 m. Salon of 1868. Musée d'Orsay, Paris.

flower of their genius. The conscientious wonder in the face of these striking examples, still very close to us, if truly one can understand anything in art other than the works of one's own generation, that is to say, those with whom one was twenty years old. It is probable that the pictures of Courbet, Manet, Monet, and *tutti quanti* contain beauties apparent to young people in short jackets and top hats but which escape the rest of us, our old Romantic manes already streaked with threads of silver.[12]

The anguish Gautier expressed was similar to the anonymous cry of 1855: "Alas! in art as in politics, isn't the error of today almost always the truth of tomorrow?"[13] The issue was not that an older generation was incapable of understanding youth, but that, since the 1789 Revolution, the rate of change had accelerated and differences between generations had become profound. The Second Empire established this pattern of rapid and radical change as the norm, in art as well as in other spheres of life. The security offered by tradition was giving way to the anxiety of the present, characteristic of our modern period.

Nieuwerkerke did not share Gautier's insight, however, and was personally responsible for the rejection of one of Monet's paintings. He blamed Daubigny for the liberalism of the Jury.[14] Still sensitive to the protests of 1867, the art administration attempted to protect itself from charges of favoritism by setting up a special committee to award the two Grand Medals of Honor, one each for painting and sculpture. Under

the Presidency of Nieuwerkerke, the committee would include the elected Presidents of each of the Juries (Robert-Fleury, Dumont, Duban, and Henriquel-Dupont) plus two members from each Jury drawn by lot on the day the committee would meet. With eight of fourteen members drawn by lot and the four Jury presidents elected, the committee would then, in principle, be above reproach.[15] The installation of the Salon was also intended to be above reproach, for it was hung alphabetically. This did not prevent Nieuwerkerke from seeing to it that Manet's paintings were placed near the ceiling, and that, at the revision, Renoir, Bazille, and Monet had their paintings taken down and badly hung in the *dépôtoir*.[16] Nonetheless, the result of all these changes in the Salon made 1868 the year of universal suffrage in art.

The triumph of genre

Genre! Everywhere genre! Genre in portraits, genre in landscape!—*Etienne Palma, "The Salon of 1868"*[17]

As in 1857, the Salon following the restrictive Universal Exposition was distinguished by its liberalism, the most striking aspect of which was the predominance of genre. While in 1857 this could be attributed to the temporary absence of the major artists, in 1868 it was the major artists who were exhibiting. Because genre was considered a foreign style, the foreign painters who, now more than ever, were exhibiting in the Salon had become quite conspicuous. Maxime DuCamp stated categorically that this phenomenon had begun in the wake of the 1855 Exposition.[18] Ernest Chesneau pointed this out immediately in his first article on the 1868 Salon, then devoted his first four articles to discussing their work, singling out Alfred Stevens (Belgium), Alma-Tadema (Netherlands), and Adolf Menzel (Prussia), all of whom showed genre.[19] Paris had retained its supremacy as the international capital of art; the price it paid was to accept what was already the international style in art.

Nor was the popularity of genre confined only to contemporary art. The grand shift of taste characteristic of the second half of the nineteenth century, the shift from large public to small private images, had brought with it a concomitant shift in taste for the art of the past. The classicism of the Italian Renaissance, so esteemed by Academicians, the seventeenth-century French masters, so eloquently praised by Cousin, were being replaced by the elegance and intimism of eighteenth-century works and a taste for the little Dutch masters.[20]

Among the paintings exhibited at the Salon of 1868 were Manet's *Portrait of M. Emile Zola* (Plate 124), Renoir's *Lise* (Plate 125), Pissarro's *Côte de Jallais, Hermitage* (Plate 126). Yet the special Jury, this Jury for which such pains had been taken to ensure its "objectivity," awarded the Grand Medal of Honor for painting to Gustave Brion for his *Bible Reading: Protestant Interior in Alsace* (Plate 127).[21] This medal, traditionally reserved for a history painter, had never before been given to a painter of genre. Here was final proof that the old order had changed. History painting had been dethroned and would not again regain its former authority.

The award of the Grand Medal of Honor to a genre painter met with a variety of responses. The eclecticism set in motion in 1855 had reached a point at which not only

126. Camille Pissarro, *Côte de Jallais, Hermitage*, 1867, 0.87 × 1.149 m. Salon of 1868. The Metropolitan Museum of Art, New York. Bequest of William Church Osborn, 1951.

125. Auguste Renoir, *Lise*, 1867, 1.811 × 1.121 m. Salon of 1868. Folkwang Museum, Essen.

the critics, artists, and public were incapable of seeing or appreciating a taste different from their own (that was an old phenomenon) but the hierarchical structure which had rationalized the whole system had irrevocably broken down. Castagnary wrote: "We find ourselves all rushing about on the same dark terrain, without map or guide, pressing on confusedly in the shadows, everyone shouting at the least glimmer of light in his direction, 'There's the star, follow it!'"[22] This response was qualitatively different from the praise or criticism directed at Ingres, for underlying that was always the recognition that he did, in fact, represent the French School as defined by the Institut de France. By 1868 the entire system had been thrown into question, and Brion represented no more nor less than the quite fallible choice of a group of jurors who held their office at the whim of the electorate, and were replaced year by year. The critics who associated the death of Ingres with the beginning of aesthetic anarchy proved correct, but the same process was taking place in all spheres, on all levels of society, and not just in France: the principle of unquestioned authority was giving way to that of popular choice. A brief investigation of the response to Brion will show the scope of this change in art.

There were, first of all, those who were completely unprepared for the choice of Brion. Several of the critics who had published their reviews before the awards didn't even mention him, apparently not realizing that he would be a strong contender for the Medal of Honor.[23] Others, of various critical persuasions, were frankly bewildered by

127. Gustave Brion, *Bible Reading: Protestant Interior in Alsace*, engraving by Rajon from *Gazette des beaux-arts*. (Painting exhibited Salon of 1868. Present whereabouts unknown.)

the choice. Ernest Chesneau always supported authority, yet called Brion's work "an interesting picture but one which the Jury has strangely aggrandized by judging it worthy of a Medal of Honor."[24] Castagnary called Brion "the unexpected laureate" and added that the public had passed in front of the picture without noticing it, the critics had considered it merely a little genre painting, carefully executed but lacking in talent, while the Jury had found in it a masterpiece. He concluded: "the phenomenon is peculiar."[25] Others expressed stronger viewpoints. Louis Auvray wrote that his fellow painters were astonished at the award because Brion's painting was inferior even to his own general level.[26] *L'Illustration* published an entire page of caricatures by Bertall entitled "Everything for Alsace. Remarks on the Medals at the Exposition of 1868," the centerpiece of which was Brion's painting captioned:

"GRAND MEDAL OF HONOR":

The interior of the Alsatian charcoal burner,
or, A man's home is his castle, by M. Brion.

Some people seem astonished to see the Medal of Honor awarded to this picture. Frivolous men, they don't understand that at the moment when war might threaten our eastern frontiers, it is good politics to do something for Alsace.[27]

192

And yet the structure of the Awards Jury made this sort of manipulation unlikely.

A more probable explanation is that the key to Brion's success was his mediocrity, a quality described by Duret as the necessary ingredient of "bourgeois art." Auguste de Belloy wrote of him: "M. Brion has just about never, to this day, either scandalized or edified anyone. At an equal distance from the two extremes, he has been long content to amuse and to move us mildly with these scenes of Alsatian customs which have made his reputation, a reputation as modest as his talent."[28] Brion represented the *juste milieu* of the 1860s. He was a genre painter, true, but elevated enough for Charles Blanc to compare him to Greuze.[29] He represented peasants, true, but, as Louis Auvray commented, they had about them "a noble appearance which has nothing in common with the vulgarity and coarseness of Millet's Realism."[30] His painting would never inspire violent passions, wrote Chaumelin, and neither, it seemed, would his peasants, who were praised for their honesty, tranquillity, piety, and patriarchal values.[31] He could even be praised as the best of the new young Naturalists; he was certainly the least controversial.[32] He seems to have been a genuinely popular choice, possibly a compromise among candidates each objectionable to a different section of the Jury. At the Awards Ceremony, according to Chaumelin, "Loud and prolonged applause showed that the choice of M. Brion and M. Falguière for the Grand Medals of Honor were greeted with general approval."[33]

True to Second Empire art politics, however, the Government was not pleased with the very results it had done so much to bring about. At the Awards Ceremony, maréchal Vaillant presided, and explained that the Jury had not found any history painting sufficiently worthy to receive the Grand Medal of Honor and so had awarded it to a painting of genre: "But I must remind you not to forget that genre painting can not occupy the first rank among the manifestations of art, and that the most brilliant and successful genre picture will always remain an anecdotal work and, so to speak, a private work."[34]

But time was running out for the Second Empire art administration. The liberalism of the 1860s had set in motion a train of events which had resulted in the loss of authority of all aesthetic directives proceeding from Government and Academy. The preferences of Vaillant or Nieuwerkerke were no longer relevant. The triumph of genre was complete.

20
The End

IN THE SPRING OF 1868, the laws on censorship of the press were relaxed; it was a reform which, once the Universal Exposition was over, could no longer be delayed by a Government that called itself liberal.[1] The immediate result was a barrage of criticism of every aspect of the regime; the art administration was not neglected. The rancor left by years of mismanagement led to a frankness in the 1868 Salon critiques that made several of them read like diatribes, recounting in detail every failing of the administration. The most comprehensive ones were written by Edmond About for the *Revue des deux-mondes* and Pierre Petroz for the *Revue moderne*, both opposition journals, one of the Right, the other of the Left. Not to be outdone, Emile Zola wrote a short polemic for *La Tribune* which appeared after the Salon had closed. Their main charge was the same, that the Second Empire had no art policy, decisions being made on the basis of political expediency or personal greed. About wrote of the fine-arts administration, directing his attack at Nieuwerkerke:

> He creates and destroys, judges and reverses himself, issues decrees as he pleases and tears them up when they have served their purpose, that is to say from one year to the next. It's a little state within the state and his personal power is as unlimited as it is irresponsible ...
>
> This authority, mobile as a wave yet firm as a rock, is empowered to exhibit when and how it pleases the work of our artists.[2]

Pierre Petroz extended the attack beyond Nieuwerkerke personally to include the entire administration and its policies: "It follows opinion, it doesn't inspire it. Having no firm principles of its own it has an irresistible propensity to accept those of public authorities—such as the Fourth Class of the Institute—even while it is subverting them."[3] Commissioned works were so badly chosen, he stated, that the administration didn't dare exhibit its purchases before they were dispatched to the provinces. Once there, they were often immediately put in storage and never seen again. Public commissions were given by short-sighted administrators who paid as little as possible, imposed impossible deadlines, and, as a result, got hasty, botched work. The Salon itself, formerly an event of dignity and prestige held in the Louvre, had deteriorated: "Today, in the corner of an all-purpose building, neither greenhouse nor hall but used for both, a simultaneous exhibition is thrown together of fine arts and fine vegetables, between a

show of carriage-makers and, no doubt, an exposition of cheese."⁴ With all of this, where did one look for aesthetic leadership?

In the judgments of the journals? It's anarchy, whimsy, cliquishness, and advertising carried to the most extreme degree imaginable. In the official awards? Nothing is more capricious nor more arbitrary: if a list were made up of French painters in hierarchical order according to the number and importance of prizes that these eternal schoolboys have received from the Ministry, you would die laughing. The public of collectors and speculators have, then, only one recourse, that is to regulate their enthusiasm by the prices at the Hôtel Drouot and to buy the talents that sell the best.⁵

Zola started off the same way, by saying: "Our Ministry of Fine Arts is one of the most incompetent ever seen."⁶ He wasted no time on details, however, but went right to the heart of the matter:

As far as Government is concerned, there are only two possible routes: the most absolute despotism or the most complete liberty. Let it choose and swiftly.

I mean by despotism the most absolute autocratic reign of the Académie des beaux-arts. It was wrong to wrest the power from its hands in order to confide it to an elected jury whose judgments vary year by year . . .

Half measures are dangerous. They kill governments. A well-organized despotism, especially in art, is preferable to limited freedom. From the moment when the administration admitted that the academic jury was worthless, it was necessary to cut to the quick, to destroy the institution and to create free exhibitions. It hasn't had the courage. So now it finds itself in a cruel dilemma confronted with the problems it has caused and which its half-liberal decisions will continue to cause . . .

The administration will delay in vain, it will be forced, sooner or later, to reinstate the Academy or to throw the doors wide open.⁷

Finally freed of censorship, these critics totalled up the art policies of the Second Empire and found it bankrupt. Many of their charges could be traced to Napoléon III who was, at best, ignorant in matters of art and simply tried to please the greatest number, or to his Surintendant, Nieuwerkerke, whose taste was so accurately described by About as a mixture of the socially prominent and the politically expedient. There were also social processes at work which would have had their effect regardless of the personalities involved. Duret and Chesneau well understood the social and economic changes that governed the major shift in style which separated the first half of the century from the second, from large public works to small intimate easel paintings. Whatever regime spanned the third quarter of the century would have been faced with the same economic and social forces that affected the entire world. Rapid industrialization, concepts of progress, theories of democracy and liberalism, the rise of the bourgeoisie with its own culture, all were factors operative throughout Europe and America. The shift in taste described in this study was the cultural concomitant of the political and economic shift begun by the French Revolution. As culture follows political and

economic factors, almost another century was required for the triumph of what Duret called "bourgeois art."

In this study we have traced the parallel traditions of art and craft in France, from their origins in the guild system through the conflicts which followed the establishment of the Académie des beaux-arts. We have seen that exhibitions themselves served, from their inception, the ends of government, and met with resistance on the part of Academicians. In the era of Universal Expositions, the two traditions of art and craft—by now art and industry—converged and clashed, for the aesthetic sphere, which had maintained an uneasy and contradictory coexistence with the commercial sector, was increasingly rationalized on the same terms. Industrial expositions provided a framework for this assimilation of art into a commercial context; in a series of preliminary and symbolic skirmishes from 1848 to 1857, the Salon was first displaced from its traditional and prestigious location in the Louvre, then installed in the Palais de l'Industrie, obliged to share space with agricultural and industrial expositions.[8]

During the Second Empire, the art world in France changed irrevocably, and the two Universal Expositions served as catalysts for many of the changes. The major transition in aesthetic mode, from large public to small private works, was accomplished in two stages. The eclecticism established in 1855 dismantled the classical system of the hierarchy of categories by implicitly placing them all on the same level; the immediate effect was an unstable coexistence among all styles which, in the absence of strong direction from Government or Academy, had then to compete for public favor. By 1867 this temporary equilibrium had given way to the supremacy of genre painting, for, in the intervening years, the bourgeoisie had replaced the Academy as the arbiter of taste and had imposed its own aesthetic preference: history painting was forced to yield to genre. Since genre painting was already the preferred style of Northern Europe, the Universal Expositions that were the chief vehicle for the introduction of foreign art into France served to consolidate its triumph. The group of painters later known as Impressionists must be seen as part of this overall movement away from the heroic and towards small intimate scenes from everyday life. In fact, they were genre painters, despite Modernist attempts to define genre painting in a pejorative sense by first eliminating from this category its best work.

The retrospective exhibitions given to major artists in 1855 were the outcome of the Romantic emphasis on the Individual, with the implication that each artist has a particular development and style, a separate history. The ideology promulgated by the retrospective exhibition, emphasizing individual self-referential development—the concept of progress redefined in aesthetic terms—has proved to be the principal Modernist tool for understanding art apart from its social and political milieu. In this new setting, official medals and honors began to lose their significance, for art was increasingly divorced from the public arena. As conservatives so often, and so correctly, charged, the absence of institutional authority had resulted in a kind of aesthetic anarchy in which individual histories and styles came to replace that of the French School.

The arbitrary quality of the awards given by the Second Empire art administration and its Salon and Exposition juries aggravated the situation, and the contradictory directives of its official pronouncements on art implied in the end that there were no

longer any absolute values, all was relative. As Pierre Petroz stated, the only certainty lay in commercial value. One result was the rise of alternate institutions during this period, the growing importance of art dealers and gallery exhibitions as an alternative to the vacillation of the art administration. Careers were increasingly made outside the system, the commercial backing of the bourgeoisie becoming more important than empty honors from the State. As the careers of Decamps and Meissonier had shown, the Government would, in any case, eventually ratify a popular success. In the late 1860s, critics and artists often referred to the once-cherished medals as schoolboys' prizes: the Government had vacillated too much—and changed too often—to maintain any authority in art. The shock of the 1855 canonization of Delacroix had provoked the realization that nothing was eternal, that everything, even aesthetic values, could change. Thus confidence was undermined in all future judgments, and critics began the modern custom of citing, like litanies, the names of artists once scorned, later praised.

Another result of the collapse of the traditional art system was the increasing determination by artists to play an active role in their own fate. Courbet's successful challenge to the Government in 1855 was of the utmost importance in this respect, for he showed that artists could organize their own exhibitions and successfully establish their careers without official sanction from either Government or Academy. The first Impressionist show in 1874, originally planned by Bazille and his friends in 1867, was the direct result of Courbet's and, later, Manet's example.

Zola had correctly stated in 1868 that, once embarked on a path of liberalism, the Government had no choice but to follow it out to the end. Despite minor vicissitudes, the Government, after having wrested control of art institutions from the Academy, was forced to make greater and greater concessions until, in 1881, it was obliged to abandon the Salon entirely, a move proposed by Chennevières in 1863[9] and predicted as inevitable by Zola five years later.

The Second Empire marked the end of the traditional world of art as it had existed in France for two centuries. By 1868 the transition to our modern world, capitalist and cosmopolitan, was virtually complete and, in two years, the Second Empire itself would cease to exist. Nonetheless, the Second Empire had established, in large part through its Universal Expositions, many of the attitudes and institutions of the modern art world.

Notes

An abstract of Part I was presented under the title of "The Origins of Universal Expositions in France" at the Frick Symposium in the History of Art, New York City, 1981.

Chapter 1

1 See "Le Palais de l'Industrie" in Dumas (2), 312.

2 Although there was a small exhibition in 1665, the first Salon is usually considered to be that of 1667. See Institut de France (1), I:318, 9 April 1667; Fontaine, 625–30.

3 Boileau, 129, art. XII. The first compilation of guild customs and regulations was made by Etienne Boileau, Provost of Paris, ca. 1268; for the regulations, see XLIV, XCVI–XCVII, CXLII, 127–30. All regulations and official documents pertaining to the guilds from 1391 to their suppression in 1793 were either summarized or published by Lespinasse.

4 Lespinasse, II:194, art. 16. Before 1391, artists were concentrated in the corporations of *Ymagiers Tailleurs* and *Paintres et Tailleurs d'ymages*.

5 See Montaiglon (1), I:9–10. These memoirs are identified as those of Henri Testelin, the first *secrétaire* of the Academy; the exemptions he refers to would have been *brevets* to individual artists and thus not included in Lespinasse.

6 Ibid., I:11–12.

7 The petition of the Communauté is published in Montaiglon (1), I:19–21.

8 Ibid., I: 21–35. On the foundation of the Academy, see also Pevsner, 82–108.

9 The artists' *Requête* was written by Charmois and is published in Vitet; see "Pièces justificatives," 195–207.

10 On the history of these categories, see Kristeller.

11 For a thorough discussion of this issue, see Rensselaer W. Lee, *Ut Pictura Poesis: The Humanistic Theory of Painting*, New York, 1967, 41–48.

12 Louis XIV's response, *Arrêt du Conseil d'Etat, 27 janvier 1648*, is given in L'Institut de France (2), CIV–CVI.

13 Pevsner provides a good summary of these feuds, and the compilations of legal documents give ample evidence of continued friction; see Boileau, Lespinasse, Vitet, Montaiglon (1), and L'Institut de France (1) and (2).

14 By *Brevet du Roy, 28 décembre 1654*, Academicians were freed from a variety of taxes and services required of members of the guild, and given various legal privileges equal to those enjoyed by members of the Académie française, established in 1635; see Lespinasse, II:207–209 and Vitet 236–39. For the requirement that all court artists join the Academy, see *Arrêt du Conseil, 8 février 1663*, L'Institut de France (2), CXXIII–CXXV.

15 "Art," *Le Dictionnaire de l'Académie françoise*, 5th ed., 2 vols., Paris, an VII (1798), s.v.; also see "Beaux-Arts," *Le Grand Robert de la langue française*, Alain Rey, ed., 6 vols., Paris, 1985, s.v.; and the discussion in Kristeller.

16 Montaiglon (1), I:61–62. The Procès-verbaux of the Academy do not mention this early decision, but a later discussion leaves no doubt that it was a long established custom; see the entry for 2 December 1684 in L'Institut de France (1), II:291–92.

17 L'Institut de France (1), I:257, art. XXV; also see *Statuts et règlements, 24 décembre 1663*, art. XXV, in L'Institut de France (2), CXXXV, and Fontaine.

18 For the early history of expositions in France, see Institut de France (1), I–III, passim; the livrets for Paris 1673 and 1699; *Le Mercure galant*, September 1699, 224–27; Florent LeComte, "Description des peintures,

sculptures & estampes exposez dans la grande gallerie du Louvre dans le mois de septembre 1699," *Cabinet des singularitez d'architecture, peinture, sculpture, et graveure,* 3 vols., Paris, 1699–1700, III:241–273; "La Première exposition de peinture au Louvre, en 1699," *Magasin pittoresque* 18 (September 1850): 305–307; Pierre Marcel, "Notes sur les 6 Expositions du règne de Louis XIV," *Chronique des arts et de la curiosité,* 9 January 1904, 10–13, 16 January 1904, 19–20; Fontaine; Georg Friedrich Koch, *Die Kunstausstellung,* Berlin, 1967.

19 *Le Mercure galant,* ibid., 224–27; this account disproves Démy's contention that the Académie des sciences held an exhibition in the Louvre at the same time.

20 For a more extended discussion of this issue, see Mainardi (9).

21 See *Statuts de la Communauté des peintres et sculpteurs et de l'Académie de Saint-Luc, 9 mars 1730,* in Lespinasse, II:215–19; Guiffrey (2), 15.

22 On the Salons of the Académie de Saint-Luc, see Guiffrey (2), 30–43, 89–92. The seven exhibitions were held in 1751, 1752, 1753, 1756, 1762, 1764, 1774 and included 186 artists and 1,252 works of art of which at least half were portraits; for the *livrets* see Guiffrey (1). For lists of productions legally requiring the services of a member of the Communauté, see Lespinasse, II:216, art. 3, and 217, art. 15.

23 See Locquin, 60–63; Maurice Du Seigneur, "L'Art et les artistes au Salon de 1882 avec une introduction sur les expositions particulières," *Gazette des beaux-arts,* May 1882, 535–56; Colette Caubisens-Lasfargues, "Le Salon de peinture pendant la Révolution," *Annales historiques de la Révolution française,* April–June 1961, 193–214.

24 Hahn, 41; Hahn mentions this throughout his study.

25 L'Institut de France (2), LXXXIV–XCII; also *Le Mercure galant,* May 1699, 1–15.

26 See Paris, 1683; also Endrei.

27 See Maurice Daumas, *Les Instruments scientifiques aux XVIIe et XVIIIe siècles,* Paris, 1953, 138–39.

28 For an account of exhibitions in England, see Luckhurst; also see Hahn, 111; Daumas, 138–40.

29 Andrew Trout, *Jean-Baptiste Colbert,* Boston, 1978, 123ff; G.R.R. Treasure, *Seventeenth Century France,* London, 1966, chap. 21.

30 See *Encyclopédie ou Dictionnaire raisonné des sciences, des arts et des métiers par une société des gens de lettres,* 35 vols., Paris and Neufchastel, 1751–65: "Industrie," "Art," Maîtrise," s.v.

31 *Edit du roi, février 1776,* Lespinasse, I:162–75;

Edit du roi, août 1776, ibid., I:175–88.

32 *Déclaration, 15 mars 1777,* L'Institut de France (2), CXLVIII–CLIII.

33 Ibid., *Statuts et règlements, 2 septembre 1777,* art. XXXIV, CLXIII.

34 *Décret, 2–17 mars 1791,* Lespinasse, I:188–91; *Loi, 8 août 1793,* L'Institut de France (2), CCIII–CCV.

35 L'Institut de France (2), *Loi sur l'organisation de l'instruction publique,* 3 brumaire, an IV (25 October 1795), 6–7.

Chapter 2

1 On the fêtes see Dowd and Ozouf.

2 Archives Nationales (hereafter AN) ADXVIIIA 60, *Rapport fait au nom du comité de salut public par Maximilien Robespierre sur les rapports des idées religieuses et morales avec les principes républicains, et sur les fêtes nationales. Séance du 18 floréal, l'an second de la République française;* see art. VII, 36–37. The report is included among Robespierre's published writings.

3 Costaz (2), II:315–16. As the revolutionary new year began in September, even contemporaries often erred when translating dates back to the Gregorian calendar. A different account came from Mazade d'Avèze, who was at the time Commissaire of Gobelins, Sèvres and Savonnerie. He claimed that the original idea was his and that he had actually organized the first such exposition, scheduled for Ier jour complémentaire, an V (17 September 1797). It was cancelled when the Directory decreed that all nobility had to be thirty leagues from Paris on that day. Mazade averred that on his subsequent return to Paris he did indeed mount the show, but he provided no date. His claims were presented in a memoir written many years later in an unsuccessful attempt to obtain a government pension; see Mazade d'Avèze. The first part of his story is somewhat corroborated by an article in *Gazette nationale,* Ier jour complémentaire, an V (17 September 1797), 1456, entitled "Grande fête au château de Saint-Cloud." Although Mazade claimed that products of Parisian merchants were also to be exhibited, the announcement mentioned only those of the national manufacturies. No confirmation is available for the second exhibition he claims to have organized; his vagueness about the date and the long delay in putting forth his claim tend to discredit him. Nonetheless, histories of the national and universal expositions frequently cite his account.

4 The event was added to the main fête on short notice; the first announcement was sent out on 9 fructidor, an VI (26 August 1798). This and other documents of 1798 are contained in AN F12 985; some are reprinted in Neufchâteau. The official announcements were published in *Gazette nationale*, 11 fructidor, an VI (28 August 1798), 1366, and 18 fructidor, an VI (4 September 1798), 1395. The exposition was prolonged to 10 vendémiaire (1 October); see *Gazette nationale*, 5 vendémiaire, an VII (26 September 1798), 17.

5 A complete description of the 1798 Fête de la fondation de la République of Ier vendémiaire, an VII, can be found in the *Procès-verbal*, AN ADXVIII C 468, doc. 58; also see the *Programme*, published separately and in AN ADVIII-18. The entire issue of *Le Rédacteur*, 4 vendémiaire, an VII (25 September 1798), was devoted to an account of the fête and exposition; there were also lengthy accounts in *Gazette nationale*, 1, 3 vendémiaire, 2 brumaire, an VII (22, 24 September, 23 October 1798), and *Journal des débats*, Nos. 133–34, vendémiaire, an VII (September 1798); also see the *Catalogue* and *Procès-verbal* of the 1798 industrial exposition.

6 *Procès-verbal*, AN ADXVIII C 468; the speech is included in Neufchâteau, II:292–97.

7 See Simian. There are also good discussions of Neufchâteau in Leith, 138, and A. Mathiez, *La Théophilanthropie et le culte décadaire 1796–1801*, Paris, 1904, 429ff.

8 AN ADXVIII C 468, doc. 58.

9 Ibid. Unfortunately the statue has not survived.

10 See AN F12 985, *circulaire*, 24 vendémiaire, an VII (15 October 1798), also published in Neufchâteau, I:228–32.

11 AN C462, dossier 35, No. 39: *Le Directoire exécutif, au Conseil des cinq cents*, 8 thermidor, an VII (26 July 1799).

12 See the *Programme* for the 1799 *Fête de la fondation de la République*.

13 Chaptal's *Rapport présenté aux Consuls de la République par le Ministre de l'Intérieur* was published in *Gazette nationale*, 16 ventôse, an IX (7 March 1801), 691; joined to it was the *Arrêté du 13 ventôse*, signed by Bonaparte as First Consul, decreeing—once again—an annual exposition of industry.

14 The 1889 *Rapport* included a history of industrial expositions which stated, without evidence, that 1801 saw an unsuccessful attempt to unite art and industry; see I:28; this has subsequently been repeated and embellished in many histories. On the exposition, see the 1801 *Procès-verbal* and *Catalogue*. Press accounts include *Gazette nationale*, 3 vendémiaire, an X (25 September 1801), 3–6; *Journal des débats*, "Ministre de l'Intérieur," 4 vendémiaire, an X, 3–5, 5 vendémiaire, an X, 3–4, (26, 27 September 1801); *Le Citoyen français*, Ier jour complémentaire, an IX (18 September 1801); the *Programme* was published in *Gazette nationale*, 15 fructidor, an IX (2 September 1801). See also the 1801 Salon catalogue. On David's show see the announcement in *Gazette nationale*, 5e jour complémentaire, an IX (22 September 1801), 1506; on the occasion of his first private show he published a brochure justifying the admission fee; see David, 1799.

15 See Dowd, 119; The documents in AN FIC III-Seine 25 identify Chalgrin as the "architecte des fêtes nationales" and most of the correspondence is addressed to him. The role of Neufchâteau was also important, however, as Mathiez pointed out. Chalgrin is identified as the architect of the 1801 fête in *Gazette nationale* of 3 vendémiaire, an X (25 September 1801), 3.

16 See the 1802 account by Camus; see also *Journal des débats*, 17 nivôse, an X (17 January 1802), 3. The florid style in which Camus described all the exhibitions was the cause of the misunderstanding, for his account formed the basis—usually unacknowledged—of most nineteenth-century accounts. His phrase, "no art is excepted," subsequently quoted to "prove" that art and industry participated in the same exposition, originally carried a footnote attributing it to Neufchâteau's *circulaire* of 9 fructidor, an VI (26 August 1798), announcing the first industrial exposition; Neufchâteau was referring to the mechanical arts not the fine arts.

17 Camus, 430.

18 See, for example, Blanchard de la Musse, *De l'Influence des arts sur le bonheur et sur la civilisation des hommes*, Paris, an X (1801).

19 1798 *Catalogue*, 18; see also the untitled article in *Gazette de France*, 2 July 1805, 1127.

20 No one has advanced any evidence of quarrels between artists and artisans at the expositions, nor have I been able to find any. There is, however, a directive sent from the Ministre de l'Intérieur Decazes to the Préfets in 1819, apparently in response to criticism that *artistes* (i.e. artisans) were not receiving prizes; he stated: "A mechanic, a simple foreman or even a very good worker ... These are the artists that the King wanted to honor"; See 1819 *Rapport*, 392.

21 See Camus; also the first history of the

national expositions by Achille de Colmont, 6–7.

22 The *Procès-verbal* of the third exposition (1802) divided the products into mechanical arts (e.g. clockmaking, monetary art, scientific instruments) and fine arts (e.g. goldsmithing, engraving, furniture). Subsequent catalogues and reports followed this schema, which became increasingly complex.

23 It became customary for each *Rapport* to show progress by listing the number of exhibitors in previous expositions. After 1849 the charts presented a complete summary; see Plate 7. Laborde published a chart for the Salons; see 220; the statistics for the 1849 Salon are taken from the 1850 Salon catalogue.

24 See the 1819 *Rapport*, 55–56; each subsequent *Rapport* listed those taken into the *Légion d'honneur*.

25 See the 1827 *Rapport*, xvi; his request was made at the Awards Ceremony, 5 October 1827.

26 Engravings of the paintings were reproduced in Moléon et al., I:19.

27 See Rey; a copy is in AN ADXI 67.

28 The decorations were described in the 1849 *Rapport*, I:xxix–xxxiii.

29 For a discussion of this concept, see Walter Cahn, *Masterpieces. Chapters on the History of an Idea*, Princeton, N.J., 1979.

30 For Neufchâteau's speech, see AN ADXVIII C 468, doc. 58; for the Jury's statement see the 1801 *Procès-verbal*, 35.

31 For the disillusioned Saint-Simonian reaction, see Flachat, 35.

32 For an anlysis of this situation, see Rosenthal, 3–78.

33 Laborde, 224.

34 In the *arrêté* and *circulaire* announcing the 1849 exposition, the word *artiste* did not appear; this is a change from earlier expositions, although the term was used less and less as the century advanced; for the official announcements, see the 1849 *Rapport*, I:v–x.

Chapter 3

The section of this chapter entitled "French sculpture, English morals" is abstracted from Mainardi (5); "The painting exhibition that might have been" is a summary of Mainardi (8).

1 For a survey and bibliography of early expositions, see Carpenter.

2 A good general account of British exhibitions is that of Luckhurst. On the 1851 Great Exhibition of Works of Industry of All Nations, see the Archives of The Victoria and Albert Museum, the official *Catalogue* and *Reports* and Cole's memoirs. Some recent accounts include ffrench, Gibbs-Smith, and Hobhouse. French accounts include the eight-volume official report, and Chevalier (1). On the relationship of 1849 to 1851, see the V & A Archives, I: (Document 10) *A Report on the Eleventh French Exposition of the Products of Industry, prepared by the direction of and submitted to the President and Council of the Society of Arts by Matthew Digby Wyatt, Architect. September 1849. London*; also I: (Document 5) *Statement of Proceedings Preliminary to the Exhibition of Industry of All Nations, 1851.*

3 Cole, I:123; for his account of the 1851 Exhibition, see 116–205. Also see V & A Archives, I: (Document 6) *Minutes of Meeting 30 June 1849 at Buckingham Palace. Prince Albert, T. Cubitt, H. Cole, F. Fuller, J. Scott Russell*, 2.

4 Laborde, 234.

5 As virtually every French history cites these dates without documentation, I include the following brief survey. In 1833, J. Boucher de Perthes (see Bibliography) suggested at a local industrial exposition that these events be made international; considering his modest position as a customs inspector, his speech is interesting only in that it later provided an apology for French priority in the conception of international expositions. Démy's claim that the Jury in 1844 asked for an international exposition is untrue; compare Démy, 32, and the 1844 *Rapport*, I:L. Four months before the opening of the 1849 exposition, L. Buffet, the Ministre de l'Agriculture et du Commerce, did send a *circulaire* to the members of the *chambres de commerce* asking if they wanted to invite foreign industry to participate; they did not; see AN ADXIXD 256, *Ministère de l'Agriculture et du Commerce, Division de commerce intérieur, de l'industrie et de la police sanitaire et industrielle. Bureau de l'industrie. Circulaire No. 2. Paris, le 31 janvier 1849*. There are many variations of these claims, none supported by evidence.

6 See 1851 *Reports*, 1547.

7 Ibid., 235; see also "Exposition Universelle de Londres en 1851," 304.

8 Laborde, 235–37. Although the Procès-verbal of the Académie des beaux-arts does not mention this decision, it was frequently incomplete.

9 See the 1851 *Catalogue*, II: Nos. 1407–8; 1215–16; 45–46.

10 See Janin; he was the drama critic of the *Journal des débats*. Other accounts in French

periodicals include: Valon; "Exposition Universelle de Londres en 1851"; see also the weekly publication *Le Palais de cristal*.

11 Pradier received a Council Medal, DeBay and Etex Prize medals; see the 1851 *Liste des médailles*.

12 On Clésinger's *Femme piquée par un serpent*, see the Clésinger dossiers, Documentation du Musée d'Orsay; Théophile Gautier, "La Femme piquée par un serpent de M. Clésinger," *L'Artiste*, 22 August 1847, 122–23 and engraving; Thoré (2), "Le Salon de 1847," 536; Gustave Planche, "Le Salon de 1847," *Revue des deux-mondes*, May 1847, 541–43; A. Estignard, *Clésinger, sa vie, ses oeuvres*, Paris, 1900; Luc Benoist, "Le Sculpteur Clésinger (1814–1883)," *Gazette des beaux-arts*, 1928, II: 283–96; Luc Benoist, "La Femme piquée par un serpent d'Auguste Clésinger," *Bulletin des musées de France*, May 1931, 95–97; Jean Ziegler, "Baudelairiana. Madame Sabatier (1822–1890), Quelques notes biographiques," *Bulletin du bibliophile*, 1977, 365–82; Peter Fusco and H. W. Janson, *The Romantics to Rodin*, Los Angeles and New York, 1980, 175–76; Mainardi (5), "Appendix: Clésinger's 'Femme couchée.'"

13 Frédéric Chopin in a letter to his family in Poland, 8 June 1847, *Correspondance de Frédéric Chopin*, Bronislas Edouard Sydow, ed., 3 vols., Paris, 1953–60, III:284; quoted in Ziegler, 371. Théophile Gautier, "Sculpture," *L'Artiste*, 15 July 1848, 204.

14 See Gautier, 1847, and Thoré (2), "Salon de 1847," 536.

15 Gautier, 1847, 122.

16 The accusation came from Planche; see his "Salon de 1847," 541–43. Clésinger wrote to his lifelong friend Charles Weiss; quoted by Ziegler, 373, from his journal (30 June 1847, Bibliothèque municipale de Besançon). The *Bacchante* measures only 1.94 meters, but, considering the pose, is nonetheless larger than a life cast.

17 Fabien Pillet, "Beaux-Arts. Sculpture. Salon de 1848," *Le Moniteur universel*, 17 April 1848, 851; see also Gautier, 1847, who announced that Clésinger had just finished the *Bacchante*. Arsène Houssaye recounted that on 3 February 1848, Clésinger invited his friends to his studio where *La Bacchante* and *La Femme piquée* were both on display; the general preference was for the *Bacchante*; see Houssaye, "Le Salon de 1848," *L'Artiste*, 12 March 1848, 1.

18 Pillet, 851.

19 Théophile Gautier, "Le Salon de 1848," *La Presse*, 23 April 1848, 1–2, and "Sculpture," *L'Artiste*, 15 July 1848, 204 and engraving.

20 Valon, 224–225.

21 Laborde, 380–81. Laborde mistakenly called Clésinger's work *La Femme piquée par un serpent*, confusing it with the sculpture of the previous year; it is a mistake that many will make after him. The 30th class was Fine Arts, the 5th group was Heavy Machinery. The British had a majority on the Jury, eight of fifteen members.

22 1851 *Reports*, 685. In the section listing jury awards, only Clésinger received an "explanation."

23 Ibid., 701. A similar opinion was expressed in "The Great Exhibition," 23 August 1851, 242.

24 Charles Baudelaire, *Salon de 1846*, David Kelley, ed., Oxford, 1975, 242–43.

25 1851 *Reports*, 700.

26 The 1851 Exhibition received little coverage in the French press; the history of Clésinger's participation in it does not appear in any of the books, articles, or catalogues on the artist. Clésinger's name does not appear on the 1851 *Liste des médailles*.

27 AN F21 525. The complete correspondence is published in Mainardi (8).

28 1851 *Reports*, cci, cciii.

Chapter 4

1 A good discussion of the art world of the previous period is contained in Rosenthal, 1–78.

2 For a summary of the problems of defining the bourgeoisie, see Peter Gay, *The Bourgeois Experience. Victoria to Freud*, Vol. I: *The Education of the Senses*, New York and Oxford, 1984, 18–31. I am indebted to Daniel Sherman for discussions on this topic.

3 DuCamp (5), I:130.

4 The literature on Napoléon III is extensive; most studies, however, pay little attention to his taste in the arts (or lack thereof). An exception is that of Williams; see also T. A. B. Corley, *Democratic Despot, A Life of Napoleon III*, London, 1961; For a contemporary account, see Chennevières, "L'Empereur et l'Impératrice," Part II, 1–19. In his evaluation of the Emperor's taste, Chennevières was more positive, and possibly less reliable, than most of his contemporaries.

5 On Eugénie's taste in art, see Chennevières, Part II, 1–19; Kurtz, 330; Leroy, 117–40. On her taste in interior decoration, see Philadelphia Museum of Art, *The Second Empire*, 12.

6 Exposition Universelle de 1855 (5), 57.

7 On Prince Napoléon, see Edgar Holt; also Soubies, 3e série, 197–201. On the Maison Pompéienne, see Philadelphia Museum of

Art, *The Second Empire*, 63–64, 259–60. On his collection, see *Catalogue d'une collection d'antiquités par M. Fröhner, conservateur-adjoint des musées impériaux*, Paris, 1868; the sale was held on 23 March 1868 and identified as that of Prince Napoléon (annotated catalogue, Bibliothèque Nationale).

8 The best biography of Princess Mathilde is that of Castillon du Perron, Paris, 1963. She is mentioned often in Viel-Castel (2); see especially III: 27 April 1855. Her taste in art was discussed by Frédéric Masson, "La Princesse Mathilde," in the sale catalogue of Galerie Georges Petit, Paris, *Collection de S.A.I. Madame la princesse Mathilde, Catalogue des tableaux anciens, tableaux modernes, objets d'art et d'ameublement ..., 17–21 May 1904*, reprinted in *Les Arts*, May 1904. In addition to works by Giraud, her collection contained works by Toulmouche, de Nittis, Philippe Rousseau, Bonnat and one Meissonier watercolor.

9 As Nieuwerkerke was almost universally disliked, the only positive biography is that of his protégé Chennevières (see "Le Comte de Nieuwerkerke," Part II, 83–110); its reliability may be gauged by his attribution of Nieuwerkerke's rapid advancement to his friendship with Napoléon III. Other sources include Henriet, Malitourne, Galichon (4), Beaumont.

10 See Soubies, 3e série, 203–205; also Mercey (2). In his memoirs of Nieuwerkerke, Chennevières adopts his mentor's point of view towards Mercey.

11 Soubies, 3e série, 201–203.

12 On Morny, see Parturier and Grothe. For his taste in art, see Jacquemart. He held auctions in 1842, 1843, 1845, 1848, 1852, and there was a posthumous sale in 1865. See *Galerie de M. le duc de Morny, tableaux et objets d'art*, Paris, 31 May–12 June 1865. At his death, his collection of contemporary art included Decamps, Diaz, Gérôme, Meissonier, Th. Rousseau, and (although it is not mentioned) Courbet. On Morny and Courbet, see Mainardi (1).

13 Philadelphia Museum of Art, *The Second Empire*, 12–13.

14 Viel-Castel (2), II: 15 April 1852.

15 Kurtz, 122.

16 Viel-Castel (2), II: 27 July 1853.

17 These figures are taken from Angrand. Although he has not published the figures from 1860–1870, M. Angrand has kindly informed me that he has found no great changes in the second decade of the Second Empire. His article contains a good overview of the government art administration. In view of these statistics, it is difficult to accept the thesis of Albert Boime that the Second Empire attempted to impose realism as its official style; see Boime (4).

18 The incident was related by Viel-Castel (2), II: 30 October 1852; for confirmation, see AN F21 96: Marquet. The practice continued; see Viel-Castel (2), IV: 14 July 1857.

19 See, for example, the lists published in *L'Artiste*, 24 August 1856, 111–12.

20 Archives du Louvre X: Salon de 1857; correspondence of 17 October 1857. The inscriptions can still be seen on frames of paintings in provincial museums.

21 Ibid.; correspondence of 3 and 23 October 1857. Chennevières stated that the imperial couple chose the paintings bought on the civil list, but as it contained a high proportion of religious works, it is doubtful if this represented the personal taste of Napoléon III. Eugénie, who might be imagined to prefer such works, is instead credited by Chennevières with having chosen Baudry's *La Perle de la vague* from the Salon of 1863; considering her prudishness, this is highly unlikely. More work needs to be done on the personal taste of all of these important Second Empire figures.

Chapter 5

1 See Exposition Universelle de 1855 (7), 3.

2 The exact profit was £186,000; see Gibbs-Smith, 3–5.

3 *Discours prononcé par S.A.I. le prince Napoléon, Président de la Commission Impériale, à la séance d'inauguration de l'Exposition Universelle. 15 mai 1855*, Exposition Universelle de 1855 (7), 399–403.

4 On Pastoret and legitimist politics, see Soubies, 2e série, 162–65, and Delord (3), II:118–24. For his proposal see Institut de France, Archives de l'Académie des beaux-arts, Procès-verbaux, I, 8 March 1851.

5 For Brussels, see Lord Pilgrim, "Mouvement des arts," *L'Artiste*, 1 August 1851, 16; for Berlin, see "Mélanges," *Revue des beaux-arts*, 1 January 1852, 15–16.

6 See the catalogues for the 1953 New York and Dublin Exhibitions. William H. Gerdts clarified this point in his unpublished paper "Art and the Crystal Palace," presented at the symposium "Crystal Palace/42 Street/ 1853–54," C.U.N.Y. Graduate Center, 1974.

7 AN F12 3182; the decree was published in *Le Moniteur universel*, 30 March 1852, 517. Also see Pierre de La Gorce, 1:57.

8 On the Palais de l'Industrie, see AN F21 519,

F12 2895, F12 3182, F12 3183, F12 70619–5. Contracts between Achille Fould, Ministre d'Etat and M. de Rouville, Directeur de la Compagnie du Palais de l'Industrie are in F21 519, F12 2895. Also see *Convention* and *Cahier des charges relatif à la concession du Palais de l'Industrie, 29 August 1852*, in Exposition Universelle de 1855 (7), 164–69. Plans and descriptions were published in Barrault and Bridel; for a short account of its subsequent history, see Maglin. It was repurchased by the Government in 1857; see *Loi relative au rachat par l'Etat du Palais de l'Industrie du 6 juin 1857, Bulletin des lois*, 11e série, 9 (January–June 1857): 1021–32.

9 For the subsequent history of this innovation, see Mainardi (3).

10 Delacroix (2), 10 May 1854.

11 Exposition Universelle de 1855 (7), 49.

12 Ibid., *Décret instituant une Exposition Universelle de l'Industrie, 8 mars 1853*, 170.

13 The account of Frédéric de Mercey, Commissaire général de l'Exposition Universelle des Beaux-Arts, is generally reliable; see Mercey (1).

14 On Eugénie's role, see Mercey (1), 468–69, and *Discours prononcé par S.A.I. le prince Napoléon, Président de la Commission Impériale, à l'ouverture de la session du Jury d'admission et d'examen des oeuvres d'art, 20 mars 1855*, in Exposition Universelle de 1855 (7), 398.

15 Delord (3), II:123–24.

16 Mercey (1), 469; the meeting took place 16 May 1853.

17 *Décret instituant une Exposition Universelle des Beaux-Arts, 22 juin 1853*, in Exposition Universelle de 1855 (7), 171–72.

18 *Discours prononcé par S.A.I. le prince Napoléon, Président de la Comission Impériale à l'ouverture des travaux de cette Commission, 29 décembre 1853*, in Exposition universelle de 1855 (7), 396–97.

19 The decree of 22 June 1853 cancelled the Salons at the same time as it announced the Exposition Universelle des Beaux-Arts.

20 *Décret instituant la Commission Impériale, chargée de diriger l'Exposition Universelle de l'Industrie et des Beaux-Arts, 24 décembre 1853* in Exposition Universelle de 1855 (7), 172–75; the members are listed. Visconti died in December 1853 and was replaced by Léon Vaudoyer; Henriquel-Dupont resigned 7 March 1854 and was not replaced; see AN F21 519.

21 Viel-Castel (2), II: 27 December 1853, and Chennevières, Part II: 103. The appointment of Saulcy, curator of the Musée d'artillerie, as the only museum representative on the Imperial Commission was no doubt intended, and taken, as a public insult to Nieuwerkerke.

22 Exposition Universelle de 1855 (7), 11–12.

23 Prince Napoléon's 1853 speech was published in *Le Moniteur universel*, 27 July 1853, and included in Exposition Universelle de 1855 (3), XLIV–XLVIII.

24 Archives du Louvre X: Salon de 1855, memorandum *Exposition Universelle des Beaux-Arts*. The memorandum was neither signed nor dated but as it discussed various issues settled by the *Règlement* of April 1854, it was probably anterior to that date.

25 The contracts between Achille Fould, Ministre d'Etat, and M. de Rouville, Directeur de la Compagnie du Palais de l'Industrie, are in AN F21 519; see those of 10 December 1853, 17 July 1854, 26 October 1854; also see AN F12 2895, F12 70619–5, and *Bulletin des lois*, 11e série, 4 (July–December 1854): No. 1973: 404–405.

26 Prince Napoléon, *Discours ... 15 mai 1855*, Exposition Universelle de 1855 (7), 399–403; Mercey (1), 475.

27 Chemin-Dupontes, *Journal des débats*, 19 April 1854, in AN F12 3184.

28 Exposition Universelle de 1855 (7), 42–49; also see AN F21 519 for the treaty of 17 July 1854 annulling that of 10 December 1853 and returning the exposition to the Louvre. *L'Artiste* announced in "Mouvement des arts," 15 August 1854, 29–30, that the show would be in the Louvre.

29 See AN F21 519, treaty of 26 October 1854, for the construction of the Palais des Beaux-Arts; see also AN F12 2895 and F12 70619–5; Exposition Universelle de 1855 (7), 42–49; Mercey (1), 475–76. For the public announcement, see Lord Pilgrim, "Mouvement des arts," *L'Artiste*, 15 November 1854, 124.

30 *Discours ... 15 mai 1855*, Exposition Universelle de 1855 (7), 399–403.

31 Ibid., 81–82.

32 Luckhurst's discussion of English exhibitions is detailed and reliable; see 15–62. A good recent study is that of Jon Whiteley, "Exhibitions of Contemporary Painting in London and Paris, 1760–1860" in Haskell (2), 69–87.

33 See David, 1799. He did this again at the time of the 1801 industrial exposition; see the announcement in the *Gazette nationale*, 5e jour complémentaire, an IX (22 September 1801), 1506.

34 AN F21 550/60: Budget de 1848, 1849, 1850. Also AN F21 519: Statistique, and Mercey (1), 485.

35 Archives du Louvre X: Salon de 1855, memorandum *Exposition Universelle des Beaux-Arts*.

36 Mérimée to Madame de Boigne, 8 July 1855, in Prosper Mérimée, *Correspondance générale*, Maurice Parturier, ed., 2e série, I (1853–1855): No. 2272(N). For a discussion of the entrance fees, see Exposition Universelle de 1855 (7), 49, 82–85; also AN F21 519, Organisation générale.

37 Mouton, 5.

38 Mercey (1), 486.

39 The apology for such poor attendance was given in AN F21 519, *Note pour Monsieur de Mercey. Nombre de visiteurs à l'Exposition Universelle des Beaux-Arts*. Also see Exposition Universelle de 1855 (7), 483–93.

40 *Règlement général de l'Exposition universelle de 1855, 6 avril 1854*, in Exposition Universelle de 1855 (7), 176–94. The eight *groupes* comprised thirty *classes*, further broken down into *sections*; a *XXXIe classe*, Domestic Economy, was later added. The structure represents a typical nineteenth-century world view; the groups included: I. Industries having as their object the extraction or production of raw materials; II. Industries having as their object the use of machinery; III. Industries founded on the use of physics and chemistry or relating to the sciences and education; IV. Industries relating to the learned professions; V. Manufacture of mineral products; VI. Manufacture of fabrics; VII. Furniture and decoration, fashion, industrial design, printing, music; VIII. Fine Arts. The Fine Arts were subdivided into three classes: XXVIII. Painting, engraving and lithography; XXIX. Sculpture and medal engraving; XXX. Architecture. Photography was included with the decorative arts in the *VIIe groupe*. For the detailed classification system, see Exposition Universelle de 1855 (7), 255–348.

41 *Discours . . . 15 mai 1855*, ibid., 399–403.

42 Archives du Louvre X: Salon de 1855, memorandum *Exposition Universelle des Beaux-Arts*. The fear of the remnants of the School of David refers less to Ingres than to the "Old Guard," Heim, Abel de Pujol, Picot—a well-organized clique within the Academy.

43 Exposition Universelle de 1855 (7), 13–14.

44 Delacroix (2), 24 March 1854; for the Fine Arts *Règlement*, see Exposition Universelle de 1855 (3), XXX–XXXI.

45 On Morny's collection, see Chapter 4, Note 12, above.

46 AN F21 519, Jurys d'admission; see the hand-written memorandum from the Imperial Commission, *Placement définitif*.

47 For an expansion of this analysis, see Mainardi (7).

48 Delord (3), II:174.

49 Zeldin (1), 14.

Chapter 6

1 For a thorough explication of Napoléon III's system, see Zeldin (1).

2 On Ingres's political milieu, see Blanc (6), 175, and Lapauze, 465–73.

3 See Laurent-Jan, "M. Ingres, Peintre et Martyr," a satirical biography published in *Le Figaro* on 3 September 1843, reprinted 30 December 1855, 2–7.

4 Ingres to Marcotte, 1 February 1854; the letter was published in Blanc (6), 175–76.

5 Ibid., 176.

6 Ibid., 177. On 13 August 1854, Ingres wrote to Marcotte that he still had not reached a decision; ibid., 177.

7 Ibid., 178.

8 Ingres to Frédéric de Mercey, n.d.; the letter was published in Leroi, 904. Guénot (1), 343, reported on 15 November 1854 that although Ingres had initially refused to participate in the Exposition, he later agreed on condition that he have a private gallery.

9 Frédéric de Mercey to M. le Ministre d'Etat, 12 January 1855, in AN F21 88: Ingres.

10 See Exposition Universelle de 1855 (3), No. 3343, *Apothéose de l'Empereur Napoléon Ier*.

11 All subsequent citations are from Delacroix (1), *Correspondance* and Delacroix (2), *Journal*.

12 On Delacroix's commission for *La Chasse aux lions*, see AN F21 74: Delacroix; see also Delacroix (2), 20 March 1854.

13 Delacroix to Mademoiselle Mazuyer, 24 March 1855; Delacroix (1), III:249–50.

14 Delacroix wrote to Mercey to complain; see Delacroix to Frédéric de Mercey, 26 March 1855; ibid., III:250–51; see also Delacroix (2), 24 March 1855.

15 See Delacroix to Prince Napoléon, 11 April 1855; Archives du Louvre P30: Delacroix. For the response, see le comte de Nieuwerkerke to Varcollier (Secretary to Prince Napoléon), 11 April 1855, ibid. Part of the correspondence was published in Delacroix (3).

16 Dumas (1), 10 June 1855, 360.

17 Delacroix to Charles Baudelaire, 10 June 1855; Delacroix (1), III:266. Also see Delacroix to Philippe de Chennevières, 1 September 1855, in which, after hearing that Chennevières intended to rehang the painting exhibition, Delacroix wrote to express his satisfaction with his installation and to request that it be left unchanged; ibid., V:198.

18 Decamps wrote an autobiography, full of self-pity, in the form of a letter to his patron

Véron, dated 20 October–15 November 1854. It was first published in *La Revue de Paris* (which Véron founded) and later reprinted in the latter's memoirs. See Decamps and, for a general study, Mosby.

19 Jadin to le comte de Nieuwerkerke, 22 February 1855; Archives du Louvre P30: Decamps (Alexandre), Dossier relatif à l'exposition des tableaux et dessins, 1855. The following correspondence is contained in this dossier.

20 Ibid.: Nieuwerkerke to Decamps, 27 February 1855.

21 See ibid.: Decamps to Nieuwerkerke, 1 April 1855, and Nieuwerkerke to Decamps, 4 April 1855.

22 See Durande, 310. On Vernet, also see the exhibition catalogue *Horace Vernet: 1789–1863*, Ecole nationale supérieure des beaux-arts, Paris, 1980.

23 On Vernet's commission for *Napoléon Ier entouré des maréchaux et généraux morts sur le champ de bataille*, see AN F21 111: Horace Vernet; the painting was destined for the Tuileries but never finished.

24 Durande published the letter but did not identify "X"; see 311.

25 Gustave Courbet to Alfred Bruyas, published in Courbet (3), 485–90, and Courbet (4), 63–76. The date is given as December 1854 but this must be erroneous as Courbet did in fact submit a list of paintings before the deadline of 30 November. December would have been late to begin discussing a commission for a painting to be completed before the Universal Exposition; it is more likely that the letter was written earlier in the year.

26 See Aimé Gros, *François-Louis Français. Causeries et souvenirs par un de ses élèves*, Paris, 1902, 195–96.

27 Courbet to Alfred Bruyas, n.d.; Bibliothèque Nationale (hereafter BN), Cabinet des estampes, Yb 3 1739(8): Lettres de Gustave Courbet, No. 10; also published in Courbet (3) and (4). The announcement in "Mouvement des arts," *L'Artiste*, 15 April 1854, 94, stated that before 30 November artists were to send the Imperial Commission a list of paintings they would like to exhibit and an estimate of space required; works themselves were to be submitted to the Jury between 15 January and 15 March 1855. This letter was probably written in the fall as Courbet stated that he had sent in his list of paintings; it is obviously later than the one describing his luncheon with Nieuwerkerke.

28 Ibid., No. 8: Courbet to Bruyas, n.d.; also published in Courbet (3). As the deadline for submitting work was 15 March and Courbet

mentioned in the letter that he had obtained a two week extension, it was probably written in late Frebruary or early March.

29 Ibid., No. 7: Courbet to Bruyas, n.d.; also published in Courbet (3) and (4); probably written in early April when the jury decisions became known.

30 Ibid., No. 10: Courbet to Bruyas, n.d.; also published in Courbet (3); probably written in late April when Courbet was arranging his show.

31 Le Préfet de Police to the Ministre d'Etat, 21 April 1855; AN F21 521B, Correspondance avec des artistes. Courbet's request has not been preserved.

32 Ibid.: Préfet de Police to the Ministre d'Etat, 1 May 1855. It was the Préfet who informed the Ministre that Courbet claimed the rue Amélot address was an error. There is another letter, undated, granting Courbet permission to have his show on the avenue d'Antin or in the faubourg Montmartre.

33 Ibid.: Le Ministre d'Etat to the Préfet de Police, n.d.

34 See Note 29, above.

35 Courbet to Bruyas, n.d. in Courbet (3), 479–81. The letter was written after the opening of the Exposition at the Palais des Beaux-Arts on 15 May as he complained about the installation of his paintings there. The contract with Legros for the construction of his pavilion was dated 15–16 May 1855; see the first of seven boxes of Courbet papers in the BN, Cabinet des estampes, Yb 3 1739.

36 See Courbet (1).

Chapter 7

1 *Discours ... 15 mai 1855*, Exposition Universelle de 1855 (7), 401.

2 Two unsigned and undated proposals are in AN F21 519, a third in Archives du Louvre X: Salon de 1855, memorandum *Exposition Universelle des Beaux-Arts*. The artists' desire for an elected jury was expressed by L. Clément de Ris, "Mouvement des arts," *L'Artiste*, 17 December 1854, 152.

3 *Décrets instituant le jury d'admission et d'examen des oeuvres d'art, 20 janvier 1855*, Exposition Universelle de 1855 (7), 215–19; Jury members were listed.

4 Although Zeldin (1) discusses only electoral politics, the tactics used were strikingly similar.

5 George Sand to Maurice Dudevant-Sand, 23 May 1855; see George Sand, *Correspondance*, Georges Lubin, ed., 15 vols., Paris, 1964–79, XIII: No. 6658.

6 The registers of work submitted, though incomplete, have been preserved in AN F21* 2793.

7 *Discours ... 20 mars 1855*, Exposition Universelle de 1855 (7), 398. Prince Napoléon later admitted in his official report that the severity of the Jury had been necessitated by the shortage of space; ibid., 51.

8 Guénot (2), 137. Guénot did not cite Lehmann and Müller by name, but from the description it was obvious who was meant.

9 Delord (1). Delord was later the author of the six volume *Histoire du second Empire, 1848–1869*.

10 For the statistics, see Guyot de Fère, January–February 1855, 6; Guénot (2), 138; "Chronique," *Revue universelle des arts*, 1855, I: 70. The register is in AN F21 *2793.

11 Delacroix to Adolphe Moreau, 5 April 1855; Delacroix (1), V:195–96.

12 Guyot de Fère, 11 May 1855, 31.

13 AN F21 *2793; in the *Procès-verbaux du Jury d'admission*, sessions of 7 and 9 April 1855, these paintings are marked "R" for "Refused", then "Rev," for "Revision," then "Ad." for "Admitted."

14 See Exposition Universelle de 1855 (3).

15 Courbet to Alfred Bruyas, n.d., in Courbet (4), 85–89. The letter was obviously written in April as Courbet had already learned of his refusal by the Jury and was in the process of setting up his own show.

16 Delacroix to Mercey, 26 March 1855, Delacroix (1), III:250; on Vernet, see Leroi, 905; Decamps to Nieuwerkerke, 9 April 1855, Archives du Louvre P30: Decamps (Alexandre), Dossier rélatif à l'exposition des tableaux et dessins, 1855; Théodore Rousseau to the comte de Morny, n.d., Cabinet des dessins, Musée du Louvre.

17 Mercey (1), 479.

18 Exposition Universelle de 1855 (7), 61–62; see also AN F21 519, memorandum *Placement définitif*.

19 For an extended discussion of these ideas, see Swart (1), and Mainardi (7).

Chapter 8

1 Exposition Universelle de 1855 (5), 55–56.

2 This was mentioned by many of the critics; see, for example, Perrier (1), 13 May 1855, 15–16.

3 Gautier (2), I:2.

4 For a more extensive discussion, see Mainardi (7).

5 Auvray (3), 53–54.

6 See Goncourt, DuCamp (1), Gautier (2), De-

lécluze (1), Lavergne. According to Taxile Delord, the only influential men of letters who rallied to the Empire were Sainte-Beuve, Alfred de Musset, Prosper Mérimée, Emile Augier, and Théophile Gautier; see Delord (3), II:272. Prince Napoléon's book first appeared in articles in *Le Moniteur universel* as the work of Adrien Pascal, Chef du service de la publicité près de la Commission Impériale, supposedly compiled from statements made by Prince Napoléon during his visits to the Palais des Beaux-Arts. It consists largely of long quotations from Gautier—with some notable differences; see Exposition Universelle de 1855 (5). On the French press, see Bellanger, Bellet, and Collins.

7 Cousin (1), I: "Cours de l'histoire de la philosophie (1828)," 5–114; see 109. For an extensive discussion of eclecticism, see Boime (5), 3–35.

8 Cousin (1), I:102.

9 Ibid., I:108.

10 *La Grande Encyclopédie, Inventaire raisonné des sciences, des lettres et des arts par une Société de savants et de gens de lettres*, 32 vols., Paris, 1886–1902, s.v. "Eclectisme" by Adolphe Thiers.

11 Cousin (2), 206. First published in 1853, there were eighteen editions in the nineteenth century. Cousin's aesthetic ideas were first put forth in his "Du Beau réel et du beau idéal" of 1816 in his *Premiers essais de philosophie*; for a thorough discussion, see Frederic Will, *Flumen Historicum. Victor Cousin's Aesthetic and Its Sources*, Chapel Hill, N.C., 1965. I am indebted to Jack Spector for this reference.

12 Gautier (2), I:5.

13 Calonne (1), 21 (1855): 108, and Lavergne, 4.

14 Cousin (1), I:70.

15 Gautier (2), I:9.

16 See, for example, Perrier (1), 4 November 1855, 127; DuPays, 2 June 1855, 350.

17 This appears to have been a widespread phenomenon, mentioned by critics as diverse as, for example, Baudelaire (1), 26 May 1855, and Prince Napoléon in Exposition Universelle de 1855 (5), 59.

18 Cousin (1), I:83–90; the eleventh lesson is on Universal History. Another influential philosopher of the period was P. S. Ballanche, *Essais de palingénésie sociale*, Paris, 1830. For a cultural rather than political explanation of nineteenth-century French interest in Universal History, see Joseph C. Sloane, *Paul Marc Joseph Chenavard, Artist of 1848*, Chapel Hill, N.C., 1962.

19 Cousin (1), I:5–114, "Cours de l'histoire de

la philosophie (1828)." In addition, Vico was translated by Jules Michelet, and Herder by Edgar Quinet; Cousin claimed that he encouraged them to do so; ibid., I:89. Hegel developed these ideas in his lectures, but his *Philosophy of History* was published posthumously, in 1832, and not translated into French until the twentieth century.

20 Ibid., I:87.

21 See Sloane, *Chenavard*, 84–117, and G. L. Hersey, "Delacroix's Imagery in the Palais Bourbon Library," *Journal of the Warburg and Courtauld Institutes* 31 (1968): 383–403. Lee Johnson has challenged Hersey's reading; see his "A Corrected Plan of Delacroix's Ceiling in the Library of the Palais Bourbon," ibid., 32 (1969): 420–21.

22 Cousin (1), I:88.

23 Johann Gottfried Herder, *Idées sur la philosophie de l'historie de l'humanité*, Edgar Quinet, trans. and ed., 3 vols., Paris, 1827–28, I:i–ii. In his preface, Herder stated that these ideas were developed in his treatise *Encore une philosophie de l'histoire pour l'éducation du genre humain* of 1774; in his *Idées sur la philosophie* (first published in 1784) he substituted the metaphor of a flower which buds, blooms and dies.

24 See Prévost-Paradol; it was subsequently republished as *Essai sur l'histoire universelle*, and was used by French lycées into the twentieth century. On Prévost-Paradol, see Pierre Guiral, *Prévost-Paradol 1829–1870. Pensée et action d'un libéral sous le second empire*, Paris, 1955.

25 Paul d'Ambly, "Critique," *L'Artiste*, 1 June 1854, 136–38.

26 See Exposition Universelle de 1855 (5), 171; Baudelaire (1), 26 May 1855; see also Gautier (2), I:3.

27 For a thorough discussion, see Swart (2).

28 Fould spoke at the Awards Ceremony of the 1853 Salon to encourage artists to participate in the 1855 Universal Exposition; see Exposition Universelle de 1855 (3), XLV.

29 Loudun (1), Paris, 1855, 203.

Chapter 9

1 See Fremy, 23 October 1855.

2 Vignon, 183–84.

3 George Sand to Maurice Dudevant-Sand, 23 May 1855; see George Sand, *Correspondance*, Georges Lubin, ed., 15 vols., Paris, 1964–79, XIII: No. 6658.

4 Exposition Universelle de 1855 (5), 110.

5 Ibid.; the portrait was not listed in the catalogue, but its last-minute inclusion was here explained by Prince Napoléon; it is visible in Plate 33. For the identification of the paintings shown in Plate 33, see Trapp (1).

6 Gautier (2), I:142.

7 Ibid., I:143.

8 See Nadar (2), 19 August, 16 September 1855; DuCamp (1), 23; Delécluze (1), 7, 204, 260.

9 DuCamp (1), 417; he was describing Ingres and his followers.

10 Gautier (2), I:143.

11 Nadar (2), 23 September 1855.

12 Ibid., 16 September 1855.

13 See Villemessant.

14 Ibid., 2–7; the author was identified as "L. J."

15 Calonne (1), 21 (1855): 109, 112.

16 Enault, "La Chapelle de M. Ingres," 3 June 1855; the anecdote was published 6 May 1855.

17 See Blanc (6), 178.

18 See About (1), 116, and Vignon, 214–15.

19 Gebaüer, 20.

20 Gautier (2), I:143.

21 Baudelaire (2), 131.

22 Ibid.; also see La Rochenoire, I:41–42; Mantz (1), 221; Petroz (1), 30 May 1855.

23 Charles Baudelaire to François Buloz, 13 June 1855; see also Baudelaire to Auguste Vitu, 9 June 1855, in which he complained, "le père Ingres m'a donné un mal de chien;" Baudelaire to Philoxène Boyer, ca. 20 June 1855, in which he announced that he had found another review for his Ingres article; Baudelaire to the President of the Société des gens de lettres, 29 June 1855, in which he asked for a loan because he had been fired by his journal; Baudelaire (3), I:313–16.

24 Mantz (1), 177.

25 About (1), 208.

26 For a discussion of the divisions within the Academy, see Rosenthal, 238–44.

27 Nadar (2), 16 September 1855. On the other hand, Calonne showed himself aware of all the nuances of politics within the Academy; see Calonne (1), 21 (1855): 113.

28 On Heim, see Soubies, 2e série, 50–53; Delécluze (1), 208–209; Calonne (1), 21 (1855): 118; also see M. de Saint-Santin (Philippe de Chennevières), "M. Heim," *Gazette des beaux-arts* (hereafter GBA), 1 January 1867, 40–62.

29 Exposition Universelle de 1855 (5), 126.

30 Goncourt, 12.

31 Exposition Universelle de 1855 (5), 134–35; see also Gautier (2), I:283–84.

32 On fears for history painting, see Delécluze (1), 7. On Gérôme's commission for *Le Siècle d'Auguste: Naissance de N.S. Jésus Christ*, see AN F21 83: Jean Léon Gérôme; the commission was given in 1852 for 20,000 francs.

33 Exposition Universelle de 1855 (5), 171.
34 Several major artists abstained, such as Gleyre, Delaroche and Ary Scheffer among the painters, David d'Angers, Préault among the sculptors; Barye showed with industry. All the abstentions were mentioned and regretted by the critics.
35 See Swart (1).
36 On "l'apôtre du laid," see Ingres's 1855 letter published in Blanc (6), 183; Lapauze, 500, and Delécluze (1), 214; on "un peintre de décadence," see Calonne (1), 21 (1855): 128. For a more extensive discussion, see Mainardi (7).
37 Cousin (2), VI.
38 In a recent article, Francis Haskell has attempted to use the exceptions to disprove the rule; that is, he has cited critics whose politics and aesthetic positions were incongruent, as well as collectors whose tastes differed from the expected norm. This demonstrates only that history is a social science; despite individual variants, the generalization stands; see Haskell (3).
39 Lavergne, 71; for a similar opinion see Calonne (1), 21 (1855): 109.
40 Petroz (1), 2 May 1855.
41 Loudun (1), 13–14. Loudun's articles were originally published in the legitimist L'Union; his description of Delacroix as a revolutionary was not intended as praise.
42 "Mélanges," Revue des beaux-arts 6 (15 May 1855): 200.
43 Gautier (2), I:167.
44 Ibid., I:167.
45 Ibid., I:170.
46 Exposition Universelle de 1855 (5), 118–19; either a typographical error or an Ingrist typesetter has caused 1855 to be written as 1851 in the text.
47 Delacroix to Théophile Gautier, 22 July 1855; see Delacroix (1), III:279–80.
48 Lavergne, 87–88.
49 Delécluze (1), for example, dated the beginnings of the schism at 1824, the first Romantic attack on Classicism; 214, 241, 245; see Mainardi (7).
50 About remarked this; (1), 215.
51 Delécluze (1), 285–89.
52 Planche (1), 15 September 1855, 1156.
53 Mantz (1), 459; Petroz (1), 19 June 1855.
54 See, for example, Mantz (1), 458; La Rochenoire, II:67.
55 Petroz (1), 19 June 1855; also see Gebaüer, 141.
56 Exposition Universelle de 1855 (5), 146.
57 Sensier, 229.
58 Goncourt, 18.
59 See Decamps.

60 Decamps threatened to withdraw but did not; see Alexandre Decamps to le comte de Nieuwerkerke, 9 April 1855, and Nieuwerkerke to Decamps, 11 April 1855; Archives du Louvre P 30: Decamps. About was quite witty on the subject; see (1), 181–82.
61 La Rochenoire, I:51–52; About (1), 180–81; Enault, 17 June 1855.
62 "Mosaïque," Revue des beaux-arts 6 (1855): 353.
63 Goncourt, 45.
64 Vignon, 214–15.
65 Planche (1), 15 September 1855, 1150; also see Petroz (1), 11 June 1855.
66 Etex, 37–38.
67 Exposition Universelle de 1855 (5), 122–23.
68 For attacks on genre painting, see Delécluze (1), 12–13, 261; DuPays, 18 August 1855, 115–18; Calonne (1), 20 (1855): 501–502.
69 Goncourt, 17; see also Delécluze (1), 5; Loudun (1), 12.
70 Etex, 56, note 1; see also Planche (1), 15 October 1855, 408–12.
71 Perrier (1), 8 July 1855, 130.
72 Petroz (1), 17 September 1855; DuCamp (1), 218.
73 "Mosaïque," Revue des beaux-arts 6 (1855): 352–53; Georges Guénot, "Le Monde artistique, 17 septembre," ibid., 377–78; Gautier (2), II:65–66; Viel-Castel (2), III:28 August 1855. See also AN F21 519 for the list of purchases.
74 Delécluze (1), 241.
75 Exposition Universelle de 1855 (5), 110, 114.
76 About (1), 135.
77 Gautier (2), II:15, and Vignon, 219, mentioned that engraving had popularized the work of Vernet. Virtually everyone mentioned his popularity; see, for example, Gebaüer, 57; Loudun (1), 123; Enault, 10 June 1855, 4.
78 DuCamp (1), 205; he was not even discussed by Petroz.
79 See Rosenthal, 202–31.
80 Delécluze (1), 232; Perrier (1), 17 June 1855, 85–86; Vignon, 220.
81 Enault, 10 June 1855.
82 DuPays, 7 July 1855, 11–14.
83 Exposition Universelle de 1855 (5), 116; Gautier (2), II:12.
84 "Chronique," Revue universelle des arts, 1855, I:308.
85 Revue des beaux-arts 6 (1855): 138, 254.
86 Guyot de Fère, 11 May 1855, 33; July 1855, 82.
87 Edouard Houssaye, "Le Monde Parisien," L'Artiste, 15 April 1855, 221.
88 See Champfleury.
89 Charles Perrier (2).

90 See Fernand Desnoyers.
91 Nadar (2), 16 September 1855, 4; Lavergne, 85.
92 For a more extensive discussion, see Mainardi (1).
93 DuPays, 28 July 1855, 71.
94 See Quillenbois.
95 See Daumier's cartoon in *Charivari* (Plate 67), 8 June 1855, and Nadar's cartoon (Plate 68) in *Le Journal pour rire*, 13 October 1855.
96 DuCamp (1), 236.
97 Champfleury, 1.
98 Planche (1), 15 September 1855, 1151.
99 Perrier (2), 14 October 1855, 87.
100 Auguste Villemot, "Chronique Parisien," *Le Figaro*, 8 July 1855.
101 Delord (2), "Exposition des beaux-arts. L'Annexe Courbet," 4 July 1855.
102 Gebaüer, 127.
103 Belloy (1), 7 September 1855; see also Gautier (2), II:155–56.
104 Mantz (1), 364.
105 Delacroix (2), 3 August 1855.
106 Delacroix noted that Courbet had lowered the entrance fee to ten centimes; see Delacroix (2), 3 August 1855.
107 Courbet to Alfred Bruyas, 9 December 1855; see Courbet (3), 485.

Chapter 10

1 Petroz (1), 17 September 1855; on French ignorance of foreign art, see Clément de Ris, 9 June 1855, 35.
2 See *Règlement général de l'Exposition Universelle de 1855, 6 avril 1854*, art. 5 and 8, in Exposition Universelle de 1855 (7), 176–94.
3 See, for example, Calonne (1), 20 (1855): 695–706; Loudun (1), 2.
4 Exposition Universelle de 1855 (5), 96. Italy, not yet unified, was represented by Tuscany, the Kingdom of the Two Sicilies, the Papal States, and Sardinia.
5 Gautier (2), I:9.
6 Loudun (1), 7; on the Belgians, see also Clément de Ris, 9 June 1855, 35.
7 Mantz (1), 29.
8 On the Belgians, see Petroz (1), 7 August 1855; Perrier (1), 4 November 1855, 128; 19 August 1855, 213; Gebaüer, 221–22; Delécluze (1), 19, 194; Calonne (1), 20 (1855): 706–709.
9 Exposition Universelle de 1855 (5), 76.
10 On French knowledge of and attitudes towards Germany, see Swart (2), 47, 80–81, 98.
11 Gebaüer stated that the Düsseldorf painters had refused to participate because they weren't allowed to elect their own jury; see Gebaüer, XII–XIII.
12 Calonne (1), 20 (1855): 509–12.
13 Gautier (1), I:6.
14 Peisse, 17 June 1855.
15 Ibid., 25 May 1855; also see Delécluze (1), 153–54, 178–79.
16 Gautier (2), II:192; also see Calonne (1), 20 (1855): 507–509; Perrier (1), 5 August 1855, 189.
17 Calonne (1), 20 (1855): 509; Planche (1), 15 August 1855, 798, 820–21; see also Peisse, 25 May and 17 June 1855.
18 Planche (1), 15 August 1855, 798, 820–21; see also Delécluze (1), 7–8, 260–62.
19 DuCamp (1), 373; see also Petroz (1), 13 August 1855.
20 Mantz (1), 79.
21 On French attitudes towards Britain, see Swart (2), 55–58, 62.
22 On British art as materialistic, see Loudun (1), 3; on British ignorance, Gebaüer, 193.
23 Gautier (2), I:9; Loudun (1), 5; Lavergne, 8–9; the words used were *Individualité, Excentricité, Bizarrerie*.
24 Their popularity in France through engravings was mentioned by Delécluze (1), 109; Perrier (1), 26 August 1855, 226; Calonne (1), 20 (1855): 495.
25 Gautier (2), I:72.
26 While Landseer and Mulready were known in France through engravings, neither their, nor the Pre-Raphaelites', actual paintings were known at all; see Delécluze (1), 148; Lethève, Rodee. Virtually all the critics commented on the popularity of the British exhibition; see Exposition Universelle de 1855 (5), 100; Lavergne, 8; Calonne (1), 20 (1855): 493–94.
27 For the charge of French chauvinism, see "French Criticism on British Art," *The Art Journal* (1855): 229–32; For a recent statement, see Pointon, an earlier version of which appeared in Haskell (2). Pointon's article surveys the French reaction to British painting in 1855, but offers as explanation only French chauvinism; there are a number of factual errors, e.g. her assertion that most of the paintings in Courbet's exhibition had been rejected by the Jury, or that there were no French collectors who bought contemporary art.
28 Petroz (1), 4 July 1855; see also Calonne (1), 20: 495.
29 Perrier (1), 4 November 1855, 127; see also Delécluze (1), 2, 194; Calonne (1), 20 (1855): 493; About (1), 34; Petroz (1), 4 July 1855; Gebaüer, 221–22.
30 Lavergne, 9.

31 See Swart (2), 55–58; also Renan.

32 See Swart (2), 97; Montalembert's "crime" took place in 1857.

33 Delécluze (1), 12–13, 261.

34 Planche (1), 1 August 1855, 471; see also Perrier (1), 26 August 1855, 226; Delécluze (1), 8–9; Calonne (1), 20 (1855): 501–503.

35 Lavergne, 23; Renan, II:245–46. While Renan attacked England as the corruptor of taste, he praised Germany as the home of philosophy; see also Lavergne, 12–15.

36 Loudun (1), 3–4. The statement outraged the British; see "French Criticism," *The Art Journal*, 229.

37 Calonne (1), 20 (1855): 501–502.

38 Delécluze (1), 227.

39 Petroz (1), 31 July 1855; on British "modernity," see Gautier (2), I:8.

40 Delacroix (2), 17 June 1855; on French attitudes, see Swart (1).

41 Mantz (1), 124.

42 DuCamp (1), 320.

Chapter 11

1 The *Règlement général, 6 avril 1854*, specified that the 28e Jury (Painting, drawing, engraving) would have 20 members (15 French and 5 foreign) but also stated that representation would be proportional to participation; see Exposition Universelle de 1855 (7), 176–94, art. 59–60. As foreign participation became more extensive, the Jury composition changed. The *Décret, 19 mai 1855*, raised the total to 32 members (ibid., 220–21); the *Liste définitive du jury international de l'industrie et des beaux-arts* was published three times, 25 March, 10 August, and 6 October 1855 (ibid., 221–38). The list of Jury members published in Exposition Universelle de 1855 (3) is incomplete; an accurate list was published in the 1857 Salon catalogue.

2 Blanc (1).

3 See the memorandum *Exposition Universelle des Beaux-Arts* in the Archives du Louvre X: Salon de 1855.

4 *Décret, 10 mai 1855*, Exposition Universelle de 1855 (7), 240–44; Mercey (1), 491.

5 Delacroix (2), 15 October 1855.

6 The totals for all the Fine Arts (*8e groupe*) were: 16 Medals of Honor, 67 First Class Medals, 87 Second Class, 77 Third Class, 222 Honorable Mentions; in addition there were 40 nominations to the Légion d'honneur. For Industry there were 112 Grand Medals of Honor, 252 Medals of Honor, 2,300 First Class Medals, 3,900 Second Class, 4,000 Honorable Mentions; the corresponding awards were titled differently. See Exposition Universelle de 1855 (7), 406, and the 1857 Salon catalogue, XXXIX–LX.

7 "Mouvement des arts," *L'Artiste*, 11 November 1855, 152; the engraver Henriquel-Dupont also received a Medal of Honor.

8 Voting records have been preserved in the Archives du Louvre X: Salon de 1855, dossier 4, and also in AN F21 519.

9 Guénot (3), "Clôture de l'Exposition Universelle de 1855," 432. For Delacroix's and Villot's reaction, see Delacroix (2), 16 November 1855. The voting records are in the Archives du Louvre X: Salon de 1855, dossier 4.

10 Archives du Louvre X: Salon de 1855, dossier 4. According to the Archives du Louvre records, the artists who received First Class Medals because of Winterhalter were: Henry Scheffer, Abel de Pujol, Rouget, Corot, Chenavard, Huet, Lehmann, Larivière. The incident was reported in *L'Artiste*, 11 November 1855, 152–53, and *Revue des beaux-arts* 6 (1855): 431.

11 "Chronique," *La Revue universelle des arts*, 1855, II:239; also "Mosaïque," *Revue des beaux-arts* 6 (1855): 476; *L'Artiste*, 2 December 1855, 197.

12 Mercey (1), 491–92.

13 Exposition Universelle de 1855 (7), 156.

14 Guénot (3), 457; Vernet was called "le chef de l'école nationale."

15 The letter was published by Charles Blanc (6), 183.

16 Delacroix (2), 5 November 1855.

17 Lapauze, 477; also see Louis Flandrin, *Hippolyte Flandrin, sa vie et son oeuvre*, Paris, 1902, 151–54.

18 Mme Ingres to Jacques-Edouard Gatteaux, n.d., in Lapauze, 477–78.

19 "Chronique," *La Revue universelle des arts*, 1855, II:237. Gudin was promoted to Commandeur, Heim to Officier; Decamps was already Officier, and Meissonier was, for the moment, left at Chevalier. The careful planning that went into the shifts of rank among artists is shown by a document in the AN, *Liste des artistes vivants ayant obtenu des récompenses antérieurement au Ier mai 1853*, which gave Légion d'honneur dates, ranks and Academic membership for each of the French Medal of Honor winners; see AN F21 519.

20 *Discours . . . 15 novembre 1855*, Exposition Universelle de 1855 (7), 406.

21 Lapauze, 478.

22 Silvestre (2), 9. In 1856 Silvestre published some letters Vernet wrote in 1842–43; Vernet tried to suppress them and a lawsuit resulted, of which this is the memoir.

23 Ibid., 9–10: Horace Vernet to Prince Napoléon, 19 January 1856. The records in AN F21 111: Horace Vernet, show that the painting was never finished. After Vernet's death, his heirs gave the painting *St. George* to the Government in 1865 to settle the advance paid ten years earlier. Vernet did, however, receive and execute other commissions after 1855. According to Silvestre, Vernet actually wrote a letter presenting *The Battle of Alma* to King Jérôme of Westphalia, the father of Prince Napoléon; Silvestre (2), 10. The Government must have found a way to pacify Vernet for *The Battle of Alma (Crimea), 20 September 1854* appeared in the 1857 Salon, with the notation "Collection of His Imperial Highness Prince Napoléon;" see the 1857 Salon catalogue, N° 2620, and Lapauze, 478–81.

24 "Chronique," *La Revue universelle des arts*, 1855, II:240; the source was not identified other than that the article was reprinted from another journal.

Chapter 12

1 Paul Mantz (2), 9 (1857): 422–23.
2 Perrier (3), VIII; also see Thoré (2), "Nouvelles tendances de l'art," XIII; cte L. Clément de Ris, "Mouvement des arts," *L'Artiste*, 6 July 1856, 10; Castagnary (6), "Philosophie du Salon de 1857," I:15; Burty (1), July 1857, No. 1, 111–12.
3 The speech was published by Lord Pilgrim, "Mouvement des arts," *L'Artiste*, 23 December 1855, 235.
4 See Hautecoeur, and Gautier (3). See also Institut de France, Archives de l'Académie des beaux-arts, Procès-verbaux: 8–15 February 1851; Delacroix applied in 1837, 1838, 1839, 1849, 1851, 1853.
5 On Ingres, see Amaury-Duval, 185–86. Vernet objected that the rules called for a discussion of the candidate's merits which had not been held; see the Archives de l'Académie des beaux-arts, Procès-verbaux: 3, 10, 17, 24 January 1857. Hautecoeur states that Delacroix was elected on the tenth round, but cites no source. *Revue des beaux-arts* stated that Delacroix obtained 22 out of 37 votes; see "Mosaïque," 1 February 1857, 53.
6 Archives de l'Académie des beaux-arts, Procès-verbaux: 24 January 1857.
7 Ibid., 21 March 1857. The Procès-verbal for each meeting listed attendance and committees.
8 Rosenthal, 15.
9 "Ministère de la Maison de l'Empereur," *Le Moniteur universel*, 21 November 1856, and

L'Artiste, 23 November 1856, 316; this first announcement scheduled the Salon from 25 March to 25 May, with work to be submitted to the Jury 1–10 February, less than two months away. For a more extensive discussion see Mainardi (10).

10 The agricultural exposition was to be held 1–10 June. As a result of artists' protests their Salon was rescheduled to follow it; see cte L. Clément de Ris, "Mouvement des arts," *L'Artiste*, 30 November 1856, 328–29; "Ministère de la Maison de l'Empereur," *Le Moniteur universel*, 11 December 1856; *L'Artiste*, 14 December 1856, 13. The announcement of the composition of the Jury was made in the *Moniteur* announcement of 11 December 1856, and *L'Artiste*, 14 December 1856, 13–14.

11 Archives de l'Académie des beaux-arts, Procès-verbaux: 22 November 1856.

12 Paul Delaroche died on 4 November 1856. As the decision to turn the Salon over to the Academy wasn't announced to its members until 22 November, there was adequate time to discuss the inevitable candidacy of Delacroix. It is also to be noted that, although it was traditional for a eulogy to be read shortly after the death of each Academician, Delacroix, who died in 1863, was not eulogized until 1876; see Jules Guiffrey, *Les Membres de l'Académie des beaux-arts de 1796 à 1910. Notes bibliographiques*, Paris, 1911, 46.

13 See the announcement in *Le Moniteur universel*, 11 December 1856, and *L'Artiste*, 14 December 1856, 13–14; also Auvray (1), 3–5. On the Medal of Honor and paid admission, see the 1857 Salon catalogue, LXI–LXVIII.

14 The critics continued to criticize the policy of paid admission; see, for example, Auvray, 3–5; Delécluze (2), 2 July 1857; DuCamp (4), I:343–44; Montaiglon (2), 533–34.

15 Montaiglon (2), 534.

16 See the 1857 Salon catalogue; Gautier (4), 14 June 1857, 190; Auvray (1), 8–9; Delécluze (2), 2 July 1857. Paul de Saint-Victor quoted Victor Hugo's metaphor of printed books and Gothic architecture "Ceci tuera cela" to describe the effects of photography on painting; see Saint-Victor (1), 29 August 1857.

17 Auvray (1), 8. Auvray described himself as "Secrétaire-administrateur du Comité central des artistes;" his Salon criticism always included information on the contemporary art world.

18 The paintings for the Salon d'honneur would have been chosen by Nieuwerkerke. It was described by About (2), 5–6; Planche (2), 15 July 1857, 386.

19 The awards were listed in the 1859 Salon catalogue.

20 Fould's speech was published in *Le Moniteur universel* of 16–17 August 1857 and reprinted in the 1859 Salon catalogue, VIII–X.

21 See Delécluze (2), 20 June 1857; Planche (2), 15 July 1857, 377–403.

22 Perrier (3), VIII; see also cte L. Clément de Ris, "Mouvement des arts," *L'Artiste*, 6 July 1856, 10.

23 Castagnary (6), I:15.

24 Perrier (3) used "L'Art nouveau" as the title for the last chapter of his book; see also Burty (1), July 1857, No. 2, 122–24.

25 Gautier (4), 14 June 1857, 190–91.

26 Nadar (3), 58; see also Loudun (2), 32–33; Delécluze (2), 2 July 1857; Perrier (3), 120.

27 See Thoré (1), Mantz (3), Blanc (2), and the catalogue for Manchester 1857.

28 Castagnary (6), I:3.

29 Letter from Ingres to Magimel, 3 July 1857, published in Lapauze, 504.

30 Perrier (3), 184.

31 Calonne (2), 610; Delécluze, 2 July 1857; also see Fournel, July 1857, 744. Most of the critics praised *After the Masked Ball*; see, for example, Gautier (4), 5 July 1857, 245; Planche (2), 15 July 1857, 392; Montaiglon (2), 546.

32 *L'Artiste* published an engraving of Courbet's *Valley of Ornans* on 31 August 1856, and of *Valley of the Loue* on 19 October 1856.

33 Mantz (2), 10 (1857): 52; also see Gautier, *L'Artiste*, 20 September 1857, 34; Fournel, August 1857, 739.

34 Pérignon (1), 3–4.

Chapter 13

1 For a discussion of the various political approaches to the Second Empire, see Campbell, and Zeldin, (1).

2 On artists' reactions to each Salon, see Bazin, Rewald, and Chennevières, Part II: 6–8. A chart showing the relative harshness of the Juries is in White, 142–43.

3 See Delacroix (2), 12 October 1853.

4 Rioux de Mailloux, *Souvenirs des autres*, Paris, 1917, as quoted in Amaury-Duval, 220–21. The quarrel between Nieuwerkerke and the Academy was mentioned often in the Procès-verbaux of the Académie des beaux-arts in 1860 and 1861; also see *Le Moniteur universel* of 10 May 1860.

5 Viel-Castel (2), VI: 5 April 1863.

6 Ibid.; Viel-Castel noted that Chennevières, as curator of the Luxembourg, had acted with Nieuwerkerke.

7 The relevant archives and official documents are in AN ADXIXD 20/21/23 and F21 565; also see the Archives de l'Académie des beaux-arts, Procès-verbaux: 24 August 1861. Only four independent artists were elected.

8 On the Salon des refusés, see Boime (1) who dates the first major challenge to the Academy as the arbiter of French art at 1863; as has been shown in Part Two of this study, I place it at 1855. Also see Daniel Wildenstein, "Le Salon des refusés de 1863," *GBA*, September 1965, 125–52; Rewald, 77–89. The new *Règlement* was signed 14 August 1863 and published in the 1864 Salon Catalogue, XXIII–XXIX.

9 On the reform of the Ecole, see Boime (2), and Rewald, 89–90. Maxime DuCamp gave a hilarious account; see Ducamp (5), I:217–24. The reforms were published in *Le Moniteur universel*, 13 November 1863, and in *GBA*, "Ecole Impériale et spéciale des beaux-arts," 1 December 1863, 563–72.

10 On the Salon of 1864, see Boime (1), Bazin, Rewald, 102–107.

11 Ibid.; see Rewald for a year by year account of the Salon.

12 Auvray (3), 9.

13 Chennevières, Part II, 1–19. It is difficult to know whether Chennevières's account of the Emperor's taste is reliable, or to what degree the Emperor's Salon purchases reflected his own taste. The large proportion of religious paintings on Chennevières's list would seem to imply that paintings were being chosen for other reasons. Napoléon III's preference for tasty nudes has been amply corroborated by other sources; see, for example, Ludovic Halévy, *Carnets*, Daniel Halévy, ed., 2 vols., Paris, 1935, I: 27 November 1863. See above, Chapter 4, Note 4, for bibliography on Napoléon III.

14 Chennevières noted this last intention as that of Napoléon's and Eugénie's personal art purchases; see Part II, 13–14.

15 In addition to the bibliography cited above in Chapter 4, Note 5, see Chennevières, Part II, 1–19. On her taste in interior decoration, see Philadelphia Museum of Art, *The Second Empire*, 12. Chennevières's account of her taste in art is somewhat more positive than that given by the rest of her biographers; see Kurtz, 330, and Leroy, 117–40.

16 In addition to the bibliography cited above in Chapter 4, Note 8, see Castillon du Perron, 183, 203–206, 212–13.

17 In addition to the bibliography cited above in Chapter 4, Note 7, see Edgar Holt, 118–19, 194, 205, 210.

18 In addition to the bibliography cited above in

Chapter 4, Note 12, see Chennevières, Part IV, 123–27.

19 See the bibliography cited above in Chapter 4, Note 9. All the scandals mentioned here were known to Nieuwerkerke's contemporaries. Chennevières mentioned them but attempted to "explain;" others were less kind; see, for example, "Alfred Emilien, comte de Nieuwerkerke," in Pierre Larousse, *Grand dictionnaire universel du XIXe siècle*, 15 vols. and 2 supp., Paris, 1865ff, s.v. Maxime DuCamp recounted the story of how the imperial delegation was chased from the Ecole in 1864; see Ducamp (5), I:217–24.

20 *Bulletin des lois de l'Empire français* 35 (1870), Nos. 17390, 17391, 17392, all dated 2 January 1870. The new administrative structure can be seen in the 1870 *Almanach impérial*, Sections X and XI.

21 On Vaillant, see "Jean-Baptiste Philibert Vaillant" in Larousse, *Grand dictionnaire*, s.v. His speeches were published in the annual Salon catalogues beginning in 1864 (which contained his 1863 speech). Under Vaillant the fine arts were accorded a ministry level post; Nieuwerkerke reported to him in the same way that Mercey was responsible to Fould when the fine arts were a branch of the Ministère d'Etat.

22 See Chennevières and "Charles-Philippe Chennevières-Pointel" in Larousse, *Grand dictionnaire*, s.v.

Chapter 14

1 The speech was given at the Awards Ceremony, 25 September 1819; reprinted in the 1819 *Rapport*, XIII–XIV. The exposition took place in the Louvre, offering the conjunction of art and industry here praised.

2 Galichon (3), 409.

3 Until the 1873 Vienna Exposition, no other country but England merited the publication of official French Government reports; see the bibliography in Comité français des expositions, 271–73.

4 See Eugène Rouher, *Rapport à l'Empereur, 22 juin 1863*, reprinted in 1867 Paris (3), 2–3; see also Document No. 4, ibid., *Documents concernant l'organisation de l'association de garantie*, which listed the contributions by date. The Government and the City of Paris each gave 6,000,000 francs.

5 An *Exposition universelle des produits agricoles et industriels* was decreed on 22 June 1863 in response to Rouher's *Rapport*, ibid., 1. The Imperial Commission was appointed 1 February, 4 March, 1 July 1865, 6 January 1866;

ibid., *Deuxième décret, Quatrième décret, Cinquième décret*, 3–11, No. 19, 161. Prince Napoléon's letter of resignation of 27 May 1865 is in the Archives du Louvre, Exposition Universelle de 1867, dossier 2; he stated: "This decision was taken as a result of the publication in this morning's *Moniteur* of a letter addressed to me by His Majesty the Emperor." The dispute came about as a result of Prince Napoléon's speech in Ajaccio in which, as a representative of the Emperor but without his permission, he attacked the Pope and called for extreme liberalization of the Empire; see Edgar Holt, 205. The Prince Impérial was named President of the Exposition by *Décret*, 22 February 1866; see 1867 Paris (3), No. 20, 165.

6 Ibid., *Deuxième décret, 1 février 1865*, 3–5. Rouher had requested the art exposition in his 1863 *Rapport*, ibid., 2–3.

7 For the *Règlement général, 12 juillet 1865*, see 1867 Paris (3), No. 6, 45–52. The classification comprised ten groups: I: Works of Art; II: Materials and Applications of the Liberal Arts; III: Furniture and Other Domestic Objects; IV: Clothing (Including Fabrics) and Other Wearable Objects; V: Raw Materials; VI: Everyday Objects; VII: Food and Drink; VIII: Living Products and Specimens of Agricultural Establishments; IX: Living Products and Specimens of Horticultural Establishments; X: Objects Exhibited Especially to Improve the Physical and Moral Condition of the Populace.

8 *Arrêté concernant l'admission et l'envoi des oeuvres d'art, 12 mai 1866*, ibid., No. 22, 166–68.

9 For the records, see Archives de l'Académie des Beaux Arts, Pièces annexes: 1866, No. 39, and Procès-verbaux: 22, 29 September 1866.

10 Ibid., Procès-verbaux: 29 September 1866.

11 The *Avis* modifying the constitution of the Admissions Jury was published in *Le Moniteur universel*, 11 November 1866, 1298. Because of the problems caused by the Academy's refusal, the elections originally scheduled for 1–2 November were postponed to 15–16 November. Chennevières had written to Nieuwerkerke, 17 October 1866, stating that the artists couldn't hold their elections without knowing how many places they were to fill and urging Nieuwerkerke to push Rouher to make a decision; AN F21 523. Nieuwerkerke then wrote to Rouher proposing that the elected artists' section be increased to two-thirds of the Admissions Jury; ibid., draft of letter from Surintendant to Ministre d'Etat (Nieuwerkerke to Rouher), 18 October 1866.

12 See the Archives du Louvre, Exposition Uni-

verselle de 1867, Chennevières's memorandum to Nieuwerkerke dated 12 November 1866, in which he listed the elected artists. The list was published in *La Chronique des arts et de la curiosité* on 2 December 1866, 276–77; also see 1867 Paris (3), No. 25, *Arrêté instituant le jury d'admission des oeuvres d'art (Section française), 25 novembre 1866*, 182–85. The arrêté naming Dauzats to replace Ingres is in AN F12 3185.

13 Nieuwerkerke, as Surintendant des Beauxarts, was named President of the Admissions Jury. The government appointees included the collectors Maurice Cottier and Louis Lacaze, the artist Charles Leroux (who also had a political career as a government candidate), the curator Frédéric Reiset, the art critic Paul de Saint-Victor, and three sons: Welles de La Vallette, son of the Ministre de l'Intérieur, J. Halphen, son of a rich merchant, and the marquis Maison, son of a Napoléonic General. See 1867 Paris (3), No. 25, 25 November 1866, 182–85.

14 Charles Blanc and Théophile Gautier served on the Sculpture Jury; Chesneau's report is included in 1867 Paris (5), I.

15 See *Arrêté concernant l'admission et l'envoi des oeuvres d'art, 12 mai 1866*, 1867 Paris (3), No. 22, 166–68.

16 Galichon (1).

17 *Deuxième arrêté, 29 septembre 1866*, 1867 Paris (3), No. 22, 169. Nieuwerkerke was named President of all the Juries by the *Arrêté, 25 novembre 1866*; ibid., No. 25, 182–85. Rousseau was identified as the President of the Admissions Jury for painting and drawing in the list of jurors published in the 1868 Salon catalogue, VII–XX.

18 Unfortunately the registers and minutes of the Admissions Jury have been lost. The information on jury decisions has been taken from *La Chronique des arts et de la curiosité*, which seemed very well informed; see "Nouvelles," 10 February 1867, 44. The Exposition eventually included 254 French artists with 684 works, as the works awarded prizes in the 1867 Salon were moved to the Universal Exposition; this was reflected in the second edition of the catalogue, published at the end of the Exposition.

19 Although the petition has not been preserved, an anonymous article about it was published as "Correspondance de Paris, 23 janvier 1867" in *Le Courrier du centre*, Limoges, 24 January 1867, and *Le Salut public*, Lyon, 25 January 1867; the clippings are in AN F21 523.

20 Adolphe Yvon to Ministre le Surintendant Nieuwerkerke, 12 May 1866, in AN F21 522;

he succeeded in having his two paintings of Malakoff included in the Exposition. *La Chronique des arts et de la curiosité* reported on 10 March 1867 that Prince Napoléon had refused to lend works by Français, Breton, Pils, and Gustave Moreau; "Nouvelles," 78. On 7 April it reported that his collection at the Palais-Royal (where he lived) would be open to the public; "Nouvelles," 109. Emile Galichon (1) reported the rumors that the Government didn't want to lend works from museums or other public collections. Undoubtedly it was this criticism and the resulting scandal that caused the hasty revision of the rules.

21 Courbet to Bruyas 18 February 1867; BN, Cabinet des estampes, Yb 3 1739 (8): Lettres de Gustave Courbet; published in Courbet (3), 496–97, and Courbet (4), 121–23.

22 Exposition Universelle de 1855 (7), 140–41.

23 Paul Mantz (6), 1 July 1867, 7.

24 See *Grand Album de l'Exposition Universelle, 1867*, XII; also Fr. Ducuing, "Le Jardin central. Du Pavillon des monnaies au grand vestibule," *L'Exposition Universelle de 1867 illustrée*, 7 October 1867, 239–40.

25 See Galichon (3); for a similar critique, see DuCamp, "Les Beaux-Arts à l'Exposition Universelle" in DuCamp (3), 291–97.

26 See Louvrier de Lajolais.

27 Mantz (6), 1 July 1867, 8.

28 Blanc (3), 12 April 1867.

29 "Nouvelles," *La Chronique des arts et de la curiosité*, 5 May 1867, 142.

Chapter 15

The section of this chapter entitled "Manet's *View of the Universal Exposition*" is based on Mainardi (2).

1 Vaillant's speech was reprinted in the 1867 Salon catalogue, VIII–XII. At the 1865 Salon, Vaillant had announced only that there would be an 1867 Universal Exposition of Art; the decision to hold the annual Salon was probably made in 1866 at the same time as the decision to limit the space for art in the main exhibition.

2 The Academy's refusal to participate extended to the Salon Jury as well and so it also was redefined as two-thirds elected artists. The records of the elected and appointed Jury are in the Archives du Louvre X: Salon de 1867, dossier 1867 X 20. The Government appointed Cottier, Lacaze, Reiset, Théophile Gautier, marquis Maison; Rousseau was elected its President, Fromentin its secretary; the elected artists were the same as for the

Exposition Admissions Jury. See the 1867 Salon catalogue, LXXXX–LXXXXIV and the *Règlement*, XVIII–XXIII.

3 See "Nouvelles," *La Chronique des arts et de la curiosité*, 10 March 1867, 78; on 28 April 1867, 134, *La Chronique* announced that artists could sign the petition at M. Taluet's, 55 rue du Cherche-Midi. On 2 June 1867 the extension was announced; see "Une Réponse aux artistes," *La Chronique*, 172.

4 Castagnary (1); also see a news item titled "Correspondance de Paris, 1 avril" in AN F21 530, notated that it appeared in *Le Phare de la Loire* (Nantes) and *La Gironde* (Bordeaux), 9 April 1867; it appears to be a paraphrase of Castagnary's article.

5 Emile Zola to Antony Valabrègue, 4 April 1867; Zola (4), I:485–86. It is more likely that the Jury's conservatism was owing to the Universal Exposition.

6 The petition is in the Archives du Louvre X: Salon de 1867; it is dated "samedi, 30 mars 1867" and is in the handwriting of Frédéric Bazille, who was the first to sign immediately after the text.

7 The correspondence is in the Archives du Louvre X: Salon de 1867: Artistes refusés: demandes pour une exposition. On 13 April 1867, the Under-Secretary for the Cabinet de l'Empereur sent several of the demands to Nieuwerkerke with a note that they were in his jurisdiction. The artists' representatives were: President, Louis-Frédéric Grosclaude (Grosclaude fils), a portraitist who exhibited in the Salon 1849–1880 (birth and death dates unknown); Philippe Honoré Pinel, a genre painter who showed at the Salon 1848–1868 (birth and death dates unknown); Marc-Alfred Chataud (1833–?), an orientalist who lived in Algeria after 1892; Pierre-Isidore Bureau (1827–1876), a landscape painter. Grosclaude signed Bazille's petition as délégué, linking it to the request for an appointment with Nieuwerkerke of 9 April, signed by the above representatives.

8 Ibid.: Nieuwerkerke to Frédéric Grosclaude, Président délégué, 11 April 1867.

9 Ibid. The manifesto is undated.

10 Nieuwerkerke's refusal was reported in "Nouvelles," *La Chronique des arts et de la curiosité*, 28 April 1867, 134, and 5 May 1867, 142.

11 See "Nouvelles," *La Chronique des arts et de la curiosité*, 28 April 1867, 134, and 5 May 1867, 142; see also the announcement in *Le Figaro*, 22–23 April 1867, 3.

12 The letter was addressed to Monsieur le Surintendant des Beaux-Arts, dated 5 May 1867; AN F21 530: Salon de 1867. There are several similar letters in this dossier and in that of the Archives du Louvre X: Salon de 1867.

13 Bazille's letter was published in Poulain, 78–80; although undated, it was probably written in April.

14 Ibid., 82–83; the letter is undated but, as Bazille mentioned that Courbet's and Manet's shows were about to open, it was probably written in May.

15 On the Salon of 1867, see Lagrange (3), 35 (August 1867): 992; Saint-Victor (2), 9 May 1867; About (3), 22 May 1867; Challemel-Lacour; Castagnary (3), 25 May 1867.

16 Castagnary (3), 25 May 1867.

17 See the 1867 Salon catalogue; also About (3), 13 June 1867.

18 Saint-Victor (2), 9 May 1867.

19 See Babou, 284.

20 Gustave Courbet to Alfred Bruyas, 18 February 1867, BN, Cabinet des estampes, Yb 3 1739(8): Lettres de Gustave Courbet; reprinted in Courbet (3), 496–97, and Courbet (4), 121–23.

21 Gustave Courbet to Alfred Bruyas, 28 May 1867, BN, Cabinet des estampes, Yb 3 1739(8): Lettres de Gustave Courbet; also published in Courbet (3), 496–97.

22 Bazille stated this in an undated letter to Monet, probably written around 22 May 1867 as he mentioned that Courbet's show would open in a week; see Poulain, 81.

23 Pierre Dax, "Chronique des Beaux-Arts," *L'Artiste*, 1 June 1867, 479.

24 A portrait of Courbet by L. Petit was on the cover of *Le Hanneton illustré*, 13 June 1867; Gill did one for the cover of *La Lune*, 9 June 1867.

25 See Chesneau, "Groupe I," in Paris 1867 (5), I:86. Chesneau's articles were originally published in *Le Constitutionnel*, a leading imperialist journal, then reprinted as Chesneau (1); see 324–25. His official report is a heavily edited version of this book.

26 On Courbet see Chesneau (1), 326–29, and Lagrange (3), 35 (August 1867): 1024. Also see DuCamp (3), 343–44; his critique was originally published in *Revue des deux-mondes*.

27 Duret, 101.

28 Pérignon (1), 3–4.

29 Castagnary (4).

30 "Chronique," *Revue universelle des arts*, 1855, I: 240.

31 Edouard Manet to Emile Zola, 2 January 1867, in *Manet raconté par lui-même et par ses amis*, 2 vols., Geneva, 1953, I:47. Because of the complicated procedure, there has been some confusion in historical accounts which variously state that Manet had not been

invited to exhibit, that he did not apply because he was afraid of being rejected, or that he was in fact rejected.

32 See Chesneau in Paris 1867 (5), I:84–85. Zola reprinted his essay of 1 January 1867, "Une nouvelle manière en peinture. M. Edouard Manet," as a pamphlet to accompany Manet's private exhibition, adding a preface reiterating Manet's statement that the jury would have accepted a few of his pictures; see Zola (1), 5. In view of Manet's complete rejection by the more lenient Salon Jury of 1866, it is unlikely that he would have met with any success in 1867.

33 Manet borrowed 18,305 francs from his mother, according to A. Tabarant, *Manet et ses oeuvres*, Paris, 1947, 135. Zola, in a letter of 8 May 1867 to the editor Lacroix, said Manet had already spent 15,000 francs (the show opened 24 May); see Zola (4), 302–304.

34 Courbet to Bruyas, 28 May 1867, BN, Cabinet des estampes, Yb 3 1739(8); published in Courbet (3), 499–500.

35 Manet (1), "Motifs d'une exposition particulière," 6. While Manet's statement has often been attributed to Zacharie Astruc, Sharon Flescher in her study *Zacharie Astruc, Critic, Artist and Japoniste*, New York, 1978, 104, feels it is stylistically dissimilar to his writings.

36 Pierre Dax, "Chronique des beaux-arts," *L'Artiste*, 1 May 1867, 328; 1 June 1867, 479.

37 Edmond Bazire, *Manet*, Paris, 1884, 51; also see Jacques de Biez, *Edouard Manet*, Paris, 1884, 36–37. Biez also recounted the story that Courbet said Manet's *Olympia* was as flat as a playing card.

38 See David, 1799, 7.

39 MM. Jouy et Jay, *Salon d'Horace Vernet. Analyse historique et pittoresque de quarante-cinq tableaux exposés chez lui en 1822*, Paris, 1822, 4.

40 See Courbet (1); in 1867 Courbet did not issue a manifesto with his catalogue.

41 Manet (1), 5.

42 Antonin Proust, *Edouard Manet, Souvenirs*, Paris, 1913, 55.

43 "Nouvelles," *La Chronique de l'art et de la curiosité*, 2 June 1867, 174. In a letter to Antony Valabrègue, 29 May 1867 (five days after Manet's exhibition had opened), Zola wrote that it wasn't doing well but he hoped that his pamphlet would help; see Zola (4), 305–308. Monet wrote to Bazille, 25 June 1867, stating that Manet's receipts were improving; see Poulain, 94.

44 Manet's letter to Zola concerning the pamphlet is published in Denis Rouart and Daniel Wildenstein, *Edouard Manet, Catalogue raisonné*, 2 vols., Lausanne and Paris, 1975, I:14.

45 Zola, "Nos Peintres au Champ-de-Mars," in Zola (3), 107–15; originally published in *La Situation*, 1 July 1867.

46 Jules Claretie's account was published in *L'Indépendance belge*, 15 June 1867.

47 Duret, 103–11.

48 Chesneau (1), 343.

49 Ibid., Chapter VIII; for a discussion of Manet, 338–45.

50 Manet painted several middle-distance street views in 1877–78, but this was his only panorama. See Theodore Reff, *Manet and Modern Paris*, National Gallery of Art, Washington D.C., 1982.

51 On Manet's picture construction, see Nils Gösta Sandblad, *Manet, Three Studies in Artistic Conception*, Lund, 1954, 17–64; Jean C. Harris, "Manet's Race-Track Paintings," *The Art Bulletin* 48 (1966); 78–82; Alain de Leiris, "Manet: Sur la plage de Boulogne," *GBA*, January 1961, 53–62.

52 See Willoch; I am indebted to the author for clarifying some points in his article for me.

53 Berthe Morisot's painting was traditionally identified as *View Downstream From the Pont d'Iéna*, shown in the 1866 Salon, causing historians to assume that Manet was inspired by her painting; see Paul Jamot, "Etudes sur Manet," *GBA*, January 1927, 27–50. M. L. Bataille and Georges Wildenstein, in their *Berthe Morisot, Catalogue des peintures, pastels et aquarelles*, Paris, 1961, identified *View Downstream* as another painting (catalogue No. 11), completely unlike Manet's, and redated her *View of Paris from the Trocadéro*, shown here, to 1872 (catalogue No. 23).

54 J. G. Links, *Townscape Painting and Drawing*, New York, 1972, 124. I am indebted to Ann Sutherland Harris for bringing this study to my attention.

55 This was the view recommended in *L'Exposition Universelle de 1867 illustrée*, the official publication of the Exposition; see Fr. Ducuing, "L'Empereur au Champ de Mars et l'ouverture de l'Exposition," No. 2, 18, and comte de Castellane, "La Seine et l'Exposition," No. 3, 47–48. Of the twelve views of the Exposition preserved in the Bibliothèque Nationale, Cabinet des estampes, ten show the view from the Trocadéro; see the collection *Exposition Universelle 1867, Champ-de-Mars*, I. This view was recommended outside of Exposition years as well: see Dumas (2), 237.

56 Sigurd Willoch was the first to suggest this in his 1976 article. Previous scholars had cited Goya's *Pradera de San Isidro* until it was

discovered that Manet had not been able to see it during his trip to Spain; see Elie Lambert, "Vélazquez et Manet," *Vélazquez, Son temps, son influence. Actes du colloque tenu à la casa de Vélazquez, les 7, 9 et 10 décembre 1960*, Paris, 1963, 121–22. Mazo's *View of Saragossa* may also have been available to Manet through an engraving published in Charles Blanc, *Histoire des peintres de toutes les écoles*. The volume *Ecole Espagnole*, published as a book in 1869, was probably available earlier in fascicles (the paging is not continuous). W. Bürger wrote the section "Juan Bautista del Mazo" and stated that Velázquez painted the figures in Mazo's *View of Saragossa*; modern scholarship has rejected this theory but it was widely held at the time. Bürger also noted that at comte de Gessler's 1866 sale in Paris there was a *Vue de ville* possibly representing Saragossa or Pamplona, with figures attributed to Velázquez. Considering Manet's interest in Spanish painting, it is reasonable to assume that he attended this sale; in any case, his *View of the Universal Exposition* had Spanish as well as popular sources.

57 Zola (1), 24.
58 See Links, 116–20.
59 Dumas (2), I: Chapter II: 107–10.
60 Daumier's first lithograph on the subject appeared in *Charivari*, 5 January 1867, his last on 26 November 1867. They are reproduced in Loys Delteil, *Le Peintre-Graveur illustré*, 31 vols., Paris, 1906–26, XXVIII (Daumier): No. 3547–3610.
61 See, for example, *Paris-Guide*, II:1380; also *L'Exposition populaire illustrée*, (1867): No. 1, 2–6.
62 Fr. Ducuing, "Le Phare électrique anglais," *L'Exposition Universelle de 1867 illustrée*, (1867): No. 26, 406–407. An engraving of the lighthouse appeared on page 408. For a further discussion of this structure and its significance, see Mainardi (3).
63 For a further discussion of the relationship between "seeing" and "picture-making," see Finkelstein. Sigurd Willoch has called my attention to an article by Werner Hofmann, "Poesie und Prosa, Rangfragen in der neueren Kunst," *Jahrbuch der Hamburger Kunstsammlungen* 18, Hamburg, 1973, 173–92; Hofmann discusses the Epinal print (the prose) in relation to Manet's vision (the poetry). For a different reading of the relation between Manet's picture and its public occasion, see Clark (3), 60–66.
64 John Richardson, *Edouard Manet, Paintings and Drawings*, New York, 1958, 13; Richardson wrote of Manet's "compositional

difficulties" in his paintings of the 1860s, including his *View of the Universal Exposition*. Michel Florisoone, *Manet*, Monaco, 1947, XX, called it "clumsy." Alan Bowness, "A Note on 'Manet's Compositional Difficulties,'" *The Burlington Magazine* 103 (June 1961): 276–77, responded to Richardson by stressing Manet's search for informal compositions suitable for scenes of everyday life.

65 For a general discussion of Manet's use of popular imagery, see Anne Coffin Hanson, *Manet and the Modern Tradition*, New Haven and London, 1977, 36–43, 58–68. Alain de Leiris has noted the quality of caricature in Manet's work of the 1860s; see Note 51 above. Manet's images of working-class women are similar to those of caricaturists such as Cham; see Cham (5) and (7). Earlier collections such as *Les Français peints par eux-mêmes* showed the same general "types": "La Ménagère Parisienne" (1841 edition, III:17–23); "L'Ouvrier de Paris" (1842 edition, V:361–76); "Les Cris de Paris," (1841 edition, IV:201–209).
66 "La Mode," *Le Follet, Journal du Grand Monde, Fashion, Polite Literature, Beaux-Arts, etc*. This magazine, published in English, included a fashion column which was a report from Paris, translated from French. Short skirts were described beginning in May, and small oval bonnets were reported in the June issue. *Le Monde illustré* also had a fashion column, "Courrier de la mode," written by vicomtesse de Renneville who preached "simple elegance." She too may have seen Manet's extravagant creature, for on 15 June, after having previously reported the small hats and the absence of crinolines, she wrote: "Let's not even discuss the coquettes badly dressed in chiffon ..." (375–76). On current fashions, also see "Les Modes du printemps," *L'Illustration*, 25 May 1867, 333–34.
67 For a discussion of *cocottes* and *cocodottes*, see Octave Uzanne, *Monument esthématique du XIXe siècle. Les Modes de Paris. Variations du goût et de l'esthétique de la femme 1797–1897*, Paris, 1898, 165–67.
68 *Les Français peints par eux-mêmes* included a discussion of *La lionne* (as the *amazone* was then called); see the 1841 edition, II:9–16. Manet subsequently painted the *amazone* several times; see Rouart and Wildenstein, I: Nos. 160, 394, 395, 396. The *Amazone*'s riding habit changed little during the century: Renoir, Constantin Guys and Daumier all depicted her in approximately the same attire. For an example contemporary with Manet, see the advertisement of Lavigne &

Cheron, 1867, reproduced in Joanna Richardson, *La Vie Parisienne 1852–1870*, London, 1971, 244.

69 They were identified as a provincial couple by Etienne Moreau-Nélaton in his *Manet raconté par lui-même*, 2 vols., Paris, 1926, I:92. While his Tyrolese hat and short jacket and her parasol, sash, and short skirt were fashionable, they represented a more bourgeois, less dandified fashion than shown by either the young woman on their left or the two gentlemen on their right; see Uzanne, 177, and "La Mode," *Le Follet*, June 1867. A caricature in *Le Monde illustré*, 27 April 1867, 260, "Les Etrangers sont dans nos murs," showed English tourists dressed similarly; the French liked to show the English dressed in "sensible" clothing. An advertisement for "tourist and shooting suits," almost identical to the man's outfit, was in *Bradshaw's Handbook to the Paris International Exhibition 1867*, London, 1867, vi. The bourgeois couple reappeared, with minor changes, in Manet's 1869 *Departure of the Folkestone Boat* and have been there identified as Léon Leenhoff and Madame Manet; it is likely that Manet either copied them from his *View of the Universal Exposition*, or used the same preliminary sketches for both; see Rouart and Wildenstein, I: No. 147.

70 He appears here in the same attire as in *Luncheon in the Studio* of 1868; for his outfit, see the fashion plates for 1 May 1867 issued by Edward Minister and Son, included in the New York Public Library collection *Costume plates showing styles for men, taken from French fashion journals of the period between September 1854 and February 1869*, New York, 1900, IV (January 1866–February 1869). It is not surprising that Léon Leenhoff should be dressed in English fashions, for London was the ruler of men's fashion just as Paris determined women's styles. The anthology *Le Diable à Paris, Paris et les Parisiens*, 2 vols., Paris, 1845–46 (reprinted 1857 and 1868), had a cartoon by Bertall, "Les Enfants à Paris," showing the different types of children (II:256–57). Léon is similar to the obviously bourgeois child captioned "Fort en thème" who is shown next to a *voyou*, a lower-class child. *Les Français peints* also included a chapter on "Le Gamin à Paris" (1841 edition, II:161–70). Manet depicted the *gamin* several times: an etching of 1861 shows him, with Léon's large dog, as does the related painting; see Jean C. Harris, *Edouard Manet, Graphic Works*, New York, 1970, No. 11, and Rouart and Wildenstein, I: No. 47. There is also an 1862 lithograph, Harris No. 30.

71 Bertall had a cartoon, "Coup d'oeil sur l'Exposition Universelle de 1867," in *L'Illustration*, 31 August 1867, 141, which showed a fashionable dandy pair much like Manet's *cocodotte* and *petit crevé*. In March 1867 a verse was published mocking this style: "Le chapeau de forme est très bas. / Le gilet est presque invisible; / Le pantalon, lui, c'est risible, / Est collant du haut jusqu'en bas. / L'habit est plus court qu'une veste, / Le tout est si court qu'on en rit; / Devons-nous parler de l'esprit? / Il est aussi court que le reste." See Uzanne, 178.

72 Because of the proliferation of uniforms according to battalion, function, rank and occasion, it is difficult to make an exact identification. Théodore Duret, Manet's contemporary, identified them as Imperial Guardsmen; see his *Manet et son oeuvre*, Paris, 1902, No. 92. The history by Auguste Richard, *La Garde (1854–1870)*, Paris, 1898, showed photographs of Imperial Guardsmen wearing seemingly identical uniforms; see 177, 222, 271. The Imperial Guard was created by Napoléon III in 1852, immediately after the *coup d'état*, to imitate that of the first Empire; see Richard, 1.

73 For some early French examples, see the work of Israël Silvestre, principal engraver to Louis XIV, in Israël Silvestre, *Vues de Paris*, Paris, 1977. The more ambitious the panorama, the more inclusive the staffage; see particularly No. 118, *Veüe du Palais des Tuileries du costé du Jardin*, 1668. I am grateful to Leonard Slatkes for several discussions on the meaning of staffage in Northern townscape images.

74 For a summary of the findings of Manet scholars on this subject, see Hanson, 58–68.

75 For the early history of balloons, see François-Louis Bruel, *Histoire aéronautique des monuments peints, sculptés, dessinés et gravés, des origines à 1830*, Paris, 1909; also see John Grand-Carteret and Léo Delteil, *La Conquête de l'air vue par l'image (1495–1909)*, Paris, 1909.

76 On Nadar's balloon, see Fulgence Marion, *Les Ballons et les voyages aériens*, Paris, 1869, 229–47; the activities of Nadar's balloon during the Exposition were reported in "L'Aérostation en présence de l'exposition," *L'Exposition populaire illustrée*, (1867): No. 9, 70–71.

77 See the full-page illustration of *Le Géant* in *L'Exposition populaire illustrée*, (1867): No. 9, 72.

78 See, for example, Bruel, No. 54.

79 Victor Hugo, "Plein Ciel," *La Légende des siècles*, 2 vols., Paris, 1859, II:219–48. George Mauner cites Hugo's poem in connection

with Manet's images of balloons, but inter-
prets them in a religious sense; see his *Manet,
Peintre-Philosophe. A Study of the Painter's
Themes*, University Park, Pa., and London,
1975, 173–76.

80 Hugo, "Plein Mer," *Légende*, II: 207–17.

81 Hugo, "Plein Ciel," *Légende*, II: 241.

82 Théophile Gautier, "A Propos de ballons,"
Le Journal, 25 September 1848, reprinted in
his *Fusains et eaux-fortes*, 1880, 253–64; see
256.

83 For the Daumier lithograph, see Delteil,
XXVIII: No. 3643. Originally published in
Charivari, 30 May 1868, it showed a little boy
looking at the balloon "Le Progrès" and
asking: "But papa why isn't it going any
higher?"

84 This same metaphoric use of the balloon-as-
globe seems to occur in Manet's 1862
lithograph *Le Ballon* (Harris, No. 23) which
also includes a full spectrum of Paris society,
from a crippled beggar to ladies and
gentlemen. See the article by Douglas Druick
and Peter Zegers, "Manet's 'Balloon':
French Diversion, The Fête de l'Empereur
1862," *The Print Collector's Newsletter* 14
(May–June 1983): 38–46.

85 On the Krupp cannon, see "A propos de
canons," *L'Exposition populaire illustrée*,
(1867): No. 5, 39. When the King of Prussia
visited the Exposition with Bismarck, he was
taken on a ceremonial tour of the gardens,
the Prussian section, the exhibitions of
machinery and art; he later returned without
the official party to study the exhibition of the
French War Ministry. This was reported in
the press; see "S. M. le roi de Prusse à
l'Exposition," *L'Exposition populaire illustrée*,
(1867): No. 7, 50.

86 Manet (1), 3–7.

87 Zola (1), 11. Manet's "crime" was his disres-
pect for "The Beautiful."

88 Tabarant has also dated the painting June
1867; 140.

89 The signature on the lower right was added
by Mme Manet; see Rouart and Wildenstein,
I: No. 123.

90 On Manet's state of mind during this time,
see Proust, *Manet, Souvenirs*, 55–56, and
Tabarant, *Manet*, 139.

91 Proust, *Manet, Souvenirs*, 55–56.

92 Antonin Proust, "L'Art d'Edouard Manet,"
Le Studio, 15 January 1901 (Supplement No.
28 to *The Studio*, London), 76.

93 The various sources and versions of Manet's
painting and their chronology are discussed
by Sandblad (109–61) who feels that Manet
did not begin until his return to Paris in Sep-
tember, after Baudelaire's death. A more
recent study, the catalogue *Edouard Manet and
the Execution of Maximilian*, Brown Univer-
sity, Providence, R.I., 1981, proposes that he
could have begun as early as July; see
Pamela M. Jones, "Appendix: Documenta-
tion," 116–22. Although it has been stated
that Manet was prevented by the Govern-
ment from exhibiting *The Execution of
Maximilian* at his private exhibition,
Sandblad feels it unlikely that the Govern-
ment would have had advance knowledge of
his plans. Only the first version, which did
not show the soldiers in French uniforms,
could have been finished in time. He con-
cludes that legend has confused the painting
with the lithograph, which was, in fact,
suppressed. Albert Boime, in his "New Light
on Manet's Execution of Maximilian," *Art
Quarterly* 36 (autumn 1973): 172–208, has
argued that, in the distraught frame of mind
that followed the failure of his exhibition,
Manet may have personally identified with
Maximilian who was his exact age, bore a
physical resemblance to him, and had also
been "betrayed" by lack of support from the
French Government. For a compilation of
documents on *The Execution of Maximilian*, see
the Brown catalogue and the 1983 Paris exhi-
bition catalogue, *Edouard Manet, 1832–1883*,
529–31.

94 Chesneau (1), 345.

Chapter 16

This chapter is based on Mainardi (4).

1 Thoré (3), "Exposition Universelle de
1867," II:385.

2 Ibid., II:344. Duret voiced a similar opinion;
18.

3 Lagrange (1); the announcement was made
in Galichon (2). Ingres was born 29 August
1780 and died 14 January 1867.

4 Lagrange (2), 33. The deceased history
painters included Paul Delaroche
(1797–1856), Ary Scheffer (1795–1858),
Horace Vernet (1788–1863), Eugène Dela-
croix (1798–1863), Hipolyte Flandrin
(1809–1864).

5 DuCamp (3), 334; also see Clément (2), 28
March 1867.

6 Thoré (3), II:344; Pierre Dax, "Chronique
des beaux-arts," *L'Artiste*, 1 April 1867, 157.

7 Clément (2), 28 March 1867.

8 See, for example, Dax, "Chronique des
beaux-arts," *L'Artiste*, 1 August 1867, 290.

9 DuCamp (3), 334; Mantz (6), 1 July 1867, 8.

10 Galichon suggested the memorial exhibition

at the same time as he announced the death of Ingres; see Galichon (2). the show was announced in "Nouvelles," *La Chronique des arts et de la curiosité*, 10 February 1867, 44.

11 See Ingres, 1867, 1. For Nieuwerkerke's role, see "Nouvelles," *La Chronique des arts et de la curiosité*, 10 February 1867, 44, and "Exposition des oeuvres d'Ingres," ibid., 7 April 1867, 109. The show ran until 15 June, with paintings from public and private collections being added during the entire period; see "Nouvelles," *La Chronique*, 24 February, 63; 24 March, 93; 5 May 1867, 142–43.

Chapter 17

1 Chesneau (1), 88.

2 *Règlement fixant la nature des récompenses et organisant les jurys chargés de les répartir, 9 juin 1866*, in 1867 Paris (3), No. 24, 173–78.

3 Ibid. See also *Arrêté nommant les membres français du jury des récompenses pour le premier groupe (oeuvres d'art), 4 mars 1867, Arrêté fixant la répartition détaillée des membres étrangers du jury des récompenses par pays, par groupe et par classe, 29 novembre 1866, Arrêté fixant la publication de la liste définitive du jury, 25 mars 1867*; ibid., No. 26, 188–95. The list of members of the Jury des récompenses was published in the 1868 Salon catalogue, X–XII. Among those eliminated, Baudry, Breton, Brion were the youngest members of the Admissions Jury; Couture, Jalabert, Dauzats ranked lowest in the voting; Hébert was in Rome, Gleyre was Swiss.

4 1867 Paris (3), No. 24, 9 June 1866, 173–78. The Fine Arts as a whole received 17 Medals of Honor (Industry 66), 32 First Class Medals (Industry 1,144), 44 Second Class Medals (Industry 4,411), 46 Third Class Medals (Industry 7,388); in addition, there were 6,247 Honorable Mentions for Industry, none for Art; totals are from 1867 Paris (6), 207.

5 "Nouvelles," *La Chronique des arts et de la curiosité*, 28 April 1867, 133; 19 May 1867, 158–59. For the Jury's request, see the Archives du Louvre, Exposition Universelle de 1867, XU 2, *Extrait du procès verbal de la séance du 22 avril du Jury International de peinture.*

6 See Blanc (3), 15 May 1867. See also Louvrier de Lajolais; Galichon (3) referred to this disagreement. There is a letter in the Archives du Louvre, Exposition Universelle de 1867, XU 20, from Nieuwerkerke to le Ministre d'Etat (Rouher), 28 April 1867, asking for the letter "written by a certain number of

Jury members" on 14 April, but the letter itself has not been preserved.

7 This was criticized by DuCamp (3), 296, and Thoré (3), II:349.

8 See "Petits événements," *Le Figaro*, 26, 29 April 1867; Pierre Dax, "Chronique des beaux-arts," *L'Artiste*, 1 May 1867, 325; *La Chronique des arts et de la curiosité*, "Récompenses," 12 May 1867, 148–49, "Nouvelles," 5 May 1867, 141. The list of prize winners was published in *Le Moniteur universel*, 2 July 1867, 848, and in the 1868 Salon catalogue.

9 Chesneau in 1867 Paris (5), I:52.

10 Montifaud, 1 June 1867, 456. Montifaud reviewed the Universal Exposition and the Salon of 1867 together.

11 Blanc (3), 15 May 1867.

12 Castagnary (6), I:7.

13 Saint-Victor (2), 9 May 1867; Saint-Victor discussed both exhibitions together.

14 Chesneau in 1867 Paris (5), I:65; also in Chesneau (1), 216.

15 Duret, 18; see also Fouquier, 18 April 1867.

16 Thoré (3), II:361.

17 Clément (2), 28 March 1867; see also Mantz (7), 23 November 1867, 331; Blanc (3), 19 June 1867; Lagrange (3), 35 (August 1867): 1003. Ingres died 14 January 1867, Cornelius 6 March 1867.

18 Clément (2), 11 April 1867.

19 Chesneau (1), 171; Chesneau's unflattering comments on Cabanel were omitted from the official report.

20 Fouquier, 18 April 1867; also see Lagrange (3), 35 (August 1867): 997.

21 Marius Chaumelin, 101. Chaumelin's critique originally appeared in *La Revue moderne*.

22 Zola (3), "Nos Peintres au Champ-de-Mars," 111; see also Mantz (6), 1 October 1867, 323.

23 Thoré (3), II:349–50.

24 Zola (3), 110.

25 Chesneau (1), 101; Blanc (3), 5 June 1867. Chesneau's negative judgment on historical genre painting was omitted from his official report, 1867 Paris (5).

26 Chesneau in 1867 Paris (5), I:49.

27 *La Chronique des arts et de la curiosité* published the names of the Medal of Honor recipients as having received votes in the following order: Meissonier, Cabanel, Gérôme, Leys, Knaus, Théodore Rousseau, Kaulbach, Ussi; "Récompenses," 12 May 1867, 148. Ussi's name was omitted entirely in the earliest lists published in "Petits événements," *Le Figaro*, 26 April 1867.

28 Blanc (3), 19 June 1867; also see Clément, (2), 27 October 1867; Mantz (6), 1 Septem-

ber 1867, 223–24; DuCamp (3), 299–300; Chesneau (1), 159; omitted from 1867 Paris (5).

29 For the political charge, see Lagrange (3), 35 (August 1867): 1006.

30 DuCamp (3), 346.

31 Thoré (3), II:374–75.

32 Mantz (6), 1 July 1867, 9–12; DuCamp (3), 317–18; Chesneau (1), 91–92.

33 Chesneau (1), 134; omitted from 1867 Paris (5).

34 Mantz (6), 1 August 1867, 134.

35 Blanc (3), 5 June 1867; also see Lagrange (3), 35 (August 1867): 1012. Duret, 72–73; also see Mantz (6), 1 October 1867, 324.

36 See Zola (3), 112–13; Blanc (3), 5 June 1867; Chaumelin, 103–104; Mantz (6), 1 October 1867, 324–25.

37 Thoré (3), II:350–51.

38 Chesneau in 1867 Paris (5), I:71; he stated it more forcefully in Chesneau (1), 241. See also Saint-Victor (2), 9 May 1867; Lagrange (3), 35 (August 1867): 1003.

39 Thoré (3), II:371. See also Chesneau (1), 156, 244; it is a theme which Chesneau reiterated throughout his study but without Thoré's political stance.

40 Thoré (3), II:371.

41 Chesneau (1), 5–6.

42 Edgar Quinet, *1815 et 1840*, deuxième édition, augmentée d'une préface, Paris, 1840; see also Swart (2), 213–57.

43 Mantz (7), 2 November 1867, 283.

44 DuCamp (3), 312.

45 Chesneau (1), 9.

46 See Mantz (6), 1 September 1867, 211–12; Thoré (3), II:403.

47 Chaumelin, 79.

48 The glaring omission was Millais who should have received a Medal of Honor; he probably refused to accept anything less and so received nothing at all. A First Class Medal went to Calderon, Second Class to Nicol, Third Class to Orchardson and Walker.

49 Besides Kaulbach and Leys, First Class Medals went to Horschelt and Piloty (Bavaria); Second Class to Menzel (Prussia); Third Class to André Achenbach (Prussia), F. Adam, and Lenbach (Bavaria). Lagrange was horrified that even in Germany the medals had gone to genre and landscape rather than history painting; see Lagrange (3), 35 (August 1867): 1003.

50 Thoré (3), II:413–35; see also Mantz (6), 1 August 1867, 144.

51 Clément (2), 11 April 1867.

52 See Thoré (3), II:427.

53 Blanc (3), 19 June 1867; DuCamp (3), 324–25; Mantz (6), 1 August 1867, 144–45.

54 1867 Paris (4); it is incomplete.

55 Chesneau (1), 421.

56 Ibid., 441.

57 Astruc (3); despite its late publication, the article was identified by Philippe Burty as having been written about the 1867 Exposition; see his "Bibliographie," *La Chronique des arts et de la curiosité*, 14 June 1868, 95. Astruc contributed a series of unreadable critiques to *L'Etendard* in 1867 and was probably fired before he could inflict this last one on the public; see Astruc (1).

58 See Society for the Study of Japonisme in Art, *Japonisme in Art. An International Symposium*, Yamada Chisaburo, ed., Tokyo, 1980, and Cleveland Museum of Art, *Japonisme. Japanese Influence on French Art, 1854–1910*, Cleveland, 1975–76.

59 Chesneau in 1867 Paris (5), I:71–73; he discussed this at greater length in Chesneau (1), 168–71; Duret, 117–23.

60 Chesneau in 1867 Paris (5), I:72, from Chesneau (1), 242–44.

61 Duret, 135.

62 Ibid., 139.

63 For a discussion of modern interpretations of the term, see Peter Gay, *The Bourgeois Experience. Victoria to Freud*, I: *The Education of the Senses*, New York and Oxford, 1984, 18–31.

64 Blanc (3), 5 June 1867; also see Chesneau (1), 311; Chaumelin, 104C; Thoré (3), II:351; Lagrange (3), 35 (August 1867): 1012.

65 On Orientalism, see Nochlin (2).

66 Zola (3), 112.

67 Chesneau (1), 220.

68 Chaumelin, 104D; also see Blanc (3), 5 June 1867.

69 Thoré (3), II:352; also see Chesneau (1), 246–47; Mantz (6), 1 October 1867, 321–22.

70 Zola (3), 109.

71 Blanc (3), 5 June 1867.

72 Mantz (7), 23 November 1867, 331; Mantz (6), 1 October 1867, 322; also see Duret, 62.

73 Pierre Dax, "Chronique des beaux-arts," *L'Artiste*, 1 May 1867, 325.

74 By the decree of 29 June 1867, Meissonier was made Commandeur of the Légion d'honneur; AN Légion d'honneur 1818, d. 30: Jean-Louis-Ernest Meissonier.

75 DuCamp (3), 346.

Chapter 18

1 Chesneau (1), 369.

2 Ibid., 304.

3 Thoré (3), II:354.

4 Duret, 21.

5 Mantz (6), 1 June 1867, 538.

6 DuCamp (3), 343.

7 Chesneau (1), 263, and in Paris 1867 (5), I:82. See Mainardi (7) for a more extensive discussion of this issue.

8 About (3), 22 June 1867.

9 Chesneau (1), 220–21.

10 Ibid., 279; for his praise, see 276–77.

11 See, for example, the article by Anne M. Wagner, "Courbet's Landscapes and Their Market," *Art History* 4 (December 1981): 410–31; she traces the development of a market for Courbet's landscapes from 1861 when Champfleury noted that he did not sell, through 1877 when, at his death, many remained unsold, to the huge success of his 1881 sale. More work needs to be done on the role of foreign patronage for French painting; see below, Note 28.

12 Chesneau (1), 262, 285–86; Thoré (3), II:353; Castagnary (4); Théophile Silvestre (3), 14, 15, 21 May 1867.

13 The complete list of Fine Arts medallists was published in the 1868 Salon catalogue.

14 See Rousseau (1), reprinted in Burty (2), 71–93. The Cercle des Arts was also called Galerie du cercle de la rue de Choiseul.

15 Castagnary (2), 2 May 1867.

16 DuCamp (3), 344.

17 Blanc (3), 19 June 1867; see also Mantz (6), 1 October 1867, 326.

18 Thoré (3), II:353–54.

19 Ibid., II:354.

20 Duret, 31.

21 Chesneau (1), 270, 279.

22 Zola (3), 114.

23 Sensier, 44–45

24 See John W. Mollett, *The Painters of Barbizon*, 2 vols., London, 1890, I:47–85. See also Rousseau (3) which has a year-by-year chronology of Rousseau's career.

25 Thoré (3), II:355–56; see also Zola (3), 113–14.

26 Sensier, 340–43. He helped Millet get *The Gleaners* into the Exposition; see Jean-François Millet to Alfred Sensier, 25 February 1867, Cabinet des dessins, Louvre; also Rousseau to Jules Dupré, undated, in Sensier, 342–43.

27 Burty (2), 121. For the Jury results, see "Récompenses," *La Chronique des arts et de la curiosité*, 12 May 1867, 148.

28 Rousseau's popularity outside France was often noted; see Sensier, 229, 350; Albert Wolff, *Notes upon Certain Masters of the XIX Century*, New York, 1886, 57–62; Mollett, I:47–85. Wagner cites similar evidence on Courbet; see Note 11 above.

29 Sensier, 350.

30 The Légion d'honneur nominations were printed in the 1868 Salon catalogue, XVIII–XX.

31 See Sensier, 348–69, for an account of Rousseau's omission and the results.

32 Nieuwerkerke's statement is legendary, and, although possibly apocryphal, accurately represented his sentiments; here quoted from Jean Bouret, *L'Ecole de Barbizon et le paysage français au XIXe siècle*, Paris, 1972, 19.

33 See Sensier, 353–54; Burty (2), 121; Jean-François Millet to Chassaing, 25 December 1867, published in Pierre Miquel, *Le Paysage français au XIXe siècle 1824–1874. L'Ecole de la nature*. 3 vols. Maurs-la-Jolie, 1975, III:481. All three contemporaries of Rousseau dated the first symptoms at the beginning of July.

34 Sensier, 352–53; see also Miquel, *Le Paysage français*, III:480, and the chronology in Rousseau (3).

35 Marie-Thérèse de Forges states that Vaillant demanded an explanation from Nieuwerkerke on 22 July 1867 as to the omission of Millet and Rousseau from the promotion lists for the Légion d'honneur; see the 1867 chronology in Rousseau (3), a Louvre catalogue, where the relevant correspondence is cited as being in the Archives du Louvre. Miquel quotes a few sentences from Nieuwerkerke's response, also cited as being in the Archives du Louvre; see his *Le Paysage français*, III:480. Mme Besson of the Archives du Louvre has assured me that the same unfortunate typographical error has slipped into these two different texts and that the documents are not in the Louvre.

36 "Nouvelles," *La Chronique des arts et de la curiosité*, 10 August 1867, 215.

37 Sensier, 357.

38 The decree was dated 7 August 1867; AN Légion d'honneur 2402, d. 2: Théodore Rousseau.

39 Jean-François Millet to Alfred Sensier, 12 August 1867, Cabinet des dessins, Louvre.

40 See *Le Moniteur universel*, 14 August 1867, 1107.

41 *La Chronique des arts et de la curiosité*, 20 August 1867, 220–21.

42 See Rousseau (2). A copy of the letter in *Le Figaro* was sent to Nieuwerkerke by the Ministre de l'Intérieur, 17 August 1867; see Archives du Louvre, P30: Théodore Rousseau. The letter was misinterpreted by Marie-Thérèse de Forges in the 1867 chronology of Rousseau (3) as being a statement of gratitude towards Nieuwerkerke as well as Napoléon III.

43 Silvestre (4).

44 Jean-François Millet to Chassaing, 25

December 1867, published in Miquel, *Le Paysage français*, III:481. Although Miquel cites this letter as being in the Cabinet des dessins, Louvre, it can no longer be located there.

Chapter 19

1 Castagnary (6), "Le Salon de 1868," I:254. Castagnary's critique was originally published in *Le Siècle*, a liberal opposition journal.
2 See "Nouvelles," *La Chronique des arts et de la curiosité*, 28 April 1867, 134, and 5 May 1867, 142.
3 The *Règlement* for the 1868 Salon was issued 5 November 1867 and printed in the 1868 Salon catalogue.
4 See Auvray (3), 11–21, for a detailed discussion of the elections. He was Director of *La Revue artistique* where his critique first appeared.
5 The lists of Jurors were published by Auvray, ibid., and also reprinted in the 1868 Salon catalogue. Auvray gave the number of votes each received; the totals were also published in "Salon de 1868," *La Chronique des arts et de la curiosité*, 29 March 1868, 51.
6 See Rewald, 185.
7 Chesneau (2), 16 June 1868; on Courbet's 1868 exhibition, see "Nouvelles," *La Chronique des arts et de la curiosité*, 24 May 1868, 83, and the letters from Courbet to Bruyas, 7 February 1868 and 10 September 1868, BN, Cabinet des estampes, Yb 3 1739(8): Lettres de Gustave Courbet; also published in Courbet (4), 130–37. His pavilion had to be taken down after his exhibition.
8 Zola (3), "Salon de 1868," 136–37.
9 Castagnary (6), I:265.
10 Ibid., I:313–14.
11 Zola (3), 123.
12 Gautier (6), 11 May 1868.
13 See "Chronique," *La Revue universelle des arts*, 1855, I:240.
14 See Rewald, 185 and, for Daubigny's defense, Castagnary (6), I:254.
15 See the *Règlement* for the Salon of 1868 published in the 1868 Salon catalogue; also Auvray (3), 6; About (4), 717.

16 Auvray (3), 33. For the installation, see also Chesneau (2), 12 May 1868; Rewald, 185–87; Castagnary (6), I:313.
17 Palma, 11 (15 May 1868): 222.
18 See DuCamp (3), 334; DuCamp stated this in his review of the 1867 Exposition.
19 Chesneau (2), 5, 12, 19, 26 May 1868.
20 Chaumelin, 106; Chaumelin's critique was originally published in *La Presse*. See also Petra ten Doesschate-Chu, *French Realism and the Dutch Masters*, Utrecht, 1974, and Haskell (1).
21 The awards for the 1868 Salon were listed in the 1869 Salon catalogue. The Grand Medal of Honor for sculpture was given to Falguière.
22 Castagnary (6), I:250.
23 Among those who did not mention him were Petroz (2), Boissin, and Paul-Pierre.
24 Chesneau (2), 30 June 1868.
25 Castagnary (6), I:280; see also Lasteyrie, 13 June 1868, and Révillon, 21 June 1868.
26 Auvray (3), 44.
27 Bertall (5).
28 Belloy (2), 902; see also Chaumelin, 148 and, on the mediocrity of the Salon, Zola (3).
29 Blanc (5), 26 May 1868.
30 Auvray (3), 63.
31 Chaumelin, 148; also see Clément (3), 3 June 1868; Saint-Victor (3), 29 May 1868; Gautier (6), 26 May 1868.
32 Grangedor, 1 July 1868, 6.
33 Chaumelin, 180.
34 Vaillant's speech was reprinted in the 1869 Salon catalogue, VIII–XII.

Chapter 20

1 See Bellanger, II:345–46.
2 About (4), 716–17.
3 Petroz (2), 10 May 1868, 356–57. The Fourth Class of the Institute is Fine Arts.
4 About (4), 720.
5 Ibid., 727.
6 Zola (2), 20 December 1868.
7 Ibid.
8 For a more extensive discussion of this event, see Mainardi (10).
9 Zola (2), 20 December 1868; Chennevières, Part IV, 69–118.

Select Bibliography

Many works cited in the text have not been included in this bibliography, in particular, short newspaper articles, monographs, catalogues raisonnés, and works of tangential interest to my main thesis; in such cases the footnotes include the full reference. In series of exhibition reviews by a single critic, the title often varied from week to week; I have included only the principal title and, where there were three or more, either the page numbers or the dates.

1. Archives

London. The Victoria and Albert Museum. Collection of Printed Documents and Forms Used in Carrying on the Business of the Exhibition of 1851. 6 vols.

Paris. Archives Nationales. Fêtes, expositions industrielles:

ADVIII-18
ADXI-67
ADXVIII A 60
ADXVIII C 468
ADXIXD 1/3
AD FIC I 84/89
FIC III-Seine 25
F12 985/991
F12 5005
F13 1024
F21 717

———. Expositions de Londres en 1851 et 1862:

ADXIX 4/5
ADXIXD 20/34
F12 3164/3167C
F21 525

———. Exposition Universelle, 1855:

ADXIX 6/19
F12 2919
F12 2926
F12 3035
F12 3182/3184
F12 2892/2917
F12 5005
F12 *5793/*5813
F12 70619-5
F21 519/520
F21 521A/B
F21 1465/1472
F21 1491/1497
F21 *2793/*2797
F70 43/46

———. Exposition Universelle, 1867:

ADXIXD 38/69
Reg. *3150-*3161B
F12 2918/3161A
F12 3185/7
F12 5006/7
F21 522/523
F80 1774

———. Salons annuels. An III–1868. F21 527/530.

———. Budgets des beaux-arts. 1811–1871. F21 559/60.

———. Travaux d'art. Commandes et acquisitions: F21 61/112. 6e série, 1851–1860. F21 113/189. 7e série. 1861–1870.

———. La Légion d'honneur. Dossiers des légionnaires à 1953. LH1/2793.

———. Circulaires 1841–1851. Ministère de l'Agriculture et du Commerce. ADXIXD 256.

Paris. Bibliothèque Nationale. Cabinet des estampes:

Exposition Universelle, 1855.
Exposition Universelle, 1867.
Yb 3 1739. Sept cartons. Courbet.
Yb 3 1739(8). Lettres de Gustave Courbet.

Paris. Institut de France. Archives de l'Académie des beaux-arts. Procès-verbaux. 1850–1870.

Paris. Musée du Louvre. Archives:
 Série P 30: Alexandre Decamps. Jean-François Millet. Théodore Rousseau.
 Série X: Salons de 1855, 1857, 1866, 1867, 1868.
 Exposition Universelle de 1867.
———. Cabinet des dessins: Correspondance:
 Gustave Courbet. Eugène Manet. Jean-François Millet. Théodore Rousseau.
Paris. Musée d'Orsay. Documentation: Jean-Baptiste Clésinger.

2. Government Publications: Fêtes, Salons, Industrial and International Expositions

1673. Paris. *Le Livret de l'Exposition faite en 1673 dans la cour du Palais-Royal.* Anatole de Montaiglon, ed. 1852.

1699. Paris. *Liste des tableaux & des ouvrages de sculpture, exposez dans la grande gallerie du Louvre.*

1792–1871. Paris. *Explication des ouvrages* Salon catalogues; exact title varied from year to year.

1798. Paris. Exposition publique des produits de l'industrie française. *Catalogue des produits industriels qui ont été exposés au Champ-de-Mars. Procès-verbal du Jury.* Vendémiaire, an VII (1798).

1798. Paris. France. Le Ministre de l'Intérieur François de Neufchâteau. *Fête de la fondation de la République. Programme. Ier vendémiaire, an VII.* Fructidor, an VI (1798).

France. Ministère de l'Intérieur. *Recueil des lettres circulaires, instructions, programmes, discours et autres actes publics, émanés du citoyen François de Neufchâteau, pendant ses deux exercices du Ministère de l'Intérieur.* 2 vols. Paris, an VII–VIII (1798–1800).

1799. Paris. France. Le Ministre de l'Intérieur Quinette. *Fête de la fondation de la République. Ier vendémiaire, an VIII. Programme.* Fructidor, an VII (1799).

1801. Paris. Exposition publique des produits de l'industrie française. *Catalogue des productions industrielles exposées dans la grande Cour du Louvre.* Fructidor, an IX (1801).

———. *Procès-verbal.* Vendémiaire, an X (1801).

1802. Paris. Exposition publique des produits de l'industrie française. *Catalogue des productions industrielles exposés dans la grande Cour du Louvre.* Fructidor, an X (1802).

———. *Procès-verbal.* Vendémiaire, an XI (1802).

France. Ministére de l'Intérieur. *Recueil des lettres circulaires, instructions, arrêtés et discours publics, émanés des Citoyens Quinette, LaPlace, Lucien Bonaparte et Chaptal, Ministres de l'Intérieur depuis le 16 messidor, an VII, jusqu'au 1 vendémiaire, an X.* Paris, an X (1802).

France. Ministère de l'Intérieur. *Recueil des lettres circulaires et autres actes publics émanés en l'an XI du Ministère de l'Intérieur.* Paris, an XIII (1804–1805).

1806. Paris. Exposition publique des produits de l'industrie française. *Notice sur les objets exposés à l'Exposition des produits de l'industrie française.*

———. *Rapport du Jury sur les produits de l'industrie française.*

1819. Paris. Exposition publique des produits de l'industrie française. *Catalogue indiquant le nom des fabricants avec la designation sommaire des produits de leur industrie.*

———. *Rapport du jury central sur les produits de l'industrie française par M. L. Costaz.*

1823. Paris. Exposition publique des produits de l'industrie française. *Catalogue des produits de l'industrie française, admis à l'exposition publique dans le palais du Louvre.*

———. *Rapport sur les produits de l'industrie française, présenté, au nom du jury central, par L. Héricart de Thury et P. H. Migneron.* 1824.

1827. Paris. Exposition publique des produits de l'industrie française. *Catalogue des produits de l'industrie française, admis à l'exposition publique dans le palais du Louvre.*

———. *Rapport sur les produits de l'industrie française, présenté, au nom du jury central, par L. Héricart de Thury et P. H. Migneron.* 1828.

1834. Paris. Exposition publique des produits de l'industrie française. *Catalogue des produits de l'industrie française, admis à l'exposition publique, sur la Place de la Concorde, en 1834.*

———. *Rapport du jury central sur les produits de l'industrie française exposés en 1834, par le baron Charles Dupin.* 3 vols. 1836.

1839. Paris. Exposition publique des produits de l'industrie française. *Catalogue officiel des produits de l'industrie française, admis à l'exposition publique dans le Carré des Fêtes aux Champs-Élysées.*

———. *Rapport du jury central.* 3 vols.

1844. Paris. Exposition publique des produits de l'industrie française. *Catalogue officiel.*

———. *Rapport du jury central.* 3 vols.

1849. Paris. Exposition nationale des produits de l'agriculture et de l'industrie française. 1849. *Catalogue officiel.*

———. *Rapport du jury central sur les produits de l'agriculture et de l'industrie exposés en 1849.* 3 vols. 1850.

1851. London. Great Exhibition of Works of Industry of All Nations. *Official Descriptive and Illustrated Catalogue.* 3 vols. and supp.

———. *Reports by the Juries on the subjects in the thirty classes into which the Exhibition was divided.* 1852.

———. France. Exposition Universelle de 1851. *Travaux de la Commission française sur l'industrie des nations.* 8 vols. Paris. 1856 – 1873.

———. France. Ministère de l'Agriculture et du Commerce. Exposition Universelle de Londres en 1851. *Liste des médailles et mentions honorables décernées aux exposants français.* Paris. 1851.

1853. Dublin. Exhibition of Art and Art-Industry. *Official Catalogue of the Great Industrial Exhibition.*

1853. New York City. Exhibition of the Industry of All Nations. *Official Catalogue of the Pictures contributed to the Exhibition of the Industry of All Nations in the Picture Gallery of the Crystal Palace.*

1855. Paris. Exposition Universelle de 1855. (1) *Atlas descriptif. Dressé par ordre de S.A.I. le prince Napoléon, Président de la Commission Impériale.*

———. (2) *Catalogue officiel publié par ordre de la Commission Impériale.*

———. (3) *Explication des ouvrages de peinture, sculpture, gravure, lithographie et architecture des artistes vivants étrangers et français exposés au Palais des Beaux-Arts, avenue Montaigne, le 15 mai 1855.* 1 vol. and 4 supps.

———. (4) *Exposition Universelle des Beaux-Arts. MDCCCLV. Avenue Montaigne. Album de 18 photographies.*

———. (5) Commission Impériale. *Visites et études de S.A.I. le prince Napoléon au Palais des Beaux-Arts.* 1856.

———. (6) *Rapports du jury mixte international publiés sous la direction de S.A.I. le prince Napoléon.* 2 vols. 1856.

———. (7) Commission Impériale. *Rapport sur l'Exposition Universelle de 1855 présenté à l'Empereur par S.A.I. le prince Napoléon.* 1857.

1857. Manchester, England. Art Treasures Exhibition. *Catalogue of the art treasures of the United Kingdom collected at Manchester, 1857.* London.

1862. London. International Exhibition. *Official Catalogue of the Fine Art Department.* rev. ed.

———. *Exposition Universelle de 1862 à Londres. Section française. Catalogue officiel publié par ordre de la Commission Impériale.*

———. *Rapport des membres de la section française du Jury international sur l'ensemble de l'Exposition et documents officiels publiés sous la direction de Michel Chevalier.* 6 vols.

1867. Paris. Exposition Universelle de Paris en 1867. (1) *Belgique. Catalogue des oeuvres d'art.* Bruxelles.

———. (2) *Catalogue général publié par la Commission Impériale.* 2 vols. I: *Oeuvres d'art.*

———. (3) *Documents officiels.*

———. (4) *Catalogue de produits et objets d'art japonais composant la collection envoyée du Japon pour l'Exposition Universelle de 1867.* 1868.

———. (5) *Rapports du Jury international publiés sous la direction de M. Michel Chevalier.* 13 vols. 1868.

———. (6) Commission Impériale. *Rapport sur l'Exposition Universelle de 1867 à Paris.* 1869.

1878. Paris. Exposition Universelle Internationale de 1878 à Paris. *Rapports du Jury international publiés sous la direction de Jules Simon.* 56 vols. 1879–82.

1889. Paris. Exposition Universelle Internationale de 1889 à Paris. *Rapport général par M. Alfred Picard.* 10 vols. 1891–92.

3. Books and Articles

About, Edmund. (1) *Voyage à travers l'Exposition des Beaux-Arts.* Paris, 1855.

———. (2) *Nos Artistes au Salon de 1857.* Paris, 1858.

———. (3) "Salon de 1867." *Le Temps,* 22, 29 May; 4, 13, 22, 26 June 1867.

———. (4) "Le Salon de 1868." *Revue des deux-mondes,* 1 June 1868, 714–45.

Académie des beaux-arts, Paris. *Rapport sur l'ouvrage de M. le comte de Laborde intitulé: De l'Union des arts et de l'industrie.* Paris, 1858.

———. *Procès-verbaux de l'Académie royale de peinture et de sculpture 1648–1792.* Anatole de Montaiglon, ed. 10 vols. Paris, 1875–92.

Allwood, John. *The Great Exhibitions.* London, 1977.

Amaury-Duval. *L'Atelier d'Ingres.* Paris, 1924.

Angrand, Pierre. "L'Etat mécène—Période autoritaire du Second Empire (1851–1860)." *Gazette des beaux-arts,* May–June 1868, 303–48.

L'Art à Paris en 1867. Album autographique. Paris, 1867.

Astruc, Zacharie. (1) "Le Salon des Champs-Elysées." *L'Etendard,* 3, 19, 26 June; 23, 28 July; 11 August 1867.

———. (2) "Salon de 1868 aux Champs-Elysées." *L'Etendard*, 19, 26, 29 May; 27 June; 7, 29, 31 July; 2, 5, 6, 7 August 1868.

———. (3) "Le Japon chez nous." *L'Etendard*, 26 May 1868.

Auvray, Louis. (1) *Exposition des beaux-arts. Salon de 1857.* Paris, 1857.

———. (2) *Salon de 1867 et les beaux-arts à l'Exposition Universelle.* Paris, 1867.

———. (3) *Le Salon de 1868 suivi d'une réfutation de la brochure de M. Hip. Lazerges.* Paris, 1868.

Babou, Hippolyte. "Les Dissidents de l'Exposition." *Revue libérale* 2 (1867): 284–89.

Barrault, Alexis and G. Bridel. *Le Palais de l'Industrie.* Paris, 1857.

Baudelaire, Charles. (1) "Exposition Universelle. Beaux-arts." *Le Pays. Journal de l'Empire*, 26 May, 3 June 1855.

———. (2) "Beaux-arts. Ingres." *Le Portefeuille. Revue critique, historique et littéraire*, 12 August 1855, 130–31.

———. (3) *Correspondance.* Claude Pichois and Jean Ziegler, eds. 2 vols. Paris, 1973.

Baudrillart, Henri. "Les Expositions Universelles." *Journal officiel de la République française*, 16 May 1878, 5284–87; 19 May 1878, 5462–64.

Bazin, Germain. "Le Salon de 1830 à 1900." *Scritti di storia dell'arte in onore di Lionello Venturi.* 2 vols. Rome, 1956. II: 117–23.

Beaumont, Edouard de. "Les Armes. Préface du catalogue en préparation de la collection de M. le comte de Nieuwerkerke." *Gazette des beaux-arts*, 1 November 1968, 373–89.

Bellanger, Claude, Jacques Godechot, Pierre Guiral, Fernand Terrou. *Histoire générale de la presse française.* 5 vols. Paris, 1969. II: *1815 à 1871.*

Bellet, Roger. *Presse et journalisme sous le Second Empire.* Paris, 1967.

Belloy, le marquis Auguste de. (1) "Beaux-arts. Exposition Universelle." *L'Assemblée nationale*, 31 May; 10, 24 June; 2, 25 July; 18, 25 August; 7, 20 September; 6, 24 October; 6, 22, 27 November 1855.

———. (2) "Promenade à l'Exposition des beaux-arts." *Le Correspondant*, 10 June 1868, 882–911.

Benjamin, Walter. "Paris—The Capital of the Nineteenth Century." *Charles Baudelaire. A Lyric Poet in the Era of High Capitalism.* Quentin Hoare, trans. London, 1973.

Berger, H. Georges. *Les Expositions universelles internationales (leur passé, leur rôle actuel, leur avenir).* Paris, 1902.

Bertall (Charles-Albert d'Arnould). (1) "Le Salon dépeint et dessiné." *Journal pour rire*, 18 August, 3 November, 1 December 1855.

———. (2) "Les Dessus de panier." *Le Journal amusant*, 12 January 1856.

———. (3) "Le Salon dépeint et dessiné." *Le Journal amusant*, 18 July; 1, 15 August; 19 September 1857.

———. (4) "Promenade au Salon de 1868." *Le Journal amusant*, 23 May 1868.

———. (5) "Tout pour l'Alsace. Considérations sur les médailles à l'Exposition de 1868." *L'Illustration*, 20 June 1868, 397.

Beulé, Charles-Ernest. *Causeries sur l'art.* Paris, 1867.

Bitard, A. *Histoire des expositions et des beaux-arts.* Rouen, 1881.

Blanc, Charles. (1) "Au Secrétaire de la rédaction." *La Presse*, 30 Octobre 1855.

———. (2) "Exposition de Manchester." *L'Artiste*, 24 May; 7, 21 June 1857.

———. (3) "Exposition Universelle de 1867. Beaux-arts." *Le Temps*, 12 April; 15 May; 5, 19 June; 18, 27 August; 2, 16, 23, 24 October; 6, 7, 20 November 1867.

———. (4) "Exposition Ingres." *Le Temps*, 28 April 1867.

———. (5) "Salon de 1868." *Le Temps*, 12, 19, 26 May; 3, 17, 23, 30 June 1868.

———. (6) *Ingres, sa vie et ses ouvrages.* Paris, 1870.

———. (7) *Les Artistes de mon temps.* Paris, 1876.

Boileau, Etienne. *Le Livre des métiers.* René Lespinasse and François Bonnardot, eds. (*Histoire générale de Paris*) Paris, 1879.

Boime, Albert. (1) "The Salon des Refusés and the Evolution of Modern Art." *The Art Quarterly* 32 (1969): 411–26.

———. (2) *The Academy and French Painting in the Nineteenth Century.* New York, 1971.

———. (3) "The Teaching Reforms of 1863 and the Origins of Modernism in France." *The Art Quarterly* n.s. 1 (autumn 1977): 1–39.

———. (4) "The Second Empire's Official Realism," in Gabriel P. Weisberg, ed. *The European Realist Tradition.* Bloomington, Indiana, 1982, 31–123.

———. (5) *Thomas Couture and the Eclectic Vision.* New Haven and London, 1980.

Boissin, Firmin. "Salon de 1868." *Etudes artistiques.* Paris, 1868.

Boiteau d'Ambly, Paul (Paul Boiteau). "Salon de 1855." *La Propriété littéraire et artistique* 1 (1855): 316–18, 354–60, 410–15, 439–43, 468–73, 493–98, 543–47.

Bonnin, A. *Etudes sur l'art contemporain. Les Ecoles françaises et étrangères en 1867.* Paris, 1868.

Boucher de Perthes, Jacques. *Exposition publique des produits de l'industrie de l'arrondissement d'Abbeville, 1833.* Abbeville, 1834.

Boyer d'Agen. *Ingres, d'après une correspondance inédite.* Paris, 1909.

Brisse, Baron Léon and Paul Gage. *Album de l'Exposition Universelle Impériale.* 3 vols. Paris, 1857–59.

Bulletin des lois. See France. *Bulletin des lois.*

Burat, Jules. *L'Exposition de l'industrie française, 1844. Description méthodique.* 2 vols. Paris, 1845.

Burty, Philippe. (1) "Le Salon de 1857." *Le Moniteur de la mode. Journal du grand monde,* July–August 1857, 111–12, 122–24, 135–36; August 1857, 147–49, 159–61, 171.

——. (2) *Maîtres et petits-maîtres.* Paris, 1877.

Calonne, Alphonse de. (1) "Exposition Universelle des Beaux-Arts." *Revue contemporaine* 20 (1855): 491–515, 695–715; 21 (1855): 107–37, 660–700.

——. (2) "Exposition des beaux-arts de 1857." *Revue contemporaine* 32 (June–July 1857): 592–629.

Campbell, Stuart L. *Second Empire Revisited: A Study in French Historiography.* New Brunswick, N.J. 1978.

Camus. "Notes sur l'exposition publique des produits de l'industrie française, qui a eu lieu dans les jours complémentaires de l'an 6 et de l'an 9, lues à la séance publique de l'Institut national, le 15 nivôse an 10." *Gazette nationale,* 17 nivôse, an X (5 January 1802), 429–30.

Carpenter, Kenneth E. "Industrial Exhibitions before 1851 and their Publications." *Harvard Business School, Kress Library of Business and Economics Bulletin* 7 (April 1971). Reprinted in *Technology and Culture* 13 (July 1972): 465–86.

Castagnary, Jules-Antoine. (1) "Le Monde artistique." *La Liberté,* 1 April 1867.

——. (2) "Exposition des oeuvres de M. Ingres." *La Liberté,* 2, 4, 15, 18 May 1867.

——. (3) "Le Monde artistique. Salon de 1867." *La Liberté,* 2, 4, 15, 18, 25, 28 May; 7 June 1867.

——. (4) "Exposition des oeuvres de M. Gustave Courbet." *La Liberté,* 11 June 1867.

——. (5) "Salon de 1868." *Le Siècle,* 10, 12, 15, 22, 29 May; 5, 12, 19, 26 June 1868.

——. (6) *Salons 1857–1870.* 2 vols. Paris, 1892.

Castillon du Perron, Marguerite. *La Princesse Mathilde.* Paris, 1963.

Challemel-Lacour, Paul-Armand. "Ouverture du Salon." *Le Temps,* 16 April 1867.

Cham (Amédée-Charles-Henri, comte de Noé). (1) *Revue comique de l'Exposition de l'industrie.* Paris, 1849.

——. (2) *Promenades à l'Exposition.* Paris, 1855.

——. (3) *Salon de 1857.* Paris, 1857.

——. (4) *Cham au Salon de 1867.* Paris, 1867.

——. (5) *L'Exposition charivarisée.* Paris, 1867.

——. (6) *La Comédie de l'Exposition. Prologue.* Paris, 1867.

——. (7) *La Comédie de l'Exposition. Ier Acte.* Paris, 1867.

——. (8) *Bouffonneries de l'Exposition.* Paris, 1868.

——. (9) *Salon de 1868. Album de 60 caricatures.* Paris, 1868.

Champfleury (Jules Husson). "Du Réalisme. Lettre à Madame Sand." *L'Artiste,* 2 September 1855, 1–5.

Chaptal, Jean-Antoine Claude. *De l'Industrie françoise.* 2 vols. Paris, 1819.

Chaumelin, Marius. *L'Art contemporain.* Paris, 1873.

Chennevières, Philippe de. *Souvenirs d'un Directeur des beaux-arts.* Paris, 1883–89.

Chesneau, Ernest. (1) *Les Nations rivales dans l'art.* Paris. 1868.

——. (2) "Salon de 1868." *Le Constitutionnel,* 5, 12, 19, 26 May; 3, 12, 16, 30 June; 1 July 1868.

Chevalier, Michel. (1) *Exposition universelle de Londres considérée sous les rapports philosophiques, techniques, commercials et administratifs, au point de vue français.* Paris, 1851.

——. (2) "Exposition Universelle." *Journal des débats,* 15 May 1855, 1–2.

Clark, Timothy J. (1) *The Absolute Bourgeois. Artists and Politics in France 1848–1851.* London, 1973.

——. (2) *Image of the People. Gustave Courbet and the Second French Republic 1848–1851.* Greenwich, Conn., 1973.

——. (3) *The Painting of Modern Life.* New York, 1984.

Clément, Charles. (1) "Exposition annuelle des Champs-Elysées." *Journal des débats,* 24, 30, April; 4, 10, 17, 31 May; 5, 15 June 1867.

———. (2) "Exposition Universelle des Beaux-Arts." *Journal des débats*, 28 March; 11 April; 1 July; 1, 28 August; 4, 9, 21, 27, 31 October 1867.

———. (3) "Exposition de 1868." *Journal des débats*, 1, 9, 18, 27 May; 3, 13, 19, 20 June 1868.

Clément de Ris, le comte L. "Exposition Universelle des Beaux-Arts." *Le Palais de l'exposition. Revue hebdomadaire illustrée*, 26 May, 9 June 1855.

Cole, Sir Henry. *Fifty Years of Public Work*. 2 vols. London, 1884.

Collins, Irene. *The Government and the Newspaper Press in France 1814–1881*. London, 1959.

Colmont, Achille de. *Histoire des expositions de l'industrie française*. Paris, 1855.

Comité français des expositions. *Cinquantenaire 1885–1935*. Asnières, 1935.

Costaz, Claude Anthelme. (1) *Mémoire sur les moyens qui ont amené le grand développement que l'industrie française a pris depuis vingt ans*. Paris, 1816.

———. (2) *Histoire de l'administration en France*. 2 vols. Paris, 1832.

Courbet, Gustave. (1) 1855. Paris. *Exhibition et vente de 40 tableaux et 4 dessins de l'oeuvre de M. Gustave Courbet*. Avenue Montaigne, 7, Champs-Elysées, Paris.

———. (2) 1867. Paris. *Oeuvres de M. G. Courbet*. Rond-Point du Pont de l'Alma, Paris, 1867.

———. (3) "Lettres inédites." *L'Olivier, Revue de Nice* 8 (September–October 1913): 485–90.

———. (4) *Lettres de Gustave Courbet à Alfred Bruyas*. Pierre Borel, ed. Geneva, 1951.

Cousin, Victor. (1) *Oeuvres de Victor Cousin*. 3 vols. Bruxelles, 1840–41.

———. (2) *Du Vrai, du beau et du bien*. Deuxième édition augmentée d'un appendice sur l'art français. Paris, 1854.

David, Jacques-Louis. 1799. Paris. *Le Tableau des Sabines exposé publiquement au Palais national des sciences et des arts, salle de la ci-devant Académie d'architecture, par le Citoyen David*. Paris, an VIII.

Decamps, Alexandre-Gabriel. "Notice biographique écrite par lui-même." In Dr. Louis-Désiré Véron, *Mémoires d'un bourgeois de Paris*. 6 vols. Paris, 1853–55. VI: 264–74.

Delaborde, Henri. (1) "Peintres modernes de la France. Jean-Dominique Ingres, sa vie et ses oeuvres." *Revue des deux-mondes*, 1 April 1867, 545–81.

———. (2) *Ingres, sa vie ses travaux, sa doctrine*. Paris, 1870.

Delacroix, Eugène. (1) *Correspondance générale d'Eugène Delacroix*. André Joubin, ed. 5 vols. Paris, 1926–38.

———. (2) *Journal, 1822–1863*. André Joubin, ed. Paris, 1980.

———. (3) *La Liberté guidant le peuple de Delacroix*. Hélène Toussaint, ed. Paris, 1982.

Delécluze, Etienne J. (1) *Les Beaux-arts dans les deux mondes en 1855*. Paris, 1856.

———. (2) "Exposition de 1857." *Journal des débats*, 15, 20 June; 2, 10, 16, 26 July; 11, 20, 29 August; 15 September 1857.

Delord, Taxile. (1) "Le Jury de Peinture." *Le Charivari*, 17 April 1855.

———. (2) "Exposition des beaux-arts." *Le Charivari*, 26, 29 June; 2, 4, 13, 15, 24 July; 5 November 1855.

———. (3) *Histoire du second Empire, 1848–1869*. 6 vols. Paris, 1869–75.

Démy, Adolphe. *Essai historique sur les Expositions Universelles de Paris*. Paris, 1907.

Depping, Guillaume. *La Première exposition des produits de l'industrie française en l'an VI (1798)*. Paris, 1893.

Desnoyers, Fernand. "Du Réalisme." *L'Artiste*, 9 December 1855, 197–200.

Desnoyers, Louis. "Beaux-arts. Exposition Universelle." *Le Siècle*, 1 July; 1 August; 11 October; 1, 9 November 1855.

Doré, Gustave. "A Propos de l'Exposition." *Le Journal pour rire*, 23 June; 27 July; 1, 15 September 1855.

Dowd, David Lloyd. *Pageant-Master of the Republic. Jacques-Louis David and the French Revolution*. Lincoln, Nebraska, 1948.

DuCamp, Maxime. (1) *Les Beaux-arts à l'Exposition Universelle de 1855*. Paris, 1855.

———. (2) *Le Salon de 1857. Peinture. Sculpture*. Paris, 1857.

———. (3) *Les Beaux-arts à l'Exposition Universelle et aux Salons de 1863, 1864, 1865, 1866 & 1867*. Paris, 1867.

———. (4) *Souvenirs littéraires*. 2 vols. Paris, 1882.

———. (5) *Souvenirs d'un demi-siècle*. 2 vols. Paris, 1949.

Dumas, Alexandre. (1) "Exposition Universelle de 1855." *Le Mousquetaire*, 3, 10 June 1855.

———. Théophile Gautier, Arsène Houssaye, Paul de Musset, Louis Enault, Du Fayl. (2) *Paris et les Parisiens au XIXe siècle. Moeurs, arts et monuments*. Paris, 1856.

DuPays, Augustin-Joseph. "Beaux-arts. Exposition Universelle." *L'Illustration*, 2, 23, 30 June; 7, 14, 21, 28 July; 4, 18, 25 August; 1 September 1855.

Durande, Amédée. *Joseph, Carle et Horace Vernet, correspondance et biographies.* Paris, 1863.

Duret, Théodore. *Les Peintres français en 1867.* Paris, 1867.

Duval, Charles L. (1) *Exposition Universelle de 1855. L'Ecole française, palais Montaigne.* Paris, 1856.

——. (2) *Beaux-arts. Le Salon de 1868.* Meaux, 1868.

Enault, Louis. "Exposition Universelle." *Le Figaro,* 15 April; 6, 27 May; 3, 10, 17 June; 1 July 1855.

Endrei, Walter G. "The First Technical Exhibition." *Technology and Culture* 9 (April 1968): 181–83.

Etex, Antoine. *Essai d'une revue synthétique sur l'Exposition Universelle de 1855.* Paris, 1856.

Exposition. For official publications, see Bibliography Section 2.

Exposition populaire illustrée. 60 livraisons. Paris, 1867.

"Exposition Universelle de Londres en 1851." *Magasin pittoresque* 19 (1851): 139–42, 265–67, 303–304, 337–44, 371–74.

"Exposition Universelle de 1855." *Magasin pittoresque* (1855): 169–70, 209–16, 337–42, 369–70, 389, 401; (1856): 21–22, 41–44.

L'Exposition Universelle de 1867 illustrée. Publication internationale autorisée par la commission impériale. 1867.

"'L'Exposition Universelle des Beaux-Arts,' at Paris." *The Art Journal* (1855): 201–203.

Ferguson, E. S. "Technical Museums and International Exhibitions." *Technology and Culture* 1 (winter 1965): 30–46.

Ferry, Gabriel. "Notre Première exposition de l'industrie au XIXe siècle." *Revue politique et littéraire, Revue bleue,* 4e série, 13 (1900): 464–68.

ffrench, Y. *The Great Exhibition, 1851.* London, 1951.

Finkelstein, Louis. "On the Unpicturelikeness of Our Seeing." In *Perception and Pictorial Representation.* Calvin F. Nodine and Dennis F. Fisher, eds. New York, 1979.

Flachat, Stéphane. *L'Industrie. Exposition de 1834.* Paris, 1834.

Fontaine, André. "L'Origine des Salons." *Revue politique et littéraire, Revue bleue,* 14 May 1910, 625–30.

Fouquier, Henry, "Exposition Universelle. Beaux-arts." *L'Avenir national,* 18, 26 April; 16 May 1867.

Fournel, Victor. "Salon de 1857." *Le Correspondant* 41 (July 1857): 532–41; (August 1857): 735–52.

France. *Bulletin des lois.* 46 vols. Paris, 1848–70.

Fremy, Arnould. "M. Prudhomme à l'Exposition. Le Peinture française." *Le Charivari,* 23 October, 8 November 1855.

"French Criticism on British Art." *The Art Journal* (1855): 229–32.

Galichon, Emile. (1) "Exposition Universelle de 1867." *La Chronique des arts et de la curiosité,* 20 September 1866, 225–27.

——. (2) "La Mort de M. Ingres." *Gazette des beaux-arts,* 1 February 1867, 105–106.

——. (3) "Les Beaux-arts à l'Exposition Universelle." *Gazette des beaux-arts,* 1 May 1867, 409–14.

——. and Edouard de Beaumont. (4) "Collection de M. le cte de Nieuwerkerke." *Gazette des beaux-arts,* 1 May 1868, 409–30.

Gautier, Théophile. (1) "Avant l'ouverture." *Le Moniteur universel,* 29 March 1855.

——. (2) *Les Beaux-arts en Europe. 1855.* 2 vols. Paris, 1855–56.

——. (3) "Eugène Delacroix à l'Institut." *L'Artiste,* 18 January 1857, 81–83.

——. (4) "Salon de 1857." *L'Artiste,* 14, 21, 28 June; 5, 12, 19, 26 July; 2, 9, 16, 23, 30 August; 6, 13, 20 September; 4, 25 October; 1, 8, 15, 22 November 1857.

——. (5) "Salon de 1867." *Le Moniteur universel,* 3 June 1867.

——. (6) "Salon de 1868." *Le Moniteur universel,* 2, 3, 9, 11, 25, 26 May; 1, 2, 4 June; 8, 19 July 1868.

La Gazette pittoresque de l'Exposition Universelle, de l'industrie, des lettres et des arts. 1855.

Gebaüer, Ernest. *Les Beaux-arts à l'Exposition Universelle de 1855.* Paris, 1855.

Gérault, Georges. *Les Expositions Universelles, envisagées au point de vue de leurs résultats économiques.* Paris, 1902.

Gervais, A. "Les Expositions nationales et universelles, 1799–1889." *Revue politique et littéraire, Revue bleue,* 24 August 1889, 238–46.

Gibbs-Smith, C. H. ed. *The Great Exhibition of 1851. A Commemorative Album.* The Victoria and Albert Museum, London, 1950.

Gigoux, Jean. *Causeries sur les artistes de mon temps.* Paris, 1885.

Goncourt, Edmund and Jules de. *La Peinture à l'Exposition Universelle de 1855.* Paris, 1855.

Grand album de l'Exposition Universelle, 1867. 150 dessins par les premiers artistes de la France et de l'étranger. Paris, 1868.

Grangedor, J. (Jules Joly) "Le Salon de 1868." *Gazette des beaux-arts,* 1 June, 1 July 1868.

"The Great Exhibition." *Illustrated London News. Exhibition Supplement*, 24 May, 5 July; 9, 23 August; 11 October 1851.

Grothe, Gerda. *Le Duc de Morny*. Raymond Albeck, trans. Paris. 1967.

Guénée, Adolphe, Ch. Potier and Eug. Mathieu. *Dzing! Boum! Boum! Revue de l'Exposition en 3 actes et 16 tableaux*. Paris, 1855.

Guénot, Georges. (1) "Préliminaires de l'Exposition Universelle des beaux-arts." *Revue des beaux-arts* 5 (1854): 341–46.

——. (2) "Le Jury des beaux-arts de l'Exposition Universelle. Envois et refus." *Revue des beaux-arts* 6 (1855): 137–42.

——. (3) "Exposition Universelle des Beaux-Arts." *Revue des beaux-arts* 6 (1855): 157–60, 177–80, 429–34, 449–57.

Guiffrey, Jules. (1) *Livrets des expositions de l'Académie de Saint-Luc à Paris pendant les années 1751, 1752, 1753, 1756, 1762, 1764 et 1774, avec une notice bibliographique et une table*. Paris, 1872.

——. (2) *Histoire de l'Académie de Saint-Luc*. (*Archives de l'art français*, Nouvelle période IX). Paris, 1915.

Guyot de Fère, "Beaux-arts." *Journal des arts, des sciences et des lettres et de l'Exposition Universelle 1855*, January-February, 11 May, July 1855.

Gunzburg, Minda. "La Peinture française et la critique à l'Exposition Universelle de 1855." Thèse de l'Ecole du Louvre, Paris, 1970.

Hahn, Roger. *The Antomy of a Scientific Institution. The Paris Academy of Sciences 1666–1803*. Berkeley and Los Angeles, 1971.

Haskell, Francis. (1) *Rediscoveries in Art. Some Aspects of Taste, Fashion and Collecting in England and France*. Oxford, 1976.

——. ed. (2) *Saloni, gallerie, musei e loro influenza sullo sviluppo dell'arte dei secoli XIX e XX. Atti del XXIV Congresso Internazionale di Storia dell'Arte*. Bologna, 1981.

——. (3) "Enemies of Modern Art." *New York Review of Books*, 30 June 1983, 19–25.

Hautecoeur, Louis. "Delacroix et l'Académie des beaux-arts." *Gazette des beaux-arts*, December 1963, 349–64.

Hennequin, Amédée. "Coup d'oeil retrospectif sur l'Exposition Universelle de 1855." *Le Correspondant*, 25 February 1856.

Henriet, Frédéric. "Le Comte de Nieuwerkerke." *Le Journal des arts*, 21, 23 January 1893.

Hobhouse, Christopher. *1851 and the Crystal Palace*. London, 1950.

Holt, Edgar. *Plon-Plon: The Life of Prince Napoléon. 1822–1891*. London, 1973.

Holt, Elizabeth Gilmore. *The Art of All Nations 1850–1873. The emerging role of exhibitions and critics*. New York, 1981.

Horsin-Déon, Simon. *Rapport sur l'Exposition Universelle des Beaux-Arts lu le 17 juin 1855 à l'assemblée générale annuelle de la Société libre des beaux-arts*. Paris, 1855.

Ingres, Jean-Auguste-Dominique. 1867. Paris. *Catalogue des tableaux, études peintes, dessins et croquis de J. A. D. Ingres, peintre d'histoire, sénateur, membre de l'Institut, exposés dans les galeries du palais de l'Ecole impériale des beaux-arts*.

L'Institut de France. (1) *Procès-verbaux de l'Académie royale de peinture et de sculpture 1648–1792*. Anatole de Montaiglon, ed. 10 vols. Paris, 1875–81.

——. (2) *Lois, statuts et règlements concernant les anciennes Académies et l'Institut de 1635 à 1889*. Léon Aucoc, ed. Paris, 1889.

Isaac, Maurice. (1) *Les Expositions en France et dans le régime international*. Paris, 1928.

——. (2) *Les Expositions internationales*. Paris, 1936.

Isay, Raymond. *Panorama des Expositions Universelles*. Paris, 1937.

Ivoy, Paul d' (Charles de Leutre). "Exposition Universelle de 1855. Exposition des beaux-arts." *La Gazette pittoresque de l'Exposition Universelle, de l'industrie, des lettres et des arts*, 24 June 1855.

Jacquemart, Albert. "Les Cabinets d'amateurs à Paris. La Galerie de M. le duc de Morny." *Gazette des beaux-arts* 14 (January-June 1863): 289–306, 385–401.

Janin, Jules. "Les Représentants de la presse parisienne à Londres." *The Illustrated London News en français*, 10 May 1851, 19.

J. E. "L'Exposition de 1806." *Revue retrospective* 11 (1890): 97–114.

Jerrold, W. Blanchard. "The History of Industrial Exhibitions." *The Illustrated London News*, 21 June 1851, 372–73.

Journal des arts, des sciences et des lettres de l'Exposition Universelle, 1855.

Koch, Georg Friedrich. *Die Kunstausstellung*. Berlin, 1967.

Kristeller, Paul Oskar. "The Modern System of the Arts: A Study in the History of Aesthetics." *Journal of the History of Ideas* 12 (October 1951): 496–527; 13 (January 1952): 17–46.

Kurtz, Harold. *The Empress Eugènie 1826–1920.* London, 1964.

Laborde, Léon. *Application des arts à l'industrie.* See: 1851. France. Exposition Universelle de 1851. *Travaux de la Commission française sur l'industrie des nations.* 8 vols. Paris, 1856, VIII.

Lacroix, Paul. (1) "M. Ingres à l'Exposition Universelle de 1855." *Revue universelle des arts,* 1855, II: 202–14.

——. (2) "Académie de Saint-Luc." *Revue universelle des arts* 13 (1861): 322–35; 14 (1861–62): 172–96, 361–71; 15 (1862): 185–97, 309–18; 16 (1862–63): 108–109, 253–69, 297–315.

Lafenestre, Georges. "L'Art au Salon de 1868." *Revue contemporaine* 98 (1868): 503–33.

La Forge, Anatole de. *La Peinture contemporaine en France.* Paris, 1856.

La Gorce, Pierre de. *Histoire du second Empire.* 7 vols. Paris, 1894–1905.

Lagrange, Léon. (1) "Bulletin mensuel. La Mort de M. Ingres." *Gazette des beaux-arts,* 1 February 1867, 206–207.

——. (2) "Ingres." *Le Correspondant* 35 (May 1867): 33–76.

——. (3) "Les Beaux-arts en 1867. L'Exposition Universelle. Le Salon." *Le Correspondant* 35 (August 1867): 992–1024; 36 (September 1867): 84–114.

Lapauze, Henry. *Ingres, sa vie et son oeuvre, 1780–1867.* Paris, 1911.

La Rochenoire, Julien de. *Exposition Universelle des Beaux-Arts. Le Salon de 1855 apprécié à sa juste valeur pour un franc.* 2 vols. Paris, 1855.

Lasteyrie, Ferdinand de. "Salon de 1868." *L'Opinion nationale.* 11, 18, 29 May; 8, 13, 20, 21, 26 June 1868.

Laurent-Jan. "M. Ingres, peintre et martyr." *Le Figaro,* 30 December 1855, 2–7. Reprinted in Laurent-Jan. *Légendes d'atelier.* Paris, 1859.

Lavergne, Claudius. *Exposition Universelle de 1855. Beaux-arts.* Paris, 1855.

Leith, James A. *The Idea of Art as Propaganda in France 1750–1799.* Toronto, 1965.

Leroi, Paul. "Le Musée de la Bibliothèque royale de Belgique." *L'Art* 59 (1894–1900), 2e série, IV: 893–905.

Leroy, Alfred. *L'Impératrice Eugénie.* Paris, 1964.

Leroy, Louis. "Salon de 1857." *Journal artistique,* 5, 12, 26 July; 16, 30 August 1857.

Lespinasse, René de, ed. *Les Métiers et corporations de la ville de Paris, XIVe–XVIIIe siècle (Histoire générale de Paris),* 3 vols. Paris, 1886.

Lethève, Jacques. "La Connaissance des peintres préraphaélites anglais en France (1855–1900)." *Gazette des beaux-arts* 53 (May–June 1959): 315–28.

Locquin, Jean. *La Peinture d'histoire en France de 1747 à 1785.* Paris, 1912.

Loudun, Eugène (Eugène Balleyguier). (1) *Le Salon de 1855.* Paris, 1855.

——. (2) *Le Salon de 1857.* Paris, 1857.

Louvrier de Lajolais, A. "Exposition Universelle." *La Chronique des arts et de la curiosité.* 14 April 1867, 115.

Luckhurst, Kenneth W. *The Story of Exhibitions.* London and New York, 1951.

Maglin, E. "Le Palais de l'Industrie." *La Nature,* 1897, II: 183–86.

Mainardi, Patricia. (1) "Gustave Courbet's Second Scandal: *Les Demoiselles de Village.*" *Arts Magazine* 53 (January 1979): 95–109.

——. (2) "Edouard Manet's 'View of the Universal Exposition of 1867'." *Arts Magazine* 54 (January 1980): 108–15.

——. (3) "The Eiffel Tower and the English Lighthouse." *Arts Magazine* 54 (March 1980): 141–44.

——. (4) "The Death of History Painting in France, 1867." *Gazette des beaux-arts,* December 1982, 219–26.

——. (5) "French Sculpture, English Morals: Clésinger's *Bacchante* at the Crystal Palace, 1851." *Gazette des beaux-arts,* December 1983, 215–20.

——. (6) "Report from Paris. Eighty-Nine Eighty-sixed." *Art in America,* February 1984, 33–37.

——. (7) "The Political Origins of Modernism." *Art Journal,* spring 1985, 11–17.

——. (8) "The Unbuilt Picture Gallery at the 1851 Great Exhibition." *Journal of the Society of Architectural Historians,* 45 (September 1986): 294–99.

——. (9) "Art and the State: The Décennale in Nineteenth Century France." *American Historical Association Proceedings, 1985.* University Microfilms, Ann Arbor, Michigan, 1986.

——. (10) "The Eviction of the Salon from the Louvre." *Art Journal,* (forthcoming 1988).

Malitourne, Pierre. "Sculpteurs contemporains; Le comte Emilien de Nieuwerkerke," *L'Artiste,* 3 August 1856, 57–60.

Manet, Edouard. (1) 1867. Paris. *Catalogue des tableaux de M. Edouard Manet exposés avenue de l'Alma en 1867*, Paris.

———. (2) 1983. Grand Palais, Paris. *Manet, 1832–1883*.

Mantz, Paul. (1) "Salon de 1855." *La Revue française* 2 (1855): 21–29, 69–80, 122–34, 165–77, 219–29, 257–68, 358–71, 457–66, 510–21, 598–608.

———. (2) "Salon de 1857." *La Revue française* 9 (1857): 422–31, 491–501, 558–69; 10 (1857): 43–55, 118–28, 178–89.

———. (3) "Exposition de Manchester." *La Revue française* 9 (1857): 357–75.

———. (4) "L'Enseignement des arts industriels avant la Revolution." *Gazette des beaux-arts*, 1 March 1865, 229–47.

———. (5) "Le Salon de 1867." *Gazette des beaux-arts*, 1 June 1867, 513–48.

———. (6) "Les Beaux-arts à l'Exposition Universelle." *Gazette des beaux-arts*, 1 July, 1 August, 1 September, 1 October 1867.

———. (7) "Exposition Universelle. Beaux-arts." *L'Illustration*, 2, 16, 23 November 1867.

———. (8) "Le Salon de 1868." *L'Illustration*, 2, 7, 16, 23, 30 May; 6, 11, 13, 20, 27 June 1868.

Marcelin (Emile Planat). "Le Public à l'Exposition. Types, impressions et menus propos." *Le Journal pour rire*, 17 November 1855.

Masson, Frédéric. "La Princesse Mathilde. Artiste et amateur." *Les Arts* 29 (May 1904): 2–8.

Mazade d'Avèze. *Idée première de l'Exposition de l'industrie française, an V de la République (1797)*. Paris 1845.

Mercey, Frédéric Bourgeois de. (1) "L'Exposition Universelle des Beaux-Arts en 1855." *Revue contemporaine* 31 (1857): 466–94.

———. (2) *Etude sur les beaux-arts depuis leur origine jusqu'à nos jours*. 3 vols. Paris, 1855–57.

Le Mercure galant, September 1699, 224–27 (1699 exposition).

Merson, Olivier. *Ingres, sa vie et ses oeuvres*. Paris, 1867.

Mitchell, P. "Success of Alfred Stevens at the Exposition Universelle of 1867." *The Connoisseur*, April 1970, 263–64.

Moléon, Gabriel-Victor de, Cochaud and Paulin-Desormeaux. *Musée industriel. Description complète de l'Exposition des produits de l'industrie française faite en 1834*. 4 vols. Paris, 1835–38.

Montaiglon, Anatole de, ed. (1) *Memoires pour servir à l'histoire de l'Académie royale de peinture et de sculpture depuis 1648 jusqu'en 1664*. 2 vols. Paris, 1853.

———. (2) "Salon de 1857." *Revue universelle des arts* 5 (30 August 1857): 533–58.

Montifaud, Marc de (Marie-Amélie Chatroule de Montifaud). "Le Salon de 1867." *L'Artiste*, 1 May, 1 June, 1 July, 1 August 1867.

Mosby, Dewey F. *Alexandre-Gabriel Decamps 1803–1860*. 2 vols. New York and London, 1977.

Mouton, Ch. "Bulletin de l'Exposition Universelle." *La Gazette pittoresque de l'Exposition Universelle, de l'industrie, des lettres et des arts*, 14 June 1855, 5.

Musée français-anglais. Journal d'illustrations mensuelles. January–December 1855.

Nadar (Gaspard-Félix Tournachon). (1) "Revue du trimestre." *Journal pour rire*, 14 April, 13 October 1855, 5 January 1856.

———. (2) "Salon de 1855." *Le Figaro*, 19, 26 août; 9, 16, 23 September; 14 October; 4 November 1855.

———. (3) *Nadar jury au Salon de 1857*. Paris, 1857.

Prince Napoléon. See Bibliography Section 2: 1855. Paris.

Raoul de Navery (Eugénie-Caroline Saffrey Chervet). *Le Salon de 1868*. Paris, 1868.

Neufchâteau, François de. See Bibliography Section 2: 1798–1800. France, Ministère de l'Intérieur.

Niel, Georges. *Le Paysage au Salon de 1857*. Paris, 1857.

Nochlin, Linda. (1) *Realism*. Baltimore, Md., 1971.

———. (2) "The Imaginary Orient." *Art in America*, May 1983, 118–30, 187–91.

Norma, Ch. "Le Salon." *Le Hanneton illustré, satirique et littéraire*, 21, 28 May; 18, 25 June 1868.

Ozouf, Mona. *La Fête revolutionnaire, 1789–1799*. Paris, 1976.

Ory, Pascal. *Les Expositions Universelles de Paris*. Paris, 1982.

Le Palais de cristal. Journal illustré de l'Exposition de 1851. 1851.

Le Palais de l'Exposition. Revue hebdomadaire illustrée. 1855.

Palma, Etienne. "Le Salon de 1868." *Revue de Paris* n.s. 11 (1868): 219–43, 412–38; n.s. 12 (1868): 78–100.

1683. Paris. *Explication des modeles des machines et forces mouvantes, que l'on expose à Paris dans la rüe de la Harpe, vis-à-vis Saint Cosme, Paris*.

1974. Grand Palais, Paris. *Le Musée du Luxembourg en 1874*.

1974–75. Grand Palais, Paris. Detroit Institute of Art, Metropolitan Museum of Art, New York. *French Painting 1774–1830. The Age of Revolution*. Detroit, 1975.

1983. Musée des arts décoratifs, Paris. *Le Livre des Expositions Universelles 1851–1989*.

Paris dans sa splendeur. Monuments, vues, scènes historiques, descriptions et histoire. 3 vols. Paris, 1863.

Paris-Guide, par les principaux écrivains et artistes de la France. 2 vols. 1867.

Parturier, Maurice. *Morny et son temps*. Paris, 1969.

Paul-Pierre (Paul Périer). *Un Chercheur au Salon. 1868. Peinture. Les Inconnus. Les Trop peu connus. Les Méconnus. Les Nouveaux et les jeunes*. Paris, 1868.

Peisse, Louis. "Beaux-arts. Exposition Universelle." *Le Constitutionnel*, 29 April; 25 May; 14, 17, 26 June; 17 July; 13, 27 November; 11 December 1855.

Pelletan, Eugène. "Exposition de peinture." *Courrier de Paris*, 10, 19, 24 July; 1, 7, 18, 29 August; 4, 6, 20, 24, 25 September 1857.

Pellisson and d'Olivet (Paul Pellisson-Fontaine and l'abbé d'Olivet). *Histoire de l'Académie françoise*. 2 vols. Paris, 1858.

Pelloquet, Théodore. (1) "A Travers le Salon de 1857." *Gazette de Paris*, 21 June; 5, 19, 26 July; 2, 9, 16, 23 August 1857.

———. (2) "Exposition Universelle de 1867. Beaux-arts." *Le Monde illustré*, 13, 20, 27 July; 3, 10, 17, 24 August; 7, 14, 21, September; 12, 19, 26 October; 9 November 1867.

Pérignon, Alexis-Joseph. (1) *A Propos de l'Exposition de peinture*. Paris, 1856.

———. (2) *Lettre de M. Pérignon sur la nécessité de transformer l'organisation de l'exposition des beaux-arts*. Paris, July 1866.

———. (3) *Deux expositions des beaux-arts*. Paris, 1866.

Perrier, Charles. (1) "Exposition Universelle des Beaux-Arts." *L'Artiste*, 13, 20, 27 May; 3, 10, 17, 24 June; 1, 8, 15, 22, 29 July; 5, 12, 19, 26 August; 9, 16, 23 September; 28 October; 4 November 1855.

———. (2) "Du Réalisme. Lettre à M. le Directeur de *L'Artiste*." *L'Artiste*, 14 October 1855, 85–90.

———. (3) *L'Art français au Salon de 1857*. Paris, 1857.

Petroz, Pierre. (1) "Exposition Universelle des Beaux-Arts." *La Presse*, 2, 30 May; 5, 11, 19, 26 June; 4, 9, 16, 23, 31 July; 7, 13, 21, 27 August; 3, 10, 17 September 1855.

———. (2) "Salon de 1868." *Revue moderne* 46, 10 May 1868, 353–63; 25 May 1868, 535–49.

Pevsner, Nikolaus. *Academies of Art Past and Present*. Cambridge, England, 1940.

Philadelphia Museum of Art, Detroit Institute of Arts, Grand Palais, Paris. *The Second Empire 1852–1870. Art in France under Napoleon III*.

Pigéory, Félix. "Envois à l'Exposition Universelle des Beaux-Arts." *Revue des beaux-arts* 6 (1855): 97–100, 116–20.

Pinkney, David H. *Napoleon III and the Rebuilding of Paris*. Princeton, 1958.

Planche, Gustave. (1) "Exposition des beaux-arts." *Revue des deux-modes*, 1, 15 August; 15 September; 1, 15 October 1855.

———. (2) "Salon de 1857." *Revue des deux-mondes*, 15 July, 15 August 1857.

Plessis, Alain. *De la fête impériale au mur des fédérés, 1852–1871. (Nouvelle histoire de la France contemporaine 9)*. Paris, 1979.

Plinval-Salgues, Régine de. "Bibliographie des expositions industrielles et commerciales en France, depuis l'origine, jusqu'à 1867." I.N.T.D., Conservatoire national des arts et métiers, Paris, 1959.

Plum, Werner. *World Exhibitions in the Nineteenth Century. Pagaents of Social and Cultural Change*. Lux Furtmüller, trans. Bonn and Bad Godesburg, 1977.

Pointon, Marcia. "'From the Midst of Warfare and its Incidents to the Peaceful Scenes of Home': The Exposition Universelle of 1855." *Journal of European Studies* 2 (December 1981): 233–61.

Poirier, René. *Des Foires, des peuples, des expositions*. Paris, 1958.

Poulain, Gaston. *Bazille et ses amis*. Paris, 1932.

"La Première exposition de peinture au Louvre, en 1699." *Magasin pittoresque* (18 September 1850): 305–307.

Prévost-Paradol, Lucien Anatole. *Revue de l'histoire universelle*. Paris, 1854.

Quillenbois. "La Peinture réaliste de M. Courbet." *L'Illustration*, 21 July 1855, 52.

Randon, G. "L'Exposition d'Edouard Manet." *Journal amusant*, 29 June 1867.

Raymon. *Les Beaux-arts en 1867*. Paris, 1867.

Réalisme. Jules Assezat and Edmond Duranty, eds. 10 July 1856.

Rebérioux, Madeleine. "Approches de l'histoire des expositions universelles à Paris du Second Empire à 1900." *Bulletin du centre d'histoire économique et sociale de la region Lyonnaise* 1 (1979): 1–17.

Reff, Theodore. *Manet and Modern Paris.* National Gallery of Art, Washington, D.C., 1982.

Regnier, Noël. *Revue et examen des expositions nationales et internationales en France et à l'étranger depuis 1798 jusqu'à 1878.* Paris, 1878.

Renan, Ernest. "La Poesie de l'Exposition." *Journal des débats,* 27 November 1855. Reprinted in *Oeuvres complètes de Ernest Renan.* Henriette Psichari, ed. 10 vols. Paris, n.d. II:239–51.

Révillon, Tony. "Le Salon de 1868." *La Petite presse,* 3, 9, 17 May; 21 June 1868.

Revue illustrée de l'Exposition Universelle de 1867. 1867.

Rewald, John. *The History of Impressionism.* 4th rev. ed. Greenwich, Conn. 1973.

Rey, Jean. *Mémoire sur la nécessité de bâtir un édifice spécialement consacré aux expositions générales des produits de l'industrie.* Paris, 1827.

Roberts-Jones, Philippe. "Opinion de quelque critiques sur la peinture française à l'occasion de l'Exposition Universelle de 1855." Thèse de doctorat: Thèse annexe, Université libre de Bruxelles, 1954.

Rodee, H. D., "France and England: Some mid-Victorian views of one another's painting." *Gazette des beaux-arts,* January 1978, 39–48.

Rosen, Charles and Henri Zerner. *Romanticism and Realism.* New York, 1984.

Rosenthal, Léon. *Du Romantisme au réalisme.* Paris, 1914.

Rousseau, Théodore. (1) 1867. Paris. *Notice des études peintes par M. Théodore Rousseau exposées au Cercle des Arts, Paris, juin 1867.*

——. (2) "Correspondance." *Le Figaro,* 16–17 August 1867; "Nouvelles." *La Chronique des arts et de la curiosité,* 20 August 1867, 220–21.

——. (3) 1967–68. Musée du Louvre, Paris. *Théodore Rousseau 1812–1867.*

S. "Lettres sur l'Exposition Universelle des Beaux-Arts à Paris." *La Revue universelle des arts,* 15 June, 15 July, 15 August, 15 September, 15 November, 15 December 1855; 15 January, 15 February 1856.

Saint-Santin, M. de (Philippe de Chennevières). "M. Heim." *Gazette des beaux-arts,* 1 January 1867, 40–62.

Saint-Victor, Paul de. (1) "Salon de 1857." *La Presse,* 26 June; 10, 11, 18, 26 July; 4, 11, 16, 29, 30 August; 27 September 1857.

——. (2) "Salon de 1867." *La Presse,* 9, 23 May; 8, 26 June; 8 July 1867.

——. (3) "Salon de 1868." *La Liberté,* 10, 13, 19, 29 May; 4, 13, 21, 30 June; 7 July 1868.

Sensier, Alfred. *Souvenirs sur Th. Rousseau.* Paris, 1872.

Silvestre, Théophile. (1) *Histoire des artistes vivants, français et étrangers, études d'après nature.* Paris, 1855–56.

——. (2) *A Messieurs de la Cour Impériale de Paris. Première chambre. Audience de mardi, 7 juillet 1857. Mémoire de Théophile Silvestre contre Horace Vernet.* Paris, 1857.

——. (3) "Les Artistes vivants au Champ-de-Mars et aux Champs-Elysées." *Le Figaro,* 21 April; 4, 14, 15, 21 May 1867.

——. (4) "Funérailles de Th. Rousseau à Barbizon." *Le Figaro,* 26 December 1867.

Simian, Charles. *François de Neufchâteau et les expositions.* Paris, 1889.

Sloane, Joseph C. *French Painting Between the Past and the Present. Artists, Critics and Traditions from 1848 to 1870.* Princeton, N. J., 1951.

Soubies, Albert. *Les Membres de l'Académie des beaux-arts depuis la fondation de l'Institut.* 2e série: *1816–1852;* 3e série: *1852–1876.* Paris, 1906–11.

Spencer, Eleanor P. "The Academic Point of View in the Second Empire." In *Courbet and the Naturalistic Movement.* George Boas, ed. Baltimore, Md., 1938, 58–72.

Swart, Koenraad W. (1) "'Individualism' in the Mid-Nineteenth Century (1826–1860)." *Journal of the History of Ideas* 23 (January–March 1962): 77–90.

——. (2) *The Sense of Decadence in Nineteenth-Century France.* The Hague, 1964.

Tabarant, Adolphe. *La Vie artistique au temps de Baudelaire.* Paris, 1942.

Tamir. *Les Expositions internationales à travers les âges.* Paris, 1939.

Tardieu, Alexandre. "L'Exposition Universelle des Beaux-Arts." *Le Constitutionnel,* 7, 14, 21, 28 August; 4, 25 September 1855.

Thierry, Edouard. "Exposition Universelle de 1855. Beaux-arts." *Revue des beaux-arts,* 202–205, 227–30, 247–51, 268–72, 286–89, 308–12, 327–31, 347–51, 373–77, 392–98, 411–14, 434–38.

Thoré, Théophile. (1) *Trésors d'art exposés à Manchester en 1857 at provenant des collections royales, des collections publiques et des collections particulières de la Grande-Bretagne par W. Bürger.* Paris, 1857.

——. (2) *Salons de T. Thoré. 1844, 1845, 1846, 1847, 1848,* Paris, 1868.

———. (3) *Salons de W. Bürger, 1861 à 1868, avec une préface par T. Thoré.* 2 vols. Paris, 1870.

Tintamarre-Salon. Exposition des beaux-arts de 1868. Paris, 1868.

Tourneux, Maurice. *Salons et expositions d'art à Paris (1801–70), essai bibliographique.* Paris, 1919.

Trapp, Frank Anderson. (1) "The Universal Exhibition of 1855." *The Burlington Magazine* 107 (June 1965): 300–305.

———. (2) "Expo' 1867 Revisited." *Apollo*, February 1969, 112–31.

Valon, Alexis de. "Le Tour du monde à l'Exposition de Londres." *Revue des deux-mondes*, 15 July 1851, 193–228.

Vermersch, Eugène. "Courbet." *Le Hanneton illustré, satirique et littéraire*, 13 June 1867.

———. "A Propos du Salon." *Le Hanneton illustré, satirique et littéraire*, 14 May 1868.

Véron, Dr. Louis-Désiré. (1) *Mémoires d'un bourgeois de Paris.* 6 vols. 1853–55.

———. (2) *Nouveaux mémoires d'un bourgeois de Paris.* Paris. 1866.

Vervynk, D. and E. Dubois. *Histoire des expositions industrielles depuis 1798 jusqu'à nos jours.* Paris, 1867.

Viel-Castel, le comte Horace de. (1) "L'Exposition Universelle. Beaux-arts." *L'Athenaeum français*, 19 May; 2, 16 June; 7 July, 11 August, 6 October 1855.

———. (2) *Mémoires du comte Horace de Viel-Castel sur le règne de Napoléon III, 1851–1864.* L. Léouzon Le Duc, ed. 6 vols. Paris, 1883–84.

Vignon, Claude (Noémi Cadiot). *Exposition Universelle de 1855. Beaux-arts.* Paris, 1855.

Villarceaux, X. de. "Les Prix de 1867." *L'Artiste*, 1 September 1867, 429–41.

Villemessant, Hippolyte de. "Feuilleton du Figaro." *Le Figaro*, 30 December 1855.

Vitet, Louis. *L'Académie royale de peinture et de sculpture, étude historique.* Paris, 1861.

White, Harrison C. and Cynthia A. White. *Canvases and Careers: Institutional Change in the French Painting World.* New York, 1965.

Williams, Roger L. *Gaslight and Shadow. The World of Napoleon III, 1851–1870.* New York, 1957.

Willoch, Sigurd. "Edouard Manets 'Fra Verdensutstillingen, Paris 1867'." *Konsthistorisk tidskrift* 45 (December 1976): 101–108.

Zeldin, Theodore. (1) *The Political System of Napoleon III.* London, 1958.

———. (2) *France 1848–1945.* 2 vols. Oxford, 1977.

Zola, Emile. (1) *Ed. Manet, Etude biographique et critique.* Paris, 1867.

———. (2) "Causerie." *La Tribune*, 20 December 1868, 7.

———. (3) *Salons.* F. W. J. Hemmings and Robert J. Niess, eds. Geneva and Paris, 1959.

———. (4) *Correspondance.* B. H. Bakker, ed. 4 vols. Montreal and Paris, 1978–83. I: *1867.*

Photographic Acknowledgments

Photographs have been supplied by and reproduced courtesy of owners, with the exception of the following:

Alinari, Florence, 100; Alinari-Giraudon, 52; Bulloz, Paris, 15, 63; Caisse Nationale des Monuments Historiques et des Sites, Paris, 114; Foto Marburg, 105; Giraudon, Paris, 71, 83, 125; Lauros-Giraudon, Paris, 18, 39, 41, 48; Felix Nadar/© Arch. Phot. Paris/S.P.A.D.E.M., 117; Roger-Viollet, Paris, 80.

Index

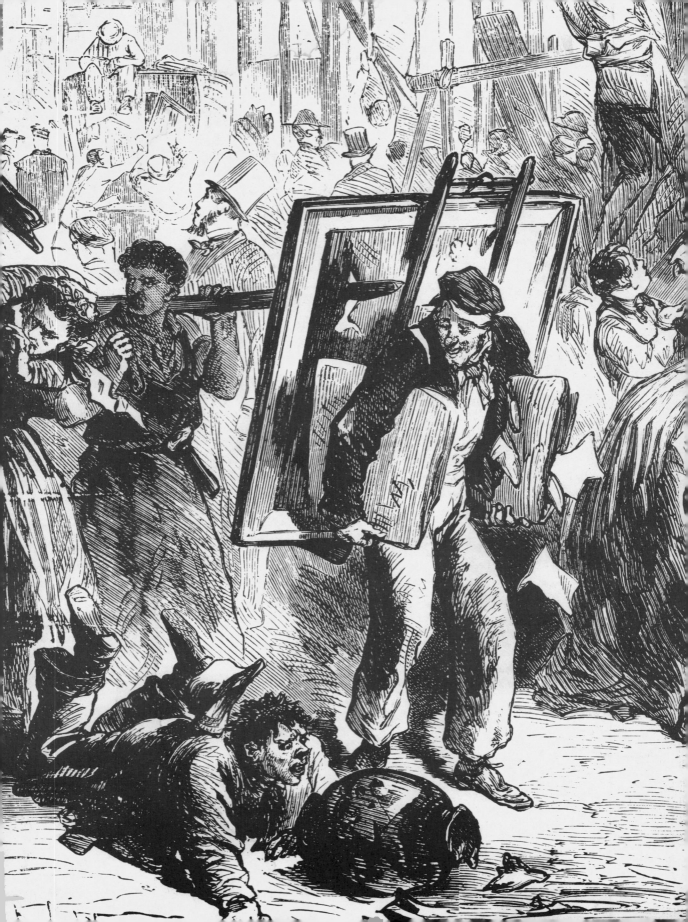